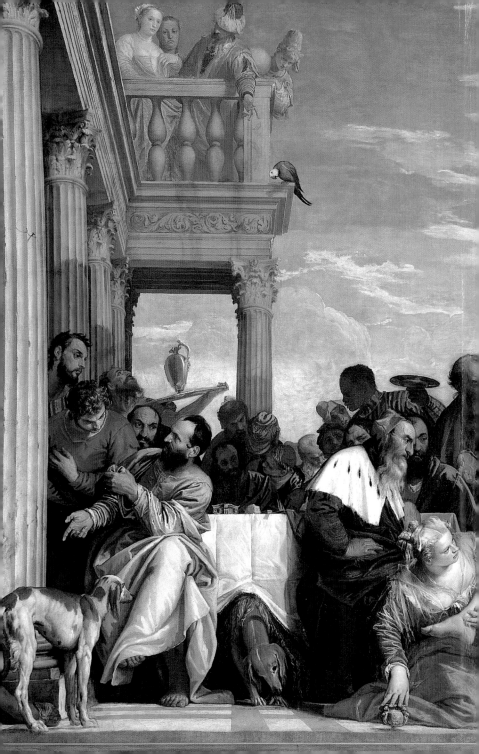

Silvia Malaguzzi

Food and Feasting in Art

Translated by Brian Phillips

The J. Paul Getty Museum
Los Angeles

A Guide to Imagery

Italian edition © 2006 by Mondadori Electa S.p.A., Milan
All rights reserved. www.electaweb.it

Series Editor: Stefano Zuffi
Original Graphic Design: Anna Piccarreta
Original Layout: Paola Forini
Original Editing: Chiara Guarnieri
Original Image Research: Marta Alvarez, Irene Giannini
Original Technical Coordinator: Andrea Panozzo
Original Quality Control: Giancarlo Berti

English translation © 2008 J. Paul Getty Trust

First published in the United States of America in 2008 by
The J. Paul Getty Museum

Getty Publications
1200 Getty Center Drive, Suite 500
Los Angeles, California 90049-1682
www.getty.edu

Mark Greenberg, *Editor in Chief*

Ann Lucke, *Managing Editor*
Mollie Holtman, *Editor*
Robin H. Ray, *Copy Editor*
Pamela Heath, *Production Coordinator*
Hespenheide Design, *Designer and Typesetter*

Printed in Hong Kong

Library of Congress Cataloging-in-Publication Data
Malaguzzi, Silvia
[Cibo e la tavola. English]
Food and feasting in art/Silvia Malaguzzi ; translated by Brian Phillips.
 p. cm.
Includes indexes.
ISBN 978-0-89236-914-0 (pbk.)
1. Food in art—Dictionaries—Italian. 2. Dinners and dining in
art—Dictionaries—Italian. I. Title.
 N8217.F64M2513 2008
 704.9'49641-DC22

 2007026824

Page 2: Paolo Veronese, *The Feast in the House of
Simon* (detail), 1556. Turin, Galleria Sabauda.

Contents

7 Food in the Figurative Context

43 From Allegory to Still Life

65 The Places and Rituals of Dining

119 Food and Drink

315 The Dining Table and Its Furnishings

380 General Index

381 Index of Artists

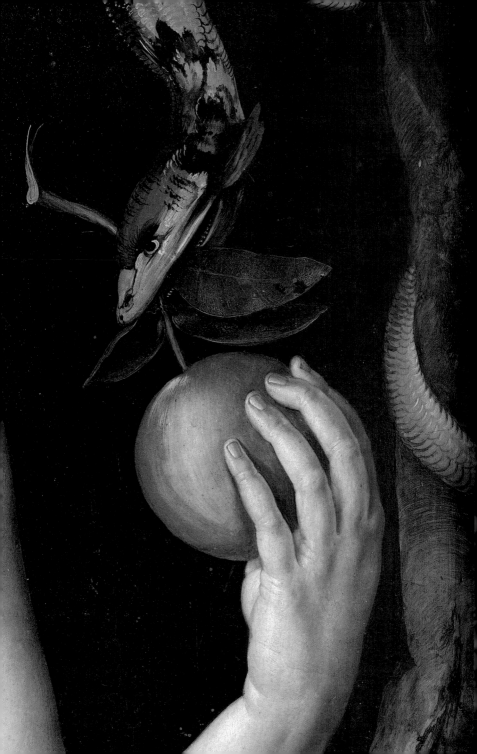

FOOD IN THE FIGURATIVE CONTEXT

Old Testament
Original Sin
Belshazzar's Feast
The Gathering of the Manna
The Feast of Absalom
The Banquet of Esther and Ahasuerus

New Testament
The Feast of Herod
Christ in the House of Simon
Christ in the House of Martha and Mary
The Feast in the House of Levi
The Marriage at Cana
The Parable of the Wedding Banquet
The Last Supper
The Supper at Emmaus

Lives of the Saints
Saint Hugh in the Carthusian Refectory
The Miracles of Saint Benedict
The Feast of Saint Gregory the Great

Mythology
The Feast of the Gods
Philemon and Baucis
The Battle of the Lapiths and Centaurs

Literature and History
Plato's Banquet
The Banquet of Cleopatra
The Story of Nastagio degli Onesti

◄ Albrecht Dürer, *Eve* (detail), ca. 1507.
Madrid, Prado.

In this first reference to food in the Old Testament, eating is associated with sin. At the same time, swallowing food came to be seen as an act of consciousness.

Original Sin

Sources
Genesis 3:1–6

Iconography
This Old Testament episode is one of the most frequently represented in both painting and sculpture from the Middle Ages onward

When God created the world and man, he placed the latter in the Garden of Eden, where there were trees of every kind. They were pleasing to look at and laden with delicious fruit. In the midst of the garden were the tree of life and the tree of knowledge of good and evil. God gave Adam permission to eat the fruit of every plant except that of the tree of knowledge, declaring that if he disobeyed he would surely die. Then God created woman as a companion for man. The serpent, craftiest of all creatures, asked Eve whether God had denied them the right to eat the fruit of all the trees in the garden. To this Eve replied that the only prohibited tree was in the inner garden and that eating its fruit would be lethal. But the serpent told her not to heed the Creator's warning, arguing that God was acting not from a desire to protect Adam and Eve but from fear that if they ate the fruit, they would possess knowledge of good and evil and would thus become like God. Eve, persuaded by the serpent's logic, tasted the fruit of the prohibited tree and found it so delicious that she offered some to Adam. Their eyes were immediately opened and, realizing that they were naked, they tried to cover their nakedness with leaves. When God discovered their disobedience and guilt, he banished them from Eden.

► Peter Paul Rubens,
Adam and Eve, 1598.
Antwerp, Rubenshuis
Museum.

This feast is an explicitly pagan celebration. When it is interrupted by a terrifying manifestation of God, its sacrilegious nature is laid bare.

Belshazzar's Feast

In the 6th century B.C., Belshazzar, son of Nebuchadnezzar, was king of Babylon. One day he invited his lords to a formal banquet. As the wine flowed, he ordered that gold and silver drinking vessels that his father had taken from the temple in Jerusalem be brought in for his guests, wives, and concubines. As they were imbibing wine from these precious vessels and praising the pagan gods, a disembodied hand appeared and wrote words in a mysterious language on the wall of the banquet hall. The terrified king sought someone who could decipher the mysterious writing. The queen recalled the name of Daniel, a wise man who had lived in the kingdom since the reign of Nebuchadnezzar. Daniel was offered great power and riches if he could decipher the message on the wall. The prophet rejected the bribe but nevertheless deciphered the disquieting message. He reminded the king that his severe, arrogant father, Nebuchadnezzar, had been ignominiously deposed, and he rebuked Belshazzar for sacrilegiously drinking from the vessels from the house of God and worshipping pagan gods instead of God Almighty. Consequently, said Daniel, God was using this written message to announce the end of the king's reign, that he had been judged and found wanting, and that his kingdom would be divided between the Medes and Persians. That same night Belshazzar was killed, and Darius the Persian took over his kingdom.

Sources
Daniel 5:1–30

Iconography
This subject is treated only rarely in art, though it had a vogue in Italian and Flemish painting of the 16th and 17th centuries. It offered artists the chance to deploy the theatrical style of contemporary painting to create the uncanny atmosphere of a historical miracle

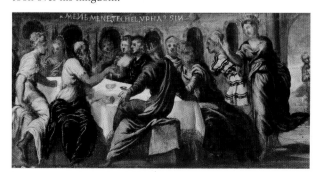

◀ Tintoretto, *Belshazzar's Feast*, ca. 1541–42. Verona, Castelvecchio.

Among Christians, this subject is an Old Testament precedent for Holy Communion. Here food is an instrument of Divine Providence, sent to save the lives and souls of the faithful.

The Gathering of the Manna

Sources
Exodus 16:1–32

Iconography
Among Old Testament stories rendered in art, the gathering of the manna is not a very common iconographical subject and appears to be confined to certain geographical areas. It is found principally in 15th- to 18th-century painting

The Israelites journeying under the leadership of Moses had left Egypt and now found themselves in the Wilderness of Sin, without food or any chance of obtaining it. So they rose up against Moses and Aaron, the high priest, demanding to know why the Lord had not caused them to die in Egypt, where they could still eat their fill, whereas here they would certainly die of starvation. The Lord heard their complaints and, speaking to Moses, promised that every day he would cause enough bread to rain down from heaven to satisfy every member of the congregation of Israel. So Moses gathered his people together and reported what God had told him. He announced that from now on there would be meat at twilight and bread in the morning for everyone. That evening, a flock of quails alighted at the camp, and in the morning, when the ground was covered with dew, the Israelites found the Lord's "bread," "a fine flake-like thing, fine as hoarfrost on the ground." As God had bade them, every day

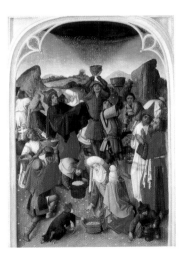

▶ Master of the Gathering of the Manna, *The Gathering of the Manna*, 1470. Douai, Musée de la Chartreuse.

each person gathered enough for his or her daily needs. God arranged that on the sixth day the people should gather twice as much, so that on the day of rest none need be gathered. The bread looked like coriander seed but tasted like wafers made with honey and was called manna. The Israelites lived on this substance for forty years, until they reached the land of Canaan.

During a feast, wine deprives Amnon of any ability to resist. His weakness allows Absalom to carry out his scheme of revenge.

The Feast of Absalom

King David's son Absalom had an attractive sister, Tamar, as well as a half-brother named Amnon, the eldest of David's sons. Amnon fell in love with Tamar and one day enticed her into his bedroom, where he took advantage of her and then cast her off. Others learned of this outrage. David was grieved and angry but did nothing to punish his own son. Absalom felt that the rape should be kept secret, but he developed a simmering rancor toward Amnon because of his unworthy behavior. Two years went by and Absalom devised a scheme for revenge. One day during sheepshearing, Absalom arranged a feast, to which Amnon was invited. Absalom ordered his servants to watch his brother closely and to report when he was sufficiently drunk to be incapable of resisting assault. When the time came, the servants were ordered to kill Amnon, as revenge for the loss of Tamar's honor. Absalom fled the scene, and David, overwhelmed with grief at the death of his son, spent three years in mourning.

Sources
2 Samuel 13

Iconography
This is a rare iconographical subject but seems to appear more frequently in the 17th century, when the pictorial language of the time was congenial to theatrical banquet scenes and there was a taste for crude violence and dramatic events

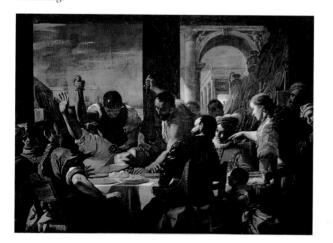

◄ Mattia Preti, *The Feast of Absalom*, ca. 1657. Naples, Museo di Capodimonte.

A convivial feast gives Esther a chance to defend her people. It provides a period of relaxed intimacy that allows her to gain the favor and the ear of King Ahasuerus.

The Banquet of Esther and Ahasuerus

Sources
Esther 5:4–8

Iconography
Esther's banquet is depicted less often than her meeting with Ahasuerus. As with the other feasts in the Old Testament and the Gospels, it was especially favored by court painters and the prestigious personalities who placed commissions with them, because it provided a pretext for representing scenes of luxury

▼ Giorgio Vasari, *The Banquet of Esther and Ahasuerus*, ca. 1548. Arezzo, Museo Statale di Arte Medievale e Moderna.

In the 5th century B.C., King Ahasuerus ruled over 127 provinces, from India to Ethiopia. After repudiating his wife, Vashti, the king chose Esther, a beautiful Jewish woman whom her guardian, Mordecai, had offered in marriage to the king. Mordecai ordered Esther not to reveal that they were both Jewish. In time, Esther gained the favor and love of the king. One day, an anti-Semite called Haman was promoted to a high position among the princes and immediately took a strong dislike to Mordecai, who was not under his authority. Out of spite toward Mordecai, Haman told Ahasuerus that among his subjects was a scattered people who threatened the unity of his rule because they avoided common observances. Ahasuerus gave Haman full authority to act, and he began to persecute the Jews. In desperation, Mordecai and Esther appealed to God to spare their people, and after days of prayer, Esther decided to beg the king for mercy. To her surprise, she was warmly received, and, summoning her courage, she invited her future husband and Haman himself to two successive splendid banquets. At the second, Esther revealed that she was Jewish, and that she, Mordecai, and the Jewish people were the objects of fierce persecution on the part of Haman. Ahasuerus listened and was both surprised and indignant at what was taking place in his kingdom. He moved immediately against Haman, saving Esther's people.

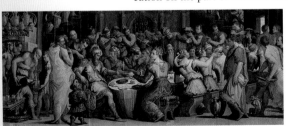

The banquet lends the occasion an official status. Because the king cannot break a promise made in public to Salome and Herodias, the events that follow become inevitable.

The Feast of Herod

John the Baptist had, rightly, accused Herod of behaving reprehensibly in marrying Herodias, the wife of his dead brother Philip. The apostle's admonition had fueled a great hatred on the part of Herodias. On her advice, King Herod imprisoned John, and Herodias tirelessly encouraged her husband to get rid of this inconvenient presence and condemn John to death. But Herod lacked the will to do so, because he appreciated John's sense of justice and holiness, willingly listening to him and following his advice. One day, Herod arranged a banquet to celebrate his birthday, inviting Galilean princes, officials, and other notables. Herod's stepdaughter Salome was called in to dance before the assembly to entertain the guests. Her graceful dances so pleased the king that he pledged to fulfill any desire she might express. Salome was unsure what to ask for, but on her mother's advice she asked the king for the head of John the Baptist. Herod could not go back on a promise made in the presence of his guests and so, with great reluctance, he ordered that John be executed. The saint's bleeding head was brought to Salome on a salver, and she handed it over to her mother.

Sources
Mark 6:17–29

Iconography
This is one of the most popular subjects in Italian and other European art, with countless examples of the episode from the 15th to the 17th century. There are many reasons for its popularity: female beauty, the banquet scene, an elegant court setting, the gruesome image of John's severed head, and the contrast between that image and the luxurious atmosphere of a court banquet

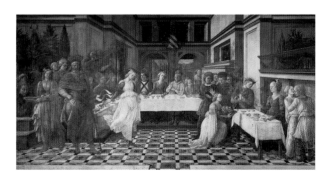

◀ Filippo Lippi, *The Dance of Salome*, from *Scenes from the Life of Saint John the Baptist*, ca. 1460. Prato, cathedral.

The Feast of Herod

The gold vessels on the sideboard next to the royal table demonstrate the economic power and social status of the hosts, not to mention that of the person who commissioned the painting.

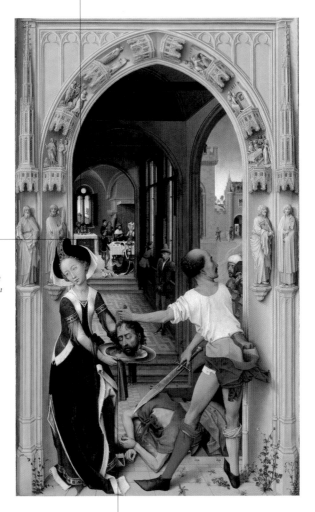

Because the execution of Saint John takes place at the banquet, it acquires a certain macabre official status.

▲ Rogier van der Weyden, *The Beheading of Saint John*, from *The Saint John Triptych*, ca. 1455–60. Berlin, Gemäldegalerie.

The decapitation, a central element in the narrative, is placed in the foreground.

14

The meal is an act of hospitality on the part of the Pharisee. But the dinner with Jesus is overshadowed by the devotions of a repentant sinner, who washes the Lord's feet.

Christ in the House of Simon

Luke's Gospel tells that Jesus was one day invited to a meal by a Pharisee named Simon. As Jesus was sitting at the table, a well-known city prostitute came into the host's house with a jar of perfumed ointment. She crouched at Jesus' feet and began to kiss them, bathing them in tears, wiping them with her hair, and anointing them with the ointment. As the Pharisee watched, he thought to himself that if Jesus really was a prophet he would surely have known that the woman was a public sinner and would have recoiled from her attentions. Jesus then turned to him and presented him with an allegorical image: "A certain creditor had two debtors: one owed five hundred *denarii* and the other fifty. When they could not pay, he canceled the debts for both of them. Now which of them will love him more?" The Pharisee replied without hesitation that it would certainly be the one with the greater debt. Christ agreed and provided an explanation of the story's symbolism: in spite of her sinfulness, the great love she showed meant that her sins were forgiven, for those who have shown great love enjoy divine forgiveness. Jesus then turned to the woman and said: "Your sins are forgiven" and then "Your faith has saved you; go in peace."

Sources
Luke 7:36–50

Iconography
This proved a very popular subject in Italian and other European art, especially in the Middle Ages and the 17th century. There are a great many examples up to the 18th century. The reasons for its success are the usual ones: banquet scenes allowed artists to depict luxurious interiors, while at the same time the biblical reference provided the moral lesson of the sinner redeemed

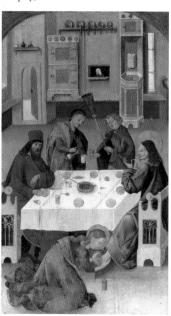

◄ Gabriel Mälesskircher, *The Feast in the House of Simon*, 15th century. Nuremberg, Germanisches Nationalmuseum.

15

Christic in the House of Simon

Christ sits in the place of honor at the head of the table.

The feast is a demonstration of the Pharisee's hospitality, but it is also where Christ publicly forgives the sinful woman from the city.

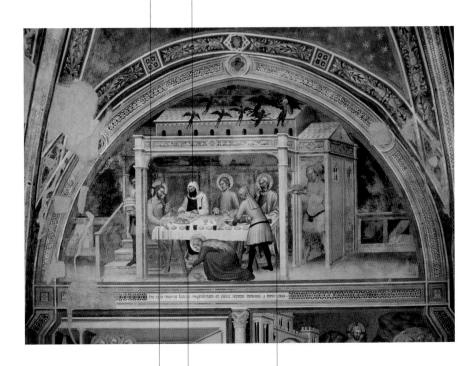

Given the Gospel context, the bread and wine on the table are symbols of the Eucharist.

The hair and ointment jar show that the artist has identified the sinful woman as Mary Magdalene.

The tablecloth, typical of Perugian manufacture, contains an allusion to the communion table, since this kind of cloth was much used for liturgical purposes.

▲ Giovanni da Milano, *Christ in the House of Simon*, second half of the 14th century. Florence, Santa Croce, Rinuccini Chapel.

In works on this subject, the food and the sumptuously laid dining table are indicative of the hospitality offered by Martha to the Lord, as she seeks to satisfy his material needs.

Christ in the House of Martha and Mary

During his journey to Jerusalem, Jesus stopped at a village where he was welcomed into the home of a woman named Martha. While she was busy in the kitchen preparing a special meal and hospitality suitable to a person of his importance, her sister Mary (often referred to as Magdalene) sat at the Lord's feet to listen to his words. Martha was upset that her sister was leaving her to do all the domestic work, and she urged Jesus to ask Mary to give a helping hand. He declined to do so and instead turned abruptly to Martha, saying: "Martha, Martha, you are worried and distracted by many things; there is need of only one thing. Mary has chosen the better part, which will not be taken away from her." This episode from the Gospel of Luke is often used to convey the philosophical idea of the contrast between the active and the contemplative life. The Lord indicates that the latter is the right and surest choice if his word is to be understood.

Sources
Luke 10:39–42

Iconography
This Gospel subject is frequently found not only in Italian art but also in the northern pictorial tradition, where, however, it acquires its own particular characteristics after 1550. It is often used as an excuse for depicting elegant rooms or kitchens overflowing with attractive foodstuffs and delicacies

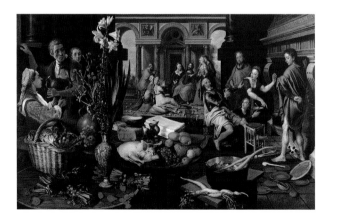

◀ Pieter Aertsen, *Christ in the House of Martha and Mary*, 1553. Rotterdam, Boymans–van Beuningen Museum.

Christor in the House of Martha and Mary

The eggs may be a symbol of the Resurrection.

Grapes are not simply a food for the table. They also remind us of wine and hence refer to the blood of Christ and his Passion.

Martha's hospitality is conveyed by her carrying a tray of glassware.

The laden dining table conveys the hospitality offered to Christ by Martha.

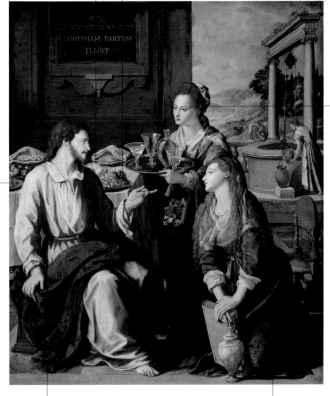

Christ points to Mary Magdalene as one who has chosen the way of contemplation: the better way to understand his teaching.

Mary Magdalene kneels at Christ's feet and listens to his preaching.

▲ Alessandro Allori, *Christ in the House of Martha and Mary*, 1605. Vienna, Kunsthistorisches Museum.

In this case the shared table is a clear indication of Christ's familiarity with sinners. Veronese presents the meal as a ritual that brings spirits together.

The Feast in the House of Levi

As Jesus was walking along the seashore at Capernaum, people gathered around him seeking advice. When he met a tax collector called Levi, Jesus told Levi to follow him. Levi obeyed and offered his hospitality. At Levi's house, when Jesus and his disciples sat down to eat, they were joined there by many tax collectors and other sinners who were among his followers. The Pharisee scribes were scandalized that Christ would share a table with such people and asked his disciples to explain this incomprehensible behavior. But when Jesus heard the question, he replied: "Those who are well have no need of a physician, but those who are sick; I have come to call not the righteous, but sinners." This Gospel episode of Christ conveys a central aspect of Christian preaching, for what Christ did provoked criticism and led to the Pharisees' question.

Sources
Mark 2:13–17

Iconography
Paolo Veronese's depiction of this subject seems to be unique in Christian iconography. It has hence been suggested that he chose to call his painting *The Feast in the House of Levi* only because his painting was criticized as too profane for a depiction of the Last Supper

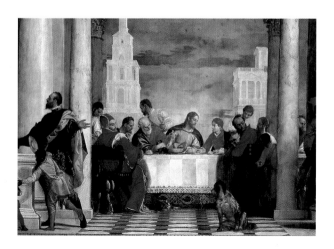

◀ Paolo Veronese, *The Feast in the House of Levi* (detail), 1573. Venice, Gallerie dell'Accademia.

The presence of a cupbearer, whose task was to serve wine to the guests, draws attention to the absence of a carver, who would have been responsible for carving the meat.

The empty glass reminds us of wine and refers to the Passion of Christ.

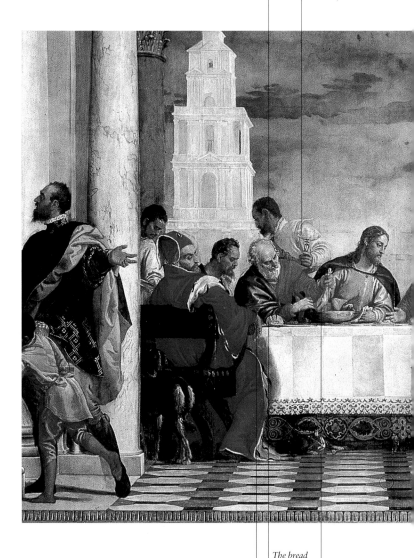

One of the tax collectors is cutting a piece of meat for Jesus in a way that suggests considerable familiarity between them. It was against the rules of etiquette in the artist's own day, when the carver alone was responsible for cutting meat.

The bread lying on the table recalls the Eucharist.

The cuts of roast meat are linked to the idea of Christ as a sacrificial victim.

The white tablecloth laid on top of a piece of damask exemplifies the contemporary custom of changing the tablecloth after each course. This detail helps convey the elegant ambience of the supper, no doubt conforming to the wishes of the patron who commissioned the painting.

▲ Paolo Veronese, *The Feast in the House of Levi* (detail), 1573. Venice, Gallerie dell'Accademia.

Christ performed his miracle before a crowd of guests at a formal wedding feast. Jesus is associating the wine with his blood, albeit indirectly.

The Marriage at Cana

Sources
John 2:1–10

Iconography
This is a very common subject in Italian and other European art from the Middle Ages to the 18th century. Apart from its doctrinal content, the subject allowed artists to provide detailed depictions of the wedding feast. Since such feasts were customary everywhere, these paintings provided a significant expression of culture, customs, and taste. They remain an important source of information about everyday life

Christ's first miracle was performed at the town of Cana during a wedding to which he had been invited along with his mother, Mary, and his disciples. During the feast, the host ran out of wine. Mary informed Jesus of this unexpected setback and he replied, enigmatically, "O woman, what have you to do with me? My hour has not yet come." Mary then turned to the servants and said, "Do whatever he tells you." Jesus ordered that six water jars intended for purification rites be filled to the brim with water. When this was done, Jesus asked the men to draw some liquid out and take it to the chief steward for tasting. After drinking what had now miraculously become wine, and not knowing where it had come from, the steward told the bridegroom that he was surprised that the new husband had kept the best wine for the close of the feast, contrary to the usual practice at wedding celebrations. Of clear significance in the episode is Jesus' apparently irrelevant reply to his mother, because it establishes a link between the wine and "his hour." The latter phrase is understood as referring to the time of his sacrifice and therefore links the wine and his blood.

▶ Carlo Bononi, *The Marriage at Cana*, early 17th century. Ferrara, Pinacoteca Nazionale.

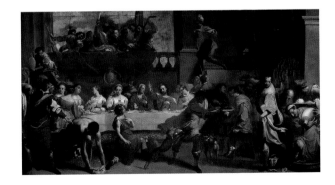

Among the vessels on the side-
board at the rear is one shaped
like a pelican, a bird that was a
traditional symbol of Christ.

The wedding feast is
the setting for Christ's
miraculous transforma-
tion of water into wine.

The pig's head is
a symbol of sin.

In the world of
chivalry, swan was
a delicacy. Here it
may be an allusion
to the Eucharist
because of its pure
white feathers and
its habit of washing
itself before eating,
but it is also a sym-
bol of Venus, god-
dess of love. In one
of Bosch's many
otherworldly
touches, the swan
spouts fire, possibly
a reference to the
myth that the swan
sings when about
to die.

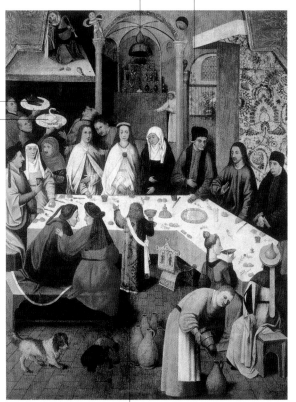

The cupbearer, with his back
to us, is offering a cup of the
miraculous wine to the bride,
seated opposite him.

▲ Hieronymus Bosch, *The Marriage
at Cana*, ca. 1475–80. Rotterdam,
Boymans–van Beuningen Museum.

The wedding banquet is a symbol of the kingdom of heaven. When called by the Lord, only those who accept the invitation to attend are admitted.

The Parable of the Wedding Banquet

Sources
Matthew 22:1–14; Luke
14:16–24

Iconography
This is an unusual subject,
perhaps because the Gospel
text, especially in Luke's
version, invites the artist
to represent the guests as
street people: an ugly
crowd of the blind, lame,
and afflicted

One Gospel parable compares the kingdom of heaven to a banquet organized by a king for his son's wedding. He sends his servants to summon the guests, and when they refuse to come, he sends more servants to repeat the offer. Again those invited say that they are not available and some actually mistreat and kill the servants sent to invite them. The king is enraged by this senseless reaction and sends his army to punish the criminals, meanwhile instructing his servants to invite to the banquet any passersby in the city streets. They obey, and the hall fills with guests. Matthew's Gospel tells us that when the king enters, he notices one man who is not dressed for a wedding. When asked why this is so, he fails to respond, and the king has him thrown out, because "many are called but few are chosen." The wedding represents the union of Christ and the Church, the king's servants are the prophets, and the indisposed guests are the Jews who do not accept the invitation because they do not accept Christ as the Messiah. The unsuitably dressed man in Matthew's account was interpreted as an unrepentant sinner, who is therefore unworthy to attend the wedding banquet, that is, to enter the kingdom of heaven.

▶ Domenico Fetti, *The Parable of the Banquet*, 1620. Dresden, Gemäldegalerie.

Christ gathers his followers for supper one last time. The food has special symbolic significance: Jesus himself defines the bread as his body and the wine as his blood.

The Last Supper

The Last Supper is Jesus' last meal with his disciples at Jerusalem. On the day of the Jewish Passover, Jesus orders his disciples to organize its celebration, and in the evening he sits down to supper with the twelve. During the meal, he says: "Truly I tell you, one of you will betray me." This grieves the apostles, who begin asking him who the traitor might be, and Jesus replies that he will be betrayed by the one who dipped his morsel of bread in the bowl with him. Judas realizes that his master's words refer to him. While they are eating, Jesus breaks the bread and blesses it, calling it his body and offering it to all those present. Then he takes the cup, gives thanks, and passes it to his disciples so that they all might drink, calling it his blood, poured out for the forgiveness of sins. He then declares that he will never again drink of the fruit of the vine until the day when he will be reunited with his disciples and will be able to talk to them in his father's kingdom (Matt. 26:17–29). In Mark's Gospel (14:12–26) and that of Luke (22:7–23), the narrative is substantially the same, though there are differences: in those versions, the place chosen for the Last Supper is revealed to the apostles in the city by a man carrying a jar of water. In John's Gospel (13:21–30), it is Christ himself who takes a piece of bread from the dish and gives it to Judas to show that he is the traitor; when he urges Judas to do quickly what he is going to do, Judas leaves the table. The episode represents the institution of the sacrament of the Eucharist by Christ himself.

Sources
Matthew 26:17–29; Mark 14:12–26; Luke 22:7–23; John 13:21–30

Iconography
The Last Supper is widespread in Western art and one of its oldest subjects. It already appears in paleo-Christian art and is fully developed in 6th-century Byzantine mosaics, becoming codified in a form that was to be subject to many interpretations but few modifications over the centuries

▶ Giambattista Tiepolo, *The Last Supper*, 1745–50. Paris, Louvre.

The Last Supper

This is thought to be the earliest representation of the Last Supper in Western art.

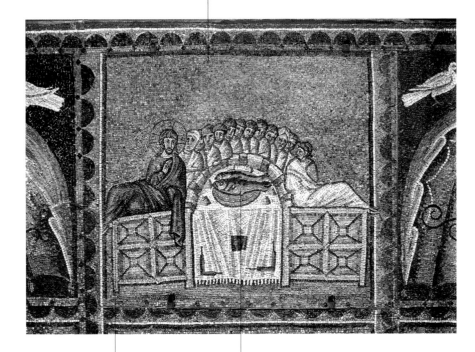

The positions of Christ and the apostles reflect the Roman custom of lying on triclinia at meals.

The fish is a symbol of Christ. In Greek, the Lord is called Jesus Christos Theou Uios Soter. The initial letter of each word taken in sequence forms the word ichthus (ΙΧΘΥΣ), which is the Greek for fish.

▲ Mosaic with the Last Supper, early 6th century. Ravenna, Sant'Apollinare Nuovo.

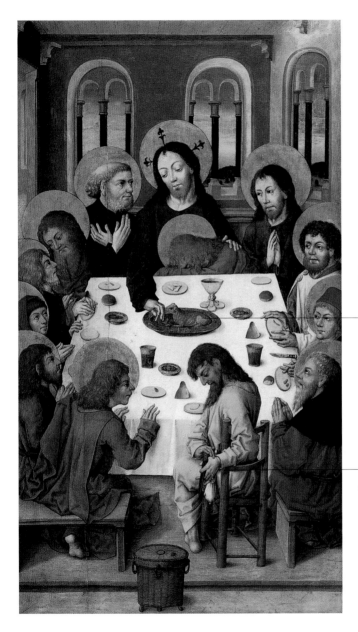

Instead of the bread and wine of the Eucharist, we see here the lamb, the traditional sacrificial victim and an allusion to the sacrifice of Christ.

The knife that Judas is replacing in its sheath tells us that his betrayal has already taken place.

▲ Master of the Housebook,
The Last Supper, ca. 1480. Berlin,
Gemäldegalerie.

The purpose of the supper is to feed the travelers, but it is also the moment when Christ chooses to reveal to his disciples, by blessing and breaking bread, that he is the risen Lord.

The Supper at Emmaus

Sources
Luke 24:29–33

Iconography
This subject entered
Christian iconography
comparatively late (around
the 12th century) and
has often been used for
its Eucharistic content
and its reference to the
Resurrection. It was a par-
ticular favorite of 16th-
century Venetian artists
and later of 17th-century
artists across Europe

In the week following the death of Christ, two of his disciples happened to be walking to the village of Emmaus, not far from Jerusalem. On the way, another traveler joined them and began talking about things concerning Jesus, though he seemed to be unaware of his Passion and death. The disciples told the traveler of their hope that Jesus would free Israel, and of their disappointment that, three days after his death, nothing seemed to have happened. Moreover, they could not explain why, when some women had gone to his tomb three days after his death, they had found it empty. The traveler then reminded them of the prophecies that had foretold what would happen to Christ. When they reached the village, he made to continue on his way, but they urged him to stay with them since it was almost evening. When the traveling companions were seated at the table and were preparing to eat supper together, the traveler took the bread and blessed, broke, and distributed it, thus revealing his true identity as Jesus Christ. As soon as they recognized him, he disappeared from their sight. All they could do was return to Jerusalem to tell the others what had happened and how Jesus had revealed himself by blessing and breaking bread.

◀ Mathieu Le Nain, *The Travelers to Emmaus*, 1635–60. Paris, Louvre.

During the Supper at Emmaus, the traveling companions have gathered around Jesus. They watch in amazement as he reveals his true identity by repeating the blessing of bread that he had performed during the Last Supper.

As in the Last Supper, the bread here represents the body of Christ.

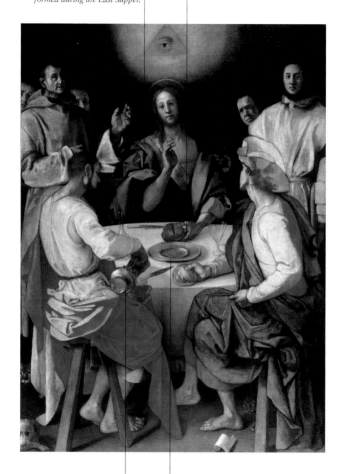

The wine provides a clear reference not only to the blood of Christ in the Eucharist but also to its use as a drink that encourages the recognition and contemplation of the truth.

In the early 16th century, individual diners did not always have their own plates: sometimes all the diners shared a single plate. In this case, the plate is suggestive of the communion paten.

▲ Pontormo, *The Supper at Emmaus*, 1525. Florence, Uffizi.

Two elements combine in this single episode: a record of how the saint helped a small monastic community to survive, and the importance of rules about eating in monasteries.

Saint Hugh in the Carthusian Refectory

Sources
Guigo I, prior of the Grande Chartreuse, "Life of Saint Hugh," *Acta Sanctorum*, April 1

Iconography
This very rare subject is closely connected to Carthusian monasticism, celebrating Saint Hugh as the man responsible for founding the order

▼ Francisco de Zurbarán, *Saint Hugh in the Carthusian Refectory*, 1630–35. Seville, Museo Provincial de Bellas Artes.

Saint Hugh (1053–1132) was canonized just two years after his death. He was named bishop of Grenoble as a very young man (in 1080), but after two years in the position he retired to the monastery of Chaise-Dieu in the diocese of Clermont, where he observed the Benedictine rule for a year. Then, at the request of Gregory VII, he resumed the direction of his diocese, which was in a state of complete indiscipline and promiscuity, and he finally succeeded in bringing it under control. In 1085, he welcomed Saint Bruno and his companions, granting them the site where the Grande Chartreuse was built. This small monastic community was extremely poor, relying for its sustenance on food given by the bishop. One Sunday, he sent them some meat, but since the monks rarely ate meat, especially during Lent, they debated whether they should eat it; but as they talked they fell into a deep sleep and remained for some time in this soporific state. Hugh, meanwhile, had been away on a journey, but he returned on Ash Wednesday and paid a visit to the Carthusians. He was amazed to find that they were just waking after their long sleep, having lost all sense of time. During their collective slumber, the meat on their plates had turned to ash. The monks interpreted this strange event as a miracle: a message from above expressing approval of their monastic abstinence.

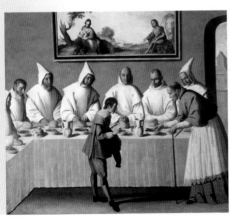

Episodes from the life of Saint Benedict reveal an ambivalent attitude toward food: it involves the temptation to gluttony, but it is also a manifestation of the divine.

The Miracles of Saint Benedict

Born at Norcia in the 6th century, Saint Benedict was most renowned for founding the monastic order that bears his name. He became a hermit at a young age and founded the monastery of Monte Cassino, where he wrote the Rule—an inspiration for many Western monastic communities from that time onward. Certain episodes in his life connected with food and fasting have found expression in art. One legend tells us that a priest had carefully prepared his paschal meal when God warned him in a vision that Saint Benedict was suffering from hunger not far away; the priest set out to find him in order to share his meal with him. Saint Benedict was a stern character, and, according to legend, his hermit brethren became extremely unhappy with the climate he had created in the community. One day they tried to kill him by poisoning his wine, but before drinking, Benedict blessed the cup, which miraculously broke: the poisoned wine was spilt and Benedict's life was saved. A similar episode occurred with a piece of poisoned bread. In another legend two monks from his community left the monastery to secretly indulge their gluttony at a hostelry. On their return they found that Benedict already knew of their misdeed, and chided them. Another story tells that once, during a food shortage at the monastery, only five loaves of bread remained; but Benedict miraculously caused his fellow monks to find quantities of flour in the monastery atrium.

Sources
Gregory I, *Dialogues*, book 2

Iconography
Numerous medieval and Renaissance fresco cycles depict scenes from the life of Saint Benedict, the most substantial being the cycle in the monastery at Monte Cassino. The purpose of the frescoes was to remind Benedictine monks of the exemplary life of the saint who had given them their Rule

▼ Sodoma, *Scenes from the Life of Saint Benedict* (detail), ca. 1505–8. Monteoliveto, abbey.

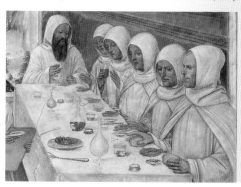

31

The feast was set to celebrate the union between the Church, symbolized by the dining table, and Christ himself, underscoring the primacy of the Eucharist among the sacraments.

The Feast of Saint Gregory the Great

Sources
An anonymous 7th-century monk from Whitby
(F. A. Gasquet, *Life of St. Gregory the Great*, 1904);
Paul the Deacon (770–80,
H. Grisar in *Zeitschrift für katolische Teologie* 11
[1987], pp. 158–73); John the Deacon (872–82), *Acta Sanctorum*, March 11

Iconography
This is a very rare subject in art

Pope Gregory I (ca. 540–604), also known as Gregory the Great, was one of the Latin fathers of the Church. He was born in Rome of a noble family and when his father died, he joined the Benedictine order, abandoning civil and political life in order to serve the Church. He consequently converted his palace into a monastery and lived there as a monk until he became pope. Among the stories told about him is one about a miraculous banquet held at his home. Legend has it that Gregory was in the habit of inviting twelve poor people to supper in memory of the twelve disciples who sat with Christ at the Last Supper. One evening, a thirteenth guest sat at the pope's table and proved to be Christ himself. The symbolism of the story seems fairly clear. The saintly pope represents the Church itself, while Christ is himself, welcomed at the Church's table with his twelve disciples, thereby repeating the ceremony of the Last Supper with all its sacramental significance.

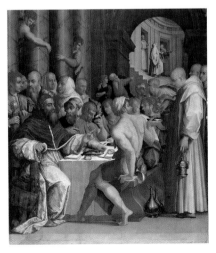

► Giorgio Vasari, *The Feast of Saint Gregory the Great*, ca. 1540. Bologna, Pinacoteca Nazionale.

As we can see from the story of Peleus and Thetis and that of Cupid and Psyche, the marriage feast is a traditional and very ancient form of celebration.

The Feast of the Gods

The myth of Peleus and Thetis differs from that of Cupid and Psyche, but they both treat the subject of marriage. In Greek mythology, Peleus was the king of Phthia in Thessaly, while the nymph Thetis was a daughter of Nereus. Zeus and Poseidon had quarreled over Thetis's hand, but because Themis had foretold that the son of Thetis would become greater than his father, they thought it better to marry her to a mortal, Peleus. But Thetis objected and tried to wrestle out of Peleus's clutches by transforming from bird to tree to tigress. Finally Peleus, with advice from the centaur Chiron, caught her, made her resume the form of a goddess, and married her on Mount Pelion in the presence of the gods. The Muses sang, and everyone brought gifts. In the myth of Cupid and Psyche, Venus was jealous of the girl's great beauty. The goddess ordered Cupid (Eros) to make Psyche fall in love with a lowly person. Instead, Cupid fell in love with Psyche himself. Every evening at sunset he went to see her, insisting, however, that she never look at him. Psyche accepted this condition, but one day she broke her promise, lighting a lamp to look at him as he slept. Cupid awoke, furious, and abandoned her, but Psyche refused to give him up.

Sources
Pindar *Pythian* 3.92ff.;
Apollodorus 170; Catullus
Carmina 64.31ff.; Apuleius
Metamorphoses 4–6

Iconography
A popular subject in
ancient art, which was
developed in painting from
the Renaissance to the 18th
century because of its
archaeological interest and
the excellent excuse it pro-
vided to represent lavish
banquets in mythological
settings

After long wanderings she was finally forgiven, and the two were married at a feast attended by the gods. Allegorically, it symbolizes the union of the soul (*psyche*) and desire (*eros*).

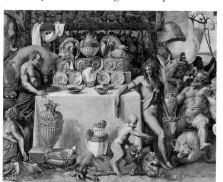

◄ Giulio Romano, *The Marriage of Cupid and Psyche* (detail), ca. 1528. Mantua, Palazzo Te, Cupid and Psyche Room.

33

Here we see the rustic banquet organized by the satyrs in honor of Cupid and Psyche. Its position opposite the feast of the gods is meant to illustrate the contrasting but complementary aspects of love: the elevated and the material.

The hybrid human-animal figures are a clear allusion to the more instinctive side of human nature.

▲ Giulio Romano, *The Banquet on the Island of Cythera*, 1527–30. Mantua, Palazzo Te, Cupid and Psyche Room.

The satyr Pan is seen offering a bread roll to a naked goddess. This can be taken as an erudite reference to the belief among the ancients that the Latin word panis (bread) derived from the name of the god.

Mercury is the messenger sent by the gods to break up the disorderly feast and endow it with harmony of a superior order.

The Feast of the Gods

The nautilus was a typical ornamental object of the time. Here it is fashioned into a ceremonial cup and identifies the person holding it as the principal god—in this case Jupiter or Neptune.

The cake in the center, lit by candles, underscores the nuptial nature of the scene. Sweet dishes are traditionally associated with the rituals that celebrate joyful occasions in life.

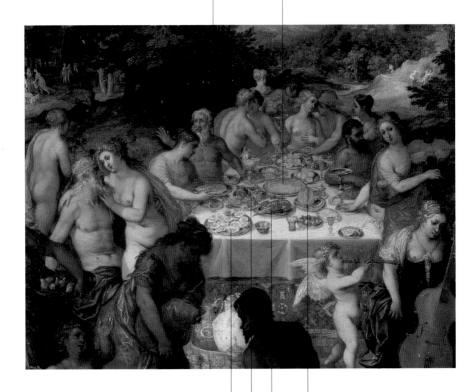

Oysters are a refined aphrodisiac. They show that this is a wedding feast and emphasize the sensuality of the scene.

Melons were renowned in antiquity for their sweetness. In this case there is a symbolic reference to the sweetness of conjugal union.

The erotic atmosphere is intensified by the presence of artichokes, which were thought to be an aphrodisiac.

The lobster is here to remind us that the marriage of two marine deities is being celebrated.

▲ Hendrik van Balen I, *The Feast of the Gods*, early 17th century. Angers, Musée des Beaux-Arts.

This supper is an expression of hospitality, welcome, and charity, all the more poignant for being offered by a poor couple. In the humble setting, the guests' identities are revealed.

Philemon and Baucis

In his *Metamorphoses*, Ovid tells of a poor elderly couple who one day offer hospitality to two travelers who have been turned away by all the other villagers. They invite their guests to dine, offering them ham and vegetables from their kitchen garden, as well as cheese, eggs served in earthenware bowls, other hot dishes, wine, and finally figs, walnuts, dried fruit, dates, plums, apples, and grapes. At the center of the table they place a honeycomb. During the supper, a bowl is inexplicably and repeatedly refilled with wine, and the couple's only goose, which they have decided to slaughter for the meal, takes refuge with the two strangers, who prevent their hosts from killing it. In reality, the guests are none other than Jupiter and Mercury, as they ultimately reveal. When torrential rain is about to flood the entire region, the gods, out of gratitude toward Philemon and Baucis, take them up a mountain to safety. Their cottage is spared and changed into a temple, and at their own request the two become its priest and priestess. In accordance with their wishes, husband and wife die at the same moment and are changed into an oak and a lime tree. There is a certain affinity between this myth and the Supper at Emmaus, with Jupiter and Mercury representing God the Father and Christ, while Philemon and Baucis are like the two disciples who, as night falls, offer hospitality to their unidentified traveling companion, later revealed as Christ.

Sources
Ovid *Metamorphoses*
8.617–721

Iconography
Precisely because of its parallels with the Gospel story of the Supper at Emmaus, the tale of Philemon and Baucis often appears in 17th-century Flemish painting

▼ Workshop of Peter Paul Rubens, *Mercury and Jupiter with Philemon and Baucis*, 1620. Vienna, Kunsthistorisches Museum.

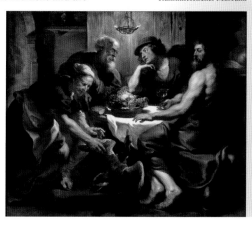

A wedding banquet becomes the setting for a massacre touched off by the drunken behavior of a lecherous centaur.

The Battle of the Lapiths and Centaurs

Sources
Ovid *Metamorphoses*
12.208–536; Boccaccio,
De genealogia deorum
gentilium, 9.29

Iconography
The battle of the centaurs
appears in the decoration
by Phidias on the pediment
of the Parthenon, and from
time to time among the
mythological subjects
depicted in the Renaissance.
But the banquet that was
the setting of the battle
often completely disap-
pears, leaving only a brutal
battle scene

A passage in Ovid's *Metamorphoses* tells how the wedding feast of Hippodamia and Pirithous, king of the Lapiths, abruptly turned into a bloody battle between the Lapiths and the centaurs. The Lapiths were peace-loving inhabitants of Thessaly who had organized a splendid banquet to celebrate the marriage of their king and his bride, Hippodamia. The centaurs had also been invited to the celebration, but during the meal, the centaur Eurytus drank too much and was overcome with desire for the bride. As a result, the feast degenerated into a brawl involving all the guests. In the end, the centaurs were driven off, thanks to the assistance of Theseus, who was a friend of Pirithous and hence among the guests. The battle of the centaurs is a traditional theme in Greek art, becoming widespread in the closing stages of Hellenism as a figurative expression of the Athenian victory over the Persians, in which the Lapiths stood for the Athenians, and the centaurs represented the barbarian Persians. Because centaurs, hybrids that were half-man, half-horse, were associated with behavior driven by brutality, violence, and instinct, the battle was an allegory of the superiority of Greek culture over that of foreign barbarism.

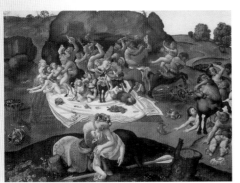

◀ Piero di Cosimo, *The Battle of the Lapiths and Centaurs* (detail), late 15th century. London, National Gallery.

*The banquet provides a venue for an elite group of philoso-
phers to meet and discuss profound matters in a pleasant,
refined setting.*

Plato's Banquet

This iconographic subject is in effect the figurative expression of
a literary form: in the case of Plato's work *The Banquet*, it
expresses philosophy. Symposiac literature consisted of works
that recorded conversations held at symposia (wine cere-
monies), and they had a precedent in Homeric descriptions of
banquets; but the masterpiece in the genre is Plato's, where a
banquet frames a series of philosophical discussions. The ban-
quet in question may have actually taken place during the
Lenaea festivities of 416 B.C. The participants discussed the
theme of love in its various and complex forms. Between
courses, the guests drank wine according to a prearranged pro-
cedure. The wine produced a state of ecstatic inebriation that
was considered essential to the cognitive experience, a process
of understanding that engendered a kind of union with the tran-
scendental. Plato claimed that the Dionysian experience at the
banquet played a key part in the search for truth.

Sources
Plato *The Banquet* and
Phaedrus 48

Iconography
From an iconographical
point of view, Feuerbach's
work seems to be a *hapax
legomenon*. It is visual evi-
dence of the fascination
exerted by Greek archaeol-
ogy and Plato's work in
19th-century erudite circles
in Germany

▼ Anselm Feuerbach,
Plato's Banquet, 1869.
Karlsruhe, Kunsthalle.

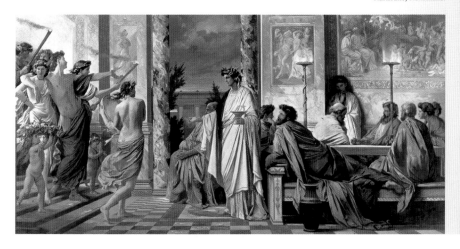

The feast held by Egypt's powerful queen is the setting for a wager. It is organized with the specific aim of using ostentatious luxury and wealth to carry out a seduction.

The Banquet of Cleopatra

Sources
Pliny *Naturalis historia* 9.119; Macrobius *Saturnalia* 3.17.14–18

Iconography
This subject could bring together a number of attractive elements: physical beauty, the famous queen, and the spectacular magnificence of her court. That is why it proved popular in Mannerist painting, which exploited the more obscure stories from antiquity; 17th- and 18th-century painting was interested in the theatrical possibilities provided by mythological and exotic events

Cleopatra was queen of Egypt in Hellenistic times. In order to combat the looming threat from Rome, she used a political strategy based on her personal magnetism and on the hypnotic power of her lavish lifestyle, complete with spectacular pomp and ceremony. While still very young, she had been the lover of the much older Julius Caesar, thereby postponing his political and military plans. She subsequently had a long, deep relationship with the triumvir Anthony, which ended with their deaths. One element in Cleopatra's seduction of Anthony was a fabulous banquet, which she wagered would cost more than ten million sesterces—an incredibly large sum. Even after a succession of the most succulent, costly delicacies on the dining table, she still had not spent the requisite sum. She had a servant bring her a cup of vinegar, dropped one of her magnificent pearl earrings into it, and promptly drank it off. The arbiter of the event took possession of the matching pearl for fear that she would do the same with it. He kept it as a souvenir. When the Romans conquered Alexandria, Cleopatra's pearl was divided into two and sent to decorate the ears of the colossal statue of Venus in the Pantheon in Rome.

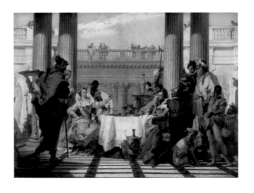

▶ Giambattista Tiepolo, *The Banquet of Cleopatra*, 1740. London, National Gallery.

*In this case the banquet is a social occasion organized by
Nastagio, who, after seeing a dramatic apparition, seeks to
persuade the woman he loves to return his affection.*

The Story of Nastagio degli Onesti

This story from Boccaccio's *Decameron* tells how Nastagio
degli Onesti is wandering one day in a pine forest, thinking dis-
consolately of the young woman who obstinately rejects his
love. Suddenly he finds himself watching a dramatic scene: a
disheveled woman, in flight from an armed horseman, is
attacked by dogs that the man has stirred up against her and is
killed by the horseman himself. But the scene is unreal: these
are the unquiet souls of the horseman and his victim, who peri-
odically reenact the same tragic sequence in the pine wood.
Nastagio sees a similarity between this event and his own situa-
tion and decides to arrange for his own lady to witness the
tableau, hoping in this way to persuade her to accept his love. He
organizes a banquet, during which the scene is enacted before
her horrified eyes. She yields before the persistence of her lover
and grants him her hand. Finally, the marriage of Nastagio and
his lady is celebrated with another splendid banquet.

Sources
Boccaccio, *Decameron*, 5.8

Iconography
Apparently the only repre-
sentation of this subject in
art is a series of panels
from Botticelli's workshop.
The setting created by the
artists is a reflection of the
Medici court environment

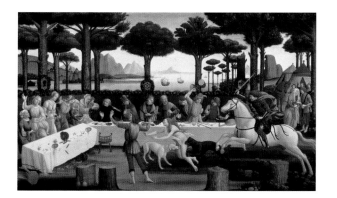

◄ Workshop of Botticelli,
*The Banquet Arranged by
Nastagio degli Onesti*,
1483. Madrid, Prado.

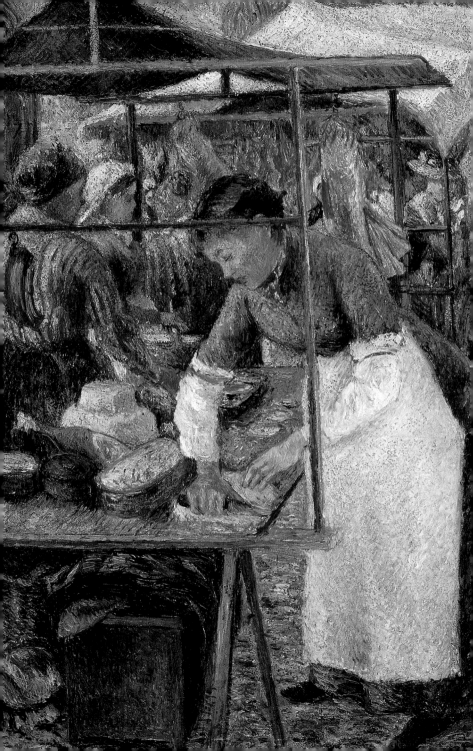

FROM ALLEGORY
TO STILL LIFE

The Sin of Gluttony
The Sense of Taste
Xenia
Fantasies
The Golden Age of Still Life
The Nineteenth Century and Still Life
The Twentieth Century and Food
Genre Scenes and Food

◄ Camille Pissarro, *The Pork Butcher*
(detail), 1883. London, Tate Gallery.

The allegorical representation of gluttony has a clear doctrinal purpose: it provides a negative model, reminding the spectator of the risks involved in sinning without repentance.

The Sin of Gluttony

Sources
Cassianus, *PL* 49, col. 210;
Benedict, *PL* 46, col. 321;
Gregory, *PL* 76, col. 556;
Rabanus Maurus, *PL* 112,
cols. 1246–48

Iconography
Gluttony appears quite fre-
quently in medieval repre-
sentations of the Last
Judgment and in vice and
virtue cycles. It is com-
monly found in the art of
the 15th and 16th centuries
in both Italy and Flanders

The sin of gluttony is a sign of progress, in that the increasingly sophisticated preparation of food marks the advancing stages of moral corruption. Originally, the use of food was dictated solely by need and was therefore characterized by simplicity and parsimony. In biblical exegesis, Original Sin is interpreted primarily as a sin of gluttony, resulting from God's forbidding the use of certain fruits as food. This idea that the first sin was one of gluttony was prevalent in the Middle Ages, as was its corollary that gluttony was the root of all evil. Man's natural desire for food is what chiefly leads him into temptation and provides easy access to the universe of sin. Gluttony therefore becomes one of the seven deadly sins and is the subject of quotations and descriptions in many exegetical writings. Gluttony is often depicted in representations of Hell as part of the Last Judgment, where space is often

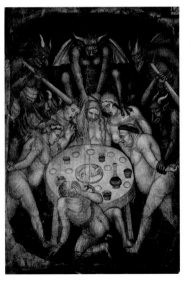

▶ Taddeo di Bartolo, *Hell: The Gluttonous*, late 14th century. San Gimignano, collegiate church.

devoted to the damned and their sins, or, in summary pictorial treatments of doctrine, it may appear among the personifications of vices and virtues. It is usually shown allegorically in the form of food-laden tables around which the gluttonous are seated, or it may be personified by corpulent human beings with bulging bellies, shown in the act of eating. Pigs and wolves are often associated with gluttony, since they are known for their voracity.

A pig is a symbol of sin, and here, in the form of a trotter and hence of food, it is an emblematic representation of gluttony.

The commode is a clear reference to the undignified fate of so much food.

Gluttony is one of the seven deadly sins illustrated in Bosch's work. Gluttony is a progressive sin, because it involves the degeneration of the natural desire for food, and it was seen as inevitably leading to moral corruption.

Sausages are a food with a very ancient tradition, and because they are associated with pigs, they are symbols of gluttony.

▲ Hieronymus Bosch, *Gluttony*, from *The Seven Deadly Sins and the Four Last Things*, 1475–80. Madrid, Prado.

The pies on the roof reference a Flemish proverb, "The roof is tiled with tarts." They signify the wealth of food temptation in the Land of Cockayne, a place where one may live in idleness and still have plenty to eat.

The live goose is a symbol of the persistent sinner, and hence, as an item of food, it represents the sin of gluttony repeated without remorse.

The pig is a symbol of sin, and since all its parts can be used as food, it is an emblem of gluttony.

By depicting men from three different social classes, Bruegel portrays the Land of Cockayne as a creation of the collective imagination without distinction of rank or wealth.

The feet of a chick can be seen emerging from the egg, which has been pierced with a knife. This is a humorous reference to the greed of the three gluttons, who, in their eagerness to eat the egg, failed to notice that it is far too old.

The Land of Cockayne is an imaginary place where food is abundant and easy to obtain. Its function was to offset the very real fear felt in an age of famine and poverty.

▲ Pieter Bruegel the Elder, *The Land of Cockayne* (detail), 1567. Munich, Alte Pinakothek.

Allegories of the five senses are full of ambiguity. They illustrate the function of the senses within the human body, but they also warn us that the senses can lead us astray.

The Sense of Taste

Aristotelian philosophy posited that the five senses are distinct ways of perceiving the nature of external reality and that life, the soul, and perception are interrelated. The sensory perceptions obtained through the body are seen as underlying our vital functions, but within the soul they also provide a basis for intellectual activities such as imagination, thought, and hence understanding. According to Aristotle, the passage from perception to knowledge is achieved by means of the *sensus communis*, whose task is to coordinate all sensory impressions. The senses are also given a hierarchical classification, with sight as the highest form followed by hearing, smell, taste, and touch. They are also related to the four elements: sight to water, hearing to the air, smell to fire, and taste to earth. The idea that the senses underlie intellectual understanding was accepted by subsequent ancient writers, and even the Christian Middle Ages did not reject this view. In medieval times, the senses were still viewed as precious instruments for acquiring understanding, but they were also seen as diabolical weapons capable of leading man into temptation and sin.

Sources
Aristotle *De sensu sensatu* 1.436b.1 and *De anima* 2.5.416b.32; 2.12.424b.21; 3.1.424b.22; 3.13.435b.25

Iconography
This subject is not found in ancient art but begins to appear in a very didactic form in the Middle Ages. It is in the latter half of the 16th century and throughout the 17th, however, that it is represented, especially in Flemish art, in the form of scenes from everyday life. From the 18th century onward, the senses are reduced to the status of decorative quotations within other contexts

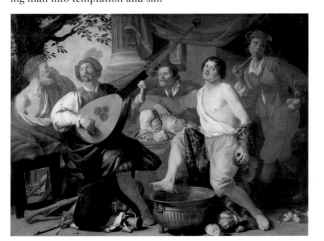

◄ Theodoor Rombouts, *The Five Senses*, early 17th century. Ghent, Museum voor Schone Kunsten.

47

Three of the five senses are conveyed here through an elegant banquet, where activities and customs associated with aristocratic feasts are depicted.

The lute player evokes not only the sense of hearing but also the age-old practice of entertaining diners with music.

The peacock represents the ephemeral nature of physical beauty and the unjustified vanity that it stimulates.

Oysters, traditionally held to be an aphrodisiac, evoke the sense of taste and are also suggestive of sensuality in general.

The rich dishes, including pheasant, on the lady's table also refer to the sense of taste. At aristocratic banquets, it was customary for trophies of game to be cooked and then refeathered. Their presence was often purely decorative.

The quantities of game, fruit, and vegetables of all kinds in disorderly array not only refer to the sense of taste but may also convey the idea of the thoughtless abuse of sensory pleasure.

▲ Jan Brueghel the Elder, *Hearing, Touch, and Taste*, ca. 1616–18. Madrid, Prado.

These are still-life elements that have both a decorative and a ritual function. In either case, the food represented is indicative of the host's hospitality.

Xenia

Sources
Pliny *Naturalis historia*
5.15.112; 28.5.27; 35.112;
36.184; Petronius *Satyricon*
72

Iconography
These are wall decorations
or floor mosaics found in
Roman territories, espe-
cially in upper-class homes
at Rome, Ostia, Pompeii,
and Herculaneum

Food appears frequently in Roman art. It may have been included in the decoration of domestic settings for purely ornamental reasons. But it has been suggested that in such compositions it also had a cultic purpose, as a gift to the gods or a votive offering. Within the category of images having a specific purpose are those that Vitruvius called *xenia*, that is, still lifes of flowers, fruit, food, and crockery. These were intended as virtual expressions of homage from hosts to their guests or, as some historians suggest, as symbolic sustenance for the spirits of the dead. The literary sources provide descriptions of what Pliny calls works of *minor pictura*, which were paintings, often of great virtuosity, aimed at conveying reality in the form of illusionistic trompe-l'oeils. Descriptions in the sources suggest that the Greeks and Romans favored pictures of baskets of figs, peaches, and grapes, or household crockery and hanging game. Another still-life genre was that of floor sweepings. Such works originally had a cultic purpose but later came to have a curious decorative function. The remains of meals depicted in floor mosaics represent food left for the shades that inhabited the house. Hence it was definitely not advisable to pick up what fell to the floor or to sweep up immediately after leaving the table.

▼ Detail of fruit and vases
from the decoration in a
house at Herculaneum,
before A.D. 79. Naples,
Museo Archeologico.

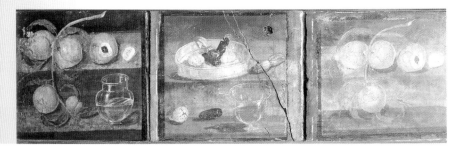

The still lifes in Roman domestic wall paintings had both decorative and ritual purposes. They were a kind of homage offered by hosts to their guests, and symbolic food for the shades of the dead.

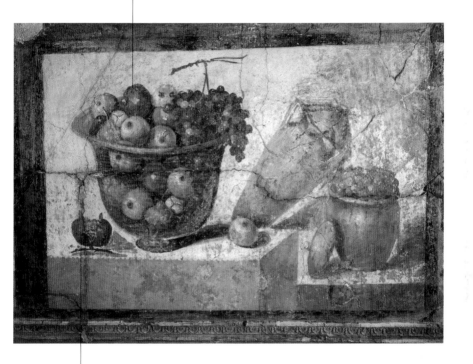

The pomegranate may allude to the myth of Proserpina, as a symbol of her cyclical return to the earth, which is itself a metaphor for rebirth.

▲ Crystal bowl of fruit, wall painting from the villa at Boscoreale, 1st century A.D. Naples, Museo Archeologico.

In Arcimboldi's fantastic illustrations of the seasons, foodstuffs are combined to produce symbolic portraits. Similarly, he created assemblages to represent the elements.

Fantasies

▼ Giuseppe Arcimboldi, *Water*, 1566. Vienna, Kunsthistorisches Museum.

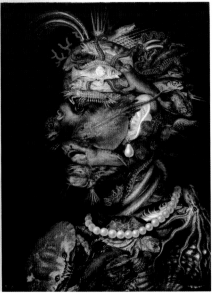

In the 16th century, the world of nature, including food and all edible *naturalia*, provided an infinite source of individual items for artistic elaboration, but it was not in itself sufficient to justify an individual artistic product or genre. In the second half of the century, however, there was an artist named Arcimboldi at work at the Habsburg court (first under Maximilian I and then under Rudolph II). He was the talented creator of a series of paintings whose principal subject was *naturalia* of all kinds. These paintings can be classified as fantasies or "caprices," in which the artist used the basic elements of the as-yet-unknown genre of still life—fruit, vegetables, animals, and so on—to compose bizarre anthropomorphic images. These constructions look like stylized portraits. But hidden within them is an encyclopaedic catalogue of nature, reflecting the taste for collecting found in the *Wunderkammern* of the time and providing an inventory of nature as it was then known. These fantasies were almost scientific illustrations, which brought together in single images the naturalist culture of the time, sometimes even introducing botanical novelties from the recently discovered New World. In addition to their role as illustrations, Arcimboldi's fantasies had a symbolic purpose: the selected *naturalia* and their arrangement in sequences of the elements and seasons demonstrated that the man who commissioned them had aspirations to universality, both in the exercise of temporal power and, at a philosophical level, in the desire to go beyond the human categories of time and space.

Fresh produce, a newly discovered fruit, or a description of the menu for a party often peep out from behind compositions that are apparently purely decorative.

The Golden Age of Still Life

The still-life genre had already acquired a certain degree of autonomy at the end of the 16th century, but it was in the following century that it became established throughout Europe. These works were private commissions in which inspiration was provided by inanimate nature in all its shapes, volumes, materials, colors, and reactions to light. The painter's skill was evidenced in the selection and arrangement of objects on aesthetic criteria, the illusionist description of them, and sometimes also the ability to convey a symbolic message. Within this pictorial context, food puts in an immediate appearance. In the early 17th century, the chief centers for still-life production were Rome and the cities of the Low Countries, but whereas in Italy the still-life painting style that developed around Caravaggio preferred compositions with scrupulously realistic descriptions of fruit, the Low Countries had their own characteristic types. In this age one frequently finds tables laden with food, frugal snacks, game in the kitchen, and tableaus in which sweet dishes take pride of place. In Spain, the genre was known as *bodegón* (literally "cellar" or "tavern") and depicted just a few types of food gathered together in limited spaces, while Florentine still lifes displayed the influence of scientific illustration. In the following century, still lifes were typically either splendid banquets or arrangements of a few plain but interesting items of food.

Iconography
The genre of still life with food is found throughout Europe in the 17th and 18th centuries. It catered to a private clientele, which appreciated its decorative qualities as well as its illusionistic and realistic idiom

▼ Michelangelo Merisi da Caravaggio, *Still Life with a Basket of Fruit*, ca. 1597–98. Milan, Pinacoteca Ambrosiana.

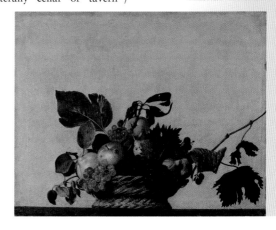

Cherries commonly represented the fruit of Paradise.

The selection of foods on the sideboard provides a spread that is both real and symbolic at the same time.

The fact that the fruit stand is made of silver, a precious metal, and has a tall stem means that it alludes to the higher dimension of Paradise—an incorruptible place, full of spiritual fruit—as well as the communion chalice.

Olives remind us of the symbolic value of the olive tree in the biblical story of Noah and the Flood. They clearly represent man's making peace with God.

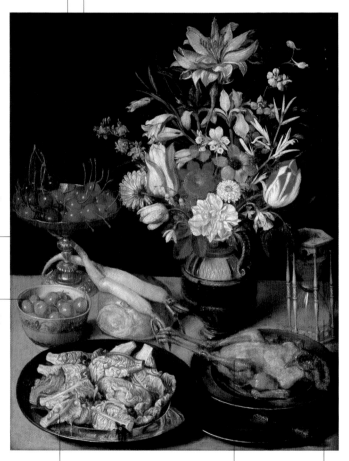

In biblical exegesis, lettuce, the plainest of plain food, was seen as conveying the concept of penitence.

The roast chicken contains a reference to Christ as a sacrificial victim for the redemption of the human race.

The hourglass reminds us that time rules over human life and makes earthly pleasures fleeting and ephemeral.

▲ Georg Flegel, *Still Life with Flowers*, ca. 1630. Stuttgart, Staatsgalerie.

Fruit and other foods were often used to celebrate the ordinary aspects of everyday life but also its rich potential, in response to a new and provocative aesthetic.

The Nineteenth Century and Still Life

The 19th century was a period of radical renewal in the still-life genre. Rising in opposition to the established decorative compositions found in Italian and Flemish art, innovative works sprang from the restless experimentation of French artists. Groups of artists with common poetic and aesthetic aims, who wished to express their creativity freely, began to bend the rules dictated by the academy. Among these art movements, an interest in still life sprang from their antiacademic stance and embodied a strong reaction against the idea that the genres should be organized on strict hierarchical lines. This mentality led to the notion, shared by Realists and Impressionists alike, that all aspects of human life deserved the same aesthetic attention, including ordinary objects and therefore food. Within the aesthetics of Impressionism, whose particular aim was to capture the fleeting moments of visual sensation, objects are given exactly the same treatment as persons. The Impressionist artist strove to capture, study, and reproduce the subjective impression of a natural phenomenon: the effects of light on form and color. Food played a part within this new 19th-century artistic approach to the real, in which artists expressed their freedom from academic restraint.

Iconography
Although still lifes with food are certainly not the principal concern of 19th-century Realist and Impressionist painting, they are nevertheless quite common, especially in French art

▼ Paul Gauguin, *The Ham*, 1889. Washington, The Phillips Collection.

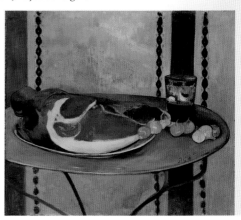

*The fruit and other foods serve to cele-
brate everyday objects and natural forms
in an antirhetorical key, and to explore
their rich aesthetic potential.*

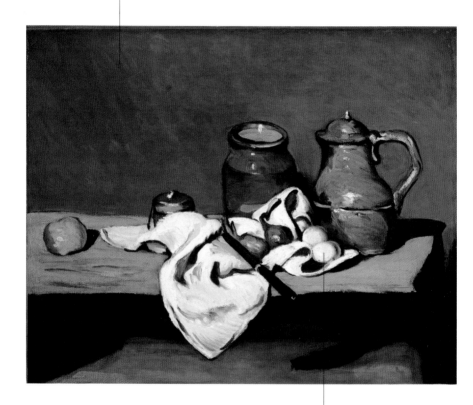

*The simple but perfect forms of the eggs
fully convey the artist's poetic sensibility,
in which natural forms become simple
geometric volumes.*

▲ Paul Cézanne, *Still Life*, 1869.
Paris, Musée d'Orsay.

Food becomes a symbol of the consumer society. The industrial-ized production of food and its display in supermarkets are seen as tangible signs of the violence of capitalism.

The Twentieth Century and Food

The 20th century is a particularly colorful chapter in the history of still life. Across the century, we find numerous avant-garde movements, including the French Fauves, German Expressionism, Cubism, and Italian Futurism, all of which found their full form in its early years. One inevitable term of reference for 20th-century avant-gardes was the mature work of Cézanne and his attention to the artistic possibilities of still life. From him the 20th century learned to embrace the idea that a work of art should be an autonomous entity with its own inherent value, complete in itself and parallel to nature. Similarly, society was accepting the idea that a work of art could have no links to reality at all, and its subject need not resemble anything that actually exists. On the other hand, 20th-century painting tried to probe the potential of the painting medium by experimenting with form and color, flattening three-dimensional perspective, and simplifying composition. The 20th-century approach to still life was largely based on these criteria and, within the genre, on representations of fruit and other foods. A separate chapter belongs to Pop Art, which took hold in the United States in the early 1960s. Pop Art was born at a time when capitalism had become firmly established. It denounced the excesses of consumerism, and, ironically, celebrated industrially produced food as a primary expression of mass goods whose consumption is obsessively encouraged by advertising.

Iconography
In the 20th century, the still life with food was no longer seen as a minor genre. It shared the destiny of the avant-gardes, spreading from France to Germany and Italy, and finally reaching the United States, where it was subject to Pop Art developments

▼ Andy Warhol, *200 Soup Cans*, 1962. Carbondale, IL, John & Kimiko Powers Collection.

In Futurist painting, the original conception of still life as motion-less is transmuted into something dynamic.

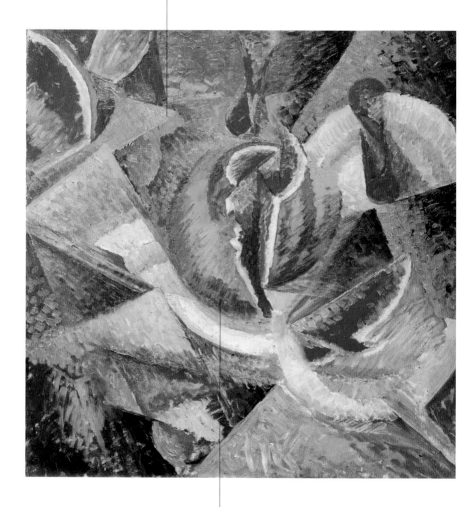

The ruptures in the watermelon are indicative of contrasting forces and illustrate the dynamism with which the Futurist aesthetic was concerned.

▲ Umberto Boccioni, *Watermelon*, 1914. Hanover (Germany), Sprengel Museum.

The obsessive crowding together of the food echoes the display of goods in a modern supermarket—a key institution in the consumer society.

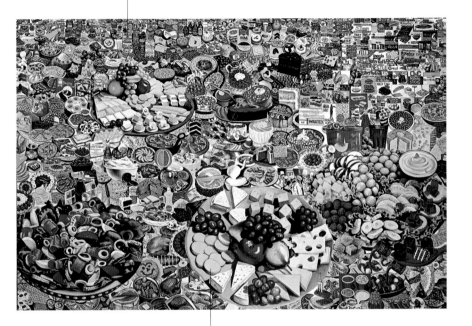

The repetition of identical forms suggests that food is no longer the imperfect product of natural and artisan activity, but the standardized outcome of industrial processes.

▲ Errò, *Food Landscape*, 1964. Stockholm, Nationalmuseum.

In late 16th-century Europe, genre painting was quite wide-spread. In this context, the role of food was to reveal and display the intimacies of domestic life.

Genre Scenes and Food

▼ David Teniers the Younger, *Wedding Scene*, 17th century. Private collection.

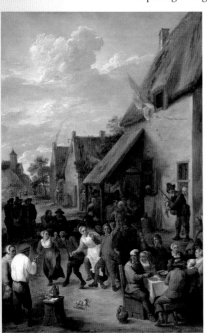

Among the various reasons for new iconographic tastes in the late 16th century were important changes in contemporary religion. In Holland and some other Protestant areas, repeated occurrences of violent iconoclasm were followed by permission to eliminate sacred images from churches, and the representation of saints was forbidden. This meant that the principal source of artists' commissions dried up, and they had to find other subjects for their work. All this occurred at a time of particular prosperity for the Low Countries, and there was considerable demand for works of art from a bourgeoisie that was acquiring ever greater economic power. This was the period, consequently, when changing social conditions led to the popularity of genre scenes. The desire to reflect the environment, customs, spirit, and feelings of the new patrons can be seen in the frequent references to food and meals, both as aspects of family intimacy and as moments in public and private life. Among the genre scenes depicting food are market, kitchen, and shop scenes. In the second half of the 16th century and throughout the 17th, food was increasingly evident in painting from Italy to Flanders. Market scenes could host quite disparate tonal levels, from the grotesque in popular paintings to the lascivious, which sprang from an intuitive association of food and sex. One can also discern in these works a subtle condemnation of ephemeral earthly pleasures.

Sweets are often
associated with
childhood.

Children taken from the streets or painted
in their humble homes are often the prin-
cipal figures in Murillo's genre scenes.

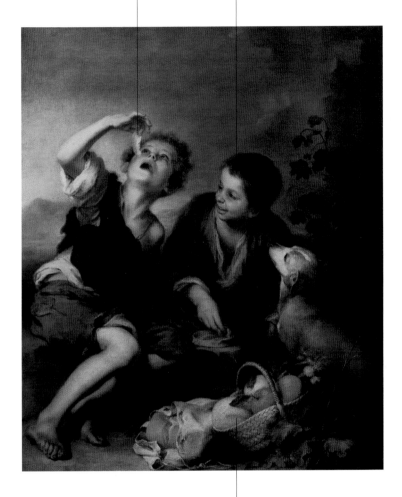

The basket of fruit and
onions serves to stress
the humble, rural tone
of the scene.

▲ Bartolomé Estebán Murillo,
Children Eating a Pie, 1662–72.
Munich, Alte Pinakothek.

The family portrait is one of the most characteristic genres of northern painting in the 16th and 17th centuries. References to the domestic ritual of the family meal accentuate the intimacy of the scene.

The head of the family establishes a relationship with the hypothetical observer by holding out a glass, as though inviting the viewer to join in a toast.

▲ Maerten van Heemskerck, *Family Group*, ca. 1530. Kassel, Gemäldegalerie.

The double fruit basket seems to contain a reference to the double allegorical significance of fruit: a symbol of earthly pleasure and also of spiritual joy.

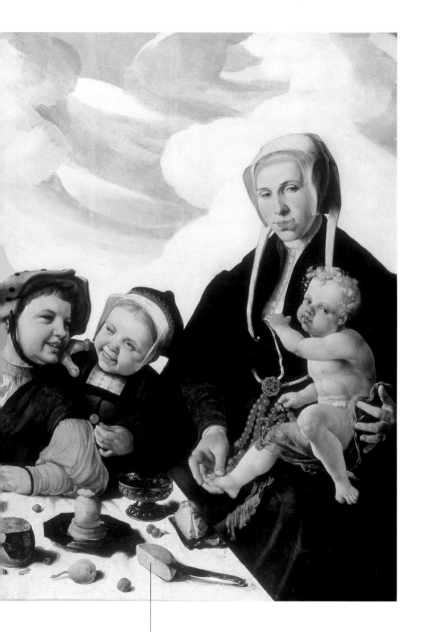

Beside the mother holding the
youngest child in her arms is a
cheese that may contain a reference
to maternity.

THE PLACES AND RITUALS OF DINING

Markets
Shops
Kitchens
Dining Rooms and Banqueting Halls
Refectories
Taverns
Cafés
Restaurants
Breakfast
Lunch
Dinner
Picnics
Banquets
Carnival, a Festival of Food
Grace before a Meal
Etiquette
Toasts

◄ Pieter Bruegel the Elder, *The Battle between Carnival and Lent* (detail), 1559. Vienna, Kunsthistorisches Museum.

The creation of markets was a significant advance in the history of the food trade, because since ancient times that commerce had been the monopoly of peddlers.

Markets

Fairs and markets came into being when peddlers banded together to trade their goods at certain specific times in the civil and religious calendar. In imperial Rome, the market was a clear indicator of the economic strength of the empire, for you could find every sort of food product there, from the plainest to the most sophisticated. Markets seem to have gone into temporary decline during the Middle Ages, when the economy was feudal, but they rose again in the 13th century as towns began once more to grow. From the late Middle Ages to the early 19th century, urban markets played an important part in the establishment of local eating habits. In the second half of the 16th century and throughout the 17th century, market scenes appeared frequently in paintings from Italy to Flanders. They celebrated the abundance brought about by an increasing trust in trade, the chief source of wealth for the new emerging classes.

▼ Telemaco Signorini, *Leith*, 1881. Florence, Galleria d'Arte Moderna.

In this period, market scenes reflected the curiosity and urge to collect found among those who assembled *Wunderkammern*. In the 18th century, market scenes acquired a new Enlightenment sense of economic well-being, which manifested itself as an optimistic feeling that hunger had been permanently conquered. In the 1880s, a substantial innovation appeared in the form of the covered market, where the buyer's attention was drawn by commercial advertisements affixed to the exteriors of buildings used to house them.

In northern European painting, market scenes celebrate economic wealth and convey a sense of trust in trade as a source of well-being for the country concerned.

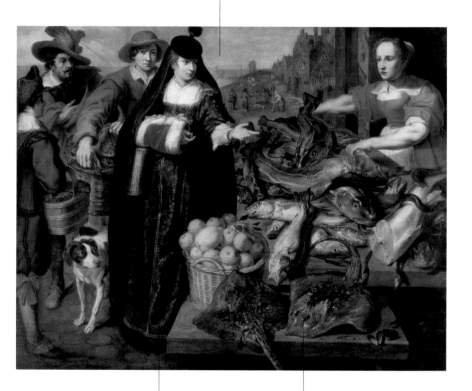

The fact that a gentlewoman, accompanied by her servants, has come to the market in person to choose fresh fish is an indication of the important role of the market in local culture.

Fish was one of the major food resources in Flemish villages, and the fish market made a significant contribution to trade.

▲ Jan Boeckhorst and Frans Snyders, *The Old Fish Market at Antwerp*, ca. 1630–40. Antwerp, Rubenshuis.

Markets

The man in rags puts his hand to his purse to produce money and thus convince the pancake seller that he can afford what he has asked for.

The fruit seller offering a bunch of grapes with a wink of her eye reminds us that they are used to make wine, a source of nutrition and joyful inebriation.

The vegetables provide a glimpse of contemporary local eating habits. Artichokes, for example, were a Tuscan specialty.

The presence of baskets and bags shows how markets had arisen from peddlers congregating.

In the 18th-century Enlightenment climate, the market in Florence was a subject worth studying for an insight into the local diet. At the same time it expressed that century's belief in progress and its confidence that hunger could be overcome.

▲ Johann Zoffany, *A Florentine Fruit Stall*, 1775. London, Tate Gallery.

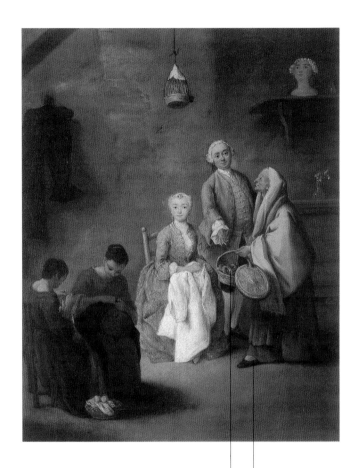

Sweets such as these fried cakes
were typical of the goods that
peddlers had sold for centuries.

Peddling was one of the earliest forms
of commerce. Even after markets came
into being, itinerant peddlers continued
to ply their trade.

▲ Pietro Longhi, *The Needlework
School*, 1752. Venice, Ca' Rezzonico.

Itinerant peddling was a common early means of selling food, but shops specializing in fresh food already existed in ancient Rome.

Shops

Meaning
Stimulation of the senses, wealth

Iconography
This subject became established in the 17th century among both Italian and Flemish artists as part of genre scenes

▼ Jean Béraud, *The Pâtisserie Gloppe on the Champs-Élysées*, 1889. Paris, Musée Carnavalet.

As the Roman Empire declined and a feudal economy became established, there was an increasing tendency for basic foodstuffs to be produced and prepared privately. Shops consequently went into decline. But when urban economies revived around the 13th century, shops regained some importance. It was in this period particularly that outlets from artisan workshops such as bakeries, cooked-meat shops, cake shops, grocery stores, and even butcher shops increased substantially in number. In medieval and Renaissance towns, shops were located on the ground floor of palaces that housed the family upstairs. Shops stretched in rows along the streets and had arched openings closed off at the bottom by one or two low walls at which the artisans worked, or on which they displayed their goods. Sometimes these walls projected slightly and were protected by a canopy, so that goods could be displayed without fear of damage. In paintings of the premodern period, especially in Flanders, such shops appear frequently, and the display and abundance of goods are suggestive of sensual earthly pleasures and the temptations they offer. The clustering of associated shops along a covered way constituted an important stage in the evolution of the modern urban shop: completely enclosed and fitted with large windows, allowing a well-illuminated view from the outside of the goods on display.

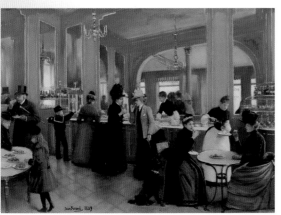

This butcher shop is a genre scene presented as unconventional theater. The animal carcasses become an art subject, subverting the aesthetic criteria of Mannerist painting, with its obsessive search for the beautiful, and arousing repugnance and dismay in the spectator.

The shop is represented in such a way as to emphasize the lower-class environment and the scene's provocative materialism.

▲ Annibale Carracci, *The Butcher's Shop*, 1582–83. Fort Worth, TX, Kimbell Art Museum.

The horn allowed shop-keepers to attract the attention of customers.

This bakery is typical of shops in the 16th to 18th centuries. Its flattened arch is partly closed off by the low wall on which goods could be displayed.

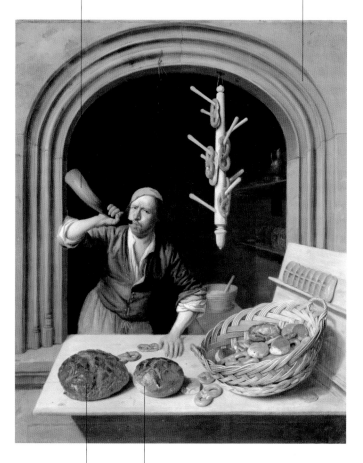

Being a basic subsistence food, bread can be seen as representing Divine Providence.

In the unevenness of the bread one can see an allegorical representation of human life, with its troubles and difficulties.

▲ Job Berckheyde, *The Baker*, ca. 1681. Worcester, MA, Art Museum.

In ancient Greece, houses did not have kitchens. The preparation of food was considered a sacred matter and was therefore carried out in public.

Kitchens

From the 3rd century B.C. onward, Roman kitchens had utensils similar to those of a modern kitchen, and in humbler homes kitchens might serve as the family gathering place as well as the dining room. In the Renaissance, the kitchens of the wealthy became larger, with massive central fireplaces or several smaller fireplaces against the wall, for spit-roasting, boiling, and making stews. The fireplaces would have firedogs and a rack and chain for supporting cooking pots and cauldrons. These were used for preparing banquets and celebratory meals for which a sumptuous and spectacular appearance was mandatory. Like an alchemist's laboratory, the kitchen had to be situated far from the eyes of hosts and guests. This was the period when the distinction between formal and informal, public and private became sharper, and the gastronomic creations produced by specialized staff took shape behind the scenes of social life. In this period, too, the kitchen became a frequent subject for the painter. Artists used the quantities of utensils and foodstuffs to celebrate abundance and hence the pleasures of the senses and curiosity about the wonders of nature. In 19th-century bourgeois apartments in Italy and France, kitchens were simple, serviceable rooms, furnished as necessary but intended only for the use of servants. The bourgeoisie in Germany, Flanders, and Anglo-Saxon countries, on the other hand, supplied their houses with large, welcoming kitchens, where it was pleasant to gather, eat, and receive guests informally.

Meaning
Domestic intimacy, wealth, alchemy

Iconography
Kitchens were a subject that appealed to northern artists. They appear especially in 17th- and 18th-century genre scenes, as well as in scenes of the same period depicting meals with Christ

▼ Martin Drölling, *Interior of a Kitchen*, ca. 1815. Paris, Louvre.

In the 16th century, the increasing separation of formal and informal, public and private, made it necessary to segregate the food preparation area from the banquet hall. Kitchens consequently became more spacious and structured.

In periods when a great deal of meat was eaten, spit-roasting was one of the most traditional and beloved cooking methods.

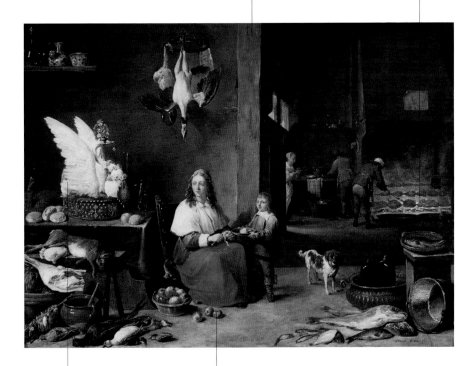

The swan has been decorated and its feathers replaced. In this period, it was customary to present such trophies at the table. The swan was a favorite in the world of chivalry because its pure white plumage made it an emblem of sincerity and purity as well as of magnanimity, because it fights only if provoked. The singing of the dying swan made it a symbol of virtue beyond physical death.

The kitchen becomes a common subject in painting at this period. Artists use the wealth of ingredients and cookware to celebrate abundance, the pleasures of the senses, and curiosity about nature.

▲ David Teniers the Elder, *The Rich Kitchen*, 1644. The Hague, Mauritshuis.

Various rooms were used for dining in the upper-class palaces of ancient Rome. But dining rooms became a rarity from the fall of the empire until the end of the 17th century.

Dining Rooms and Banqueting Halls

The process of separating the food preparation area from the dining area began in the Renaissance, though Bartolomeo Platina declared in the 15th century that the dining table should be situated according to the season: in warm, enclosed places in winter, and in the cool of the open air in summer, without a particular room being set aside for meals. There is evidence of evolving customs, moreover, in the changing shape of the dining table: in the Middle Ages, it consisted of a board resting on two trestles and was therefore easily dismantled, whereas in the Renaissance it was a solid, elaborate, and fixed piece of furniture, to be placed in a room that also had a sideboard for displaying and storing tableware. In the 17th century, the dining room became established as a specific room within the house: an intimate place where the family could gather and receive guests. Two centuries later, it became a room that typified the new wealthy bourgeoisie. Something rather different was required for a banquet with a large number of guests. In the late Middle Ages, it was the custom for noble families to receive their guests in the street, with tables set out under a loggia, while in feudal castles, banquets were served in the most capacious hall in the building. In Renaissance aristocratic dwellings, similarly, banquets were held in one of the largest rooms, with refined theatrical decor and stunningly ostentatious table settings. From Roman times onward, the garden was a place for both ordinary meals and banquets in good weather.

Sources
Platina, *De honesta voluptate et valetudine,* book 1, chap. 12

Meaning
Domestic intimacy, elevated style and refinement

Iconography
A frequent setting for genre scenes in Flemish painting. Also used in scenes of meals with Christ from the 16th to the 18th century. For the Impressionists, it was a preferred setting for scenes of domestic intimacy

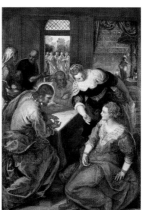

◄ Tintoretto, *Christ in the House of Martha and Mary,* ca. 1580. Munich, Alte Pinakothek.

75

Because this curious table clearly consists of a board resting on trestles, it can easily be dismantled and moved. Such an arrangement was necessary because no one room was set aside for meals.

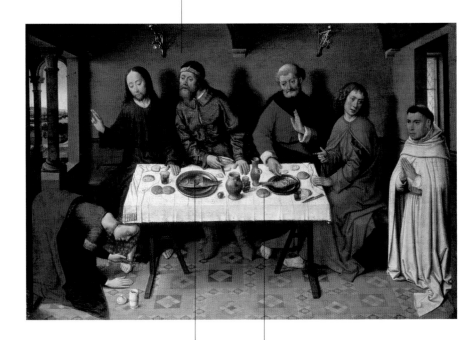

Fish as a main course in a Gospel meal represents Christ himself.

The bread is an allusion to the Eucharist.

▲ Dieric Bouts the Elder, *Christ in the House of Simon*, ca. 1440. Berlin, Gemäldegalerie.

The dining room comes into its own as an intimate place for family gatherings and receiving guests in the 19th century, when the social position of the wealthy bourgeoisie becomes established.

The presence of soup tureens and plates on the table makes it clear that there is a new concept of table arrangement. In this century, matching dinner services become very widespread, along with the numerous soup tureens, sauce boats, butter dishes, and other increasingly specialized items for serving the various dishes.

▲ Mary Ellen Best, *Our Dining Room at York*, 1838. Private collection.

Dining Rooms and Banqueting Halls

The scene is dominated by the statue of Venus in the niche, which emphasizes the fact that the diners are solely concerned with material pleasures.

The sumptuous, circular banqueting hall is decorated with stucco reliefs and frescoes.

The oysters, famed for their aphrodisiac qualities, are served on silver plates, establishing that they are considered a virile yet refined food.

The fact that the table is round, with no one at its head, suggests to the spectator that this is a banquet among equals. It is also noticeable that the company is exclusively male.

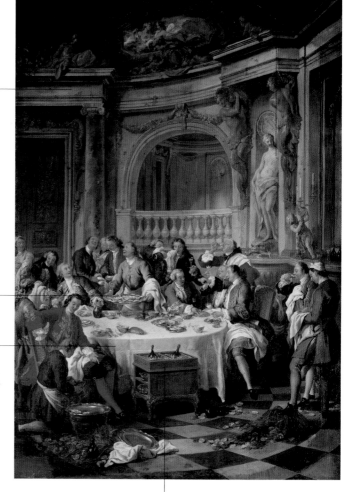

▲ Jean François de Troy, *The Oyster Lunch*, ca. 1735. Chantilly, Musée Condé.

The bottles that can be seen protruding from the cooling cabinet are small, which suggests that they contain some colorless spirit such as aquavit or gin.

The relationship between monks and food was subject to strict regulation and was laden with powerful symbolic Christian values.

Refectories

The refectory in the monastery was where the monks ate their communal meals, and its representation in pictures was intended to remind them of the spiritual precepts relating to food. There were monastic strictures on both diet and behavior, and the pleasures of eating were reduced to a minimum. From early Christian times on, and particularly among the earliest monastic communities, it was believed that any search for spiritual perfection must involve disciplined eating and even fasting. According to the Rule of Saint Benedict, in fact, nothing was less seemly for a good Christian than overeating, which would weigh upon the heart. The meat of four-legged animals was banned from monasteries, except for sick or ailing in the community: according to Aristotelian theory, meat stimulated the production of sperm, encouraging sexual activity among those for whom it was least appropriate. Even the demeanor of monks was subject to detailed regulations in the Rule. The monks were constrained to serve food to each other, a task from which no one was exempted. During their meals, moreover, a reading was called for, to be heard in absolute silence, and silence was preserved even when the monks were passing food and drink to one another. Hugh of Saint-Victor wrote at length about controlling the tongue and eyes, and he reminded his readers that eating may not begin until the blessing has taken place; furthermore, he declared that anyone seated to dine should above all think of the poor, because whoever feeds the poor is feeding God himself.

Sources
S. Benedicti Regula,
chaps. 35, 38, 39, and 40;
Hugh of Saint-Victor,
PL 176, cols. 949–52

Meaning
Didactic value

Iconography
From the late Middle Ages onward, refectories often appear in frescoes illustrating the lives of saintly monks

▼ Fra Angelico, *The Angels Serve Food to Saint Dominic and the Monks*, predella of *The Coronation of the Virgin*, ca. 1430. Paris, Louvre.

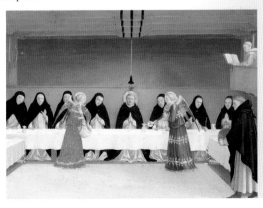

The tabernae *of ancient Rome were urban hostelries of poor repute for the use of the lower classes. In addition to serving food, they hosted gambling and prostitution.*

Taverns

Sources
Isidore of Seville, *PL* 82, cols. 540–41; Boccaccio, *Decameron*; Geoffrey Chaucer, *The Canterbury Tales*

Meaning
Popular socializing; places of ill repute

Iconography
Frequently found in the genre scenes of northern European artists in the 17th and 18th centuries

▼ William Hogarth, *A Rake's Progress: The Tavern Scene*, 1733–34. London, Sir John Soane's Museum.

The taverns of antiquity gave townspeople and travelers the chance to eat a hot meal. They advertised their services both by means of commercial signs listing the dishes available and by paintings on the interior walls, which announced the tavern's special dishes. Meals were taken sitting down, with hams and other preserved foodstuffs hanging from the rafters above, and wine was drunk either in its natural state or diluted with water, with a "take-out" option. Such places were scorned by reputable pagan society, and in Christian times they were considered dangerous locales that led citizens and especially monks to perdition. The Church condemned those of its ministers who yielded to temptation by entering a *taberna* for food and drink, except in cases of absolute necessity. In his *Etymologiae*, Isidore of Seville suggested that the Latin name *taberna* derived from the wooden boards from which the building was made, and he describes such sites as frequented exclusively by the lower classes. Nevertheless, the medieval tavern, though considered a sordid place, as in antiquity, became an integral part of urban life as a center for relaxation and amusement as well as for socializing and exchanging ideas. The tavern makes frequent appearances in medieval works of literature, such as Boccaccio's *Decameron* and Chaucer's *Canterbury Tales*. In the 16th and 17th centuries, the tavern was used as a setting for genre scenes of a popular nature, especially by Flemish artists, who often included salacious allusions in their scenes.

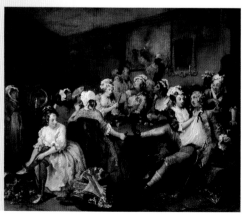

The string of garlic is hung up partly to preserve it but also to act as an amulet against the Evil One.

The tavern is seen in the background of the picture, while in the foreground is a kitchen scene. Large quantities of provisions attract the eye and allude to the sense of taste.

The customer making advances to the waitress illustrates the licentious atmosphere of taverns, which had been lowly places of ill repute since antiquity.

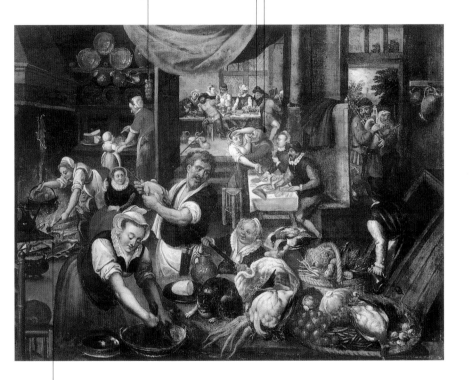

The act of cooking is a symbolic representation of the contrivances of a corrupt and sinful mind, the machinations of a devil's procuress.

▲ Marten van Cleve I, *Kitchen Scene*, 1565. Verona, Castelvecchio.

Thermopolii *in ancient Rome were effectively taverns with a stone counter facing the street. They were the antecedents of the cafés that arose in Europe in the mid-17th century.*

Cafés

Meaning
Socializing and the high life

Iconography
Cafés are often the setting for genre scenes in 19th-century French and Italian painting

▼ Vincent van Gogh, *The Café Terrace on the Place du Forum, Arles, at Night*, 1888. Otterlo (Netherlands), Rijksmuseum Kröller-Müller.

Coffeehouses appeared in Europe during the course of the 17th century in imitation of one that had opened in Constantinople in 1554. Some believe the first café opened in Oxford in 1650, but others claim that Venice had one by 1640, followed by Marseilles, Paris, and Vienna. In the 18th century, Carlo Goldoni celebrated the popularity of such places in his comedy *La bottega del caffè* (*The Coffee Shop*), bearing witness to the success not only of the drink but also of the places where it was consumed. In 18th-century England, coffeehouses evolved into exclusive aristocratic clubs where gentlemen met to drink and talk. But European cafés in the late 18th and 19th centuries were quite different. Nineteenth-century cafés were middle-class places, unlike the aristocratic salons of the ancien régime. When social classes began to mix in post-Napoleonic times, coffeehouses were frequented by all sorts of people and gradually became a political instrument, an ideal place for unofficial news to circulate. In European cafés, liberals and young members of the bourgeoisie with revolutionary ideas met to discuss politics, literature, and art, and from the mid-century onward, the cafés of Paris, now the capital of luxury and entertainment, became haunts of a pleasure-loving, cosmopolitan elite. Night life centered on the Café des Anglais, and the *café-chantant* and the *café-concert* came into being. The Impressionist painters loved the cafés, and in the late 19th century cafés came to typify Parisian life: while intellectuals and artists met there, they were democratically available to all, including the down-and-outs and alcoholics of that seductive city.

This is a period when wine was no longer made solely by peasants for family consumption but was also produced by newly created commercial wineries. Bottles of dark glass, which protected the contents from the damaging effects of light, greatly improved the quality and shelf life of wine.

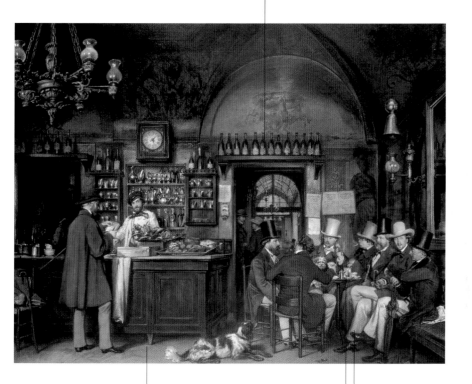

The Caffè Greco was one of the first cafés in Rome, and it still exists. It was famous for the people who frequented it.

The café took its name from the dark beverage that became very fashionable in the 18th century because of its stimulant qualities. It was a particular favorite of intellectuals.

Nineteenth-century cafés were meeting places for artists and intellectuals.

▲ Ludwig Passini, *Artists at the Caffè Greco in Rome*, ca. 1850. Hamburg, Kunsthalle.

Cafés

In the mid-19th century, when Paris was the capital of luxury
and entertainment, cafés were the preferred meeting places
for a pleasure-loving, cosmopolitan high society. This is
where the café-chantant *and the* café-concert *came into
being, with music to entertain their customers.*

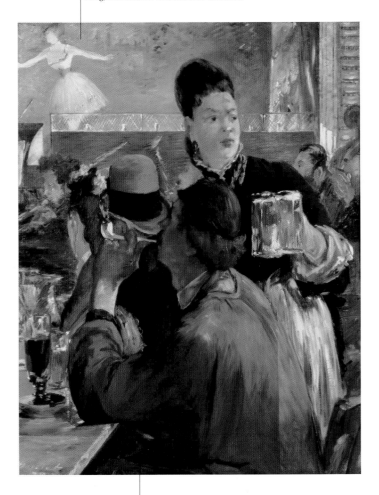

Cafés were the haunt of intellectuals and
artists, but part of their attraction was the
broad mix of people they brought
together.

▲ Édouard Manet, *A Corner of the
Café-Concert*, ca. 1877–78. London,
National Gallery.

▶ Pierre-Auguste Renoir, *The Inn of
Mère Anthony*, 1866. Stockholm,
Nationalmuseum.

In restaurants, private and public mingle in a modern form of exchange. They were a favorite setting for the cross sections of urban society so beloved by 19th-century painters.

Restaurants

Restaurants came into being in tandem with markets and fairs that obliged peasants and artisans to leave home for days at a time. In Paris, around 1760, restaurants were institutions intended for convalescents, who were given special broth as a tonic, but at the same time they offered various fixed-price menus that were available all day at individual tables. One innovation was the menu, which provided a choice; privacy and tranquility were added advantages. During the Terror, restaurants became meeting places for aristocrats precisely because of the discretion they offered; but in Napoleonic times they lost that connotation and simply became places for gastronomic enjoyment. After the French Revolution, a gastronomic revolution got under way, which aimed to simplify the preparation of food. Cooks who had been employed in the aristocratic houses of Paris found themselves out of a job, so they set up public establishments where their skills could satisfy a sufficient number of customers to make a living. Restaurants distanced themselves from traditional taverns, priding themselves on their cleanliness, good service, and refinement, especially in the type of food offered. In his 19th-century treatise, Brillat-Savarin defined the restaurant as a place of advantage to citizens and necessary for the evolution of gastronomy. There, anyone with sufficient means could sample the finest cooking, of a quality that had been available only to the aristocracy in the preceding century. A restaurant is a magical place where public and private are brought together, but its image can also be used to convey the isolation of the individual in society.

Sources
Brillat-Savarin,
The Physiology of Taste
(1825; 1999, trans.
M. F. K. Fisher)

Meaning
Socializing, fashionable
living

Iconography
Like the café, the restaurant was the setting for many French and Italian paintings in the 19th century. These works display a particular interest in urban and rural life, in both their private and public aspects

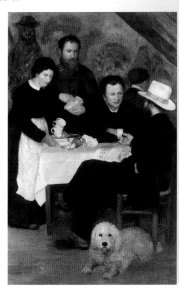

After the French Revolution, restaurants became places known for their cleanliness, good service, and refined furnishings, and especially for the fine food they offered.

Although the dining room is empty, the ancient tradition of floral decoration makes it cheerful and lends a certain serenity to the atmosphere of anticipation.

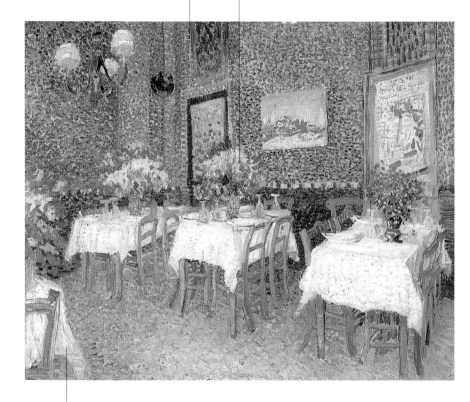

Ever since ancient times, the white tablecloth has given a dining table a sense of both cleanliness and decorum.

▲ Vincent van Gogh, *Interior of a Restaurant*, 1887. Otterlo (Netherlands), Rijksmuseum Kröller-Müller.

▶ Claude Monet, *The Breakfast*, 1868. Frankfurt, Städelsches Kunstinstitut.

The custom of taking breakfast has been around since the time of ancient Greece and Rome. It is one of the three main meals that mark out the day.

Breakfast

The Greeks ate a frugal breakfast, based on bread dipped in wine, together with cheese or fruit. They usually took it standing up and often away from home. In ancient Rome, the *jentaculum* was usually taken between eight and nine in the morning and consisted of a drink of milk, or a biscuit dipped in wine or garlic sauce, plus figs or olives. Sometimes cheese and eggs were its basic ingredients. But the habit of taking breakfast was abandoned by the Christians, though it is mentioned as a meal in the *Etymologiae* of the medieval exegete Isidore of Seville, where it is referred to as the first repast of the day, the one that breaks the nightly fast. In the 18th century, however, breakfast became an established meal, consisting of morning hot drinks and a few biscuits. In this period, breakfast was an aristocratic habit, and paintings show that it was often served in bedrooms or the small adjacent sitting rooms that were typical of upper-class homes. Precisely because it was an aristocratic habit, breakfast is shown in 18th-century paintings with explicit references to its social environment, mirroring exclusive customs and taste. In the next century, too, and continuing into the earlier years of the one following, breakfast was associated with the wealthier classes, but now it involved the industrial and financial bourgeoisie as well and was gradually descending the social scale. In 19th-century painting, breakfast seems to form part of the artistic celebration of domestic intimacy as a family ritual that is now thoroughly middle-class.

Sources
Isidore of Seville,
PL 82, col. 707

Meaning
Domestic intimacy,
refinement, aristocracy

Iconography
From the 18th and 19th centuries onward, breakfast appears in genre scenes with an Anglo-French aristocratic setting; it often occurs in Impressionist painting as well

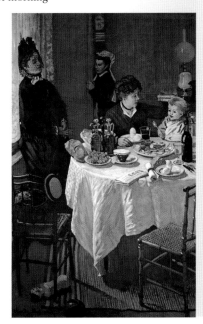

Breakfast

This work is part of a cycle depicting the unfortunate consequences of a marriage contracted for reasons of ambition and economic interest.

In this period, breakfast was taken not in the dining room, but in the bedroom or an adjacent salon.

Breakfast had been known since ancient times as a morning meal, but at this time was largely an aristocratic ritual.

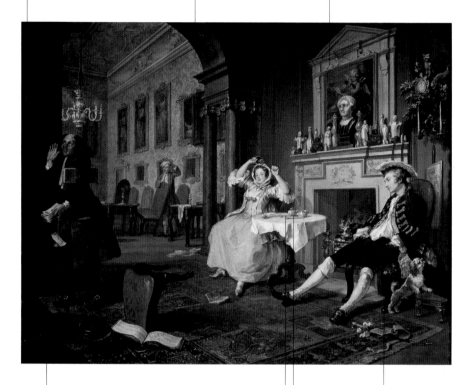

The steward is scandalized at the dissipated appearance of the couple and leaves with the bills unpaid.

The silver teapot is indicative not only of the lady's social class but also of her nationality, for tea was the national drink of Great Britain at this time.

Silverware was very fashionable among the upper classes at this time.

The chief character is exhausted after a night of merrymaking.

▲ William Hogarth, *Marriage à la mode: The Tête-à-Tête*, 1744. London, National Gallery.

Breakfast served in a small salon was a refined morning ritual of 18th-century upper-class gentlewomen.

The presence of the steward and the silver chocolate pot emphasizes the social rank of those portrayed and of the person who commissioned the picture.

Boucher was a refined interpreter of aristocratic French life in the 18th century.

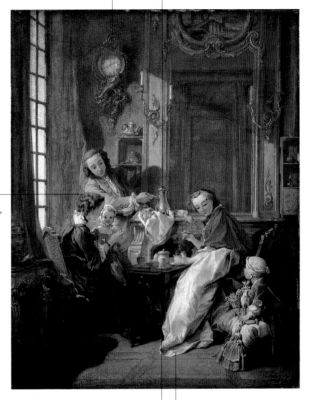

The bell-shaped cups indicate that chocolate is being served. Chocolate had been imported into France from Spain at the time of Louis XIII and was now quite fashionable.

Chocolate was principally a drink for ladies.

▲ François Boucher, *The Breakfast*, 1739. Paris, Louvre.

In antiquity, lunch was a plain meal that was often eaten away from home before midday, but it could also be an occasion for joyful gatherings of family and friends.

Lunch

Sources
Isidore of Seville, *PL 82*,
col. 707; Rabanus Maurus,
PL 111, col. 589

Meaning
Life, earthly pleasures

Iconography
Festive luncheons often
appear in 17th-century
Flemish paintings, but
lunch also serves to convey
domestic intimacy in the
works of the French
Impressionists

▼ Édouard Manet, *Lunch
in the Studio*, 1868.
Munich, Neue Pinakothek.

For the Romans, *prandium* was the first of the main meals, though it was usually eaten standing up and consisted basically of simple foods such as vegetables, fish, eggs, and mushrooms. Generally speaking, the Romans did not even wash their hands afterward. It was the same in Christian times: a frugal lunch allowed dinner to play its leading role as a meal and ritual at which the family met after a day's work. In his *Etymologiae*, Isidore of Seville said that *prandium* derived from the Latin term for the digestive system and that it was the name given to the meal eaten by soldiers before going into battle. Hence the saying *prandeamus tamquam ad inferos coenaturi* (let us eat now, for later we shall be dining in the underworld), which obviously alluded to the risk of dying in battle. The saying was repeated some centuries later by Rabanus Maurus, who emphasized, in accordance with medieval exegesis, that lunch is a symbol of one's present life and times, whereas dinner is related to death at the close of one's mortal existence. Thus lunch, which is eaten during the hours of daylight, is suggestive of the sunny, life-giving nature of the day, while dinner is related to

sunset and is therefore bound to symbolize death. Even in antiquity, lunch was not just an ordinary meal that marked out the progress of the day but also an occasion to celebrate rites and transitions, prescribed and private feasts, and special events and gatherings. From the Middle Ages onward, lunch could be the time for holding banquets with guests, as well as other celebrations and festivities.

The pewter jug was typical of 17th-century Flanders and shows that those present are drinking wine.

The man dressed as a clown is holding a ceremonial chalice out toward the spectator as though to drink his health, emphasizing the festive nature of the scene.

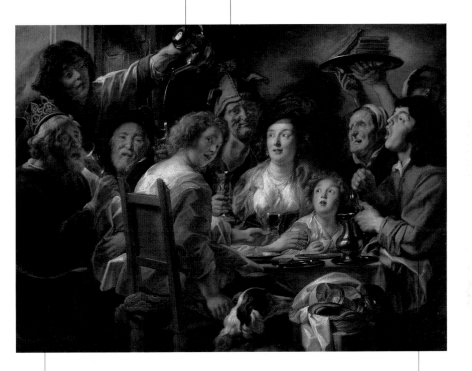

The crown on this character's head identifies him as the Bean King, whose feast day was celebrated on Twelfth Night (January 6). A bean was cooked inside a cake and whoever found it was proclaimed king of the feast. He was allowed to eat and drink as much as he liked, to the traditional cry of "The king is drinking!"

Although it took second place to dinner, lunch could also be an occasion to gather guests and friends. The joyful atmosphere in this painting echoes the idea that lunch is an emblem of life itself.

▲ Jacob Jordaens the Elder, *The King Is Drinking*, ca. 1640. Paris, Louvre.

Since antiquity, dinner has been the most important meal of the day. For the Greeks, it was much more elaborate than the other two meals, though it was not formal in nature.

Dinner

Sources
Isidore of Seville, *PL* 82,
col. 708; Rabanus Maurus,
PL 112, cols. 892–93 and
111, col. 589; Platina,
*De honesta voluptate et
valetitudine* (1474),
book 1, chap. 3

Meaning
Death, spiritual
nourishment, elevated
contemplation

Iconography
In the late 16th and early
17th centuries, artists
began to take an interest in
dinner, not only because of
its mystical value in rela-
tion to meals with Christ,
but also because it allowed
them to explore the effects
of artificial light. In the
19th century, artists used
dinner to depict social life,
especially in French
Impressionist circles

According to Isidore of Seville's etymology, the Latin term *coena* derives from the fact that it was a communal meal, as conveyed by the Greek word *koinon*, meaning "together." According to Rabanus Maurus, it was a meal that diners should take together and, unlike lunch, it was an evening ritual and could also be read in mystic terms as the end of life. In ancient Rome, dinner was the main meal of the day and was originally eaten in the late afternoon. Even more than lunch, dinner was an occasion for inviting guests, and so it remained in Christian times, when it was the principal meal of the day and provided family and friends with an opportunity to gather together. This custom was preserved in later centuries, and even in Bartolomeo Platina's 15th-century treatise dinner keeps its primary role. Unlike the other two meals, this one is an emblem of the Last Supper and the Supper at Emmaus, and so the exegetic sources endow it with a symbolic value relating to elevated contemplation and identify in it a moment of spiritual refreshment, pointing the way to eternal life.

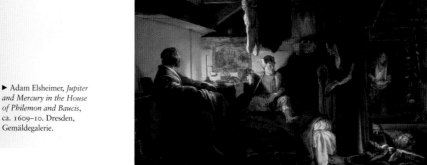

▶ Adam Elsheimer, *Jupiter and Mercury in the House of Philemon and Baucis*, ca. 1609–10. Dresden, Gemäldegalerie.

The statue of Venus is there to remind us of the love affair between the queen of Egypt and the Roman military commander.

The statue of Juno in the niche reminds us of Cleopatra's legendary riches.

The banquet is the setting for a wager between Anthony and Cleopatra. She promised to spend an enormous sum on a single dinner and, in order to keep her word, she dissolved a pearl of inestimable value in a goblet of vinegar.

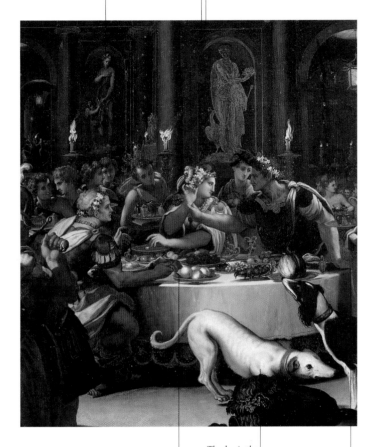

The citrus tree was called citrus medica in Latin, but the name was mistakenly applied to lemons as well. Hence the lemons at the center of the composition are an allusion to the Medici, who commissioned the painting.

The dog in the foreground reminds us of the Renaissance custom at banquets of throwing leftover food onto the floor for the dogs to clean up.

Worried that the queen might treat the other pearl the same way, the arbiter of the wager took it as a souvenir of the event.

▲ Alessandro Allori, *The Banquet of Cleopatra*, 1570. Florence, Palazzo Vecchio, *studiolo* of Francesco I de' Medici.

The evening light and the oil lamp indicate that the Last Supper is taking place at sunset. They give the painting an evocative and rather gloomy atmosphere, reminding us that dinner is a symbol of death.

Christ is seen blessing the bread, the symbol of his body.

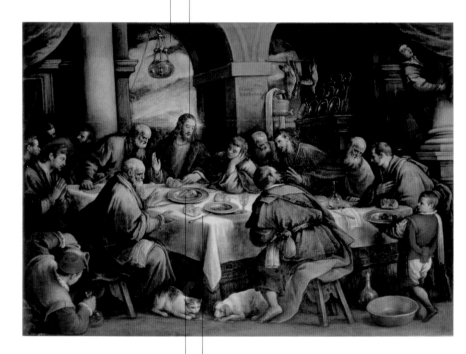

The serving dish with pieces of lamb, the traditional sacrificial animal, is an allusion to Christ's role as sacrificial victim for the redemption of humanity.

Knives were already in common use as weapons and became the first individual items of cutlery to appear at table.

▲ Francesco Bassano, *The Last Supper*, ca. 1590. Madrid, Prado.

Since ancient times, dinner has been the principal meal, bringing the day to a close with an intimate family gathering. The Gospel story has helped give that ritual a sacred aura.

The Chinese porcelain serving dish is an exotic object of a kind imported by Flemish merchants at that period.

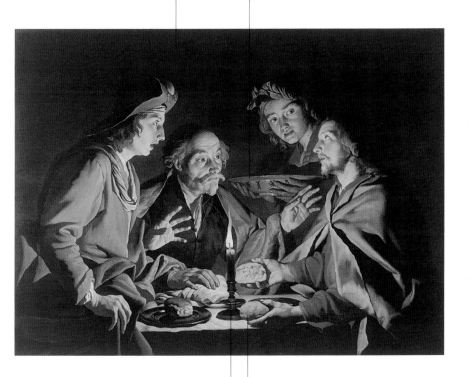

The candlelight is necessary because this meal is traditionally eaten after sunset. Flemish artists embraced the challenge of rendering artificial light in the surrounding darkness of night.

Christ reveals his identity by breaking the bread, thus repeating his action at the Last Supper.

▲ Matthias Stom, *Christ at Emmaus*, ca. 1630–40. Madrid, Thyssen-Bornemisza Museum.

From the 19th century onward, as night life became more intense, dinner became an occasion for elegant gatherings.

The napkin on the lady's lap shows that she is aware of table etiquette, which had been codified since the Renaissance.

The silver samovar, used to hold boiling water or hot drinks, suggests coffee and therefore the end of the meal.

The expensive lace-edged tablecloth emphasizes the elegance of the surroundings and reveals a predilection for white, which has always been a symbol of cleanliness and purity.

▲ Jules-Alexandre Grün, *The End of Dinner*, 1913. Turcoing (France), Musée des Beaux-Arts.

The French term piquenique *describes a meal eaten during a walk, in the open air, each person contributing food and drink to the common repast.*

Picnics

There is a fundamental difference between a picnic and a meal in the open air. Taking dinner or lunch at table in the open air was common practice before the 17th century and arose from the lack of a specifically designated dining room, as well as from the pleasure provided by a cool spot deep in a grassy garden during the heat of summer. A true picnic, on the other hand, derives from a style of eating associated with hunting. During a day of sport, it was common to pause from time to time for a drink or a snack, which was often laid out on a cloth spread directly on the ground. This custom allowed very close contact with nature and also permitted gentlemen and ladies greater freedom than was possible at table, where etiquette imposed strict rules of behavior. In 18th-century painting, picnics often appear in association with hunting scenes—hunting being an aristocratic leisure pursuit. The picnic ritual, as it developed in later centuries, also appears in Impressionist painting, but its tone there is quite different. The 19th-century *déjeuner sur l'herbe* has now lost its original connection with hunting and appears as a sophisticated urban amusement enjoyed by gentlemen, artists, and intellectuals who wish to escape from the chaotic atmosphere of the city.

Meaning
Aristocratic and chivalrous ritual, escape, amusement

Iconography
Picnics rarely appear in painting before the 18th century, but they are common in aristocratic genre scenes by 18th-century French, English, and Flemish artists. The Impressionists provided several interesting versions of the subject

▼ Gustave Courbet, *The Hunting Picnic*, 1858. Cologne, Wallraf-Richartz Museum.

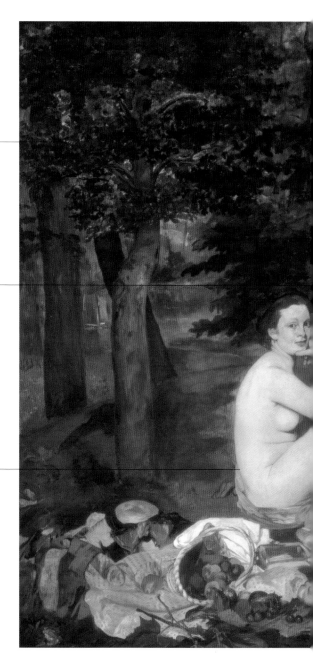

This painting aroused a great deal of controversy, and a number of contemporaries described it as indecent.

The picnic by the water was a sophisticated urban ritual, as the gentlemen's elegant city clothes make clear.

The presence of naked women would not have caused amazement in a mythological painting, but here the contrast between the women's nudity and the gentlemen's clothed state is provocative.

▲ Édouard Manet, *Le Déjeuner sur l'herbe*, 1863. Paris, Musée d'Orsay.

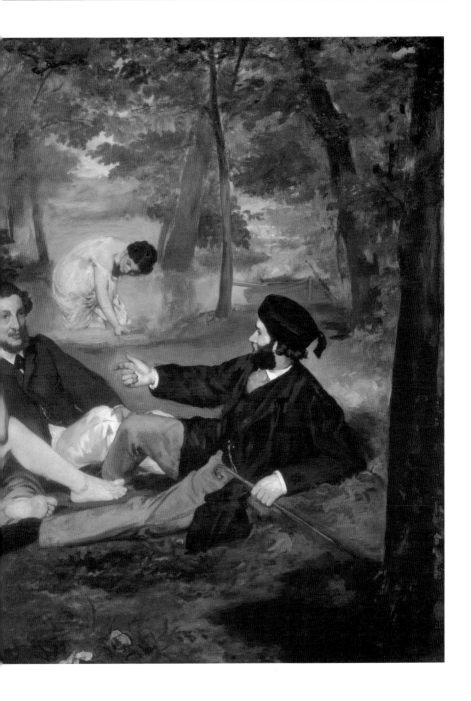

Picnics

This 18th-century picnic shows the
original link between meals in the
countryside and hunting, as well as
with out-of-town trips.

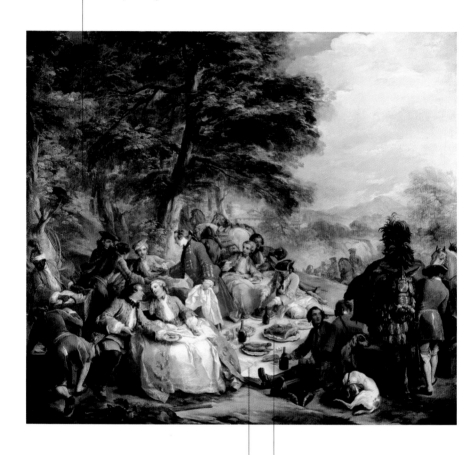

The cloth is laid directly on
the ground and conveys the
informal tone of a meal eaten
in contact with nature.

Ham was easily preserved
and transported, and it is
shown here as a typical
picnic food.

▲ Carle van Loo, *A Rest of the Hunting
Party*, 1737. Paris, Louvre.

▶ Sarcophagus of a Husband and
Wife, ca. 520 B.C. Rome, Museo di
Villa Giulia.

The Latin for banquet is convivium, *from* cum vivere *(live together). At banquets people gather to cultivate ties not just among persons but also between humans and gods.*

Banquets

In antiquity, the banquet was not only a sacred ritual, linked to sacrifice, but also a profane one. At Greek banquets, and also those of the Etruscans and Romans, diners reposed on triclinia, their feet bare and washed, so that they felt removed from earthly things and closer to the divine. For Christians, a holy banquet was a crucial moment in the relationship between man and God and acquired new spiritual values from its link to the Last Supper of Christ. Medieval exegesis stressed the symbolic significance of the banquet as an expression of election: only those who have been chosen by the Lord are worthy to sit at the table and take part. In a mystical sense, eating at Christ's table meant meditating on Holy Scripture and assimilating its spiritual nourishment. The great banquets of the Middle Ages and Renaissance gave the aristocracy a means of expressing their economic power. Their skill in organizing banquets allowed them to demonstrate not only their own strategic acumen and economic power but also their degree of culture and good taste. Banqueting was an aspect of social life in the West in all periods. It appears in painting of every age, from antiquity to the medieval world of chivalry and the splendid celebrations of the Renaissance and Baroque, as well as to 19th-century portrayals of magnificent country weddings.

Sources
Isidore of Seville, *PL* 82, cols. 540, 705–6; Rabanus Maurus, *PL* 111, cols. 573, 587

Meaning
Social and formal life; contact between man and the divine

Iconography
The banquet is key to Etruscan funerary art and is also a theme in Roman painting. It often provides a setting for Gospel and biblical scenes in Renaissance and 17th-century art and subsequently becomes the setting for both peasant and aristocratic genre scenes

The rhyton *was a ceremonial drinking vessel and an ancestor of the Renaissance drinking horn. It tells us that we are at the closing stage of the banquet, when toasts were traditionally drunk.*

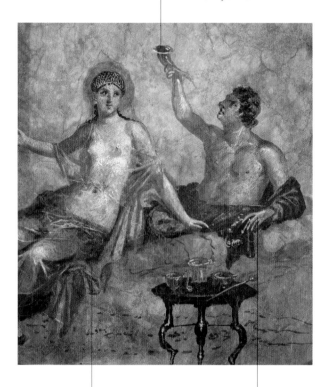

Since the figure on the left is naked, she must be either a goddess or a hetaera (courtesan), because women were excluded from Roman banquets as not being up to the level of male conversation. Only maidservants and hetaerae were admitted.

In Roman times, guests reclined on triclinia at banquets. In this position they were removed from earthly matteus in both a physical and a metaphorical sense and could establish more direct contact with the world of the divine.

▲ Fresco with a banqueting scene, from Pompeii, 1st century A.D. Naples, Museo Archeologico.

At this knights' banquet, William is surrounded by his barons. His brother, Bishop Odo, echoes Christ's action at the Last Supper by blessing the food and drink.

The fish is recognizable as such. As a symbol of Christ, it adds a sacred element to the meal.

ET HIC EPISCOPVS·CIBV·ET POTV: BE NE DIC IT·

This tapestry tells the story of William the Conqueror, Duke of Normandy, succeeding King Edward to the English throne.

▲ *The Knights' Banquet*, detail from the Bayeux Tapestry, 11th century. Bayeux, Musée de la Tapisserie.

Banquets

Ever since ancient times, the wedding feast has been a ritual celebrating a fundamental transition in private and social life.

From this time onward, sugared sweetmeats and wedding cake were the typical wedding sweets.

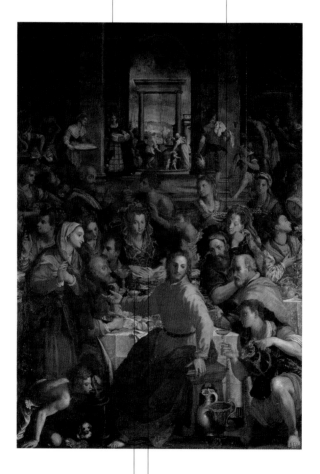

The gilded saltcellar identifies the bride as the guest of honor at the banquet, and her features reveal that she is Maria de' Medici, who married Henry IV in 1592, the year this work was painted.

The white napkin on the bride's lap emphasizes the fact that she understands the table etiquette of the time, and its whiteness reminds us that purity is a matrimonial virtue.

▲ Alessandro Allori, *The Marriage at Cana*, 1592. Florence, Sant'Agata.

This is a banquet for the officers of the civic guard of Saint Adrian, who are shown at the end of their term of office in an atmosphere of festive fellowship.

The raised glasses show that the painter has frozen the scene at the moment of a toast. Ever since antiquity, toasts have formed the concluding part of the symposium.

A silver saltcellar was a sign of distinction, so its presence beside the man turning toward the virtual spectator suggests that he had a leading position in the civic guard.

▲ Frans Hals, *Banquet of the Officers of the Civic Guard of Saint Adrian at Haarlem*, 1627. Haarlem, Frans Hals Museum.

Banquets

The banquet is held as a convivial pause in the electoral campaign.

This work is part of a cycle of four paintings illustrating the electoral campaign. The subject had been dealt with in a contemporary satirical play called Don Quixote in England, *in which the rival parties were called the Old and New Interest.*

Beneath the tone of caricature, the artist invites to us to read the scene as a metaphor. Thus the gluttonous eating alludes to the greed of the ruling Whig Party, and the dapper candidates on the left side of the table cozy up to their lower-class constituents in order to win their votes.

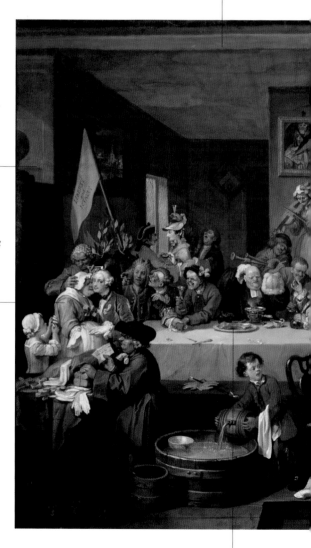

▲ William Hogarth, *The Electoral Campaign: The Banquet,* 1754. London, Sir John Soane's Museum.

The large steak bone, stripped of all its meat, is a metaphor for the tendencies of the party in power.

The bewigged man has fallen ill after eating a heap of oysters. As the dubious physician prepares to bleed him, the rival Tory party demonstrates in the street outside.

The Whig attorney has just been hit with a brick, flung by the Tory mob in the street.

The wedding feast is a sort of garden party taking place in an orchard. From ancient times onward, meals in the open air, whether celebratory or not, were an enjoyable and special event.

The toast is a celebratory act of ancient origin. One of the most typical customs in drinking a toast is to clink glasses first.

A large cut of meat such as this was a rare delicacy, reserved for festive occasions. It emphasizes the bucolic nature of the scene.

▲ Albert-Auguste Fourié, *The Wedding Feast at Yport*, 1886. Rouen, Musée des Beaux-Arts.

At Carnival, excessive eating is part of the tradition festivities. Carnival precedes Lent, a time before Easter for the mortification of the appetite.

Carnival, a Festival of Food

There is no doubt that, historically, Carnival is a continuation of the Saturnalia, the festivities in honor of Saturn. The burlesque figure (Carnival), who is publicly put to death after a period of dissipation, seems to be a direct descendant of the king of the Saturnalians. When an annual balance sheet was drawn up, sins committed had to be expiated in order not to count in the following year. Gluttony was the worst type of sin and was given substance in one last ritual eating excess, after which a rite of purification was begun. This was Lent, a forty-day period of fasting before the feast of Easter. Originally the fasting was total but limited to the days of the mystery of the Redemption, but then it became a single meal to be eaten after sunset but without meat, and for many centuries without eggs and milk products as well. The clash between Carnival and Lent became the subject of popular festivities, as well as the allegorical theme of mystery plays, where the battles enacted were based on the numerous texts written from the late Middle Ages to the 18th century. Lent always won the battle, and Carnival, in the form of a puppet or animal, was captured, tried, and condemned to death. The battle between Carnival and Lent has come down to us partly in the form of paintings that give expression to popular tradition. The symbolic meaning shared by mystery plays and paintings on this subject is that of the battle between vice and virtue.

Meaning
A liberating festival, and an expression of the sin of gluttony

Iconography
This subject appears in Flemish art in the 16th century, a time of religious turmoil and renewed sensitivity to the Gospel

▼ Pieter Bruegel the Elder, *The Battle between Carnival and Lent* (detail), 1559. Vienna, Kunsthistorisches Museum.

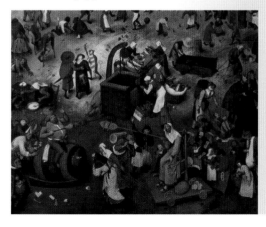

This Christian practice has a long history and is very widespread in Western culture. It expresses thanks to God for ensuring a sufficiency of food.

Grace before a Meal

Meaning
Thanks to God, moral teaching

Iconography
Grace before a meal is not a common subject in painting. It usually appears in genre scenes and finds expression in Flemish, French, and English art in the 17th and 18th centuries

The practice of saying a prayer before a meal seems to be deeply rooted in the idea that food is a means of maintaining not just the body but also the spirit, the latter being necessarily lodged in the body. In pagan and Christian ritual, food is unequivocally accepted as a symbolic link between man and God. In antiquity, sacrifices to the gods were followed by a sacred feast, and the meal that followed a funeral was both a form of farewell to the dead and an expression of hope that he or she would enjoy similar pleasures in the world beyond. As the Christian banquet par excellence, the Last Supper symbolizes the idea of food as Eucharist, as hope of redemption; and the blessing of bread by Christ not only serves as the fulcrum of that religious service but also stresses the sacred aspect of eating. The dietary rules of the Jews, which distinguish between clean and unclean foods, and those of Christians, which regulate fasting and abstention from meat, confirm the spiritual significance of eating by providing it with behavioral norms. Grace before a meal is a practice documented in the figurative arts of Protestant countries, while in the Catholic world every prayer relating to food was drawn into the ritual of the Mass, that is, into church and into the presence of a priest. Images of this kind often include children and certainly had a strong didactic purpose linked to the application of religious principles to everyday life. In addition to showing the religious piety of those depicted, grace before a meal expresses the idea of food as a divine gift, the material expression of higher spiritual values.

▼ Nicolaes Maes, *An Old Woman at Prayer*, ca. 1655. Amsterdam, Rijksmuseum.

The saying of grace not only bears witness to the piety of the person or persons depicted but also identifies food as a divine gift, the material expression of a higher spiritual principle.

The presence of the two little girls reminds us that pictures of this kind were not just "photographs" of family events but were also meant to teach the application of religious principles to everyday life.

▲ Jean-Siméon Chardin, *Saying Grace*, 1746. Paris, Louvre.

As community rituals, meals and particularly banquets required a system for regulating not only the quality and quantity of food but also the manner in which it was eaten.

Etiquette

Sources
Giovanni Della Casa,
Galateo (1558),
chaps. 5 and 29

Iconography
The paintings that refer
to contemporary table
etiquette are usually
those depicting banquets,
whether of a religious or
secular type

Recognized as communal rituals, convivial meals followed rules established in chivalric courts, where such meals were the focus of social life. As an aristocratic ritual, meals were subject to a strict hierarchical ceremonial, which often required the separation of the sexes and a codified arrangement of places at table. The medieval West differed from the ancient world in that one ate sitting down and not reclining. With this change, the Eastern type of oval or round table gave way to the rectangular table, where the diners sat only at the long sides. The hierarchy of places at table led to the idea of a place of honor at the center of the long side or on the short side: the head of the table, in other words. The size of the chair was proportional to the status of the person using it: at medieval banquets, lords sat on high-backed chairs, while the guests sat on stools or benches. This rather ungenerous arrangement was abandoned at the Renaissance table, where every guest was given a dignified place around the table, while still respecting the traditional place of honor. At this period the idea also began to develop that the criterion for distinguishing the person of high rank at table should be based not on the place he occupied but rather on the approach to food.

▼ Miniature from *Livre de Messire Lancelot du Lac*, by Gautier de Moap, ca. 1450. Paris, Bibliothèque Nationale.

The idea was gaining hold that moderation in eating—originally a religious concept—was synonymous with elegance. So the Christian and aristocratic models became fused, bringing together the original, intrinsic virtues with those acquired through Christian values, and creating a general climate favoring control of the instincts.

From ancient times, food remains were thrown onto the floor and were sometimes used to feed the poor or dogs.

One of the most extraordinary kinds of Roman still life was the so-called riparographia, *that is, mosaic representations of an unswept floor decorated with food remains.*

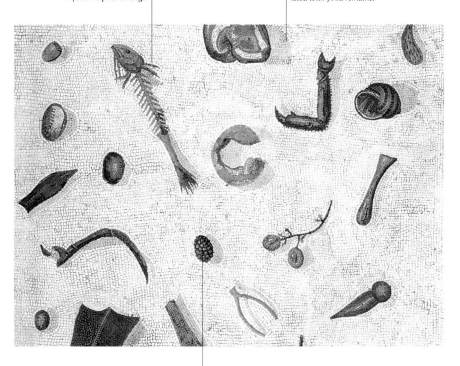

Unswept floors are a decorative reflection of a behavioral norm of cultic origin. This required that anything that fell to the floor during a banquet be left where it lay, and that the floor not be swept immediately after the meal.

▲ Mosaic of an Unswept Floor, 2nd century A.D. Rome, Musei Vaticani.

Etiquette

In the Gospel parable, a rich man is condemned to hell for refusing to give a crust of bread to Lazarus, a poor leper.

The peacock is an emblem of vanity and of the ephemeral nature of material pleasures.

The rich man displays his greed by sitting alone at table with musicians to entertain him.

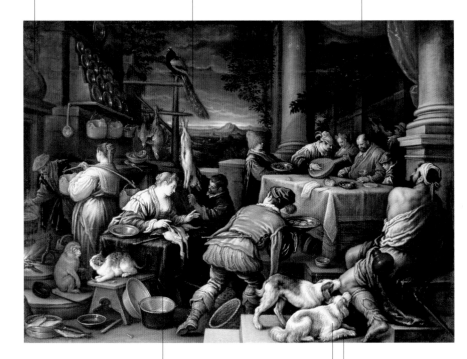

The dead goose is a symbol of the persistent sinner who is destined for damnation.

The dogs licking Lazarus's sores echo the words of the Bible and also reflect the common custom at the time of allowing the dogs to clean up the food that had fallen to the floor during a banquet.

The aim of this subject, quite common in the banqueting halls of noble palaces, was to remind one, by antithesis, of the need for moderation in eating and of the duty of those of high rank to practice charity.

▲ Leandro Bassano, *The Rich Man and Lazarus*, ca. 1590–95. Madrid, Prado.

The twilight colors of the sky remind us that dinner is the last meal of the day and is eaten after sunset.

Christ, as the principal figure at the Last Supper, sits at the place of honor at the center of the long table.

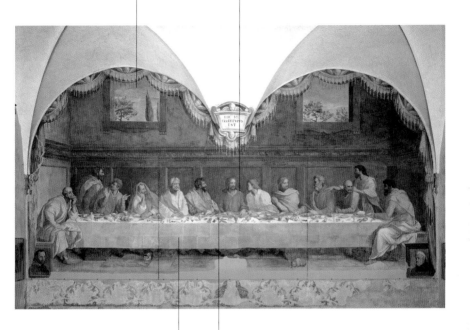

The tablecloth, with its regular folds and squares, is intended to lend a sense of cleanliness and purity to the Last Supper.

The bread, as a symbol of Christ's body, stands out on the Last Supper table and conveys its Eucharistic meaning quite clearly.

▲ Alessandro Allori, *The Last Supper*, 1582. Florence, Carmine church.

Etiquette

The host occupies the place of honor at table. His higher status is established by his chair, taller than the others, covered with a canopy—a late-medieval custom.

Herod's banquet is represented as a court dinner, illuminated by a luxurious hanging chandelier, which casts an evocative light over the whole scene.

The gold and silver plate serve to emphasize the lord's riches.

The ewer and basin remind us that it was habitual to wash one's hands frequently, not just at the beginning of the meal but also between courses. This was necessary because one ate with one's fingers.

▲ Bartholomäus Strobel the Younger,
The Feast of Herod, ca. 1625. Munich,
Alte Pinakothek.

A toast calls on everyone to drink together, usually at a banquet, and the words are accompanied by the gesture of raising one's glass in honor of a person or event.

Toasts

The Italian word *brindisi* (toast) comes from the Spanish *brindar*, which in turn comes from the German *bringe dir*, "I offer you"— an expression that Spanish troops learned from German mercenaries. The toast is an ancient custom, found in the Bible (Esther 1:7–8; Hab. 2:15) and the Homeric poems. At Greek banquets, eating and drinking were done separately, and one of the diners was put in charge of preparing drinks and organizing toasts in honor of those present or their beloveds, in a pre-established sequence. Toasts were common at Roman banquets, too, and early Christians used to drink to the health of martyrs and saints. But the custom seems to have declined and became a prerogative of northern peoples in the Middle Ages. Renaissance Italians disapproved of toasts, which were considered foreign and therefore barbarous. In the 16th century, Della Casa wrote: "The invitation to drink . . . is reprehensible in itself, and has not yet become customary in our parts, so it should not be done, and if you are invited to do so you can easily decline the invitation and say that you admit defeat, giving thanks at the same time, or else you can taste the wine out of politeness without drinking any more." Later, the custom spread throughout northern Italy without arousing disapproval. There are traditional gestures connected with toasts, such as clinking full glasses together or simply raising the glass to someone's health before drinking.

Sources
Cicero *In Verrem* 2.1.66;
Giovanni Della Casa,
Galateo (1558), chap. 29

Meaning
Socializing, celebration

Iconography
Evidence of the custom can be found in 17th- and 18th-century French and Flemish genre scenes

▼ Jean-Antoine Watteau, *Actors of the Comédie-Française*, 1718. Berlin, Gemäldegalerie.

117

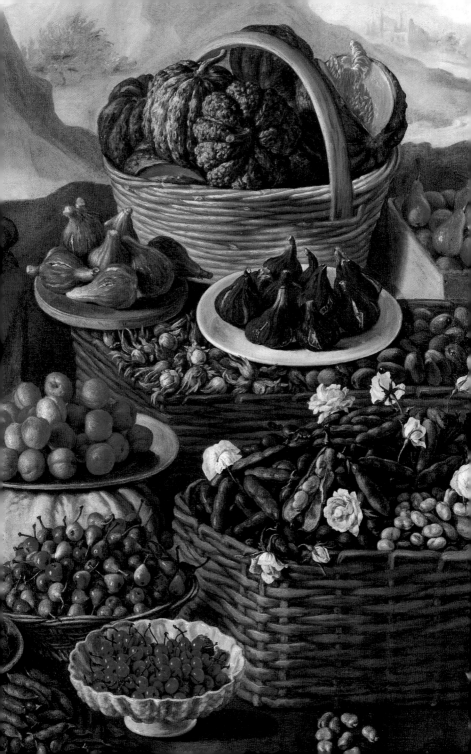

FOOD AND DRINK

Bread
Porridge and Polenta
Beef
Pork and Boar
Charcuterie
Lamb
Poultry and Game
Fish
Mollusks
Crustaceans
Milk and Butter
Cheese
Eggs
Vegetables
Garlic
Onions
Artichokes
Lettuce
Mushrooms and Truffles
Potatoes
Tomatoes
Legumes
Fruit
Apples
Melons

Figs
Chestnuts
Pomegranates
Cherries
Lemons and Citron
Grapes
Dates
Dried Fruit and Nuts
Sweets
Honey
Sugar
Salt
Pepper and Chilis
Olive Oil and Olives
Vinegar
Water
Beer
Wine
Champagne
Absinthe
Spirits
Chocolate
Tea
Coffee

◀ Vincenzo Campi, *The Fruit Seller*
(detail), ca. 1580. Milan, Pinacoteca
di Brera.

In Greek myth, bread is sacred to that irascible but generous goddess, Demeter, who taught young Triptolemus the art of agriculture, including the cultivation of grain.

Bread

Sources
Rabanus Maurus, *PL* 112, cols. 1020–21; Filippo Picinelli, *Mundus Symbolicus* (1687), book 15, chap. 18

Meaning
Hospitality, the Eucharist, charity

Iconography
It appears in scenes of meals with Christ, alluding to the Eucharist. It often appears in episodes of hospitality, such as the meeting of Abraham and Melchizedek, or Gospel stories such as Christ in the House of Martha and Mary, and the Miracle of the Loaves and Fishes. In still lifes, it may symbolize charity

The invention of bread in Neolithic times marks a key stage in man's progress from hunter to farmer and shepherd. The Romans construed a divine origin for bread, deeming that the word *panis* derived from the sylvan god Pan, allegedly the first to have cooked the grain that Ceres gave to man. Indeed, the image of Pan was actually reproduced on loaves of bread. To make bread, the best grain was selected and stone-ground. The resulting flour was mixed with oil and water and leavened with fermented dough. In Jewish culture, eating leavened bread was forbidden at the time of Pesach, so unleavened bread was made. In the Middle Ages, bread was a basic foodstuff and enjoyed a certain sacred aura thanks to Christian tradition, in which it symbolized the body of Christ in the ritual of the Eucharist, a divine food offered to the faithful. While it is a sign of Divine Providence in the Old Testament (Eccles. 9:7) and the symbolic staff of life, in the Gospels it becomes the divine food par excellence. In medieval exegesis, bread is the spiritual grace granted to those who practice the most elevated kind of contemplation; it is holy doctrine; it is Christ himself. As a basic food, it also represents the essence of charity, the consolation of those who feel hunger in a physical and spiritual sense, and the understanding of the scriptures; but it also sometimes represents excessive love of the pleasures of the flesh. Because of its slow preparation in a number of stages, bread, for Filippo Picinelli, represents fruitful labor that provides spiritual strength when completed.

After Saint Francis has prayed for the knight of Celano and heard his confession, this generous soul invites the saint to dine. Suddenly, the knight is stricken and dies before the saint's very eyes.

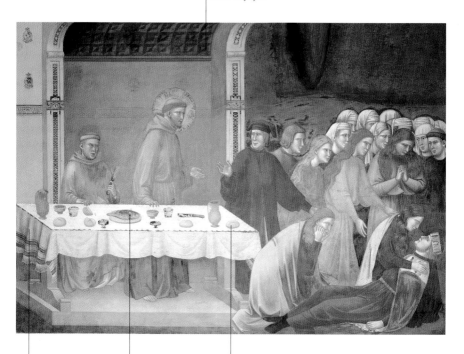

The Perugia tablecloth, decorated with pale blue and white stripes, is of a type often used for liturgical purposes. Here, the table is prepared as for a ritual meal.

The fish on the table reminds us of Christ's name.

The loaf of bread bears the sign of the cross, and so symbolically reminds us of the bread of the Eucharist, which is the body of Christ.

◀ Joos van Cleve, *The Last Supper*, predella of *The Lamentation of Christ*, ca. 1530. Paris, Louvre.

▲ Giotto, *The Death of the Knight of Celano*, 1297–1300. Assisi, upper church of San Francesco.

Bread

After defeating the raiders who had attacked the
city of Sodom and captured his nephew Lot,
Abraham was returning home when he met
Melchizedek, the king and high priest of Salem.

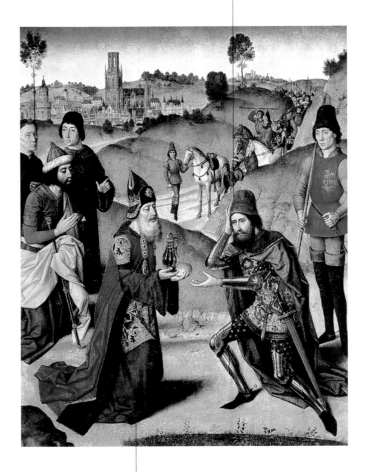

Melchizedek goes to meet Abraham,
blesses him, and offers him bread and
wine as a token of his hospitality.

▲ Dieric Bouts the Elder, *The Meeting
of Abraham and Melchizedek*, detail of
The Last Supper polyptych, 1464–67.
Louvain, Saint-Pierre.

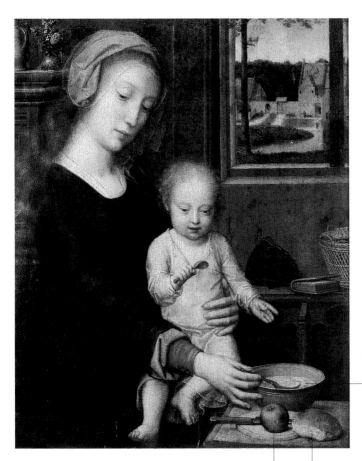

The Christ child's por-
ridge has a milk base,
which reminds us of the
Virgin's purity and her
role as mother.

The apple is the
traditional symbol
of Original Sin.

The bread beside the
apple has the Eucharistic
meaning of the body of
Christ. It is a symbol of
redemption.

▲ Gerard David, *The Virgin with the
Porridge Spoon*, 1515. Brussels, Musées
Royaux des Beaux-Arts.

Bread

The artist conveys Martha's hospitality and her efforts to welcome Christ by showing her offering him a basket of bread.

The bread seems to be a symbol both of charity, as a staple food in many cultures, and of the Eucharist.

The basket of bread can be taken as an emblem of good works.

Christ points to the listening Mary as one who has chosen the contemplative way, the right way to follow his teaching.

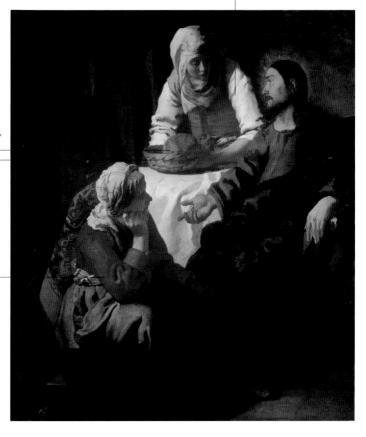

▲ Jan Vermeer, *Christ in the House of Martha and Mary*, 1654–56. Edinburgh, National Gallery of Scotland.

The white wine is an appropriate accompaniment to fish and also contains a reference to the blood of Christ.

By blessing the bread, Christ reveals his true identity to the travelers to Emmaus.

The salt placed beside Christ is a symbol of his understanding and wisdom.

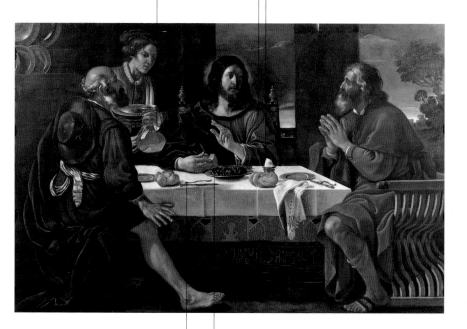

In the 17th century, individual forks appear beside knives, which had been the only individual items of tableware since their introduction to the table in late-medieval times.

The mussels, like other mollusks, symbolize hidden truth. In this case, therefore, they seem to refer to Christ's concealed identity.

▲ Lorenzo Gennari, *The Supper at Emmaus*, ca. 1626–29. Cento, Pinacoteca Civica.

Bread

This is among the works commissioned by the Accademia della Crusca in the 17th and 18th centuries. By tradition, each academician chose a nickname associated with flour, breadmaking, or the uses of bread.

The bread shown here is linked to the custom of using the soft part of bread for polishing intricate metalwork. The quote at the top is from Dante: "That his proficiency may be displayed."

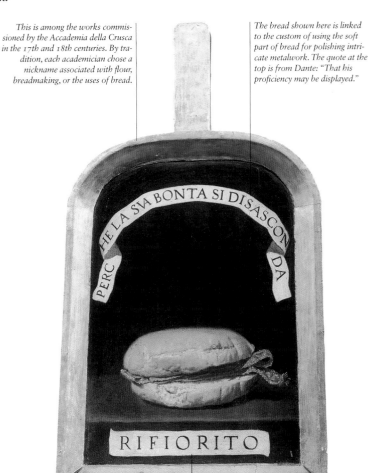

PERCHE LA SVA BONTA SI DISASCONDA

RIFIORITO

The custom of bread-related nicknames was established after the academy was founded in 1583. This was partly to express their antischolastic bent and partly because the plainness and purity of bread, as well as its high nutritional value, mirrored the qualities that inspired the academicians' language studies.

▲ Unknown Florentine artist, *The Flour Bolter of Francesco Ridolfi, called Il Rifiorito*, 1653. Florence, Accademia della Crusca.

The bread, like the wine beside it, evokes the sense of taste.

This still life is actually an allegory of the five senses. Hidden beneath the references to sensual pleasure is an implicit denunciation of false and ephemeral values.

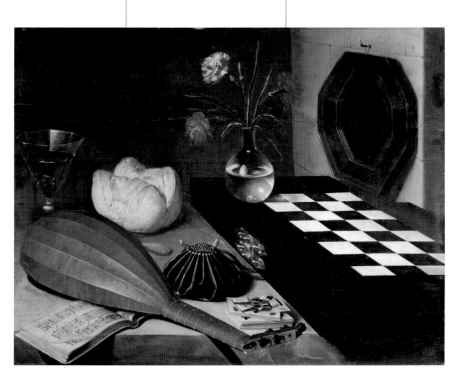

▲ Lubin Baugin, *Still Life*, 1635–40.
Paris, Louvre.

As a simple dish made from water and grain, porridge was known to the ancient Egyptians. But their porridge was made from barley, not maize, oats, or wheat.

Porridge and Polenta

Sources
Apicius *De re coquinaria*
5.1; Pliny *Naturalis historia*
18.72 and 83; Ugo Benzi,
La regola della sanità
(1620), p. 579; Christopher
Columbus, *Giornale di
bordo* (1985), pp. 78 and
81; Giovanni Battista
Barpo, *Le delizie e i frutti
dell'agricoltura e della villa*
(1533), p. 245

Meaning
Simplicity, the exotic

Iconography
Porridge made from
various cereals appears
in Flemish paintings of
peasant scenes, and maize
polenta sometimes appears
in the works of Venetian
artists such as Pietro
Longhi

The English word "porridge" derives from the French *potage*, meaning "that which is put in a pot." Porridge is made with a wide range of grains, from oats to maize. A kind of porridge based on farro was mentioned by Pliny and Apicius. In medieval peasant cookery, grains of farro or spelt, but also barley, millet, and buckwheat, were pounded in a mortar, blended with water in a pot, and stirred until fully cooked. The resulting porridge was then dressed with oil or lard. This was the food of the poor, and so it remained, even when higher-quality grains supplanted bean flour, spelt, and barley. Maize was introduced from the Americas following the voyages of Christopher Columbus, who even mentions it in his *Giornale di bordo*, saying that it had a pleasant taste and was a staple food for the New World peoples. Europeans began cultivating maize within thirty years of its introduction. The key year for the Italian corn porridge, polenta, was 1630, when Venice was devastated by plague and famine. The city fended off starvation by turning to cereals, including maize. In 1633, gastronome Giovanni Battista Barpo sang its praises, as did the medieval

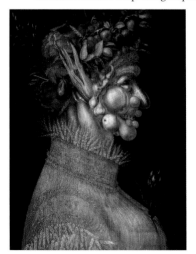

philosopher Ugo Benzi. The general acceptance of maize as the basic ingredient of polenta came in the 18th century, when it was served up not as a peasant dish but as an exotic upper-class gastronomic discovery. From there it spread to all social classes, and at certain points in the history of the 19th and 20th centuries, it was the only food available in Italy.

▶ Giuseppe Arcimboldi,
Summer, 1563. Vienna,
Kunsthistorisches Museum.

The festivities are taking place in a bare country tavern.

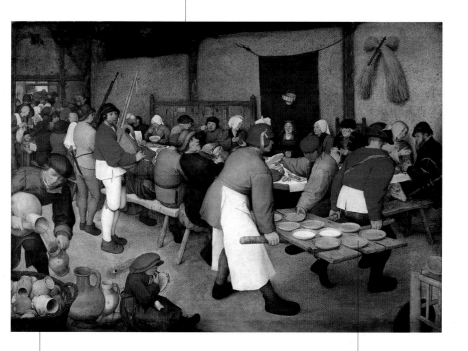

The earthenware measuring jugs emphasize the peasant nature of the festivities.

The diet of Flemish peasants was based on porridge made of mixed cereals—especially barley, which was also used to make beer, the most popular national drink.

▲ Pieter Bruegel the Elder, *The Wedding Banquet*, 1568. Vienna, Kunsthistorisches Museum.

The tarts on the roof are an allusion to the saying, "The roof is tiled with tarts," meaning that abundance and waste rule the day.

The eggs illustrate the proverb "He picks up the hen's egg and lets the goose egg escape," meaning that his greed has caused him to make a foolish decision.

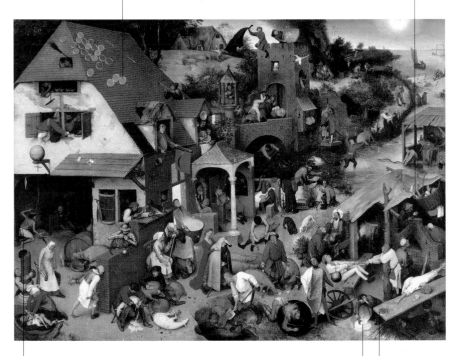

The fish is an allusion to the saying "His herring won't cook here," meaning that not everything goes according to plan.

The porridge alludes to the proverb "He who spills his porridge cannot pick it all up again," meaning that what's done cannot be undone.

The loaves are there to remind us of the saying, "He can hardly reach from one loaf to the next," meaning that he can hardly make ends meet.

▲ Pieter Bruegel the Elder, *Flemish Proverbs*, 1559. Berlin, Gemäldegalerie.

The buxom, attractive women
dressed in lower-class clothes have
led critics to think that the scene is
set in a Venetian brothel.

The scenes of everyday life that appear in
Longhi's works suggest comparisons with
Carlo Goldoni, who was writing comedies
in a similar vein in the same period in Venice.

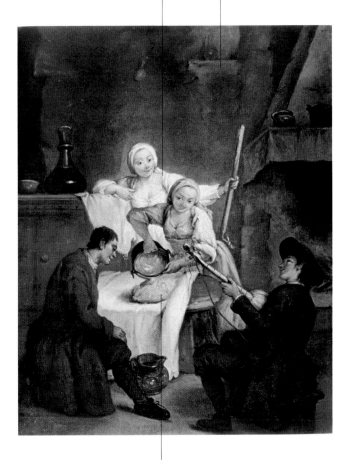

Eighteenth-century Venetian polenta was
a national dish of exotic origin. It already
held an established position in both lower-
class and aristocratic cooking.

▲ Pietro Longhi, *Polenta*, 1740.
Venice, Ca' Rezzonico.

Beef has a central role in food history not only as a dish but also in propitiatory and expiatory rites: in antiquity, religious rituals always involved offerings of meat.

Beef

Sources
Isidore of Seville, *PL* 82, col. 709; Rabanus Maurus, *PL* 111, col. 591, and 112, cols. 886–87

Meaning
Christ as sacrificial victim, the material side of human beings

Iconography
It often appears in Flemish art in connection with Gospel themes, but it also appears as a food in 17th- and 18th-century genre scenes and still lifes by Italian, Flemish, French, and English artists

▼ Claude Monet,
The Loin of Meat, 1884.
Paris, Musée d'Orsay.

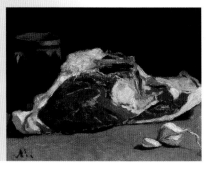

In antiquity, most meat came from animal sacrifices. The Egyptians, Greeks, and Romans set aside for the gods only a small portion of the sacrificial animal, the remainder being shared out among priests and the faithful, who gathered together at a sacred feast. From sacrificial rituals, the idea arose that butchery should observe codified religious rules, and that meat consumption should be strictly regulated. The distinction between clean and unclean foods in the pagan, Jewish, and Islamic traditions was rejected in Christianity, though some Christians impose restrictions on the consumption of meat during Lent. In Christian mysticism, meat represents the body of the Lord in his role as sacrificial victim for the redemption of humanity. In a negative sense, it refers to the material aspect of human beings, and their reprehensible inclination toward vice and sin. In the Middle Ages, butchery ceased to be a religious practice, but cutting meat remained a public act of some symbolic significance, and an aura of the sacred was attached even to cooks. Meat was excluded from the diet of monks but was the main dish at the tables of the rich, becoming a sort of status symbol. At Renaissance banquets, meat was subject to the spectacular art of the carver, whose task was to carve and serve it in public view. Paintings illustrate the central position of meat at these banquets. In the 17th century, the butchered beast became a reviled object, because its bloody carcass reminded one of death; all activities relating to the cutting and preparation of meat were relegated to the kitchen. In the 18th century, new methods of breeding brought about improvements in the selection of animals for slaughter and the preservation of meat. In this way, meat was far less prized but of much better quality.

The cake brought in by a servant reminds us that Christ's miracle takes place at a wedding.

The carver is shown in the act of carving the meat at the table in front of the bride, as was often the custom at Renaissance banquets.

The bride sits at the place of honor, as contemporary etiquette required. The hanging behind her emphasizes her central role.

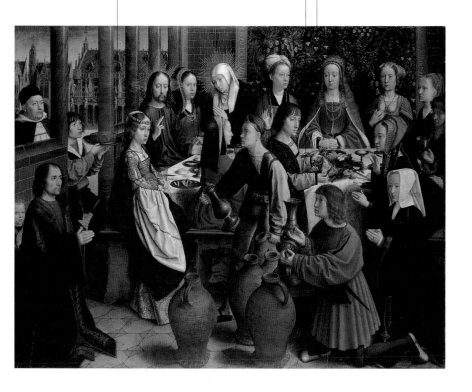

▲ Gerard David, *The Marriage at Cana*, 1500–1503. Paris, Louvre.

Beef

The Gospel scene seems to take second place to the still life in the foreground, as was customary in Flemish painting.

The meat should be seen as a symbol of Christ's sacrifice.

The fish garnished with a carnation is a symbol of Christ. A fish is a traditional emblem of Christ as sacrificial victim, and its symbolism is emphasized here by the red flower.

The pewter wine jug alludes to its contents. Wine is a symbol of Christ's blood.

The bread belongs in the Gospel scene, a sign of the hospitality offered by Martha, but it also has Eucharistic meaning as the body of Christ.

▲ Pieter Aertsen, *Christ in the House of Martha and Mary*, 1552. Vienna, Kunsthistorisches Museum.

As is often the case in Flemish paint-
ing, the Gospel scene of the Flight
into Egypt appears almost in minia-
ture behind the table laden with
food.

The quantities of butchered
meat convey not only the
wealth of food for the din-
ing table but also the idea of
Christ as sacrificial victim
for the redemption of the
human race.

The presence of the butter in
its dish and the tarts in the
foreground diminishes the
sense of disgust we feel at
the sight of the calf's head.

▲ Pieter Aertsen, *Butcher's Stall with
the Flight into Egypt*, 1551. Uppsala,
Universitet Konstsamling.

The peacock is a symbol of vanity and the ephemeral nature of earthly pleasures. Here it is shown as a carcass, which, in contrast, underlines the universal and eternal truth conveyed by the Gospel parable.

The butchered animal is the fatted calf, chosen by the father for a grand celebration in honor of the prodigal son's unexpected return.

The son kneels before his father, seeking forgiveness for his absence.

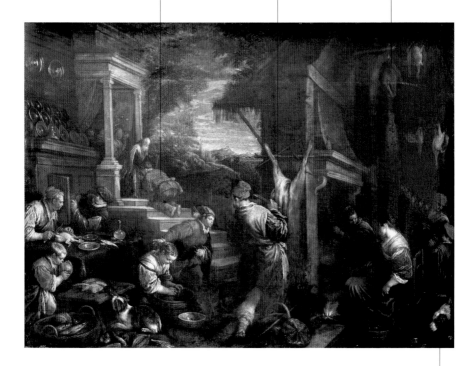

As seen here, game was usually preserved by being hung from suitable hooks.

▲ Francesco Bassano, *The Return of the Prodigal Son*, ca. 1590. Madrid, Prado.

From the Renaissance onward, meat was cut into portions by the carver, a servant whose particular job this was, before being produced at the table. In this way, the diners could all use their hands to help themselves from a single dish.

The special kind of glass called a verre d'amitié *emphasizes the comradeship of the militia officers.*

The Flanders cloth covering the table draws attention to the nationality of the banqueting militia officers and adds a note of refinement to the gathering.

▲ Frans Hals, *Banquet of the Officers of the Civic Guard of Saint George at Haarlem*, 1616. Haarlem, Frans Hals Museum.

We can tell from his crown that this is the Bean King, the chief character at the Twelfth Night party.

The presence of the clown emphasizes the carnival atmosphere of the party, where every kind of overeating was permitted.

The meat is characteristic of the splendid food at the festive table.

▲ Gabriel Metsu, *The Feast of the Bean King*, 1650–55. Munich, Alte Pinakothek.

*Meat is the principal
food excluded from the
diet during Lent.*

*By bringing together these foods and the
kitchen utensils, the painter clearly intends to
suggest that the menu is for a day outside Lent.*

*The copper pot suggests that a
main course is about to be
prepared or cooked.*

*Chardin was a particular favorite of the
encyclopaedist Diderot because of his
skill in depicting everyday objects with
illusionist realism.*

▲ Jean-Siméon Chardin, *The Meat-Day
Meal*, 1731. Paris, Louvre.

*The French authorities arrested
Hogarth at Calais as a spy, on
account of the sketches he had
made of the town.*

*This scene, with its tone of
caricature, shows two people
struggling over a side of beef
at the Calais town gate.*

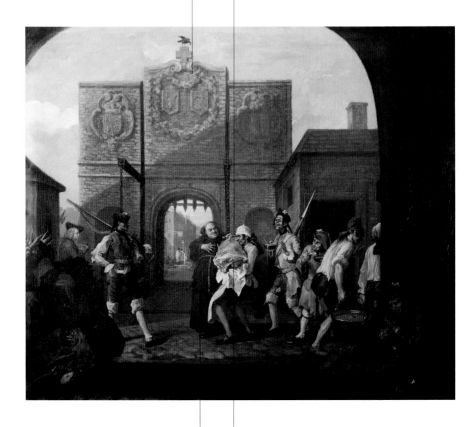

*The monk, whose corpulence suggests
his gluttony, must be seen as a symbol
of France and Catholicism, and hence
the struggle for the meat symbolizes
the battle between the French and
British for possession of Calais.*

*The side of meat can be
identified as beef, a symbol
of the English.*

▲ William Hogarth, *O the Roast Beef
of Old England (The Gate of Calais)*,
1748–49. London, Tate Gallery.

Pork has had a checkered history but has always been an important food for the lower classes, because all its parts can be eaten.

Pork and Boar

The Egyptians thought that pigs brought leprosy and they were not allowed in the temple; but in ancient Greece, pork was held in high regard, and in the *Odyssey* the swineherd Eumaeus is called divine. The Etruscans and Romans ate the meat of both pigs and boars. In Jewish and Islamic culture, the pig is considered an unclean animal and its meat an impure food. In the Middle Ages, pigs were reared by the peasantry, for whom they were an important food resource. Sausages made from pork were known as early as Roman times, when they were called *tomacula* or *lucanica*; and they were also much used in medieval cooking. In the 16th century, pork became a meat for the very poor. Pigs were sacred to Saint Anthony and often appear in paintings as his attribute, whereas in Flemish paintings or genre scenes, pork is often associated with gluttony. Christian iconography follows medieval exegesis in using pigs to represent sin: just as pigs like to roll in the mud, so the sinner wallows in the filth of his sins. For the same reason, pigs represent envy, since envy finds satisfaction in the ills of others. They also represent avarice, because, like elderly misers, they are of no use to anyone while alive but can be of great value when dead. The pig can also be an emblem of death itself, because only in death does it lose its dirty material nature, a fate it shares with the human race.

Sources
Homer *Odyssey* 14.87–134 and 20.302–14, 335–64, and 475–81; Isidore of Seville, *PL* 82, col. 428; Rabanus Maurus, *PL* 111, col. 206, and 112, col. 1064; Filippo Picinelli, *Mundus Symbolicus* (1687), book 5, chap. 41

Meaning
The sin of gluttony

Iconography
Pigs and pork appear in general representations of sin and in scenes of gluttony in 15th- and 16th-century Italian and Flemish art. Pigs, pork, and pork products also appear in genre scenes and in still lifes with food on tables. As a live animal, the pig is associated with the iconography of Saint Anthony

◄ Giuseppe Arcimboldi, *The Cook*, ca. 1570. Private collection.

The readily identifiable stone
block and knife show that a
butcher is at work here.

It seems clear from this relief that as
early as Roman times, legs of pork
were important as something to be
eaten fresh or preserved as ham.

▲ *The Butcher*, detail of a relief showing
shop signs, 1st century A.D. Ostia,
Museo Ostiense.

In this demoniac celebration, the black woman may represent heresy, the toad witchcraft, and the egg the sacrilegious host.

The scene depicts Saint Anthony Abbot, one of the founders of Western monasticism, whose asceticism gave him the power to resist all the temptations sent by Satan.

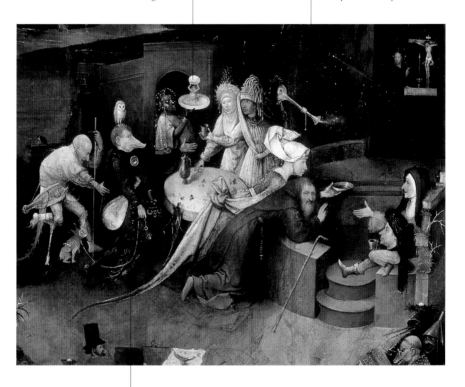

The pig is an attribute of Saint Anthony, and we would expect it to appear in his vicinity, but in this case it is also a symbol of sin. The musician with a pig's head is in fact taking part in a kind of black mass.

▲ Hieronymus Bosch, *The Temptation of Saint Anthony* (detail), middle panel of *Triptych of the Temptation of Saint Anthony*, 1515. Lisbon, Museu Nacional de Arte Antiga.

This painting is by Snyders, a pupil
of Rubens. He specialized in painting
tables laden with game and choice
foods for refined patrons.

The boar was a much-prized hunt-
ing trophy. This celebration of
hunting skills is clearly intended
for an aristocratic patron.

The artichokes reflect
the artist's decision to
include highly prized
vegetables among his
rare and choice foods.

The dog peering out from
under the table is an allu-
sion to hunting.

At this time,
lobsters were
not commonly
caught.

▲ Frans Snyders, *Kitchen Scene with a Young
Man*, 1630–40. Munich, Alte Pinakothek.

▶ Anne Vallayer-Coster, *Still Life with
Ham*, 1767. Berlin, Gemäldegalerie.

Ham resulted from the discovery that it was easy to separate the pig's leg from the rest of its body, and that it could be preserved by either smoking or salting.

Charcuterie

A Pyrenees legend tells how a pig fell into a saltwater stream, and when its body was later pulled out it was found to be still good to eat. That is supposedly how salting originated. Martial and Petronius both praised the ham, while Apicius suggests that it should be eaten with dried figs. Varro tells us that ham was exported to Rome from Gaul. The Middle Ages were a golden age for ham; the fact that it could be preserved meant that it was available throughout the year. In this period, other forms of preserved pork, such as salami and *mortadella*, were introduced; the latter was a sausage invented in Bologna and soon exported to other European countries. These kinds of sausage were much in demand from the nobility and an excellent addition to the peasant diet. During the Renaissance, too, they appeared on the table at the most sumptuous banquets. At the Renaissance table, carvers and stewards who were responsible for carving and serving meat were now also tasked with slicing ham and sausage in a stylish, elegant manner, in accordance with a precise liturgy and accompanied by elaborate gestures. The passion for ham did not diminish in the centuries that followed, and in the 18th century it became a fashionable hors d'oeuvre as well as a very convenient picnic food. Before then, ham had been homemade, but in the 19th century it became a commercial product and thus reached the dining tables of the urban bourgeoisie. Because it came from the pig, ham acquired the symbolic value of that animal, as did salami, bacon, Bologna sausage, and lard, though the latter appear in paintings much less frequently. Ham represents sin in general and gluttony in particular.

Sources
Varro *De re rustica* 2.4.10; Apicius *De re coquinaria* 7.9; Martial *Epigrams* 13.54; Petronius *Satyricon* 56.8, 66.7, and 70.2; Platina, *De honesta voluptate et valetitudine* (1474), book 6, chap. 172; Vincenzo Cervio, *Il trinciante* (1581; 1980, pp. 107–8)

Meaning
Ham, being a product of the pig, is an emblem of the sin of gluttony

Iconography
Ham, salami, and Bologna sausage appear fairly frequently in still lifes and genre scenes from the 17th to the 19th century

This merry lunch is taking place inside a house, around a table presided over by the head of the family.

The main dish at the festive meal is ham, a food kept for special occasions.

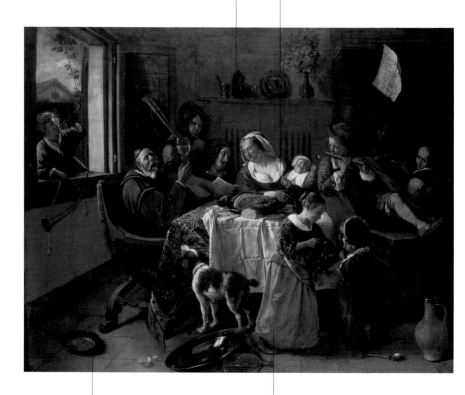

The frying pan lying on the ground gives the scene a humble flavor, which contrasts with the fine carpet covering the table, partly hidden under a white tablecloth.

The girl feeding her younger brother from a bottle emphasizes the intimate family atmosphere of the festive scene.

▲ Jan Steen, *The Merry Family*, 1668.
Amsterdam, Rijksmuseum.

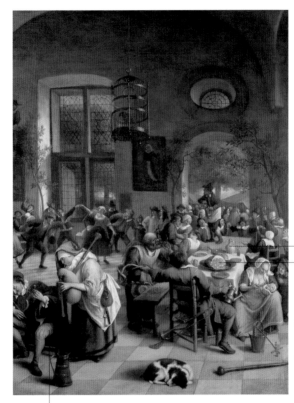

Beer was a national drink in many northern European countries and was the most popular beverage in taverns.

Sausages had for centuries been among the foods typically served in places like this. Interestingly, what is being served here is Bologna sausage, a late-medieval invention that quickly spread throughout Europe.

From ancient times onward, taverns were considered low and licentious places, but you could enjoy yourself there without constraint. The peasants' dance seems to emphasize the informal atmosphere at this Flemish tavern.

▲ Jan Steen, *At the Hostelry* (detail),
ca. 1674. Paris, Louvre.

Charcuterie

The choice of food in this still life suggests that the artist is offering his ideal menu, perhaps for a snack.

The earthenware jug echoes the modest, humble tone of the food itself and the still life of which it is the subject.

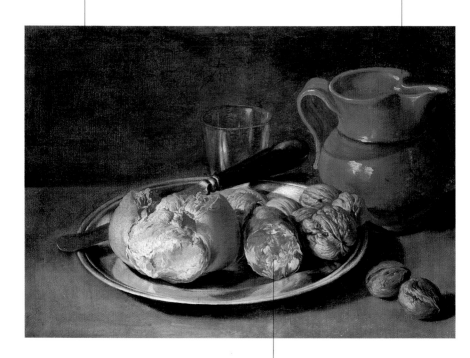

Of the many products made from pork, salami may be the most popular. There are various types, each of which is particular to a certain geographical area. This appears to be Milanese.

▲ Giacomo Ceruti, *Still Life with Salami*, mid-18th century. Milan, Pinacoteca di Brera.

The very title of the painting suggests that by placing bread and sliced sausage together, the artist is offering a menu.

The elegant blown glasses with winged stems emphasize the refinement of the setting and of the person who will eat the snack.

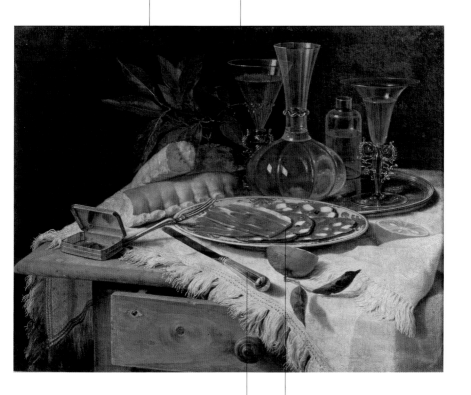

The knife and fork placed together seem to reflect an evolved etiquette, in which no direct contact is allowed between hand and food.

Because it is surrounded by refined objects, the sliced sausage loses its connotation as a food of the common people and becomes classless.

▲ Christian Berentz, *The Elegant Snack*, 1717.
Rome, Galleria Nazionale d'Arte Antica.

Charcuterie

At the time of the Romans, the best ham was imported from Gaul. French ham can thus boast ancient origins, and for Manet it was a kind of national gastronomic glory.

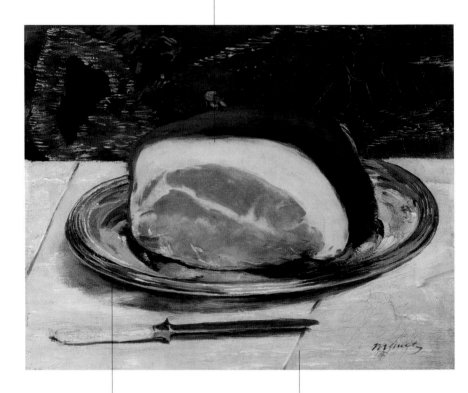

The valuable silver dish shows that ham was enjoyed by the wealthy middle class in Paris.

The platter sits on an expensive lace-edged tablecloth, which emphasizes the elegance of the surroundings and reveals a predilection for white, which has always been a symbol of cleanliness and purity.

▲ Édouard Manet, *Still Life with Ham*, 1875–78. Glasgow, Art Gallery.

*Lamb is the food of the Jewish Passover and was part of
Christian dietary usage from the very beginning, as a sacrificial
meat symbolizing the Passion of the Redeemer.*

Lamb

Lamb was well known in Greek cookery, because sheep farming
made a substantial contribution to the Greek diet. We are told
in the *Iliad* that the meat of lambs and young goats was first
flame-tenderized in a bronze bowl and then skewered by Achilles
himself and cooked on a bed of embers. Lamb was certainly
eaten by the Etruscans, though we unfortunately lack any docu-
mentary evidence thereof, and the Romans considered it a deli-
cacy; but it was above all the preferred sacrificial animal among
the peoples of the Near East and the Jews. It is significant that a
ram was substituted for Isaac in the story of Abraham's sacrifice;
this example of the traditional value of animal sacrifice reflects a
key stage in the development of primitive cultures, when human
victims are replaced by animals. The story was interpreted as
prefiguring the sacrifice of Christ, who offered himself as a vic-
tim for the redemption of humanity, and it was precisely thanks
to that link with the Jewish tradition that the lamb was adopted
by early Christianity as a symbol of the Messiah and his
sacrificial mission. In the exegetical writings of Rabanus
Maurus, the lamb is compared to Christ, for just as the lamb is
killed in sacrificial rites in its unstained purity, so Christ is with-
out sin when killed. But the lamb is also an emblem of the apos-
tles and of all those who are simple and
innocent: the saintly, and repentant sinners.
Picinelli also states that as a sacrificial animal,
the lamb represents oppressed innocence and
the just man who suffers ill treatment stoically.
For Jews, lamb is the food of Passover; for
Christians, it is the preferred food for com-
memorating the Resurrection, though mutton
or goat meat may sometimes be substituted.

Sources
Homer *Iliad* 9.264–90;
Rabanus Maurus, *PL* 112,
col. 855; Filippo Picinelli,
Mundus Symbolicus
(1687), book 5, chap. 1

Meaning
Sacrificial victim

Iconography
A lamb often appears in
association with Christ in
Gospel contexts such as
the Last Supper and the
Supper at Emmaus, or with
reference to Jewish
Passover celebrations

▼ Francisco de Goya, *Still
Life with the Head of a
Lamb*, ca. 1808–12.
Paris, Louvre.

Lamb

Christ himself points to his emblem: the head of a lamb.

As a sacrificial animal, the lamb prefigures the sacrifice of Christ, the special victim for the redemption of the human race.

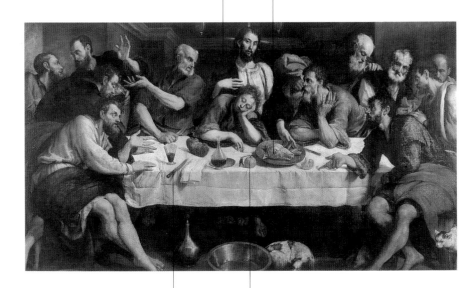

The knife beside Judas is an allusion to his betrayal of Christ.

The apple is a symbol of Original Sin.

▲ Jacopo Bassano, *The Last Supper*, 1546–48. Rome, Galleria Borghese.

The lamb, as a preferred sacrificial animal, symbolizes Christ, who is a sacrificial victim for the redemption of the human race.

Lettuce is interpreted in scriptural exegesis as a symbol of penitence. Placed here beside the lamb, a symbol of Christ, it represents the contrition necessary to wash away the crime of killing Christ.

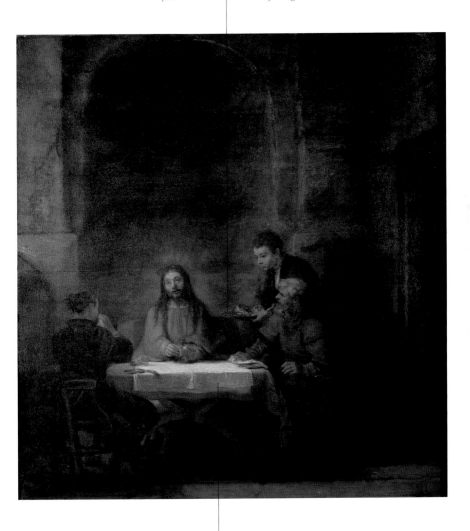

▲ Rembrandt van Rijn, *The Supper at Emmaus*, 1648. Paris, Louvre.

The tablecloth is a symbol of purity. It seems to broaden the spread of the light radiating from the risen Christ, as he reveals his identity to the travelers at Emmaus.

Lamb

For Jews, Passover is the feast that celebrates
their liberation from slavery in Egypt. The
sacrifice of the lamb was the most solemn
moment in the celebration: the lamb was
bled on the altar and the blood was col-
lected in special gold and silver bowls.

The Neoclassical furnishings
give the scene an elevated,
antique atmosphere.

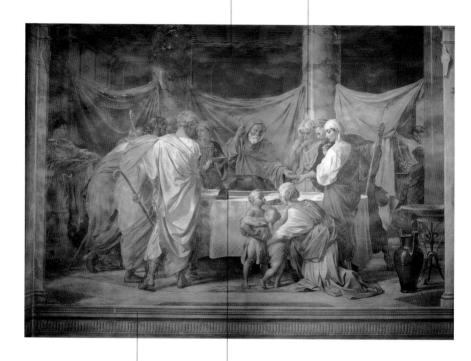

The scene shows the
domestic celebration
after the sacrifice.

During the Passover feast,
the flesh of the lamb is
eaten in its entirety.

▲ Alessandro Franchi, *The Celebration
of the Passover*, 1876. Prato, cathedral,
Vinaccesi chapel.

The origins of fowl as a food are lost in the mists of time.
We know that it was eaten in ancient Egypt, in Crete, and sub-
sequently in ancient Greece and Rome.

Poultry and Game

The Romans ate all kinds of poultry and game, even peacocks, which came from India and reached Rome via Greece. It was a sign of wealth and distinction to bring this bird to the dining table, cooked and with its splendid feathers back in place. The 15th-century writer Platina gives us detailed instructions on how to cook a peacock and present it at table with its feathers replaced. It is possible, indeed, that peacocks and swans were used purely for decorative and symbolic purposes in those days, even though they were prepared like other meat dishes. Poultry is acceptable in both Jewish and Islamic cooking and is welcomed unreservedly in Christian cooking. In the Middle Ages, poultry occupied a position of respect on the dining table of the feudal lord, where it appeared along with other meats. Goose was also widely enjoyed. During the Renaissance, the Portuguese imported guinea fowl from Africa, and that exotic bird the turkey was brought from the New World by Cortés. During the period of the Enlightenment, chickens and geese that had been reared in cap-

tivity were preferred to such game birds as pheasants and partridges, which had once been the prized trophies of the hunt. There is literary and pictorial evidence from the 15th to the 18th century that each bird had its own specific symbolism, but in Christian iconography, poultry and game have the same general symbolism as other meats in referring to Christ as sacrificial victim.

Sources
Rabanus Maurus, *PL* 112, cols. 247–48; Platina, *De honesta voluptate et valetitudine* (1474), book 6, chap. 150; Filippo Picinelli, *Mundus Symbolicus* (1687), book 4

Meaning
Sacrificial victim, abundance, wealth

Iconography
Poultry and game appear in sacred and profane banquet scenes, in kitchen and market scenes, and in food-laden still lifes in both Italian and Flemish art in the 17th and 18th centuries. Poultry sometimes appears in scenes of meals with Christ

◄ Giuseppe Arcimboldi, *The Jurist*, 1566. Stockholm, Nationalmuseum.

155

An elderly couple welcomed into their cottage two travelers who had been denied hospitality by everyone else in the village. The travelers proved to be Jupiter and Mercury.

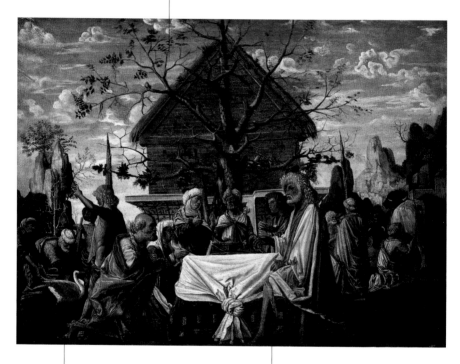

The elderly couple had decided to sacrifice their only goose in honor of their guests, but the bird sought refuge with the two strangers and they prevented their hosts from killing it.

There is a certain parallel between this story and that of the Supper at Emmaus, with Jupiter and Mercury representing God the Father and Christ, and Philemon and Baucis the two travelers.

▲ Bramantino, *Philemon and Baucis*, 1490. Cologne, Wallraf-Richartz Museum.

There may be a double meaning in the ambiguous attitude of the elderly woman toward the rooster, which symbolizes young and virile cockiness.

Similarly, the young woman in a low-cut dress is holding a turkey in her lap and looks at the spectator with a knowing glance.

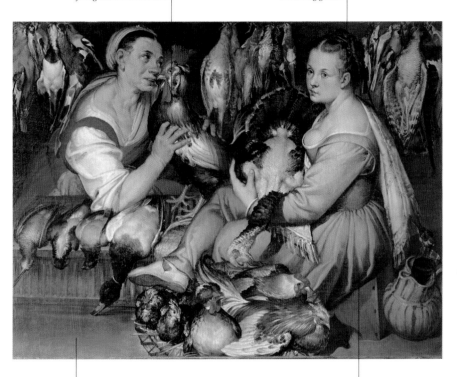

Market scenes often contain lascivious references and sexual allusions.

The different ages of the women, however, seem intended to remind the spectator of the ephemeral nature of sensual pleasure and the passing of youth.

▲ Bartolomeo Passarotti, *The Chicken Sellers*, ca. 1577. Florence, Fondazione Longhi.

It is typical of Flemish art that the parable of the banquet is barely visible in the background. Some critics believe that this expedient is intended to convey the difficulty of finding the spiritual in everyday life, where humanity is distracted by material pleasures.

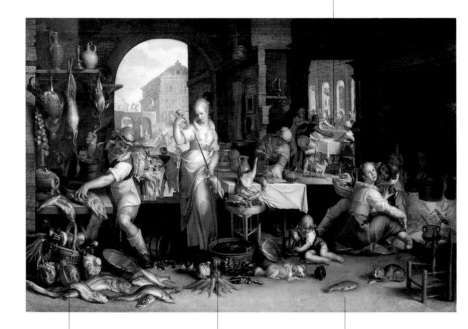

The wide variety of foodstuffs means that the eye can endlessly enjoy contemplating the abundance.

The commonest method of cooking poultry and game was on the spit. Ever since ancient times, this had added an element of theater to the banquet.

In the 16th century, the kitchen was a sort of alchemist's laboratory, a backstage room where food was transformed before being presented in the theater of the dining room.

▲ Joachim Anthonisz Wtewael, *Kitchen Scene*, 1605. Berlin, Gemäldegalerie.

The wrought iron hook with its decorative volutes suggests that we are in the real or imagined larder of a noble palace.

▲ Cesare Dandini, *Still Life with Game*, 1640–50. Florence, Uffizi.

The two suspended ducks are hunting trophies, and they may reflect the hunting interests of an aristocrat who commissioned the painting.

The juxtaposition of the various foods in this still life suggests a possible meal, one that is typical of Flemish gastronomy.

The orange blossom in the turkey's mouth suggests that the painting may be celebrating a marriage.

The turkey with its feathers restored reflects the Renaissance custom of plucking and roasting such birds and then presenting them at table with their feathers restored. Birds treated in this way were often purely decorative and not eaten.

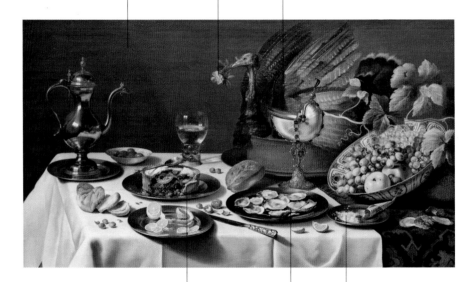

Meat pies were much appreciated in Renaissance gastronomy. Turkeys came from the New World and had been imported into Spain in the 16th century. From there they spread to the rest of Europe.

Oysters are the most characteristic seafood of the Low Countries and were thought to be an aphrodisiac.

Salt and pepper are necessary for the proper consumption of oysters, and they are symbols of the spicy aspects of married life.

▲ Pieter Claesz., *Still Life with Turkey Pie*, 1627. Amsterdam, Rijksmuseum.

Fish is an ancient staple. The seafaring Egyptians, Phoenicians, and Carthaginians all ate fish, as did the Greeks, Etruscans, and Romans, who preserved fish in brine.

Fish

The Jews were allowed to eat only fish with fins and scales, not shellfish or eels. The early Christians ate both fresh fish and salt fish. The New Testament describes the Miracle of the Loaves and the Fishes: how Jesus fed the crowd following him by blessing five loaves and two fish, which then multiplied. Fish is a fruit of Providence and in later Christian times became a special penitential food, permitted on occasions when meat was prohibited. Fish were eaten throughout the Middle Ages and Renaissance, thanks in part to the fact that, when it was dried and salted, it lasted longer than meat. Written and pictorial evidence shows that from earliest Christian times, the fish was a symbol of Christ. In fact, the Greek word *ichthus* can be formed by the five initial letters (ΙΧΘΥΣ) of the words *Jesus Xristos Theou Uios Soter*, meaning Jesus Christ, Son of God, the Savior. In medieval exegetical writings, the fish is a symbol both of Christ and of human beings considered as souls, for whom preachers were the fishermen. It is also a symbol of baptism, for just as fish cannot survive out of water, so a Christian cannot be a Christian without baptism.

Sources
Apicius *De re coquinaria* 10; Rabanus Maurus, *PL* 111, cols. 237–38 and 112, col. 1030

Meaning
Christ, Son of God, the Savior

Iconography
Fish appear as an allusion to Christ in scenes of meals with Christ and in other holy banquet paintings; in representations of the Miracle of the Loaves and Fishes; and also frequently in market and kitchen scenes in the 16th and 17th centuries, in Arcimboldi's fantasies, and in still lifes up to the 20th century. Fish, crustaceans, and mollusks usually appear in scenes of the wedding feast of Peleus and Thetis

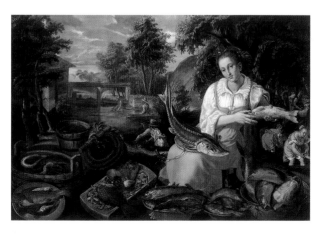

◄ Vincenzo Campi, *The Fishmonger*, ca. 1580. Private collection.

Fish

The individual goblets on the table refer to the wine they contain and hence to its symbolism as the blood of Christ.

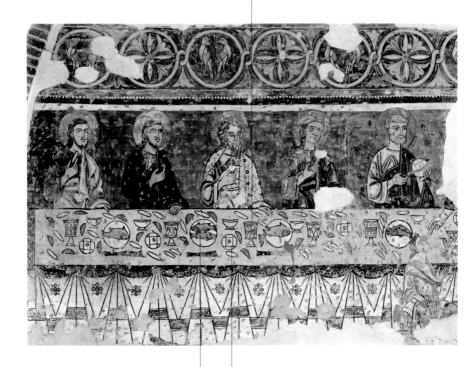

A fish on the table in a Last Supper scene is clearly a symbol of Christ.

The bread must be seen as having a symbolic reference to the body of Christ.

▲ Lombard Master, *The Last Supper*, second half of the 13th century. Mantua, Santa Maria del Gradaro.

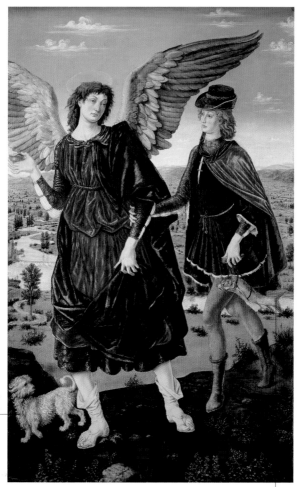

The dog is also part of the story, accompanying Tobias on his journey with the angel.

▲ Antonio del Pollaiolo and Piero del Pollaiolo, *Tobias and the Angel*, ca. 1465. Turin, Galleria Sabauda.

There is always a fish in scenes of Tobias and the Angel. In the Old Testament apocrypha, we are told how Tobias was traveling to Media in the company of the archangel Raphael when he caught a large fish that had tried to eat him. Tobias cut out its liver and gall to cure his father's blindness.

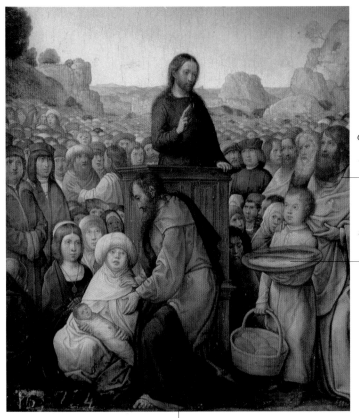

According to the Gospel, Andrew brings the boy to Christ so that the miracle can be performed.

The artist interpreted the text literally, painting "five barley loaves and two fish."

The miracle is described in all four Gospels, but the source for this painting is John (6:1–13). We are told that while Jesus was preaching up a mountain, a large crowd gathered around him. In order to feed them, he multiplied the few loaves and fish that a boy in the crowd had in his basket.

▲ Juan de Flandes, *The Miracle of the Loaves and Fishes*, 1496–1505. Madrid, Patrimonio Nacional.

Christis blessing the bread
in order to reveal himself
to the two travelers.

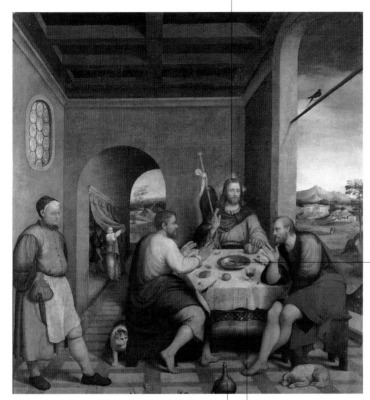

The fish on the table
is clearly a symbol of
the Son of God.

The flask is a typical vessel used
by travelers to transport their
drinks, and it must belong to
the two travelers here.

The white tablecloth is a sign of
purity and good manners. It was a
very common custom from the
Renaissance onward to spread a
clean cloth on top of a table covering.

▲ Jacopo Bassano, *The Supper at
Emmaus*, 1537–38. Cittadella,
parish church.

Fish

This appears to be a genre scene of working-class people at an inn, but one can pick out certain religious symbols in it.

The pouring of red wine is clearly a reference to the blood of Christ shed for the redemption of the human race.

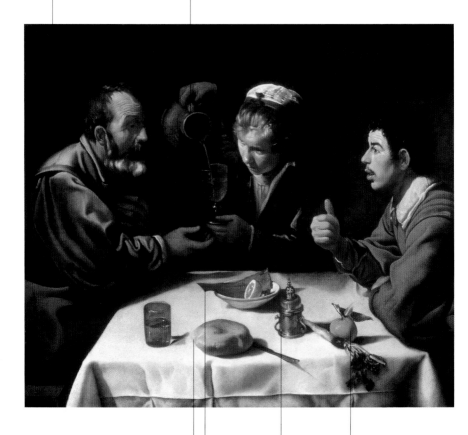

The bread refers to the body of Christ and the knife to the betrayal by Judas.

The dried fish alludes to Christ and his incorruptible message.

The gilded saltcellar and its contents symbolize divine wisdom.

The fruit is a symbol of Original Sin.

▲ Diego Velázquez, *Tavern Scene with Two Men and a Girl*, 1618. Budapest, Museum of Fine Arts.

The food and drink in this still life are typical of the Flemish tradition.

The stoneware beer jug and the horn-handled knife have a decorative but common appearance that emphasizes the simplicity of the humble food we see before us.

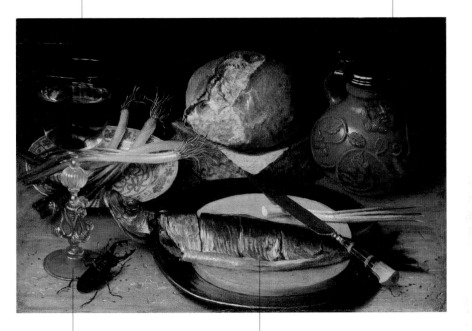

The blown façon de Venise wine glass and the Chinese porcelain dish on the left add a touch of elegance to the food depicted, unlike the objects on the other side.

Smoked herring is a nutritious food with a long shelf life, and it symbolizes the Dutch fishing industry. It figured in the diet of both the lower and wealthier classes.

▲ Georg Flegel, *Still Life*, 1635.
Cologne, Wallraf-Richartz Museum.

Fish

Chardin's evocative still life consists of just a few simple objects. The only living thing is the cat, which would like to get at the fresh salmon.

Ever since ancient times, dried fish has been a basic food in countries bordering the sea.

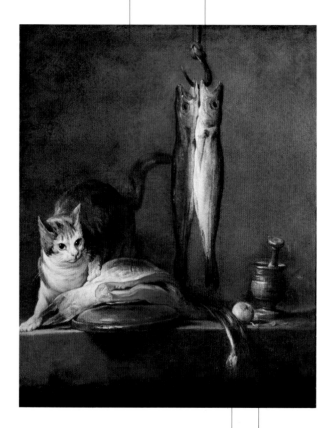

Scallions and garlic played an important part in the preparation of fish, especially in the 17th and 18th centuries, when flavorful ingredients grown in the kitchen garden became established in gastronomy at the expense of imported spices.

The use of many spices may have been in decline, but that did not apply to pepper, which was central to the preparation and preservation of food. The mortar was a necessary utensil for grinding pepper.

▲ Jean-Siméon Chardin, *Still Life with Cat and Fish*, 1728. Madrid, Thyssen-Bornemisza Museum.

This still life by Manet is inspired by the works of Chardin.

The presence of the copper pot suggests that the fish and oysters depicted are about to be cooked. Perhaps they will form the basis of bouillabaisse, a traditional French fish soup.

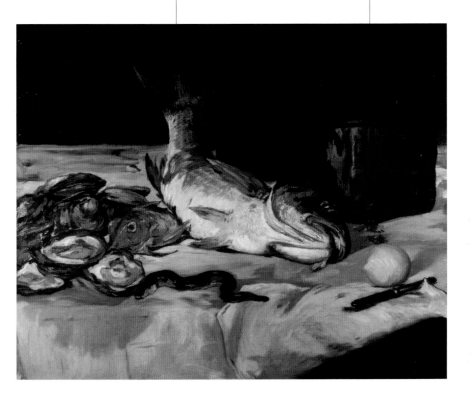

▲ Édouard Manet, *Fish (Still Life)*, 1864. Chicago, Art Institute.

In ancient Greece, oysters were a common food. No banquet was complete without a spread of oysters and sea urchins, as well as fish.

Mollusks

Sources
Varro *De re rustica* 3.3.10; Apicius *De re coquinaria* 1.9; Pliny *Naturalis historia* 9.107; Martial *Satires* 13.82; Rabanus Maurus, *PL* 111, col. 238; Hugh of Saint-Victor, *PL* 177, col. 110; Platina, *De honesta voluptate et valetitudine* (1474), book 10, chap. 366; Filippo Picinelli, *Mundus Symbolicus* (1687), book 6, chap. 15

Meaning
Female qualities, chastity, eroticism

Iconography
Oysters are often found in Flemish, French, and English genre scenes of the 17th and 18th centuries as well as in still lifes of the same period and up to the 20th century. They often appear with other seafood in connection with the wedding feast of Peleus and Thetis

Oysters, clams, and mussels have been part of the Mediterranean diet since the Neolithic Age. The Romans even devised a system for breeding them, as Varro tells us. In Roman gastronomy, oysters were a luxury dish: they were washed in vinegar and kept in jars sealed with pitch. In France, England, Holland, and Italy oysters were harvested on natural banks and were a common food in both medieval and Renaissance times. Oysters were prized for their alleged aphrodisiac powers, as one can see in many Dutch paintings, especially in the 17th century. This belief may have arisen from the feminine symbolism of the shell. According to the legend of the pearl-bearing oyster told by Pliny, and repeated by medieval and Renaissance scholars, the oyster was supposed to have been impregnated by dew entering into the shell valves when they opened at certain times of the year. Biblical exegesis took note of the anthropomorphic aspect of the story and established a parallel between the impregnation of the oyster and that of the Virgin by the Holy Spirit, hence suggesting that the shell should be seen as a symbol of Mary. Picinelli takes up the same idea. But oysters evoke not only the idea of concealed virtue, since the eatable part is firmly enclosed within the valves, but also—and for the same reason—the power of love: just as love is hidden within a person's innermost being, so the muscles of the oyster are hidden between the valves, and their tight grip prevents it from being opened.

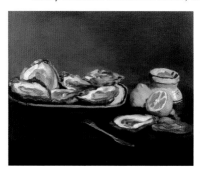

▶ Édouard Manet, *Oysters*, 1862. Washington, D.C., National Gallery.

Bosch has transformed the mussel into an unlikely marriage bed, thereby emphasizing the aphrodisiac quality of mollusks.

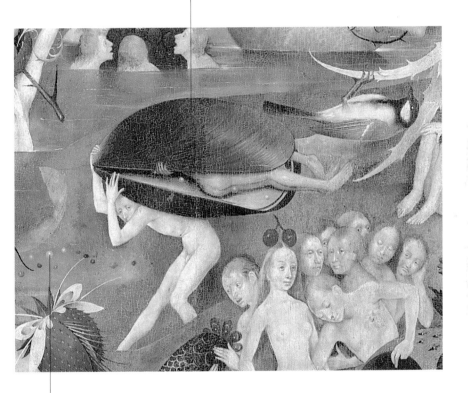

The pearls, which are the fruit of the chaste impregnation of the oyster, have emerged from the mollusk, because it has lost its traditional chastity and become a love nest.

▲ Hieronymus Bosch, *The Garden of Delights* (detail), from *Triptych of the Garden of Earthly Delights*, 1503–4. Madrid, Prado.

In this context, the oysters are bound to have their traditional aphrodisiac significance.

The presence of both men and women at the banquet suggests that we are witnessing a kind of amorous preamble.

The sensual tone of the picture in pride of place above the fireplace, with Delilah half undressed and Samson sprawled on top of her, adds to the erotic atmosphere of the banquet.

▲ Frans Francken II, *Supper at the House of Burgomaster Rockox*, 1630–35. Munich, Alte Pinakothek.

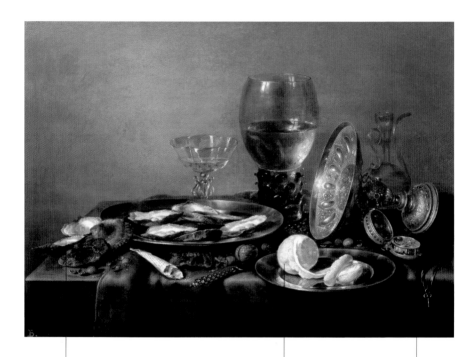

The aphrodisiac oyster must be seen not only as an emblem of the sense of taste but also as a symbol of sensual pleasure in general.

Lemon peel cut in a spiral is very common in Flemish still lifes. It may be a symbolic representation of life on earth, during which the individual frees the spirit from its physical envelope.

The presence of the watch invites the spectator to interpret the painting in a moral sense. It reminds us that life on earth and all its pleasures are destined to come to an end, and that caring for the spirit is more important than caring for the body.

▲ Willem Claesz. Heda, *Still Life*, ca. 1630. Madrid, Prado.

The girl's knowing look has been interpreted as an invitation to the spectator to join her in sampling this tasty seafood with its aphrodisiac effects.

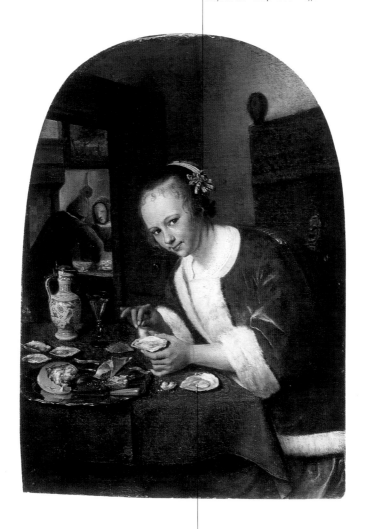

▲ Jan Steen, *A Girl Eating Oysters*, 1658–60. The Hague, Mauritshuis.

Oysters were considered a choice food in Flemish gastronomy. Since antiquity they had been thought to have aphrodisiac powers because, in opening to seed the future pearl, they mimic their human counterparts.

Mollusks

The ray's dolorous expression does nothing to stimulate the appetite: it puts one in a state of tension.

The presence of the copper pot and frying pans suggests that cooking is about to begin. In the Enlightenment climate of the 18th century, France was beginning to establish its own gastronomic identity.

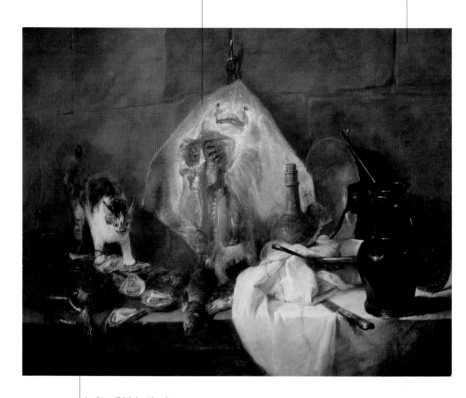

In this still life by Chardin we see once again various kinds of fish: a ray, two carps, and some oysters— all chosen in accordance with the wishes of the cook.

▲ Jean-Siméon Chardin, *The Ray*, 1725–26. Paris, Louvre.

Lobsters, crayfish, and crabs have appeared on the table at banquets since antiquity. They are emblems of rebirth and the Resurrection, but also symbols of instability.

Crustaceans

In antiquity, crustaceans were a rare luxury food, and they were also enjoyed at medieval and Renaissance tables. Platina stresses that crustaceans are a tasty but heavy food, and he suggests lightening them by cooking in water and vinegar. They were forbidden by Jewish dietary rules, which allowed only fish with fins and scales, but they do not seem to have particularly worried Christians, who have no rules forbidding their consumption. In medieval exegetical writings, both lobsters and crabs are seen as symbols of the Resurrection. This may derive from an observation passed on by Pliny, that both lobsters and crabs cast off their old shells in the spring and acquire new ones. The Resurrection symbolism is also attributed to the crab by Picinelli. In medieval exegesis, the lobster also represents conversion from paganism, heretics, and flatterers, but also preachers who reach heights of sublime contemplation and then return to virtuous activity, just as crustaceans rise to the surface of the sea only to sink down once again. In the symbolic language of actions, both the crab and the crayfish represent instability and inconstancy because of their characteristic walk, with apparently random forward and backward movements. For the same reason, they were thought to represent sin, or even the devil, who was supposed to walk backwards.

Sources
Pliny *Naturalis historia*
9.95; Rabanus Maurus,
PL 112, col. 988; Platina,
*De honesta voluptate et
valetitudine* (1474),
book 10, chap. 363;
Filippo Picinelli, *Mundus
Symbolicus* (1687), book 6,
chaps. 18 and 20

Meaning
Resurrection, inconstancy

Iconography
Crustaceans appear fairly
frequently in 17th- and
18th-century Flemish still
lifes and genre scenes. They
also sometimes appear as
delicacies in allegories of
the sense of taste

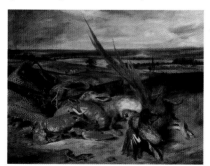

◀ Eugène Delacroix, *Still
Life with Lobsters*, 1822.
Paris, Louvre.

Crustaceans

It seems likely that the various foods brought together in this still life are intended to convey a spiritual message concerning the Resurrection and redemption from Original Sin.

Grapes, as the sources of wine, are used to convey the Passion of Christ for the redemption of humanity.

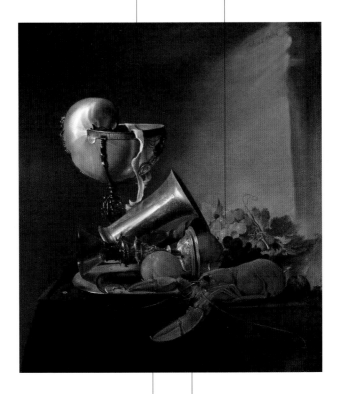

The apple symbolizes Original Sin.

The lobster is a symbol of the Resurrection because it molts its shell every year, completely renewing its appearance.

▲ Jan Davidsz. de Heem, *Still Life with Nautilus Cup and Lobster*, 1634. Stuttgart, Staatsgalerie.

The manly beer glass and the feminine pewter pot seem to suggest that this painting contains a message for a man and a woman.

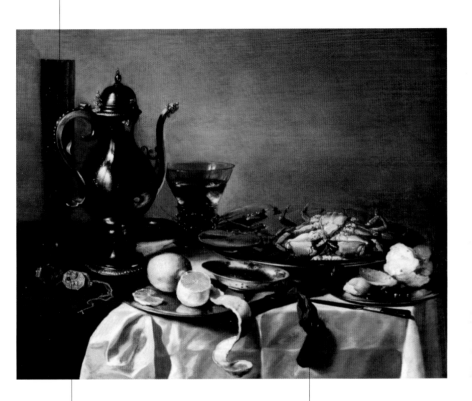

The watch invites the viewer to remember the ceaseless workings of time, which devours all. In this context, it suggests that we should read all the foods represented as symbolic.

The lobster and crab are not simply tasty foods but also symbols of the Resurrection. They remind us that taking due care of the spirit will gain us entry to the realm of divine beatitude.

▲ Pieter Claesz., *Still Life with Lobster and Crab*, 1643. Minneapolis, Institute of Arts.

Crustaceans

The man holds his glass upside down to show that he wants it to be refilled, almost as though he were trying to involve the spectator in the painting.

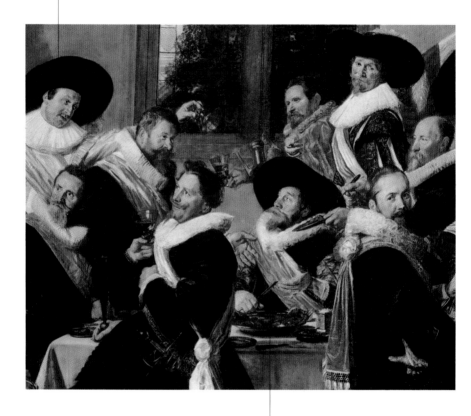

Crab is the main dish at the officers' banquet. Crustaceans have been considered a luxury dish ever since antiquity.

▲ Frans Hals, *Banquet of the Officers of the Civic Guard of Saint Adrian at Haarlem* (detail), 1627. Haarlem, Frans Hals Museum.

▶ Jan Vermeer, *The Kitchen Maid*, 1658. Amsterdam, Rijksmuseum.

Milk is a primordial food and many cultures consider it of great value for human sustenance. The same holds true for butter, a very ancient milk product.

Milk and Butter

Milk is mentioned in the Old Testament as a drink (Gen. 18:8) and as an ingredient in cooking: in Deuteronomy (41:21), we are told that goat's meat should not be cooked in its mother's milk. The promised land of Palestine is often referred to in the Bible as "the land flowing with milk and honey" (Lev. 20:24; Exod. 3:8), suggesting that it is a kind of paradise where the simplest and most wholesome foods are readily available. In biblical exegesis, milk is a symbol of maternity, but also of human nature itself, the active life and the plainest teachings, such as that of the Gospel. The whiteness of milk suggests innocence and good works. Butter, as a milk product, is another very ancient food and is also mentioned in the Bible (Prov. 30:33). It is made by churning cream, which separates into solid fat and liquid whey. The latter is then rinsed away with water. Butter was eaten not only by the Jews but also by the Egyptians, Greeks, and Arabs. The Romans, however, used it only as an ointment, judging it a barbarous food. In the Middle Ages, the Mediterranean countries used oil principally, but homemade butter was used in northern Europe. It was only in the late 19th century that butter was made on an industrial scale and became a product for mass consumption. Regarding its symbolism, butter, like milk, evokes maternity and purity, but as a product involving transformation, it is linked to the Christian idea of spiritual rebirth and the Incarnation. In biblical exegesis, butter more specifically represents the humanity of Christ, as against honey, which represents his divine nature. It is an emblem of rich spiritual virtues.

Sources
Rabanus Maurus, *PL* 111, col. 593, and 112, cols. 877 and 977; Hugh of Saint-Victor, *PL* 177, col. 150

Meaning
Milk and butter represent motherhood and the humanity of Christ

Iconography
Images of the Virgin, genre scenes with children, still lifes, and banqueting scenes

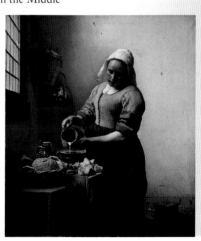

Milk and Butter

The glass is empty; that is, it does not contain the wine that would symbolize the blood of Christ. It therefore refers to the Passion as an inevitable event but one that has not yet occurred.

Within the iconography of the Madonna and Child, butter reminds us of mother's milk and therefore refers to the Virgin's maternity.

Given the presence of the Christ child, the bread has the Eucharistic significance of the body of Christ.

▲ Quentin Metsys, *Madonna and Child*, 1500–1510. Berlin, Gemäldegalerie.

This genre scene illustrates the custom, common in northern countries, of buttering bread eaten at main meals as well as at lunch and snacks.

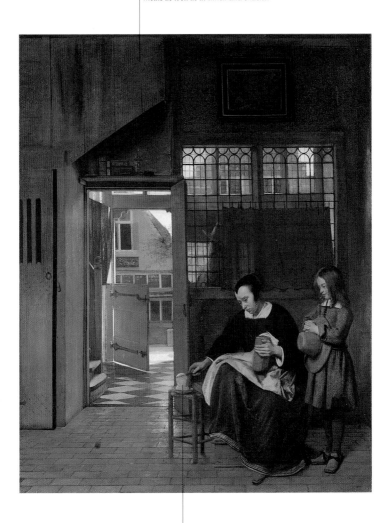

▲ Pieter de Hooch, *A Woman Preparing Bread and Butter for a Boy*, 1660. Los Angeles, The J. Paul Getty Museum.

As a food made from milk, butter symbolizes maternity and infancy.

The elderly singer wearing a kippah, the characteristic Jewish headgear, may be Adam von Noort, the artist's father-in-law and teacher. The painting may therefore be a kind of family portrait.

This is an illustration of the Dutch saying "As the old sing, so the young pipe." In other words, the young imitate the old.

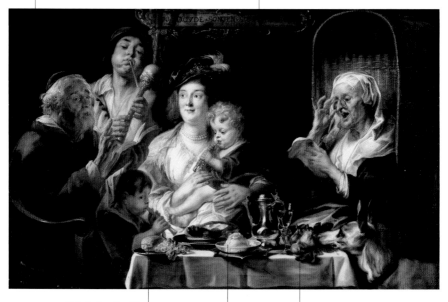

Both the bread and the bunch of grapes next to it have a Eucharistic significance and thus refer to the New Testament.

The figs are a symbol of the Old Testament, because they are the fruit of the tree whose leaves were used by Adam and Eve to cover themselves after the Original Sin.

The butter, a food emblematic of the Flemish table, here seems to act as a reference to Palestine, the land of milk and honey, as well as the motherhood of the Virgin. It thus seems to link the Old and New Testaments.

▲ Jacob Jordaens the Elder, *As the Old Sing So the Young Pipe*, 1638. Antwerp, Musée des Beaux-Arts.

▶ Leandro Bassano, *The Month of May*, 1595–1600. Madrid, Prado.

An Egyptian frieze from the 3rd millennium B.C. *gives evidence of cheese production using cow's and sheep's milk. It shows priests toiling in the cheese-making area of a temple.*

Cheese

The earliest cheese may have been made from sheep's milk, but if so it was soon followed by that made from cow's and goat's milk. In the ancient world, Greeks, Etruscans, and Romans all used cheese a great deal, and indeed the Romans thought it suitable for both elegant banquets and the tables of peasants. From the 4th century A.D., when Lenten fasting was lengthened to forty days, abstinence from meat was extended to include eggs and milk products; but in Protestant countries, cheese continued to be eaten during Lent, becoming a food for fasting periods. During the early Middle Ages, monks reared goats for their meat, milk, and cheese, and peasants at feudal castles did the same. This cheese production continued even into Renaissance times and the 17th century, but it was during the fashion for Arcadian idylls in the late 18th century that plain foods such as milk and cheese came into their own. France, in particular, produced a great variety of cheeses. In his book of gastronomy, Dumas says that the Romans were responsible for bringing cheese to Gaul; among the best known varieties he mentions are Brie, Camembert, Livarot, Roquefort, and Parmesan. As an excellent food concentrate and one that could be preserved for a long time, cheese was considered a miraculous gift of Providence. In biblical exegesis, cheese represents a firm mind and rightful reasoning. Since cheese, like butter, came from that pure substance milk, it too appears on the table in scenes of meals with Christ, and in paintings of the Madonna as an allusion to her maternity within a symbolic perspective of spiritual rebirth, linked to the fact that its production involved a process of transformation.

Sources
Columella *De re rustica*
7.2.1; Rabanus Maurus,
PL 111, col. 593, and 112,
col. 888; Alexandre
Dumas, *Grand dictionnaire
de cuisine* (1873)

Meaning
Maternity, rectitude

Iconography
Sometimes found in paintings of the Virgin, in Last Suppers, and in scenes of meals with Christ in general, and common in Flemish and Italian still lifes in the 17th, 18th, and 19th centuries

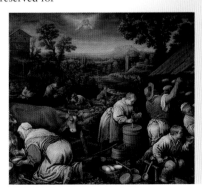

The element of caricature in
this genre scene emphasizes
its lowly atmosphere.

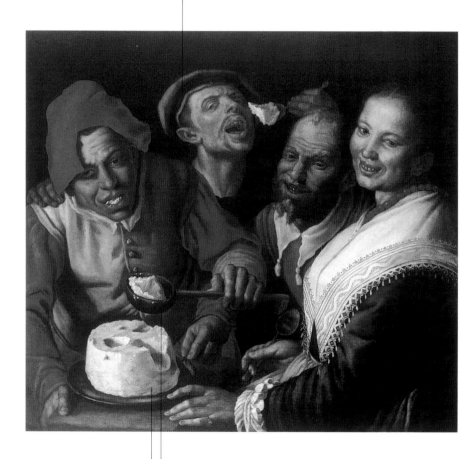

Ricotta is a bland, fresh cheese
that does not keep well.
Although of ancient origin, it is
the humblest and least note-
worthy of all cheese products.

The men are using crude kitchen implements
to wolf down the ricotta. This vulgar display
illustrates the lack of self-control in relation
to food that Della Casa, in his Galateo, criti-
cized as contrary to good manners.

▲ Vincenzo Campi, *The Ricotta Eaters,*
ca. 1585. Private collection.

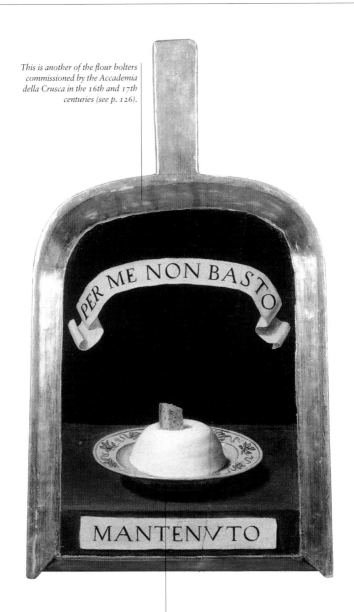

This is another of the flour bolters commissioned by the Accademia della Crusca in the 16th and 17th centuries (see p. 126).

PER ME NON BASTO

MANTENVTO

▲ Florentine artist, *The Flour Bolter of Baldassarre Suarez, Known as Il Mantenuto*, 1650. Florence, Accademia della Crusca.

The ricotta is accompanied by the motto "I am not enough by myself." This is an allusion to the fact that it is a humble cheese with little flavor and therefore needs to be eaten with bread.

Cheese

The objects are assembled
on a rustic sideboard,
which looks almost like a
larder shelf.

The eggs, here arranged in
a characteristic earthen-
ware bowl, were usually
preserved in mutton fat.

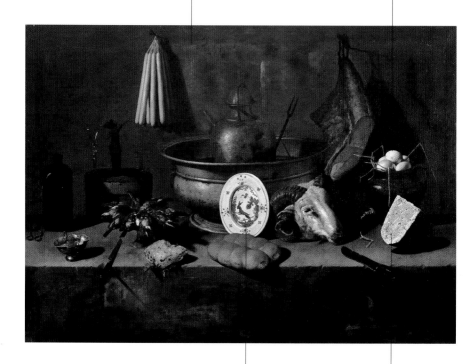

The blue and white plate, an
imitation of Chinese porce-
lain, adds a note of refinement
to the rustic tableau.

The wedge of white
cheese may be goat
or sheep cheese.

▲ Giovanni Battista Recco, *Still Life*,
ca. 1650. Naples, Museo di Capodimonte.

This composition celebrates local produce from the countryside around the Medici villa at Artimino.

The straw-covered flask is a typical rustic wine container and exemplifies the local wine production.

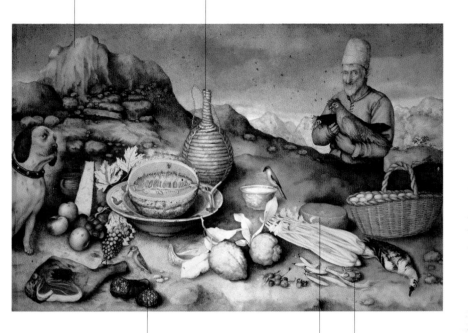

Ham and salami also belong to the Tuscan gastronomic tradition.

Sheep cheese was a typical regional product.

Artichokes were one of the most prized vegetables in Tuscany at the time of the Medici. Tradition has it, in fact, that Catherine de' Medici, wife of the king of France, was responsible for its export.

▲ Giovanna Garzoni, *The Old Man of Artimino*, 1648–51. Florence, Galleria Palatina.

The presence of cheese in a French still life is strong evidence of the country's gastronomic identity.

Brie is mentioned in Alexandre Dumas' Dictionnaire de cuisine. *It is one of the best-known types of cheese, along with Camembert, Livarot, and Roquefort.*

▲ François Bonvin, *Still Life with Brie*, 1863. Paris, Musée d'Orsay.

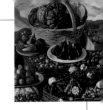

The expression de ovo usque ad mala, *meaning "from the egg to apples," conveys the completion of an action; in English we might say "from soup to nuts."*

Eggs

Eggs are a very old food and were used in ancient Egyptian cooking. The Greeks are known to have eaten eggs in the time of Pericles, and the Romans used them for sweets, garnishes, and sauces, as well as finding them an excellent food for lunch on their own. Eggs were served at the moment of *gustatio* at the start of a banquet, which gave rise to the expression *de ovo usque ad mala* to indicate that something had been completed. The Etruscans may have had the same custom, for when banquets are shown in wall decorations in their tombs, the diners are holding eggs, signifying either a gastronomic custom or possibly the beginning of the dead person's journey in the next world. Along with meat and cheese, eggs were forbidden during Lent by some religious orders. They were a common food at the tables of medieval lords, accompanying the more noble dishes of meat and cheese as a plain but choice food. From the Renaissance onward, they were considered an ideal food for convalescents and new mothers, because they were nutritious but plain. In biblical exegesis, the egg, as a container of life, represented the hope of rebirth through the Resurrection. Hence it often appears in scenes of the Birth of the Virgin or of Christ. According to Filippo Picinelli, the fact that eggs open when subjected to warmth means that they can represent the Virgin's womb, which gave birth to Jesus Christ after being touched by the rays of the Holy Spirit. They symbolize rebirth, and that symbolic value was subsequently christianized in biblical exegesis and took the form of Easter eggs, the food of the Resurrection since the Christian Middle Ages.

Sources
Apicius *De re coquinaria* 7.19; Pliny *Naturalis historia* 10.167; Rabanus Maurus, *PL* 112, cols. 1114–15; Filippo Picinelli, *Mundus Symbolicus* (1687), book 4, chap. 69

Meaning
Rebirth, resurrection

Iconography
Eggs are frequently found in Etruscan tomb decoration and often appear in scenes of the Birth of the Virgin and of Christ, in scenes of meals with Christ, in still lifes, and in 17th- and 18th-century genre scenes. Because of their perfect shape, they are also found in 19th-century still lifes from Impressionist and Macchiaioli circles

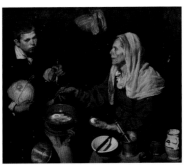

◀ Diego Velázquez, *An Old Woman Cooking Eggs*, 1618. Edinburgh, National Gallery of Scotland.

Eggs

The egg held in the right hand refers symbolically to rebirth in a new dimension after physical death.

In this wall painting from an Etruscan tomb, the subject is reclining on a triclinium, in accordance with ancient custom, as he partakes of a banquet.

The drinking vessel in the man's left hand is a traditional cup for wine, an intoxicating drink whose effects can bring one close to the sphere of the divine.

▲ Detail of frescoes in the Tomb of the Lionesses, late 6th century B.C. Tarquinia, necropolis.

In this detail of the central panel of The Garden of Earthly Delights *triptych, the egg is a strange refuge for human beings. They appear to be squeezing inside it, as though to escape from the profusion of earthly pleasures.*

The fragile shell thus suggests a return to the maternal womb as a way of escaping the corrupting influence of mortal pleasures.

▲ Hieronymus Bosch, *The Garden of Delights* (detail), from *Triptych of the Garden of Earthly Delights*, 1503–4. Madrid, Prado.

Eggs

This story, taken from The Golden Legend *of Jacobus de Voragine, tells how the Virgin was taken by her parents to the temple at the age of three. She succeeded in climbing the fifteen temple steps in spite of her tiny stature, thereby demonstrating that her journey through life was already fated to be a holy one.*

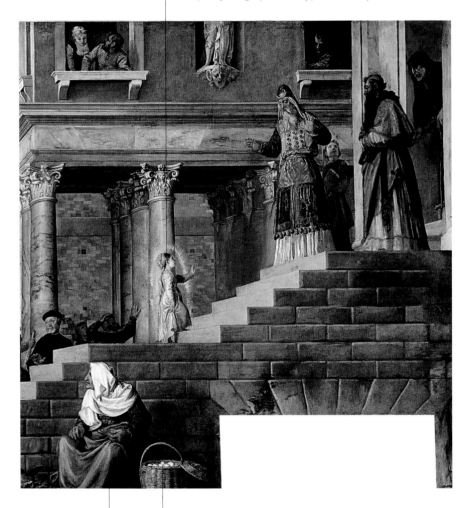

The presence of the old woman selling eggs shows that such goods used to be sold by peddlers.

The eggs are relevant to the story in that they symbolically foretell Mary's virginal pregnancy. The sources tell us that just as an egg opens and gives birth to a chick when warmed by the sun, so the Virgin is impregnated by the Holy Spirit and conceives Jesus Christ.

▲ Titian, *The Presentation of the Virgin in the Temple* (detail), 1534–38. Venice, Gallerie dell'Accademia.

The risen Christ appears to the travel-
ers at Emmaus and reveals his true
identity by blessing the bread.

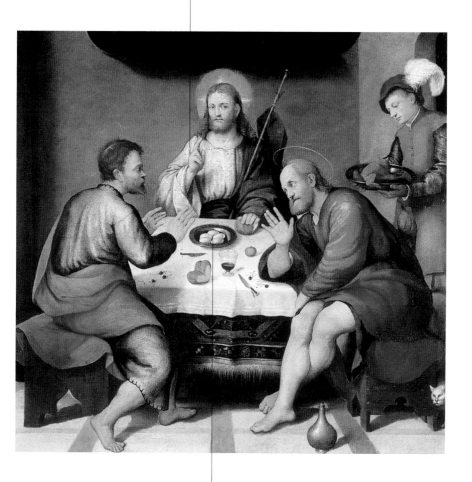

Within the context of this
Gospel story, the eggs are
clearly a symbol of the
Resurrection.

▲ Jacopo Bassano, *The Supper at
Emmaus*, ca. 1538. Fort Worth, TX,
Kimbell Art Museum.

In this painting of the Nativity, the peddler points to the Christ child with her right hand and holds the basket of eggs with her left, establishing a clear visual link between the Child and the eggs.

As biblical exegesis explains, the egg is a container of life and thus symbolizes hope for a new birth: that is, a resurrection made possible by the work of the Redeemer.

▲ Francisco de Zurbarán, *The Adoration of the Shepherds* (detail), 1638. Grenoble, Musée des Beaux-Arts.

▲ Jean-Siméon Chardin, *The Attentive
Nurse*, 1737–41. Washington, D.C.,
National Gallery.

Eggs

This "fast-day menu" shows the foods permitted during the Lenten period, when meat was prohibited.

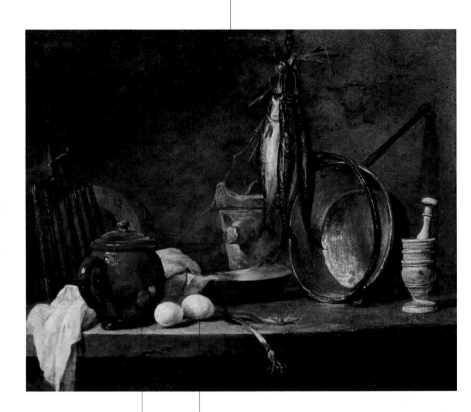

The earthenware egg jar reminds us of the importance of eggs as a food, partly because they could easily be preserved.

Eggs were a light food permitted during Lent.

▲ Jean-Siméon Chardin, *The Fast-Day Menu*, 1731. Paris, Louvre.

Vegetables have long been a part of the human diet. As symbols, they represent productive nature, which generously gives man the foods essential for his survival.

Vegetables

Vegetables were known to Egyptian, Greek, and Etruscan cooking and were widely used in Roman gastronomy, as we can tell from the recipes of Apicius. The early Christians ate them frequently, but in the Middle Ages, they were largely a food of the poor and peasants. They rarely appeared at noble banquets, partly because they were thought to be indigestible; but they made a timid reappearance at noble tables during the Renaissance, when their rustic flavors were placed alongside spicy and bittersweet foods at sumptuous banquets in a continuous play of contrasts. In the 17th century, scientific curiosity about nature led to their rediscovery as healthy foods, necessary for the well-being of the human race. Along with magnificent flowers from many different sources, the hothouses of Versailles produced all kinds of vegetables as ingredients for a gastronomy that was being simplified and that sought out more natural, unadulterated flavors. Giacomo Castelvetro and Giovanni Battista Barpo wrote treatises, in 1614 and 1633, respectively, in which they extolled products of the soil. The exotic spices that had been so fashionable in rich Renaissance cookery gave way to scented herbs providing country flavors; they were grown along with vegetables in kitchen gardens. Technological discoveries made during the Enlightenment led to improvements in agriculture, and the *philosophes* rediscovered the virtues of vegetables. In 1781, a treatise entitled *Del cibo pitagorico* outlined a vegetarian diet in harmony with the conviction of some ancients that the flesh of animals should not be eaten.

Sources
Giacomo Castelvetro, *The Fruits, Herbs, and Vegetables of Italy* (ca. 1614; 1989, G. Riley, trans.); Giovanni Battista Barpo, *Le delizie e i frutti dell'agricoltura e della villa* (1633); Vincenzo Corrado, *Del cibo pitagorico* (1781)

Meaning
Nature, seasons, Divine Providence, health

Iconography
Vegetables are often seen in 17th- and 18th-century Italian and Flemish market and kitchen scenes. They appear in the late 16th century in Arcimboldi's fantasies of the seasons, and in still lifes from the 17th to the 19th century

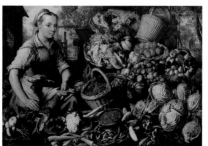

◄ Joachim Beuckelaer, *A Woman Selling Fruit, Vegetables, and Poultry*, 1564. Kassel, Gemäldegalerie.

Vegetables

Vegetables often appear in 16th- and 17th-century Flemish market scenes. They combine a taste for the picturesque with overtones of a self-indulgent sensuality that is seen as characteristic of a lower-class environment.

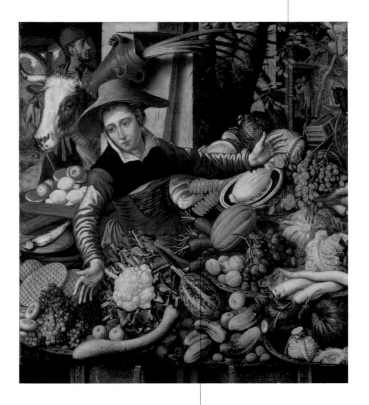

The strange, decorative shapes of the vegetables provide a pleasant kind of visual inventory of the wonderful produce of the soil, as well as an implicit message about the ephemeral nature of earthly goods.

▲ Pieter Aertsen, *Market Woman with Vegetable Stall*, 1567. Berlin, Gemäldegalerie.

Maize, the cereal from the New World, was
a recent discovery. It is used here to demon-
strate the power of the Habsburg crown,
on whose empire the sun never set.

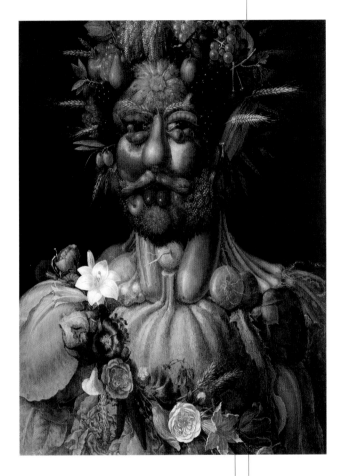

In this fantasy by Arcimboldi, fruits and
vegetables are combined to form the face of
Habsburg Emperor Rudolph II. He com-
missioned the painting and is represented as
Vertumnus, a Roman god who presided
over gardens and orchards.

The figure is assembled out of
vegetables, fruits, and flowers
taken from all four seasons of the
year, which lifts him out of nor-
mal temporal boundaries and into
the realm of the universal.

▲ Giuseppe Arcimboldi, *Vertumnus*,
1590. Stockholm, Skokloster Castle.

Garlic has been highly regarded since antiquity for both its flavor and its therapeutic qualities. In the Middle Ages it was used as a talisman to keep the Evil One at bay.

Garlic

Sources
Pliny *Naturalis historia* 19.101–11; Rabanus Maurus, *PL* 111, col. 531; Platina, *De honesta volup-tate et valetitudine* (1474), book 3, chap. 61; Agrippa von Nettesheim, *Three Books on Occult Philosophy* (ca. 1510; 1993, J. Freake, trans.), book 1, chap. 27

Meaning
Rusticity, protection against evil, sin

Iconography
Found only occasionally in Italian painting from the 15th to the 19th century, and in French and northern painting from the 16th to the 19th century

▼ Jean-Siméon Chardin, *Still Life with a Glass of Water and a Coffeepot*, 1760. Pittsburgh, Carnegie Museum of Art.

The Egyptians considered this bulb of many virtues to be a precious source of nutrition, capable of giving strength to the men building pyramids; the Greeks used it extensively in their cooking. The Romans dedicated *allium sativum* to Mars and passed down to the Renaissance the idea that garlic could endow the eater with the energies of Mars, the most hot-tempered and aggressive of the gods. The Roman legionaries used it as a protection against infections and worms, and we are told that Emperor Nero's doctor gave him garlic juice mixed with honey to clear his throat. In the Middle Ages, strings of garlic were hung at the door to ward off the Evil One, and its flesh was used not only as an aphrodisiac and medicine, but also as the basic ingredient of a sauce to accompany roast dishes. In the symbolic language of biblical exegesis, garlic represents the corruption of the mind and the bitterness of sin, because it was difficult to digest and hence the more you ate the more harmful it was. Sixteenth-century gastronomic treatises praise its versatility and its effectiveness in protecting against many dangerous illnesses; its smell was supposed to repel snakes and scorpions. When imported exotic spices gave way to kitchen garden herbs in the 17th century, garlic and onions won pride of place in the new recipes, as being vegetarian but distinctive because of their strong flavor and special qualities. In his 19th-century gastronomic dictionary, Dumas says that the smelly breath of garlic eaters was repugnant to the priestesses of the temple of Cybele, and that knights who had eaten it were banned from the court of Alfonso of Castile for at least a month. Nevertheless, Dumas himself describes garlic as essential in the preparation of both bouillabaisse and bruschetta.

The spice shop was a typical retail outlet from the late Middle Ages onward. There is an arch above the shop interior, and a counter separates the seller from the customer. The low wall next to the street could be used for displaying goods.

Then as now, garlic was preserved by braiding it into bunches. It is hung from the ceiling to keep it dry but also perhaps to ward off evil: its emanations were thought to keep malevolent spirits at bay.

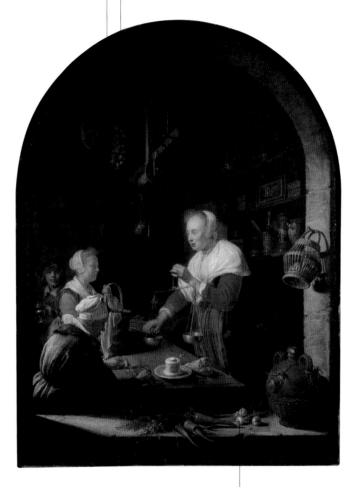

The fact that garlic is for sale beside the most expensive traditional spices imported from the East shows that there was already a trend at this period toward using the cheaper flavorings from the kitchen garden in cooking.

▲ Gerrit Dou, *The Spice Shop*, 1647. Paris, Louvre.

Onions were grown and eaten in ancient Egypt. They were given to pyramid builders in lieu of wages and were thought to be an essential food for the journey into the afterlife.

Onions

Sources
Rabanus Maurus, *PL* 111, col. 531; Platina, *De honesta voluptate et valetitudine* (1474), book 3, chap. 62; Agrippa von Nettesheim, *Three Books on Occult Philosophy* (ca. 1510; 1993, J. Freake, trans.), book 1, chaps. 24 and 27; Filippo Picinelli, *Mundus Symbolicus* (1687), book 10, chap. 10

Meaning
Rusticity, repentance

Iconography
Frequently found in still lifes and kitchen and market scenes in the 17th and 18th centuries in Italy, Flanders, and France

The Greeks, Etruscans, and Romans all used onions in cooking. They were easy to grow in kitchen gardens and appear in many ancient recipes. The Jews regretted the loss of onions when they fled from Egypt toward the Promised Land and had to make do with manna (Numb. 11:5). Onions appear to have been a favorite vegetable from early Christian times through the Middle Ages. In the 1500s, they were exported to the Americas. Onions were thought to have both aphrodisiac and laxative qualities, and to stimulate the appetite. They were very popular in the 17th century, when people were starting to favor kitchen-garden herbs and seasonings over spices; but it was in the 18th century that the onion really came into its own, gastronomically speaking, as a food both rustic and sophisticated. The fact that they caused the eyes to water led biblical scholars to conclude that they represented the corruption of the mind and the piercing pain produced by sin. In his *Mundus Symbolicus*, Picinelli

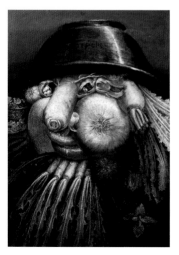

says that onions were worshipped by the Egyptians and were a symbol of obscene femininity and sin. In Renaissance magic, the tear-producing onion was linked to Mars, as were garlic, shallots, and leeks, but onions also grew or shrank in inverse proportion to the phases of the moon. For this reason, Picinelli saw them as a symbol of envy. Because onions are made up of layers, they suggest duplicity.

▶ Giuseppe Arcimboldi, *The Gardener*, ca. 1590. Cremona, Museo Civico.

The juxtaposition of food and kitchen utensils in this still life suggests that a dish is about to be prepared.

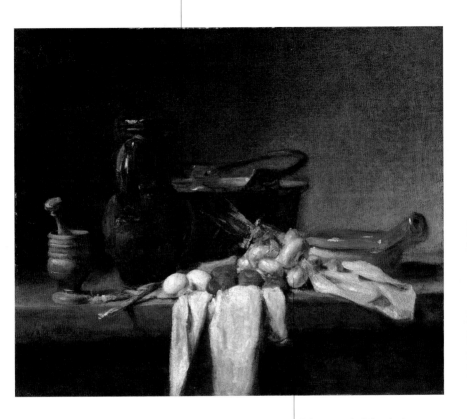

Onions were a basic flavoring in many recipes. Their presence here reminds us that French gastronomy was in the process of establishing its own sophisticated identity during the Enlightenment.

▲ Jean-Siméon Chardin, *Still Life with a Jug and Copper Cauldron*, ca. 1732. Madrid, Thyssen-Bornemisza Museum.

The artichoke is a plant of Middle Eastern origin related to the thistle. It was brought by the Arabs to Spain, where it acquired the name alcachofa *from the Arabic* al-khurshuf.

Artichokes

Sources
Ugo Benzi, *Regola della sanità* (1620, pp. 149–52); Pietro Andrea Mattioli, *I discorsi nei sei libri di Pedacio Dioscoride . . .* (1550, p. 415); Giacomo Castelvetro, *The Fruits, Herbs, and Vegetables of Italy* (ca. 1614; 1989, G. Riley, trans.); Vincenzo Cervio, *Il trinciante* (1581; 1980, p. 139)

Meaning
Aphrodisiac food, botanical discovery

Iconography
Though rarely found in paintings, artichokes do appear in Arcimboldi's fantasies and in 17th- and 18th-century still lifes, especially in Italy but also in Flanders

In the 15th century, artichokes came into common use in Italy, though they had been known in the previous century. In the 16th century, Mattioli declared that this "domestic thistle" could have a variety of shapes: open, closed, round, or pointed. It could have or lack thorns and was apparently cultivated chiefly in Tuscany. Artichokes were eaten at court, and in *Il trinciante*, Cervio devotes a chapter to them, explaining how they should be cut. Although some were opposed to artichokes—Ludovico Ariosto, for example, thought them hard and bitter—their use was widespread in Italy. They were exported to France by Italian kitchen gardeners under the auspices of Catherine de' Medici, who wanted them for her table after she married the king of France. In the 17th century, aphrodisiac qualities were ascribed to the artichoke, and Ugo Benzi advised eating them boiled and seasoned with pepper and salt. Castelvetro confirmed that they were good to eat either cooked or raw and that, thanks to Italy's temperate climate, artichokes could be grown there all year round. It appears in 16th-century

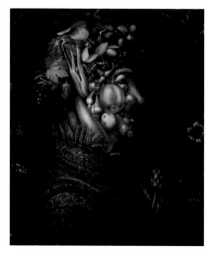

botanical treatises as a rarity, an original work of nature that appealed to the Mannerist taste for the exotic and strange. Consequently, it acquired symbolic value as a caprice of nature: strange in appearance but attractive in flavor.

► Giuseppe Arcimboldi, *Summer*, 1573. Paris, Louvre.

The gilded metal food warmer in the middle of the table is a refined accessory, giving emphasis to the elegance of the occasion and the diners.

The sensual nature of this dinner for two is emphasized by the fact that the lady is about to take the artichoke—an aphrodisiac vegetable.

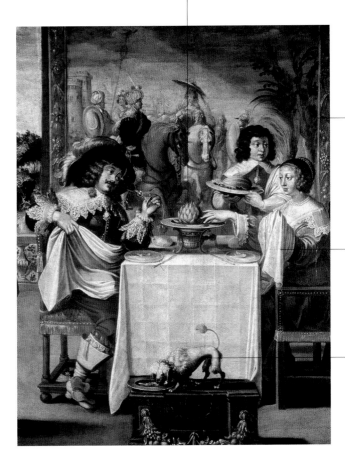

This intimate dinner for two is an illustration of the sense of taste.

Etiquette required that the napkin be placed on the lap. A napkin was necessary because food was eaten with the hands.

The dog eating leftovers from a special dish gives the painting a note of sophistication. It shows that in the 17th century it was no longer considered polite to throw leftovers onto the floor.

▲ Unknown artist, *The Sense of Taste*, ca. 1635. Tours, Musée des Beaux-Arts.

The presence of flowers in this still life adds to the decorative value of the artichoke.

The placement of artichokes next to the delicious wild strawberries suggests that the artist is trying to extol their flavor by association.

Because this is a Florentine still life, and because artichokes were cultivated especially in Tuscany, the artichoke may be seen here as celebrating a local gastronomic tradition.

▲ Unknown artist, *Still Life with Artichokes and Strawberries*, mid-18th century. Florence, Gallerie Florentine, Soffittone depository.

Romans appreciated and lauded lettuce, but in the Middle Ages only the humble ate it. Because it can quench thirst and refresh, it is an emblem of Christian charity.

Lettuce

Varro maintained that lettuce's name came from *lac* (milk) because its high liquid content stimulated lactation. Lettuce was served as a first course in peasant households in the Middle Ages but was rarely eaten in more elevated homes. During the Renaissance, lettuce made a timid appearance along with other vegetables at noble tables, but in the 17th century its fortunes began to revive, thanks to the rediscovery of nature as a subject for scientific inquiry. In literature, lettuce is praised as a healthy, pleasant food. It was dealt with in treatises, and in 1614, Giacomo Castelvetro described its qualities and urged its use by the wealthy, laying down the so-called lettuce law: "Lettuce should be well salted, with a little vinegar and plenty of oil, and he who sins against this worthy commandment deserves never to eat a good lettuce." Picinelli saw it as a symbol of Christian charity because it is full of water. Being damp and cool, lettuce is a summer food that can slake thirst, settle the stomach, and calm anger. Hence it repre-

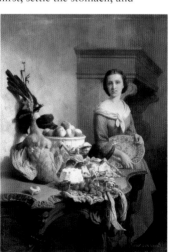

sents grace in extreme circumstances, temperance, and the control of lust. In biblical exegesis, the Jewish custom of eating lamb with lettuce, taken together with lamb as a symbol of the sacrifice of Christ, led scholars to interpret lettuce and its underlying bitter taste as a reminder of sin and a symbol of expiation.

Sources
Pliny *Naturalis historia* 19.125; Athenaeus *Deipnosophistai* 2.32.91; Rabanus Maurus, *PL* 111, cols. 531–32; Giacomo Castelvetro, *The Fruits, Herbs, and Vegetables of Italy* (ca. 1614; 1989, G. Riley, trans.); Salvatore Massonio, *Archidipno, ovvero, dell'insalata e dell'uso di essa* (1627); Filippo Picinelli, *Mundus Symbolicus* (1687), book 10, chap. 20

Meaning
Penitence, charity, health, relief

Iconography
Lettuce and salad in general are found in scenes of meals with Christ and less commonly in genre scenes set in kitchens and markets. Lettuce also occasionally appears in Italian and Flemish 17th- and 18th-century still lifes

◄ David de Noter, *A Maid beside a Food-Laden Table*, 1859. Private collection.

Lettuce

By blessing the bread, Christ reveals his identity to the travelers at Emmaus.

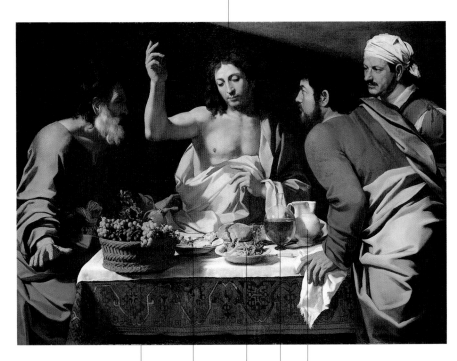

As biblical exegesis suggests, the basket of fruit has to be seen as representing New Testament teaching.

The jug of water seems to refer to the Redeemer's role as purifier.

The wine represents the blood of Christ.

Given the Gospel context, the fish must represent Christ himself.

The lettuce is an emblem of charity because its fibers are rich in liquid. It therefore represents the mercy of Christ.

▲ Master of the Acquavella Still Life, *The Supper at Emmaus*, ca. 1615–20. Los Angeles, The J. Paul Getty Museum.

This curious scene shows a woman mixing lettuce with seasoning while others look on smiling.

According to the treatises of the time, lettuce is a plain, healthy food, but above all a very refreshing food in the summer heat of the Venetian lagoon.

The two people pointing to the bowl full of lettuce leaves emphasize the central action of mixing the salad and make it clear that the intention is to publicize vegetables.

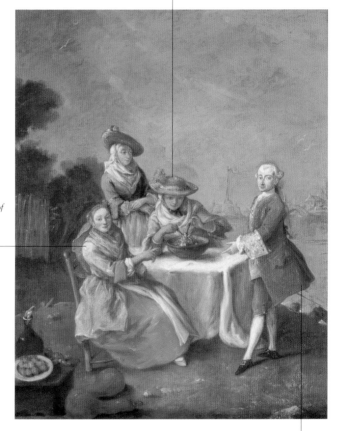

Vegetables were "rediscovered" during the Enlightenment era. The gentleman's elegant clothes show that lettuce now appealed not only to peasants but also to Venetian high society.

▲ Pietro Longhi, *In the Estuary Gardens*, 1759. Venice, Ca' Rezzonico.

Even as far back as prehistoric times, fungi have been known both as food and as potentially deadly poisons.

Mushrooms and Truffles

Sources
Horace *Satires* 2.4.20;
Apicius *De re coquinaria*
7.15; Pliny *Naturalis
historia* 19.83 and 22.96;
Martial *Epigrams* 13.48
and 50; Platina, *De
honesta voluptate et
valetitudine* (1474),
book 9, chap. 348; Castore
Durante, *Il tesoro della
sanità* (1586, pp. 130–31,
141); Filippo Picinelli,
Mundus Symbolicus
(1687), book 10, chaps.
17–36; Alexandre Dumas,
*Grand dictionnaire de
cuisine* (1873)

Meaning
Hidden evil, worldly
pleasures

Iconography
Edible fungi and truffles
appear in genre scenes set
in markets and kitchens,
but more particularly in
still lifes, in Italian,
Flemish, and French paint-
ing from the 16th to the
19th century

▶ Jacopo da Empoli,
Kitchen Scene (detail),
1624. Florence, Uffizi.

The Greeks and Romans used mushrooms for two different purposes: as food and as poison. Horace, Apicius, and even Martial registered opinions on them. As for their symbolic value, Picinelli thought they had a primarily negative connota-tion, since deadly toxins may lurk behind their pleasant taste; hence they represent the temptation to evil. The fact that they spring up abruptly and only last a few days makes them an emblem of human life in its brevity. Mushrooms also represent worldly pleasures, since both can cause death. The ancients wondered how the precious tubers called truffles were gener-ated. Picinelli thought they resulted from the simultaneous action of water, warmth, and lightning and attributed this the-ory to Plutarch. They were often mentioned and praised in Latin satires and gastronomic treatises, as well as being pre-scribed as a restorative food due to their nutritional and stimu-lant value. In the Renaissance they were thought to be an aphrodisiac and hence were often served at the banquets of rich, refined men whose intention was to prepare themselves for the pleasures of Venus. As symbols, Picinelli related truffles to sin, since they are generated in the soil but deprive the sur-rounding plants of nutrition, just as sin excludes grace. Hence truffles became an emblem of the worldly pleasures that led one away from the spiritual path. But 19th-century gastronomers sang their praises: Dumas described truffles as the *sacrum sacrorum* of the dining table, and Brillat-Savarin called them the diamonds of cookery.

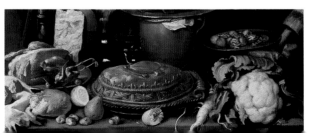

*Along with artichokes and asparagus, edible
fungi are prized fruits of the soil. They have
been known and enjoyed since antiquity.*

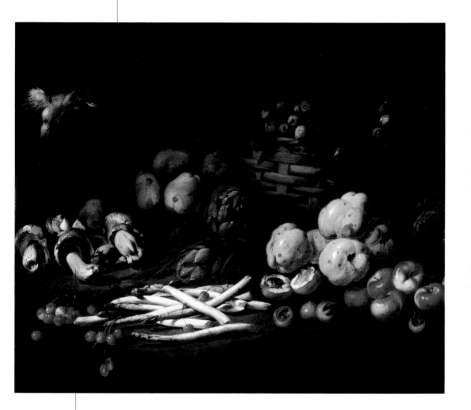

*Since deadly poison may lurk behind the
pleasant flavor of mushrooms, they are sym-
bols of the temptation to evil and of worldly
pleasures, for both may lead to death.*

▲ Carlo della Torre, *Still Life*, second
half of the 17th century. Stuttgart,
Staatsgalerie.

Potatoes came from America and reached European dining tables comparatively late. They were introduced into Europe in the 18th century but became popular only in the 19th.

Potatoes

Sources
Antoine Augustine
Parmentier, *Examen
chimique de la pomme de
terre* (1773); Alexandre
Dumas, *Grand dictionnaire
de cuisine* (1873)

Meaning
Poverty

Iconography
Mostly found in 19th-
century genre scenes
and still lifes with a
humble setting

▼ Vincent van Gogh, *Still
Life with Potatoes*, 1888.
Otterlo, Rijksmuseum
Kröller-Müller.

Potatoes originated in Peru, Bolivia, and Mexico, where they were grown from the time of the Aztecs and Incas. They were brought to Europe via Spain and Portugal by the great explorers of the second half of the 16th century but at first were used solely as cattle food. The Discalced Carmelites introduced potatoes into Italy, explaining how one eats the tuber and not the fruit or leaves, which are poisonous. Mistakes about this led to a great many poisonings at first, and despite the efforts of botanists to expand potato consumption, potatoes failed to take hold and were considered a source of disease. It was the Germans who introduced the potato to the Western diet, as the famine that followed the Thirty Years' War in the 17th century overcame diffidence toward them. The chemist Antoine Parmentier, who was a prisoner of the Prussians during the Seven Years' War, came to appreciate their taste and good qualities; when he returned to the court of Louis XVI in France, he encouraged the cooks to use them. It was thus that potatoes entered French gastronomy in the early 18th century. Others around this time tried to persuade the Italians of potatoes' good

qualities, but it was only in the mid-19th century that their use became widespread. Dumas offered a number of recipes based on potatoes, praising them as healthy, nutritious, easy to cook, and economical, and hence excellent for the working classes. According to Dumas, their success stemmed from a revolutionary decree of 1793 when the Paris Commune requisitioned all luxury gardens for growing potatoes.

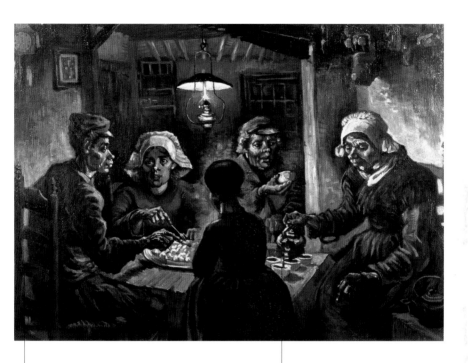

Potatoes played a large part in the diet of
the poor. Once initial suspicions were
overcome, many northern countries
adopted their use in the 19th century.

In the 18th century, coffee had been the
drink of the aristocracy, but now in the
19th its use was becoming widespread.

▲ Vincent van Gogh, *The Potato Eaters*,
1885. Amsterdam, Van Gogh Museum.

Tomatoes came from the New World. It was only in the 18th century that they took hold in Mediterranean gastronomy, in which they soon became a basic ingredient.

Tomatoes

Sources
Vincenzo Corrado,
Del cibo pitagorico
(1781, p. 30)

Meaning
Exoticism, discovery

Iconography
Tomatoes are very rare in
painting. They are mostly
to be seen in Italian and
Spanish still lifes in the
18th and 19th centuries

▼ Luis Meléndez, *Still
Life with Gherkins
and Tomatoes*, 1772.
Madrid, Prado.

Tomatoes originally came from Central and South America—especially Mexico and Peru—and like potatoes and peppers, they were brought to Europe by the Spanish and Portuguese fleets in the age of exploration. But it is unclear exactly when they were introduced to Europe and there are scarcely any relevant written documents. Europeans were at first suspicious of the tomato, which like the potato belongs to the nightshade family, of which many species are toxic. Tomato plants seemed decorative rather than useful at first, and their fruit was thought more a curiosity of nature than a versatile food to be used in the kitchen. Even botanists who raised the tomato as an exotic novelty had no hesitation in declaring it inedible or even poisonous. The tomato gained acceptance in gastronomy in the 18th century, especially in Neapolitan cooking. At this time it appeared along with the other vegetables in Vincenzo Corrado's treatise *Del cibo pitagorico per uso de' nobili e de' letterati*. The title itself made clear that the book was aimed at a cultured audience, which was to read it and make use of the vegetables praised by the author. Corrado's treatise is an example of a trend that would produce a number of cooking enthusiasts at the end of the century. Their recipes guaranteed the success of the tomato.

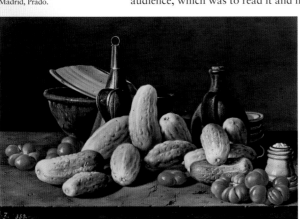

Lentils, peas, and beans have been used as food since very ancient times but they had inferior status for many centuries, ranking very low in the hierarchy of foodstuffs.

Legumes

Leguminous plants and their seeds are high in starch and valuable proteins, and humans instinctively chose them as a substitute for meat. The Egyptians were particularly fond of chickpeas, lentils, and peas, whereas beans were considered suitable only for the poor, in accordance with a kind of hierarchy that was subsequently upheld by Pliny and Columella. Legumes were also eaten in large quantities by the Greeks and Romans, who imported them from Egypt. They seem to have been primarily a peasant food in the Middle Ages, scarcely ever gracing the tables of gentlemen, who loved and consumed every kind of meat. The same treatment was meted out to legumes at the great banquets of the Renaissance aristocracy. In the 16th century, however, geographical discoveries allowed Europe to encounter new and exotic varieties of bean, and fresh interest in legumes was revived. They took gastronomic center stage at the time of the French Revolution, when the aristocratic hierarchy of foodstuffs was jettisoned in favor of an unprejudiced culinary art. In a mystic sense, they represent continence and the mortification of the body. For Picinelli, peas represent the fragility of all things human, because of their small size and small roots. Their size makes them an emblem of humility, but also of the just man aided by grace, because, in spite of their smallness, they are grown as a choice food.

Sources
Virgil *Georgics* 1.127;
Pliny *Naturalis historia*
18.123; Columella *De re rustica* 2.7.1; Apuleius
Metamorphoses 4.115;
Rabanus Maurus, *PL* 111,
col. 506; Christopher
Columbus, *Giornale di bordo* (1985, pp. 78, 81);
Filippo Picinelli, *Mundus Symbolicus* (1687),
book 10, chap. 29

Meaning
Humility, poverty,
continence

Iconography
Legumes appear in genre
scenes with humble settings
and in Italian and Flemish
still lifes from the 16th to
the 19th century. Lentils
appear in connection with
Esau. Beans appear in connection with the Bean
King, a 16th- and 17th-
century Flemish tradition

◄ Leonardo da Vinci,
*Peapods, Cherries, and a
Wild Strawberry*, 1487–89.
Paris, Institut de France.

The broken glass emphasizes the state of neglect in this humble home. The presence of scallions, a vegetable with a characteristic pungent smell, fits the rest of the pictorial context.

This is a genre scene of the type that emerged at the beginning of the 17th century and renewed art by making available subjects that had previously been thought unworthy.

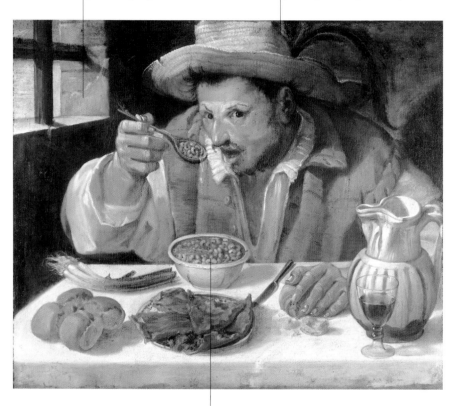

"Bean eater" aptly describes the subject here. The humblest of vegetables well defines the context of poverty and the element of caricature in the presentation of this plebeian figure.

▲ Annibale Carracci, *The Bean Eater*, 1583–84. Rome, Galleria Colonna.

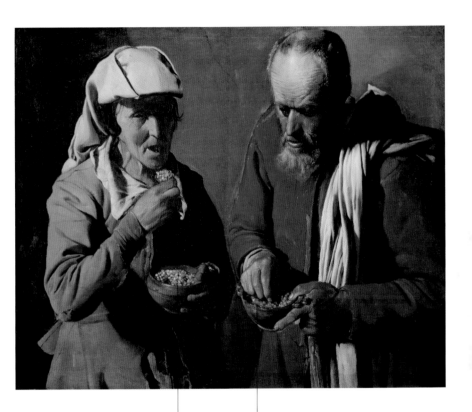

The earthenware bowls give this genre scene an even more explicitly lower-class tone and draw attention to the fact that the frugal meal is being eaten standing up.

For centuries, lentils were the most typical peasant food, and being healthy and nutritious, they were considered the best of the edible seeds. They are therefore symbols of continence and the mortification of the body.

▲ Georges de La Tour, *A Peasant Couple Eating*, ca. 1620. Berlin, Gemäldegalerie.

The olives that the old woman is handing to Jacob indicate God's approval of the new holder of the birthright.

When Esau's twin brother, Jacob, was born, he was holding Esau's heel: a sign that one day he would supplant Esau as the leader of Israel. This happened when Jacob managed to trade Esau a dish of lentils for his birthright.

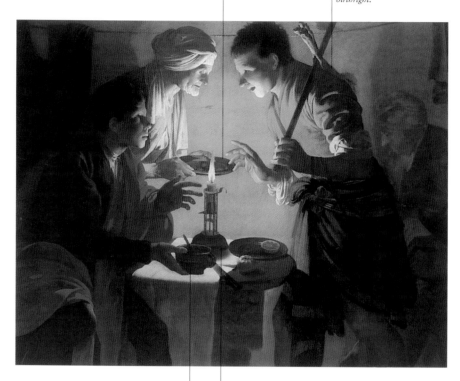

The lentils are offered in exchange for the elder twin's birthright.

The compelling light from the candle illuminates the scene and gives it a sacred aura. It also bears witness to the fascination northern artists had with the effects of artificial light.

▲ Hendrick ter Brugghen, *Esau Selling His Birthright*, ca. 1627. Madrid, Thyssen-Bornemisza Museum.

As civilization developed, man learned how to cultivate fruit, and many species that reached the West from the New World, Africa, and the East subsequently became local produce.

Fruit

Both fresh and dried fruit were eaten by the ancient Greeks and Romans either for breakfast or for dessert. Fruit was a common food in early Christian times and could be found at the close of medieval banquets, either raw or cooked. In the Renaissance, tableware had evolved, and fruit was presented in a variety of refined arrangements, the aim being not only to stimulate the sense of taste but also to embellish sumptuous tables. The medical view of fruit in the Middle Ages and Renaissance was that it was a cold, dangerous food but could at the same time stimulate the appetite: by occasionally breaking into the sequence of cooked dishes, it could refresh the palate. In the 17th century, fruit became an object of interest to naturalists, and space was made for fruit trees in private and botanical gardens. Increasing attention was paid to fruit in the 18th century, and as farming techniques improved, standards of hygiene were raised, and gastronomy made progress, fruit was increasingly grown, preserved, and eaten, thus establishing its central position in the diet. Biblical scholars saw fruit as symbolizing both the Redeemer and the Antichrist, for it could represent the body of Christ or material seductions. Sometimes fruit could be a symbol of the spiritual virtues, good examples, and the final reward of eternal life.

Sources
Rabanus Maurus,
PL 112, cols. 937–38

Meaning
Physical pleasure,
food for the spirit

Iconography
Fruit appears in paintings
of dinners and banquets,
genre scenes, and still
lifes from the 16th to
the 19th century

▼ Filippo Napoletano,
Cooling Bowl with Fruit,
ca. 1620. Florence,
Palazzo Pitti.

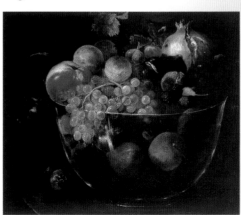

The wine alludes to
the blood of Christ.

The clear water in the glass bottle
represents the immaculate soul of
the Master, whose teaching is like
a drink of water to the thirsty.

The bread has the Eucharistic meaning
of the body of Christ and reminds us
that this is the story of the meal at
which Christ revealed his true identity
by repeating the blessing of bread as
performed at the Last Supper.

▲ Michelangelo Merisi da Caravaggio,
The Supper at Emmaus, 1596–1602.
London, National Gallery.

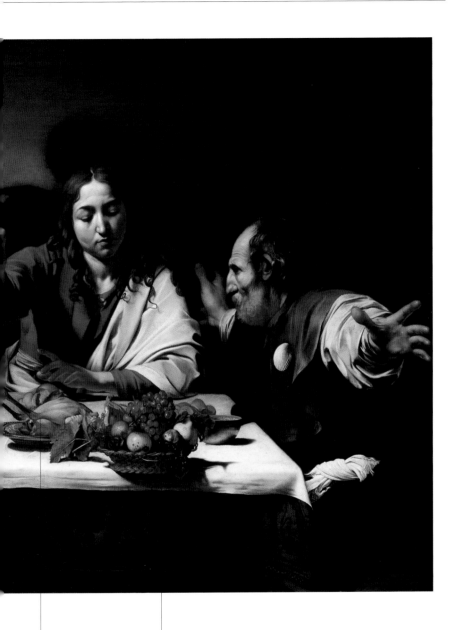

The chicken, which may
have been roasted on the
spit, symbolizes Christ as
a sacrificial victim.

According to biblical scholarship, the basket of
fruit represents Holy Scripture, the fruit itself being
the teachings of the Old and New Testaments,
which provide nourishment for the spirit.

Fruit

Market scenes are common in Italian and Flemish paintings. They celebrate the abundance that resulted from increasing confidence in trade as a source of wealth.

A subtle emphasis is given to the sensual, both in the fruit and vegetables and in the attractive fruit seller.

Campi's painting is one of a series of five inspired by the Flemish painters Aertsen and Beuckelaer. They were painted for the banker Hans Fugger around 1580.

The display of fruit and vegetables echoes the spirit of orderliness and inquiry that typified the collectors who set up Wunderkammern.

▲ Vincenzo Campi, *The Fruit Seller*, ca. 1588. Milan, Pinacoteca di Brera.

This is one of the still lifes that Caravaggio worked on when he came to Rome and was active in Cavalier d'Arpino's workshop.

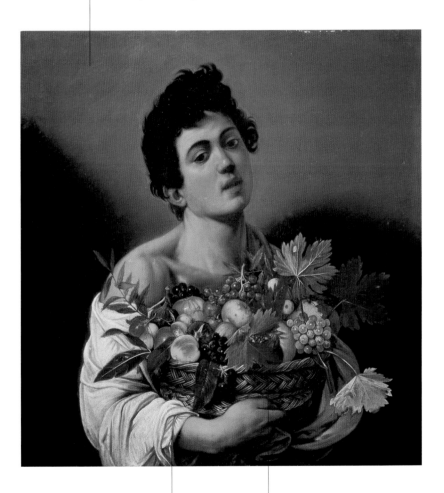

The boy's white garment contains a clear reference to the antique but perhaps also refers to the idea of the purity and innocence of the boy and his soul.

Biblical exegesis tells us that the basket of fruit represents Holy Scripture and its sweet, nourishing content.

▲ Michelangelo Merisi da Caravaggio,
A Boy with a Basket of Fruit, 1593–94.
Rome, Galleria Borghese.

Pomona was an Italic goddess who protected gardens and orchards. She is often identified in art by an accompanying cornucopia or a basket of fruit.

The complicated love story of Pomona and Vertumnus is told by Ovid in The Metamorphoses. According to legend, Vertumnus tried in vain to win over the goddess by taking on the appearance of an old woman who pleaded his cause. After this failure, he decided to reveal his own very handsome face, thereby finally gaining Pomona's love.

▲ Anthony van Dyck, *Vertumnus and Pomona*, ca. 1625. Genoa, Palazzo Rosso.

The overflowing porcelain fruit bowl symbolizes Holy Scripture. The peach, being similar to the fruit of Original Sin, suggests the Old Testament, whereas the grapes—the source of wine and a symbol of the Passion of Christ—suggest the New Testament.

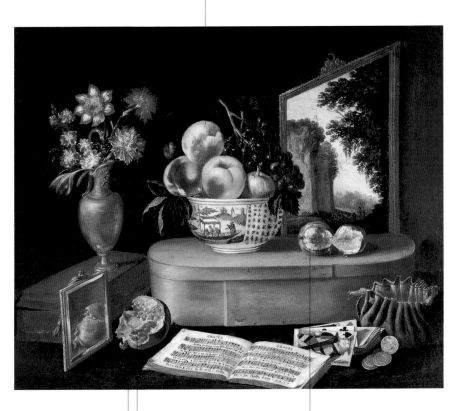

Linard's work looks like a still life but is in fact an allegory of the five senses— a common subject in 17th-century painting. At a mystic level, the senses represent both the basis of knowledge and the road that leads to sin.

The pomegranate is a flavorful fruit, and its reflection in the mirror alludes to the sense of sight. This optical play reinforces its symbolism: the pomegranate's color suggests the suffering of Christ, and its seed-filled flesh suggests the Church as a meeting place for the large numbers of the faithful. The sheet music, meanwhile, represents hearing.

Figs are famous for their sweetness and remind us of the sense of taste, while at the same time perhaps referring to the Old Testament. The fig is the fruit of the tree whose leaves served to cover Adam and Eve after the Original Sin had been committed.

▲ Jacques Linard, *The Five Senses*, 1638.
Strasbourg, Musée des Beaux-Arts.

Vesta was the
Roman goddess of
the domestic hearth.

The vestals were consecrated to her cult and were
responsible for keeping the fire in her temple
alight at all times. They took vows of the most
rigorous chastity, and the punishment for those
who broke their vows was to be buried alive.

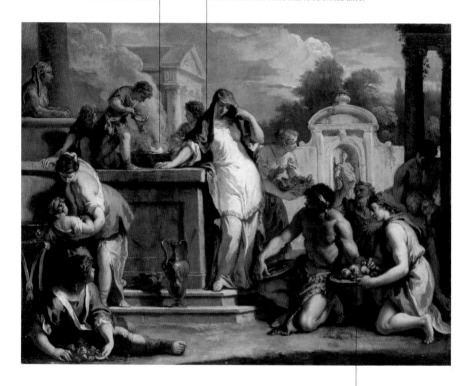

The goddess Vesta is offered a bloodless sacrifice
of fruit. This is a piece of artistic license that is in
harmony with Vesta's role as protector of the
home, the seat of divine peace.

▲ Sebastiano Ricci, *The Sacrifice to
Vesta*, 1723. Dresden, Gemäldegalerie.

Apples originally came from the Middle East and were known in ancient Egypt. The Greeks ate wild apples, and the Romans often represented them in fresco paintings on house walls.

Apples

Apples were thought to symbolize femininity, beauty, and prosperity. They appear in a number of myths. In his second labor, Hercules procures the golden apples from the garden of the Hesperides, and an apple given by Paris to Venus was partly the cause of the Trojan War. Beautiful apples were also responsible for distracting the attention of Atalanta and preventing her from winning a race against Hippomenes. In alchemy, apples were thought to represent immortality, for in the garden of the Hesperides they were the fruit that could grant eternal youth. In the 17th century they aroused the interest of naturalists, who grew apple trees in hothouses, especially at Versailles. In the Bible, the apple is a symbol of man's fall and at the same time the fruit of knowledge. Although the apple is not explicitly mentioned in the account of Original Sin, it is often mentioned in biblical exegesis of the relevant Genesis passage. It is a negative symbol in relation to Adam and Eve, but a positive one when linked to the Virgin as the new Eve, and to Christ as the new Adam. For Rabanus Maurus, indeed, the word *pomus*, interpreted mystically, represents not only Christ himself but all the saints and prophets, as well as good works and the teachings of the Bible. In *Mundus Symbolicus*, the apple represents not only the sweetness of sin but also the Virgin, for just as an apple tree is laden with nutritious fruit, so Mary feeds with maternal compassion. It acquires the significance of feminine elevation and beauty, but when worm-eaten it represents the seduction of the senses.

Sources
PL 39, col. 1951; Ambrose, *PL* 17, col. 692; Rabanus Maurus, *PL* 111, cols. 509, 512–14, and 112, col. 1030; Filippo Picinelli, *Mundus Symbolicus* (1687), book 9, chap. 28

Meaning
The fall of man, the fruit of knowledge, redemption, feminine beauty

Iconography
Apples are commonly found in scenes of Original Sin, in paintings of Atalanta and Hippomenes and the Judgment of Paris, and in the iconography of the Virgin Mary. They appear in Roman still lifes, and in Italian and Flemish genre scenes and still lifes in the 17th and 18th centuries, and on into the 19th century

◀ Bartolomeo Bimbi, *Apples*, late 17th century. Poggio a Caiano, Villa Medicea.

Apples

The drinking vessel, a container for wine, is a symbol of the blood of Christ and therefore alludes to the New Testament and Christ's Passion.

The bowl of apples reminds us of the scriptures and the Old Testament in particular and hence refers to Original Sin.

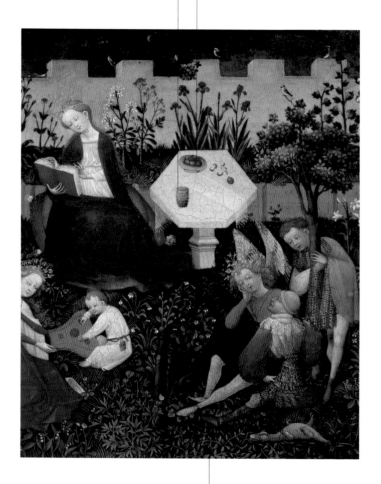

The Virgin's garden is a paradise garden and emblematic of her purity and virginity.

▲ Bohemian Master, *Mary in the Paradise Garden* (detail), ca. 1410. Frankfurt, Städelsches Kunstinstitut.

The apple is the fruit most frequently represented in paintings of Original Sin, although the Bible does not actually specify what fruit was involved.

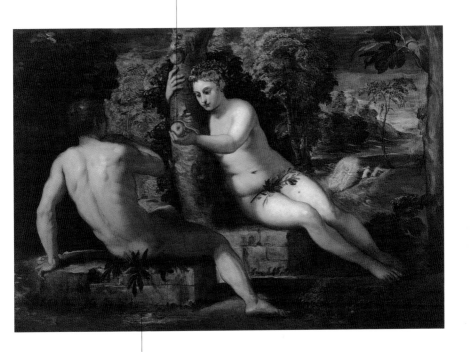

The story of Original Sin contains the first reference to food in the Old Testament. God had ordered Adam not to eat the fruit of the tree of knowledge in the garden of Eden, but when Eve offered him some, he was unable to refuse. When God discovered Adam and Eve's sinful disobedience, he banished them from Eden.

▲ Tintoretto, *Original Sin*, ca. 1550.
Venice, Gallerie dell'Accademia.

The apple is the divine fruit
that allows Hippomenes to
defeat Atalanta.

In his Metamorphoses, *Ovid tells
the story of Atalanta, a skillful
huntress who was in the habit of
challenging her suitors to a run-
ning race. The loser would be put
to death. Atalanta always won,
until one day Hippomenes man-
aged to defeat her by throwing
three golden apples into her path
to distract her attention.*

▲ Guido Reni, *Atalanta and
Hippomenes*, 1615–25. Naples,
Museo di Capodimonte.

*This representation of a young
woman peeling an apple in a spiral
may allude to human efforts to free
the spirit from its material envelope.*

*The dead hare reminds
us of the sacrifice of
Christ, who died on the
cross for the redemp-
tion of the human race.*

*Exegesis would suggest
that the basket repre-
sents Holy Scripture.*

*The apples always contain
an allusion to Original Sin.*

▲ Gabriel Metsu, *The Apple Peeler*,
ca. 1660. Paris, Louvre.

Melons and watermelons reached Greece from Africa and became part of the Roman diet from the first century B.C. onward as a sweet, exotic delicacy.

Melons

Sources
Apicius *De re coquinaria* 3.7; Pliny *Naturalis historia* 19.67; Rabanus Maurus, *PL* 112, cols. 1026–27; Platina, *De honesta voluptate et valetitudine* (1474), book 1, chap. 20; Castore Durante, *Il tesoro della sanità* (1586, p. 199); Filippo Picinelli, *Mundus Symbolicus* (1687), book 10, chap. 25

Meaning
Sweetness, earthly pleasures, friendship

Iconography
Melons usually appear with other fruit in still lifes from the 17th to the 19th century

Among the many types of fruit that were known to and enjoyed by the Romans, the melon was something sophisticated and out of the ordinary for wealthier citizens and the more demanding gourmets. Apicius mentions melons in his treatise on gastronomy. They are mentioned in the Old Testament (Numb. 11:5) and were eaten regularly by the early Christians. They continued to be enjoyed in the Renaissance and 17th century. In the mystic language of medieval exegesis, melons are a symbol of earthly joys and the pleasures of the flesh. In his treatise *De honesta voluptate et valetitudine*, Platina claims that there is not much difference between the melons he calls *pepones* and those he calls *malopepones*, for although the latter are round and ribbed while the former are smooth and oblong, Pliny himself declares that they are much the same in appearance and flavor. According to Castore Durante, they may be difficult to digest but are thirst quenching and a diuretic. For Filippo Picinelli, they are a symbol of friendship, because their external appearance is indicative of their inner nature.

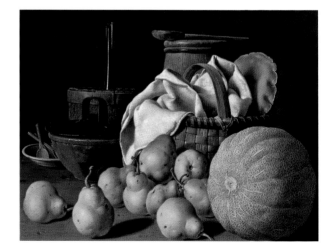

▶ Luis Meléndez, *Still Life with Melon and Pears*, ca. 1770. Boston, Museum of Fine Arts.

The exchange of glances between the two boys may perhaps be interpreted as a silent dialogue about the preference for melons versus grapes as symbols of chosen lifestyles.

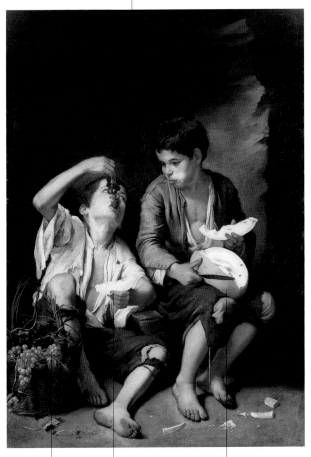

Because wine is made from grapes, and wine is a mystic drink in Christian exegesis, these grapes may contain an allusion to the spirit and its needs.

In the mystic language of medieval exegesis, the melon symbolized earthly joys and the pleasures of the flesh.

A sweet, tasty melon is not only a joy to eat for children and adults alike but also a symbol of friendship, because its external appearance is indicative of the quality of its flesh.

▲ Bartolomé Estebán Murillo, *Boys Eating Fruit*, 1645–46. Munich, Alte Pinakothek.

Figs were a basic component of the ancient Egyptian diet because they could be eaten fresh but also retained their qualities when dried.

Figs

Sources
Horace *Satires* 2.2;
Pliny *Naturalis historia*
15.68–83; Plutarch *Lives*
(*Cato*) 27.1; Rabanus
Maurus, *PL* 111, col. 513,
and 112, col. 926; Hugh of
Saint-Victor, *PL* 177, cols.
113, 146; Platina, *De honesta voluptate et valetitudine* (1474), book 1, chap.
23; Filippo Picinelli,
Mundus Symbolicus
(1687), book 9, chap. 13

Meaning
The fruit of knowledge,
fruitfulness, the sweetness
of virtue

Iconography
Found in Roman still lifes,
and in Flemish, Spanish,
and Italian still lifes in the
17th and 18th centuries.
Also found in sacred
contexts in relation to
Original Sin

The fig is one of the most significant and symbolic of all the fruits known to the West since prehistoric times. Figs were known throughout the ancient world and were particularly enjoyed by the Greeks, who saw them as a gift from Dionysus. The Romans liked them, too, and they are mentioned by Horace, Pliny, and Plutarch. In his *Lives*, Plutarch tells how Cato, wishing to set in motion the Third Punic War, appeared in the Senate with a very fresh fig, declaring that it had been picked only three days earlier at Carthage—proof, he said, that Rome should fear an enemy only three days' journey away. Fig trees are often mentioned in the Old and New Testaments, and we are bound to link to them the idea of figs as a symbol of the Creation and of abundance. Fig trees often replace apple trees as the tree of knowledge, and fig leaves are specifically mentioned in Genesis in passages referring to the Fall (Gen. 3:7). Christian scholars believed that the word "fig" derived from the word for fecundity, because of the great quantity of fruit produced by the fig tree three times a year. In mystic terms it represents the Jewish synagogue and the Old Testament. In the story of the Fall, the fig is a symbol of shame for the sin committed, but because of its sweetness, it also represents peace of mind. In the Renaissance, figs are mentioned by Platina as

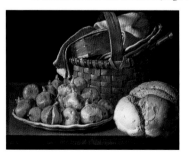

a tasty, beneficial fruit, and in Picinelli's *Mundus Symbolicus* they represent religious men, since their rough, unattractive skin conceals flesh that is as sweet as the virtues.

▶ Luis Meléndez, *Still Life with Figs*, ca. 1770. Paris, Louvre.

Bartolomeo Bimbi was court painter to
the Grand Duke of Tuscany. He painted
a series of canvases on the subject of
fruit for the Medici villa at Castello.

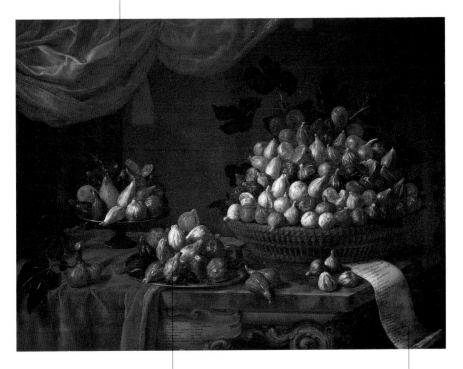

The fruits illustrated in
Bimbi's paintings are sub-
divided according to the
season when they ripen.
Figs ripen in the summer.

These still lifes were
intended to be painted
inventories of fruit and
vegetables, and they came
with a list of contents.

▲ Bartolomeo Bimbi, *Figs*, 1690–1700.
Florence, Galleria Palatina.

For thousands of years, chestnuts were used as a substitute for bread. Later, cooks developed sophisticated recipes that made them welcome even at the most splendid tables.

Chestnuts

Sources
Apicius *De re coquinaria* 5.12; Pliny *Naturalis historia* 15.92; Rabanus Maurus, *PL* 111, col. 515; Filippo Picinelli, *Mundus Symbolicus* (1687), book 10, chap. 6; Antoine Parmentier, *Treatise on the Chestnut* (1780)

Meaning
Simplicity, Divine Providence, chastity

Iconography
Chestnuts often appear with sweet dishes and dried fruit in Italian and Flemish still lifes in the 17th and 18th centuries

Roast chestnuts were already known in the days of the Romans, and Apicius suggests cooking them in a shallow pan with spices, herbs, vinegar, honey, cooked must, green oil, and pepper. In the Middle Ages, peasants in the mountains lived on chestnuts, making a kind of bread from chestnut flour. Being a peasant food, chestnuts rarely appear in the recipe books of cooks at medieval and Renaissance courts. During the 18th-century Enlightenment, however, chestnuts found fresh favor as a food among the upper classes; Antoine Parmentier, who had promoted the potato, indirectly stimulated the chestnut revival with his *Treatise on the Chestnut* (1780). Their use dwindled in the 19th century as wheat flour became more available and ink disease afflicted many trees in Europe. In biblical exegesis, chestnuts are seen as a symbol of continence, because the Latin word *castanea* was thought to derive from *castitas*, meaning chastity. In relation to the Virgin, therefore, they may refer to the virginal conception of Christ. For Filippo Picinelli, they are a metaphor for the good Christian, who has a spiny exterior like a hedgehog but is full of good qualities inside: tasty and nutritious like a chestnut. They can also represent poverty, because they are a plain food, and because they are ugly outside but replete with goodness inside.

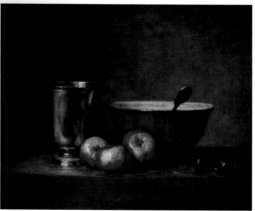

◄ Jean-Siméon Chardin, *Still Life with a Silver Goblet*, ca. 1770. Paris, Louvre.

Because they are full of oil, olives are a symbol of abundance and wealth.

Chestnuts suggest the virtue of chastity.

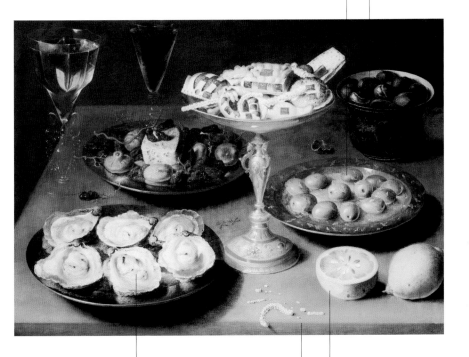

Since oysters were thought to be an aphrodisiac, they suggest the idea of physical love.

The typical wedding sweetmeat in the foreground gives a hint as to how the whole painting should be interpreted.

The whole and half lemon seem to suggest the predestined sentimental union of two individuals.

▲ Osias Beert the Elder, *Still Life with Oysters, Sweetmeats, and Fruit,* ca. 1610. Stuttgart, Staatsgalerie.

The mythical origins of the pomegranate have made it a symbol of fertility. It later became an allegory of the Church because the latter embraces the multitude of the faithful.

Pomegranates

Sources
Ovid *Metamorphoses*
5.534–38 and *Fasti*
4.607–14; Clement of
Alexandria *Protrepticon* 2;
Athenaeus *Deipnosophistai*
3.5; Arnobius, *PL* 5,
cols. 1088–97; Rabanus
Maurus, *PL* 111,
cols. 512–14, and 112,
col. 992; Hugh of Saint-
Victor, *PL* 177, col.
113–14; Filippo Picinelli,
Mundus Symbolicus
(1687), book 9, chap. 16

Meaning
Fertility, the Church,
the Passion of Christ

Iconography
Pomegranates often appear
in scenes of meals with
Christ as a symbol of the
Passion, in Flemish and
Italian still lifes of the 17th
and 18th centuries, and
also in female and family
portraits

Clement of Alexandria writes that the pomegranate was born from the blood of Dionysus. Arnobius, however, writes that while Deucalion and Pyrrha were repopulating the earth after the Deluge by throwing stones behind them, Jupiter approached the sleeping Themis to couple with her. But one of the stones struck her, and she awoke and spurned Jupiter, causing him to spill his seed. From this semen, Acdestis was born. He was a violent, lustful god and was handed over to Bacchus, who got him drunk. Once Acdestis had passed out, Bacchus tied up his feet and genitals. When Acdestis woke up, blood seeping from his genitals formed the pomegranate. The fruit was taken by the nymph Nana, who became pregnant by it and gave birth to Atys. The pomegranate was also associated with Hera, and the temptation to eat its seed kept Persephone a prisoner in Hades for the winter months. According to Rabanus Maurus, the Latin name *malum punicum* comes from the fact that it was

transplanted into the Punic region, whereas its other name, *malum granatum*, comes from its large quantity of seeds. He sees it as a symbol of the Church, formed by many people united in one faith. Its red seeds, which are as numerous as good works, virtues, and chosen men, symbolize the blood of Christ and the martyrs.

▶ Willem Kalf, *Still Life with a Porcelain Jug*, 1653. Munich, Alte Pinakothek.

The nine children around the lady remind us again of the symbolic value of the fruit.

The pomegranate in the woman's hand is a clear reference to her fertility. It derives this symbolic value from mythology and from the seed-laden appearance of its flesh.

▲ Cornelis de Vos, *Family Portrait*, ca. 1630. Private collection.

Pliny refers to cherries as a fruit from Asia Minor, imported into Italy in 74 B.C. by Lucullus, who had encountered them during the war against Mithridates.

Cherries

Sources
Pliny *Naturalis historia*
15.102; Rabanus Maurus,
PL III, col. 523;
Boccaccio,
Decameron, 6.10

Meaning
The Passion of Christ,
the fruit of Paradise

Iconography
Cherries often appear in
Flemish and Italian paint-
ings of the Virgin Mary,
in scenes of meals with
Christ, in 16th- and 17th-
century inventories of sea-
sonal fruit and vegetables
in the form of fantasies
or genre scenes, and in
Flemish and Italian still lifes
in the 17th and 18th cen-
turies. The Impressionists
also liked to paint cherries

The cherry derived its Latin name *cerasus* from a town in Pontus (Asia Minor). Cherries were enjoyed in antiquity and became part of the medieval diet in France, Germany, and England. They were eaten raw but were also used to make syrups, jams, and candied fruit; they provided an excellent base for distilling kirsch and maraschino. They appeared at noble Renaissance tables, and at Versailles in the 17th century they were grown in hothouses dedicated to providing fruit for the table and for botanical studies. Because of their red color, biblical scholars saw them as representing the blood of the Redeemer, but they were also symbols of the sweet disposition that comes from performing good works. As a spring fruit, cherries represent the Annunciation and the Crowning of Christ. According to some translations of the apocryphal Gospel of Pseudo-Matthew, a palm tree miraculously produced cherries rather than dates to feed the Child during the Flight into Egypt. In Christian iconography, the cherry is the fruit of Paradise, the antidote to the apple as the cause of Original Sin.

▶ Bartolomeo Bimbi,
Cherries, 1699. Poggio a
Caiano, Villa Medicea.

In biblical exegesis, cherries, with their deep red color, represent the blood of Christ and therefore allude to the Passion.

Cherries are also a reward for good works and therefore a symbol of Paradise. As the fruit of Paradise, the cherries in this painting could be an allusion to Eden, to which man can now aspire once more, thanks to the work of the Redeemer.

The Virgin's open hand shows that she is offering the fruit of hope to anyone looking at the painting.

▲ Antonello da Messina, *The San Cassiano Altarpiece* (detail), 1475–76. Vienna, Kunsthistorisches Museum.

In the central panel of the triptych, The Garden of Delights *celebrates alchemical transmutation, sensuality, and eroticism, making use of a complex anthology of dream symbols.*

Together with strawberries, raspberries, and bunches of grapes, the cherries in this paradise of the senses are a food for lovers: a symbol of pleasure in accordance with the interpretation of dreams in antiquity.

The two cherries are speared by the unicorn, which is a symbol of chastity. The cherries represent sensual pleasure as a corrupter of virtue.

▲ Hieronymus Bosch, *The Garden of Delights* (detail), from *Triptych of the Garden of Earthly Delights*, 1503–4. Madrid, Prado.

This bucolic scene is indicative of the 18th-century rediscovery of the countryside as an ideal background for scenes with an overtly amorous tone.

The young man's gesture in offering the freshly picked cherries to his lady can be seen as a symbolic offering of love. Cherries, with their deep red color, are an emblem of sensual pleasure.

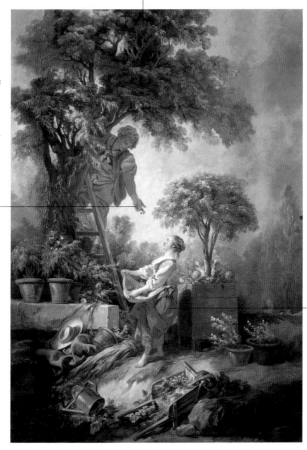

The sensual tone of the scene is symbolized by the cherries and emphasized by the young woman's gesture of gathering the fruit in her lap.

▲ François Boucher, *Picking Cherries*, 1768. London, Kenwood House.

Cherries

This is one of the earliest portraits of Victorine Meurent, who was Manet's favorite model up to 1875.

The typical bright-red color of the cherries, their sweetness, and their spherical shape, reminiscent of female curves, evoke the idea of love.

The singer's simple gesture of putting the cherries to her lips reveals a sensuality that the artist has successfully captured in the painting.

▲ Édouard Manet, *The Street Singer*,
ca. 1862. Boston, Museum of Fine Arts.

Because of its yellow color and its need for sun, the lemon was seen in 15th-century natural magic as a means of transmitting the sun's powers and providing life-giving energy.

Lemons and Citron

The citron, *Citrus medica*, comes from southwest Asia and reached Rome around the 3rd century B.C. It was used not as a food but as a flavoring and an insect repellent. The true lemon, *Citrus limon*, arrived later, reaching Europe from Africa after A.D. 1000. In his *De hortis Hesperidum*, Pontano tells us that when Venus was mourning Adonis, she asked that a tree be created in his memory. When the body of Adonis was changed into a tree, his teeth became thorns; Venus covered the tree with white flowers and citron fruit and gave it to the garden of the Hesperides. In Early Italian, the citron was associated with the cedar (the Italian word *cedro* has both meanings), and both were linked to the Virgin because their aromatic fruit was an antidote to poison. For Rabanus Maurus, the citron represents the divine, faith, the Church, and Christ himself, because the cross was made of cedarwood. When laden with flowers and fruit, the lemon tree was, for Picinelli, an expression of the beneficial principle and of God as benefactor. The cedar is also a symbol of virginity because it does not rot.

Sources
Pliny *Naturalis historia* 12.7; Athenaeus *Deipnosophistai* 3.108; Rabanus Maurus, *PL* 111, col. 517, and 112, col. 891; Hugh of Saint-Victor, *PL* 177, cols. 114–40; Giovanni Gioviano Pontano, *De hortis Hesperidum* (1514), pp. 139–40); Agrippa von Nettesheim, *Three Books on Occult Philosophy* (ca. 1510; 1993, J. Freake, trans.), book 1, chap. 23; Filippo Picinelli, *Mundus Symbolicus* (1687), book 9, chap. 8

Meaning
Fidelity, beneficence, virginity

Iconography
Lemons frequently appear in still lifes and kitchen and genre scenes, especially in 17th- and 18th-century Flemish and Spanish paintings, and are very often shown with their peel cut in a spiral

◀ Bartolomeo Bimbi, *Oranges, Lemons, and Limes*, ca. 1715. Poggio a Caiano, Villa Medicea.

Grapes have been in widespread use since antiquity and were revered as the source of wine. With the advent of Christianity, they became a symbol of the Passion of Christ.

Grapes

Sources
Clement of Alexandria
Genesis 49.11; Rabanus
Maurus, *PL* 111,
cols. 506–7; Platina, *De honesta voluptate et valeti-tudine* (1474), book 2,
chap. 26; Giambattista
della Porta, *Suae villae pomarium* (1583, p. 494);
Filippo Picinelli, *Mundus Symbolicus* (1687), book 9,
chap. 35

Meaning
The Passion of Christ,
autumn

Iconography
Grapes appear in invento-ries of seasonal produce in 16th-century fantasies as well as in 16th- and 17th-century Italian and Flemish kitchen and market scenes, and in 18th-century paint-ings of bucolic subjects.
Because of their decorative appearance, grapes also appear in 17th-, 18th-, and 19th-century still lifes

Fresh and dried grapes were known to both Greeks and Romans. In the Middle Ages and Renaissance, they were used to decorate the center of the dining table and to fill the gap between courses. They are symbolically linked to wine, whose discovery and transport to Greece were attributed in myth to Dionysus, the god of wine and intoxication. Probius tells a curi-ous legend about a shepherd of Aetolia, who was puzzled by the fact that one of his sheep often came back to the fold later than the others. He decided to follow it and discovered that the reason for the sheep's tardiness was a grapevine, on which the sheep stopped to graze. The shepherd picked some of this unknown fruit and took it to King Oeneus, who found it deli-cious and from its juice succeeded in making the first wine, which was called *oinos* after its inventor. The shepherd who dis-covered the grapes was Staphulinus, and the Greek word for

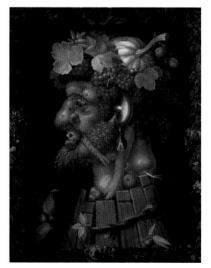

grapes, *staphulè*, was formed from his name. In the New Testament, grapes are the fruit of the vine and the source of wine, and medieval exe-gesis sees them as repre-senting the blood of Christ and the Passion, partly on account of their color. According to Picinelli, on the other hand, a bunch of grapes represents Providence.

▶ Giuseppe Arcimboldi,
Autumn, 1573. Paris,
Louvre.

The fruit stand raises the green and black grapes to a higher level than the other fruit. As a result, they gain emphasis as a symbol of the Passion of Christ and a key element in Gospel teaching.

The gilded fruit stand commands the center of the composition, contributing to its imposing elegance.

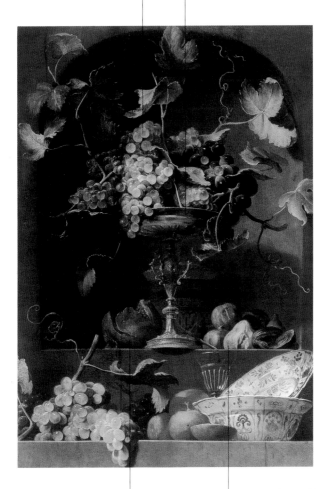

The pomegranate may represent the Church, which protects and hands down the scriptures in their entirety and unites the faithful under a single creed.

The figs may be an emblem of the Old Testament, because they are the fruit of the tree whose leaves Adam and Eve used to cover their nakedness.

▲ Frans Snyders, *Still Life with Fruit in a Niche*, ca. 1620–30. Stockholm, Nationalmuseum.

Grapes

Boucher's scene reflects the 18th-century taste for the rustic idyll and for amorous subjects set in a rich natural landscape.

Grapes remind us of the enjoyable intoxication induced by wine and symbolize earthly pleasures.

The erotic tone of the scene is conveyed by the seductive, amorous gesture of the young man as he feeds grapes one by one into his lady's mouth.

▲ François Boucher, *Are They Thinking about the Grape?*, 1749. London, Wallace Collection.

Xenophon encountered dates in Persia and wrote: "you will see that they are just like amber, and the Babylonian villagers dry them and preserve them as sweetmeats."

Dates

Dates originally came from Africa and the Middle East and were known in ancient Egypt, where they grew in abundance. The Romans ate them fresh or dried, used them for flavoring wine, and made sweet dishes out of them. When fermented, they formed the basis of alcoholic drinks. They entered the Christian diet, where they acquired spiritual meanings associated with the symbolism of the tree from which they came, the palm tree being an emblem of victory. Aulus Gellius wrote that the palm tree was so strong that it did not bend even when subjected to considerable force. On the contrary, it struggled to remain upright and for that reason is considered a symbol of those who persevere in the face of difficulty and are finally victorious. This explanation is repeated by Platina, who speaks of dates as a very sweet but indigestible fruit. He suggests that they be eaten before a meal, and that above all they be skinned and stoned in order to avoid choking, a fate that befell Alexander the Great's soldiers. Platina thought that the Latin *dactyli* reflected their finger-like shape. Among Christians, dates symbolize the pleasure of conversation with just men. Picinelli says that the palm tree is linked to the marriage of the Virgin, and that dates symbolize the happiness that comes at the end of long, hard labor. They also represent generosity, because they are spontaneously offered by the tree.

Sources
Xenophon *Anabasis* 2.3;
Aulus Gellius *Noctes atticae* 3.6; Rabanus
Maurus, *PL* 111, cols.
512–13; Hugh of Saint-Victor, *PL* 177, col. 122;
Filippo Picinelli, *Mundus Symbolicus* (1687), book 2,
chap. 30

Meaning
Sweetness, virtue,
Divine Providence

Iconography
Because they are an exotic fruit, they often appear in depictions of the Flight into Egypt, scientific illustrations, and 17th- and 18th-century still lifes

◀ Bartolomeo Bimbi, *A Dish of Dates*, ca. 1700. Florence, Galleria Palatina.

Joseph was warned in a dream that Herod was looking for Jesus in order to kill him. He took the Child and mother to safety in Egypt, where they remained until after Herod's death.

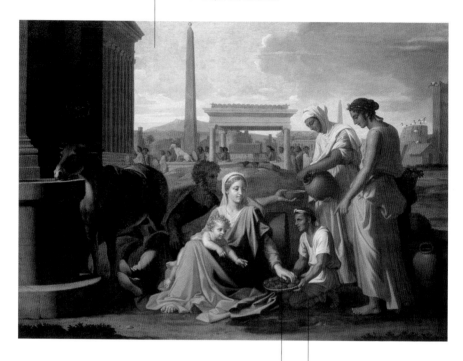

Dates take on a spiritual significance linked to the symbolism of the palm tree: the palm is an emblem of victory and therefore, in this context, of a journey safely completed. According to the sources, the date palm is so strong that even when it is weighed down it never bows but strives to remain erect. It is consequently considered a symbol of those who persevere in adversity and emerge victorious.

Jesus and Mary are resting after their arrival in Egypt, and a young Egyptian is offering them some dates, a local fruit that doubles as a symbol of generous hospitality.

▲ Nicolas Poussin, *The Holy Family in Egypt*, ca. 1655–57. St. Petersburg, The Hermitage.

At ancient banquets, dried fruit formed part of the secundae
mensae: *the Greeks changed the tabletop before serving it and
the Romans replaced the tablecloth.*

Dried Fruit and Nuts

Walnuts and almonds were part of the diet in ancient Egypt,
from whence they spread to Greece and Rome. In ancient Rome
it was customary to scatter walnuts on the floor of a bride-
groom's home on the wedding day, and so they became a sym-
bol of marriage. In Christian times, the consumption of dried
fruit and nuts held steady, and they became laden with mystic
symbolism. In exegesis, the symbolic meanings of nuts such as
almonds, walnuts, and hazelnuts were often interchangeable.
Rabanus Maurus emphasizes, for example, that these three nuts
all have similar structures: a hard shell and an edible interior.
Anagogically, the trees that produce them represent the Church,
because it brings together holy men in the same way that the
trees are laden with tasty nuts. Almonds, walnuts, and hazel-
nuts therefore represent chosen people: like the nuts, they are
concealed beneath a hard skin and hide the goodness of their
hearts behind an apparent roughness. The various stages in the
formation of nuts represent the Incarnation of Christ and the
mystery of the Trinity. Outstanding for its mystic symbolism is
the almond. According to Filippo Picinelli, almonds are sym-
bols of the Passion because their sweetness is accompanied by a
slightly bitter flavor, but they also represent Divine Providence
because they are concentrates of nutritious
material spontaneously given up by the tree,
and allude to the Virgin. Picinelli attributes to
the walnut the sense of travail and correction
involved in penitence, because of the resistance
offered by the hard shell, and for the same rea-
son he sees it as a symbol of the hardened sin-
ner who does not repent.

Sources
Virgil *Eclogues* 8.29–30;
Pliny *Naturalis historia*
16.42; Rabanus Maurus,
PL iii, col. 514; Filippo
Picinelli, *Mundus
Symbolicus* (1687), book 9,
chaps. 18 and 21

Meaning
Marriage, Divine
Providence, the Incarnation
of Christ, the Trinity

Iconography
Dried fruit and nuts often
appear in inventories of
seasonal produce, repre-
senting winter, but they are
mostly found in genre
scenes and still lifes

▼ Georg Flegel, *Large Still
Life*, ca. 1630–38. Munich,
Alte Pinakothek.

253

The lady of the house is waiting to receive the first fruits that a peasant woman is handing to her page. She acts as a kind of interpreter of the scene, in that she underscores both the contrast between the world of nature and the civilized world and their integration.

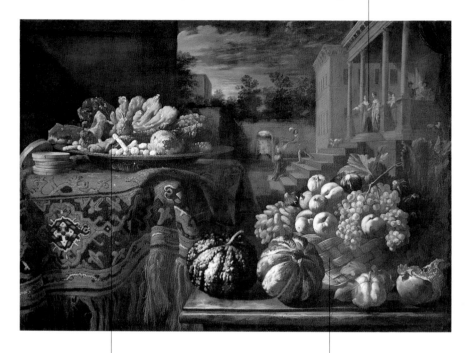

On top of a rich Anatolian carpet sits a metal dish containing a collection of lovely candied fruits. They celebrate the human skill involved in transforming natural produce into a work of art.

The fresh fruit in the humble basket celebrates nature as a wonderful producer of simple but tasty things.

▲ Pier Francesco Cittadini, *Still Life with Fresh and Candied Fruit*, ca. 1670. Trieste, Galleria Nazionale d'Arte Antica.

The gilded metal ceremonial chalice draws attention to the celebratory nature of this display of food, and the figure of Athena on the lid is suggestive of chastity and wisdom.

The fruit stand made of precious silver is a symbol of purity and it emphasizes the richness of the food display. This suggests that the painting may depict a wedding feast, especially since traditional white sweetmeats are also present.

The bread and wine allude to the Eucharist and may be interpreted as an invitation to embrace the Christian faith as a necessary condition for success in marriage.

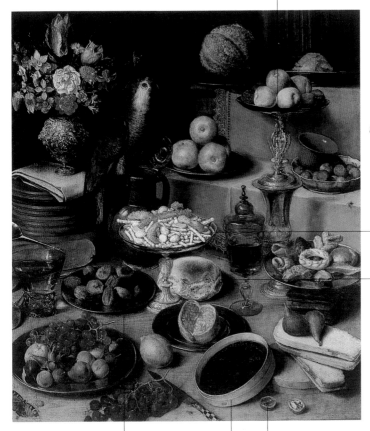

The dried figs, like the pomegranates above, express a hope of fertility.

The jelly in the foreground may allude to the joys of wedded life.

The walnut is a symbol of the Trinity but is also appropriate within this celebratory context because it is an ancient symbol of matrimony.

▲ Georg Flegel, *Large Still Life*, 1630–38. Munich, Alte Pinakothek.

Dried Fruit and Nuts

Dipping a pretzel in wine is a tradition still current in northern Europe and at the same time reminds us of the bread and wine of the Eucharist.

The rummer is a typically northern European wine glass. It tells us where the artist came from and lends an everyday, traditional tone to the whole still life.

Walnuts remind us of the concept of the Trinity because of their shells and the three stages in their development.

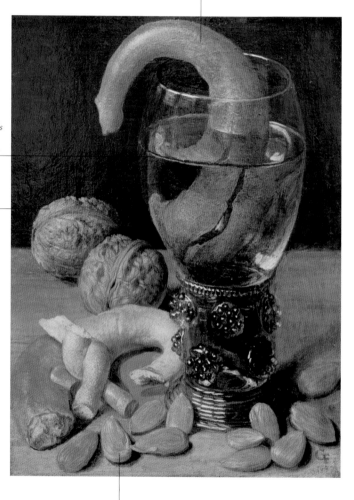

The almonds allude to the Virgin because they contain concentrated food that is spontaneously supplied by the tree.

▲ Georg Flegel, *Still Life with a Glass, Pretzel, and Almonds,* 1637. Münster, Landesmuseum.

In many cultures, sweets mark important life events. The Jews ate sweetmeats and slices of bread and honey in honor of the newborn, and ring cakes were required at weddings.

Sweets

At ancient Greek marriage ceremonies, the bride and groom exchanged sweetmeats, and the same was true in ancient Rome. Most cakes and pastries were homemade, but there were specialist bakeries as well. In the early Middle Ages, most sweets were made in monasteries, but as baking evolved from the 14th to the 16th century, so regional specialties also developed. In this period, ladyfingers and tarts came into being; and in the 15th century specialized artisans also began to make wafers. Pastry cooks in various European countries began producing thin, crisp, and delicate cornets by exposing basic pastry to direct heat and then applying special molds. Sweets were a status symbol in the Renaissance: a gastronomic indulgence for the aristocratic palate, for the most spoiled as well as the most refined. That was to remain true for the next two centuries, and it is significant that in Vincenzo Corrado's 18th-century treatise *Il credenziere di buon gusto*, cakes, confectioneries, and candied sweetmeats take pride of place. In the 17th and 18th centuries, French *patisserie* added croissants and brioches made of flour, butter, eggs, milk, and yeast, with or without sugar. In the 19th century, consumers gradually developed a preference for professionally made, as opposed to homemade, pastry.

Sources
Rabanus Maurus, *PL* 111, col. 591; Vincenzo Corrado, *Il credenziere di buon gusto* (1778, pp. 25–33); Alexandre Dumas, *Grand dictionnaire de cuisine* (1873)

Meaning
Festivity, wealth, refinement, the Eucharist

Iconography
Occasionally seen in scenes of meals with Christ, in paintings of the Madonna and Child as a food linked to childhood, and in 17th- and 18th-century kitchen or festive genre scenes. Also found in Flemish still lifes in the 16th and 17th centuries and up to the 19th century

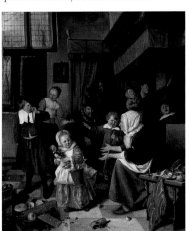

◀ Jan Steen, *The Feast of Saint Nicholas*, 1665–68. Amsterdam, Rijksmuseum.

Christis enveloped in a
cluster of light rays as he
talks to his apostles.

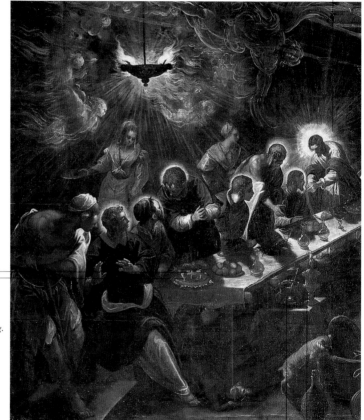

A cake at the Last
Supper is unusual.
It symbolizes the
sweetness of
Christ's body in
the Eucharist.

The candles that
light up the cake
may be due to
Tintoretto's interest
in nocturnal lighting.
That interest can
also be seen in the
luminous haloes of
the apostles and
Christ himself.

The wine-mixing bowl is an
allusion to the ancient prac-
tice of drinking wine mixed
with water in varying propor-
tions at the end of a banquet.

The ceremonial
chalice reminds
us that this is
the scene of the
first Eucharist.

▲ Tintoretto, *The Last Supper* (detail),
1592–94. Venice, San Giorgio Maggiore.

The butchered ox suggests that this is a special occasion: perhaps a wedding feast is being prepared.

The banqueting room, with its rectangular table and display of plates, is separate from the kitchen. Hence we are in a palatial home.

One woman is making pastry dough, while another, next to her, is rolling it out with a rolling pin.

The old woman is pounding an herb in a mortar, while the young woman beside her grates some Parmesan cheese.

The eggs, sugar, and butter show that a cake is being made.

This kitchen scene shows preparations for a banquet. The presence of animals and children and the smiling faces of those present emphasize the joyfulness of the occasion.

▲ Vincenzo Campi, *Kitchen Scene*, ca. 1580–90. Milan, Pinacoteca di Brera.

Since the wine may symbolize the Eucharist, it shows that luxury biscuits can have a symbolic value similar to that of bread.

The crystal decanter contains sweet wine or rose liqueur—fashionable in the 18th century—to accompany the ladyfingers. It also illustrates the elaborate shapes given to bottles in that century, making them adaptable for a variety of uses.

This kind of footed tray was fashionable in the 16th century. It throws into relief the delicate blown wineglasses.

The silver dish emphasizes the fact that the biscuits are delicacies.

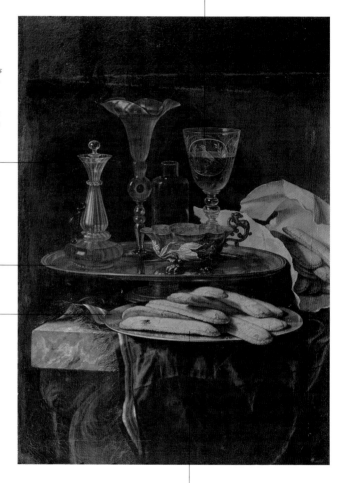

▲ Christian Berentz, *Crystal Ware and a Plate of Biscuits*, late 17th century. Rome, Galleria Nazionale d'Arte Antica.

Ladyfingers were created in Savoy in the 15th century, and they clearly demonstrate that the painting was intended for an aristocratic patron. During the Renaissance and for two centuries afterward, these biscuits were a refined gastronomic delicacy for sophisticated palates.

The wine is clearly a symbol
of the blood of Christ.

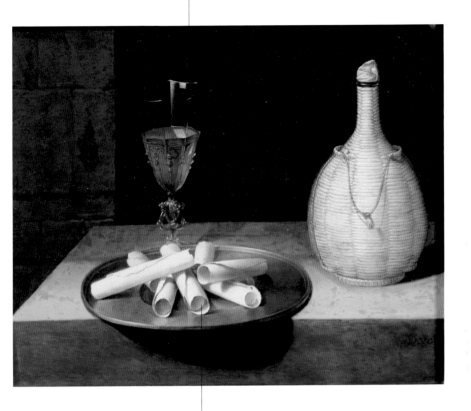

In the 15th century, specialized artisans baked
thin, delicate, crisp wafers, using a basic pastry
mix and special molds. One is bound to see an
analogy between these wafers and certain
details of the Eucharist because of the similar
type of pastry used. It may be that this still life
should be interpreted along these lines.

▲ Lubin Baugin, *The Plate of Wafers*, ca.
1633–40. Paris, Louvre.

Sweets

In Christian symbology, the two glass containers represent the mortal bodies of human beings.

The quintessential sweetness of honey makes it a symbol of the sweetness of love.

Wine was considered a suitable drink for toasts and for accompanying sweet dishes at wedding feasts. It also alludes to the wine of the Eucharist.

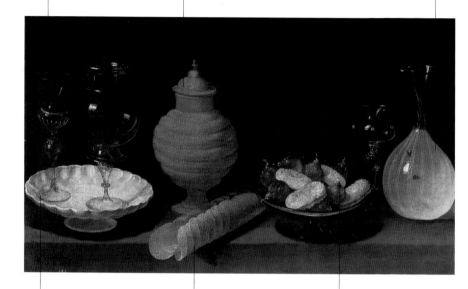

The two empty glasses on the silver dish suggest that the whole composition is intended to celebrate a marriage.

The wafers are suggestive of Holy Communion because their delicate thinness and the pastry from which they are made are similar to those of the consecrated host.

Candied figs are symbols of fruitfulness because the fig tree normally produces quantities of figs three times a year.

▲ Juan van der Hamen y León, *Still Life with Glasses, Pottery, and Sweetmeats*, 1622. Madrid, Prado.

The silver chocolate pot emphasizes the aristocratic environment in which this scene is set.

The setting is a bedroom, and we are witnessing a lady's breakfast—a ritual that at that time was largely confined to the upper classes.

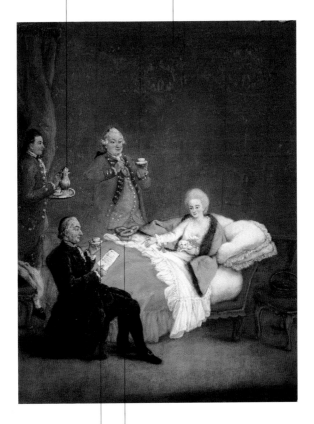

The small hemispherical cups are of Turkish inspiration. Both chocolate and coffee were drunk in Venice, one of the first cities in Europe to open a coffeehouse.

Ring cakes were sold on the streets of Venice by peddlers. They were enjoyed by both lower and upper classes and often appear in Longhi's paintings.

▲ Pietro Longhi, *The Morning Cup of Chocolate*, 1775–80. Venice, Ca' Rezzonico.

Sweets

Since sugar is an ingredient in all the foods shown in the painting, it seems likely that the whole display alludes to sweetness.

The decorative orange blossom on the brioche suggests that the food symbolizes the joys of marriage.

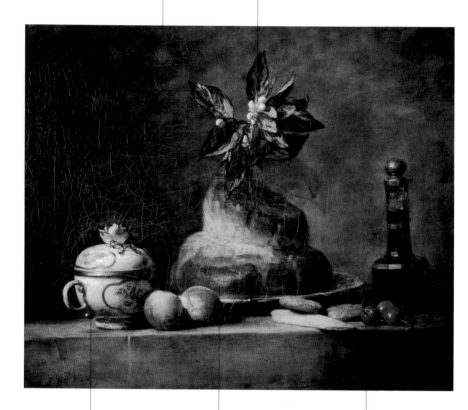

The sugar bowl is an elegant European porcelain specimen. In the 18th century, sugar was beginning to acquire universal acceptance as a food that was neither harmful to health nor sinful.

Brioches are made from eggs, butter, milk, yeast, and flour. They were not always sweetened and were sometimes used as a kind of refined bread.

The presence of cherries may indicate that the bottle contains kirsch — a sweet liqueur made from cherries and much enjoyed at that time.

▲ Jean-Siméon Chardin, *The Brioche*, 1763. Paris, Louvre.

Manet's interest in Chardin's still lifes is very clear in this painting, which offers the same subject, again with the orange blossom.

Manet's brioche, like that of Chardin, seems to allude to the joys of married life.

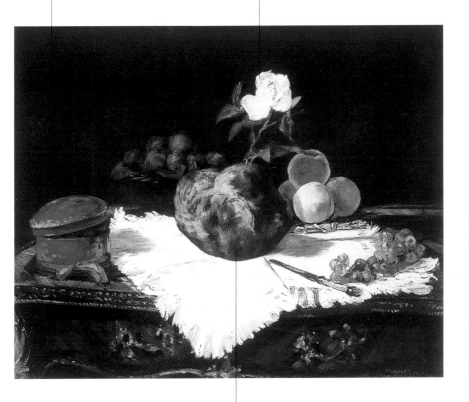

Manet's brioche may also be offered as a typical ancien régime pastry and thus used to celebrate sophisticated 19th-century French pastry making, which was now becoming increasingly refined in the hands of specialized professionals.

▲ Édouard Manet, *Brioche with a Flower and Fruit*, ca. 1870. New York, Metropolitan Museum.

The Egyptians used honey for therapeutic and even ritual purposes. It was placed in pharaohs' tombs beside the sarcophagus as food for the journey to the world beyond.

Honey

Sources
Virgil *Georgics* 1.4;
Rabanus Maurus, *PL* 111,
col. 594, and 112, col. 997

Meaning
Sweetness, divinity,
spiritual wisdom

Iconography
Very rare in painting.
Occasionally found among
the sweet foods in 17th-
century Flemish food
displays

▼ Guercino, *Samson and the Honeycomb*, 1657. San Francisco, M. H. de Young Memorial Museum.

Honey was probably discovered by chance when someone ages ago found a honeycomb that had been abandoned by its bees; this happens when the queen bee leaves to found a new hive. In myth, Jupiter was fed by bees, and Aristaeus, son of Apollo and the nymph Cyrene, was fed by Gaea on ambrosia and granted immortality. Dumas says that Pythagoras ate only bread and honey and lived to the age of ninety, declaring that his diet was of the best. The Romans used honey for making a wine called *mulsum*, for preserving certain foods, and for medical purposes. Virgil describes bees as thrifty, because they take great care in making honey and still more in preserving it. In the Old Testament, it is often referred to as a pure, natural food, a gift of Divine Providence. Hence the passage, "The young woman is with child and shall bear a son, and shall name him Immanuel. He shall eat curds and honey by the time he knows how to refuse the evil and choose the good" (Isaiah 7:14–15). In Judges 14, Samson poses the following riddle to the guests at a feast: "Out of the eater came something to eat. Out of the strong came something sweet." The answer is a dead lion, in whose carcass he had found a honeycomb. In medieval exegesis honey is an emblem of gentleness. From a mystic point of view, therefore, it represents the sweetness of God's precepts and the figure of Christ the Savior. Rabanus Maurus identifies honey as divinity itself, spiritual wisdom, and the teachings of Christ. As a negative symbol, it represents the search for the pleasures of the flesh.

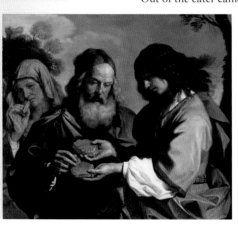

Lurking behind the sweet, ingenuous face of the little girl is her monstrous body, with a reptilian tail and reversed hands, which represent betrayal, one of the risks involved in love.

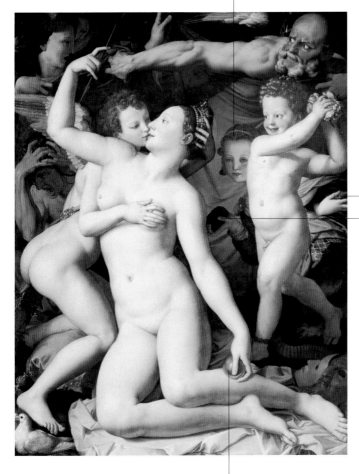

A poisonous scorpion's tail is juxtaposed symbolically with the honeycomb to represent the terrible dangers lurking behind love.

The honeycomb held in her right hand is a symbol of sweetness, the most seductive aspect of love.

The golden apple identifies the ivory figure at the center of the painting as Venus. It alludes to the story of the judgment of Paris, who chose her as the queen of beauty by awarding her the precious fruit.

▲ Agnolo Bronzino, *An Allegory with Venus and Cupid*, ca. 1545. London, National Gallery.

A follower of Bacchus is sitting atop a dried-up tree trunk. With the help of an assistant, he is making a sufficient racket that the bees swarm and leave the honey to be gathered.

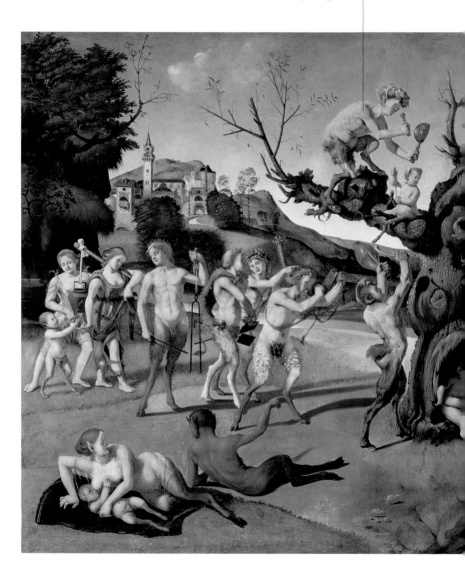

▲ Piero di Cosimo, *The Discovery of Honey by Bacchus*, ca. 1500. Worcester, MA, Art Museum.

The story of how Bacchus and his followers discovered honey is told by Ovid in his Fasti (3.725–60).

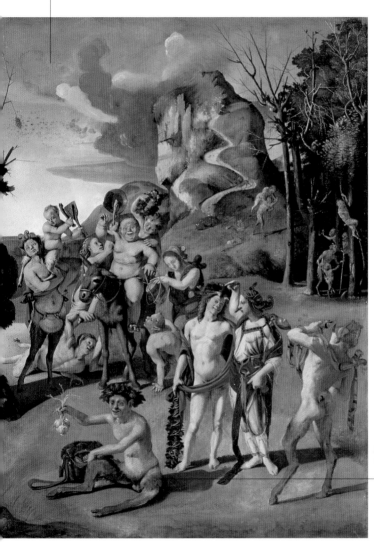

Pan is wearing a laurel wreath and displays a string of garlic. This underscores the rustic tone of the scene, the garlic being his way of keeping the Evil One at bay and ensuring the success of the enterprise.

Sugar was known to the Romans, and its use became established after the 11th century, when the crusaders gained possession of vast sugarcane plantations in the Middle East.

Sugar

Sources
Pliny *Naturalis historia*
12.32; Platina, *De honesta
voluptate et valetitudine*
(1474), book 2, chap. 37

Meaning
Sweetness, festivity, wealth
and refinement, physical
pleasure

Iconography
Rarely seen by itself, but
there are allusions to sugar
in precious, often exotic
sugar bowls in still lifes or
genre scenes from the 17th
to the 19th century

During the Middle Ages and Renaissance, sugar was an expensive commodity imported by the Venetians, who also knew how to refine it. It was mainly used for pharmaceutical purposes: sweetening in cookery was usually done with honey. When the New World was discovered, sugarcane was introduced into Central and South America. These areas became the principal sugar producers and were able to supply Europe as well as meet their own needs. During the Reformation, many honey-producing monasteries were closed, and the reduced availability of honey on the market allowed sugar to become established for the preparation of sweet dishes. In the Renaissance, aristocratic cookery adopted sugar instead of honey and invented sugared sweetmeats, a sign of distinction that concluded every important banquet. Sugar production increased in the late 17th century, thanks to intensive cultivation at plantations in the colonies, and it became less expensive. But at the same time there arose a fear of excess. A medical debate began about the merits of sugar; the reprehensible and sinful pursuit of pleasure was seen as generating a moral and religious problem of excess. Doctors in 18th-

century France came out against sugar, but the Encyclopaedists supported it as a natural food and the fruit of progress. Since it came from overseas, sugar had the attraction of the exotic, was enjoyed by women and children, and so became an emblem of femininity and the innocence of childhood.

▶ Willem Kalf, *Still Life with Nautilus Cup and Ming Sugar Bowl*, 1660. Madrid, Thyssen-Bornemisza Museum.

The use of salt as a condiment and a food preservative goes back to ancient times, as does the history of the salt trade. The Romans established the strategic routes for that trade.

Salt

Even in ancient times, there were two sources of salt: the sea, from which it could be obtained by evaporation, and the earth, from which rock salt could be extracted. The Romans valued it highly and kept it in saltcellars consecrated to the *lares*, or household gods. Soldiers were paid with a handful of salt, hence the term "salary." It had great value as a trade item and was subject to taxation from the Middle Ages onward. Italy was at the center of the salt trade, and to facilitate it the Romans constructed a network of roads called the Salt Roads. Hugh of Saint-Victor lists the many uses of salt, including seasoning food and preserving meat. To biblical scholars, salt represents intelligence illuminated by the spirit. Salt stands for wisdom but also for discretion, and even today it represents the angels and divine messengers in general, echoing the fact that, in the Sermon on the Mount, Christ calls his disciples the salt of the earth (Matt. 5:13). Because salt keeps food from decomposing, it is a symbol of protection against evil; that is why it is bad luck to spill salt on the tablecloth. According to Platina, it represents wisdom: "Cooking needs salt so that the food shall not be insipid. Thus when we describe men who are stupid and silly as insipid, we mean that they lack salt, which is to say wisdom." Picinelli declares that salt, when used in moderation, is a necessary condiment, and similarly, the witticisms and jokes that are the salt of eloquence should season speech, but not to excess. For the same reason, salt represents moderation.

Sources
Rabanus Maurus, *PL* 112, cols. 1044–45; Hugh of Saint-Victor, *PL* 177, col. 159; Platina, *De honesta voluptate et valetitudine* (1474), book 1, chap. 13; Filippo Picinelli, *Mundus Symbolicus* (1687), book 12, chap. 29

Meaning
Wisdom, protection, wealth

Iconography
Frequently seen in 15th- and 16th-century banqueting scenes and in scenes of meals with Christ, especially when they are Italian. Also found in Italian and Flemish still lifes in the 17th and 18th centuries

◄ Romanino, *The Last Supper* (detail), 1557–58. Montichiari, parish church.

Salt

The knife brandished by one of the apostles refers to the future martyrdom of Christ and at the same time reminds us of the betrayal by Judas, to whom Christ turns with a meaningful glance.

Christ sits at the center of the rectangular table, thus occupying the place of honor at the Last Supper.

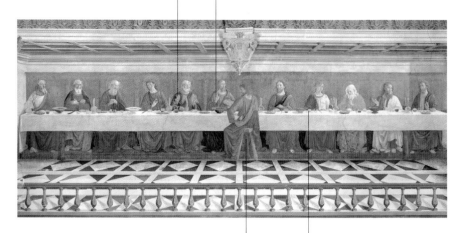

As is often the case in the iconography of the Last Supper, Judas sits on the other side of the table, isolated from the rest of Christ's disciples.

The presence of a silver saltcellar beside each apostle is a reference to Christ's description of the apostles as "the salt of the earth" in the Sermon on the Mount.

▲ Domenico Ghirlandaio, *The Last Supper*, ca. 1476. Passignano, abbey.

*The silver saltcellar repre-
sents the clarity and precious
nature of Christ's preaching.*

*By blessing the bread,
Christ reveals his identity to
the travelers to Emmaus.*

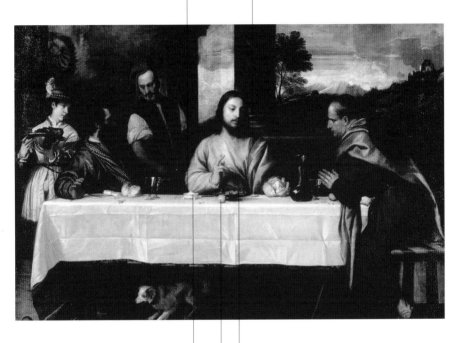

*The salt symbolizes the
Redeemer's wisdom.*

*The roasted fish is a reference
to Christ himself.*

*The apple recalls
Original Sin.*

▲ Titian, *The Supper at Emmaus*,
ca. 1535. Paris, Louvre.

The oysters refer to physical union.

The salt refers to the virtue of wisdom.

On the ceremonial chalice stands the figure of Athena, a symbol of chastity and wisdom. This seems to confirm that the display of food is linked to a marriage ceremony.

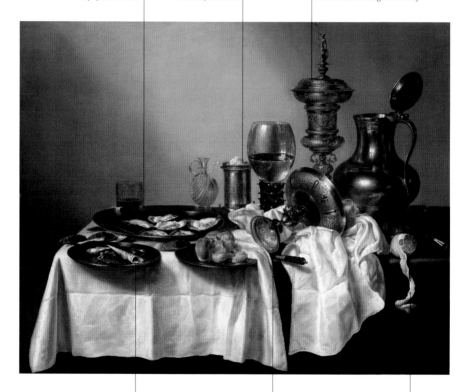

Pepper is a symbol of generosity, because it characteristically gives off its aroma when crushed in a mortar.

The silver fruit stand seems to suggest that the display of food is intended to celebrate a marriage and its values.

The lemon with its peel cut in a spiral reminds us that humankind must take care of the spirit and free it from the "peel" of material being.

▲ Willem Claesz. Heda, *Still Life with a Gilt Cup*, 1635. Amsterdam, Rijksmuseum.

This scene is taken from a story by Sacchetti in which the chief character is a parish priest called Arlotto, who is well known for his practical jokes.

The napkin tied around the neck signifies a lower-class character. Since the previous century, etiquette had deemed the practice uncouth.

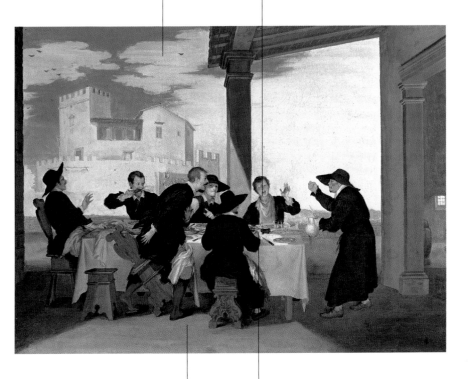

The diners have been discussing who should go down to the cellar to fetch the wine. In the end, it is Arlotto who goes, but when he comes back with a jug full of wine, he finds that his fellow diners have eaten the whole chicken.

The salt on the table provides a culinary comment on the joyful atmosphere at the feast and the witty content of the tale.

▲ Baldassarre Franceschini, *The Practical Joke about the Wine*, ca. 1640. Florence, Galleria Palatina.

The peoples of the Mediterranean basin made use of the flavors of wild plants, including those imported along spice and perfume routes that extended far to the east.

Pepper and Chilis

Sources
Pietro Andrea Mattioli,
*I discorsi nei sei libri di
Pedacio Dioscoride . . .*
(1550); Filippo Picinelli,
Mundus Symbolicus
(1687), book 9, chap. 23

Meaning
Persecuted Virtue,
Resentment

Iconography
An extremely rare subject,
pepper does appear in
17th- and 18th-century still
lifes, usually associated
with oysters. Chilis can
be seen primarily in the
17th century as a recently
introduced food from the
New World

Pepper was the best-known spice in the classical world. It was common in Greece as early as the 5th century B.C. and was even used in medicine. Spices were used by the Egyptians for embalming and by the Jews for their holy ointments. Apart from their ritual or magical uses, spices had a place in cooking, because they prevented food from fermenting and covered the odors of decomposition. During the Middle Ages, pepper and other spices were among the most lucrative goods in maritime trade, one in which Genoa and Venice took precedence. At the close of the Middle Ages, however, the Spanish and Portuguese discovered the East Asian sources of spices; in fierce competition with the Dutch and English, they edged out the Italians. During the Renaissance, spices were used a great deal. Among them, pepper reigned supreme, being used for both preserving food and its pungent flavor. In the 16th century hitherto unknown spices arrived from the New World, among them chili peppers from the Andes. In his herbal, Pietro Andrea Mattioli, a doctor, listed chilis as a variety of pepper, calling it "horned pepper of India." He described how a small green cornet turns first yellow and then coral red, and when placed in the mouth "bites" the tongue and palate. In the 17th century, the rediscovery of vegetables and kitchen-garden herbs pushed spices into a secondary role. But pepper remained very popular and decreased in price, so that even those of modest means could use it. According to Filippo Picinelli, pepper is a symbol of resentment, because when it is being reduced to a powder, its exhalations irritate the person using it. It symbolizes persecuted virtue, because it is pounded in a mortar.

▼ Willem Claesz. Heda,
Still Life with Oysters,
1637. Antwerp, Mayer van
der Bergh Museum.

The fish ready to be cooked and the herbs being pounded in Martha's mortar represent Christ and his Passion.

The Gospel scene is placed in the background, while the foreground is dominated by a kitchen scene. This is a typical device in Flemish painting.

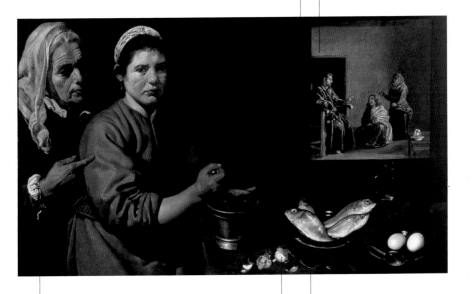

The old woman in the foreground points to Martha. Unlike her sister, who is listening attentively to the words of Christ, Martha is busy preparing a main course of fish.

Because the smell of garlic is an irritant, garlic itself is a symbol of sin.

The chili pepper is shown here as a new arrival in Spain from the recently discovered New World. Because it is so hot, it symbolizes aggressiveness.

▲ Diego Velázquez, *Christ in the House of Martha and Mary*, 1618. London, National Gallery.

The Homeric heroes drew strength from olive oil, which guaranteed eternal youth. Democritus attributed his long life to the honey he had for internal use and oil for external use.

Olive Oil and Olives

Sources
Homer *Odyssey* 10.364;
Iliad 24.584; Livy *Ab urbe
condita* 20.55.1; Rabanus
Maurus, *PL* 111, col. 523,
and 112, col. 1011

Meaning
The grace of the Holy
Spirit, conscience, charity,
and mercy

Iconography
Olives appear in the art
of antiquity, and in 16th-
century fantasies, in 17th-
to 19th-century still lifes,
and in Flemish and Italian
genre scenes of the 17th
and 18th centuries

The olive is the national tree of Greece, because when Athena and Poseidon quarreled over the possession of Attica, Athena won by making olive trees grow there. Oil from olives is sacred to that goddess, and it became a basic ingredient in practices relating to her cult as well as in the kitchen. It also figured in the Etruscan and Roman diets. Livy tells us that when Hannibal discovered that oil could be used to provide heat, he made his soldiers oil their bodies to warm and reinvigorate themselves; they went on to victory. In the Old Testament, oil is one of the gifts of the Promised Land, and it is a basic element in the Jewish liturgy and diet. In Genesis, after the Flood, a dove brings an olive branch back to the ark as a sign that divine wrath has ceased. Because it is rich in oil, the olive tree represents Divine Providence. When mixed with costly perfumes, it took on a sacred significance both in anointing the priest-king of Israel and in furnishing the sanctuary, to which it lent holiness, wisdom, and glory in the name of the Lord. Olive oil is also present in the sacraments of early Christianity as a symbol of the grace of God. In biblical exegesis, it represents the grace

of the Holy Spirit, and sometimes also conscience, charity, and mercy. On the negative side, it can symbolize flattery and heretical speech. Symbolically linked to the oil are the olives from which it derives. In exegetical writings, they represent Christ, mercy, the Holy Spirit, and the works of the just—but also those of hypocrites. For Picinelli, olives are emblems of useful toil, since they provide oil when crushed.

278

The soup tureen of European porcelain is a prestigious vessel and indicative of a luxury meal.

The cruet stand with oil and vinegar paired as condiments reflects a usage that was gradually becoming established.

The silver dish warmer is a refined utensil made of a precious metal. It raises the tone of the whole display.

One can see a certain contrast in this painting between the rustic kitchen utensils and the refined tableware. This is evidence of Chardin's interest in cookery and his desire to raise it to the level of art.

Given its specific use, the rustic, earthenware tripe casserole serves to celebrate a characteristic dish in the French gastronomic tradition.

◄ Osias Beert the Elder, *Still Life with Strawberries, Cherries, and Olives*, 1608. Berlin, Gemäldegalerie.

▲ Jean-Siméon Chardin, *The Butler's Table*, 1766. Carcassonne, Musée des Beaux-Arts.

Olives have been preserved in brine since antiquity. Their presence here suggests a happy balance of flavors.

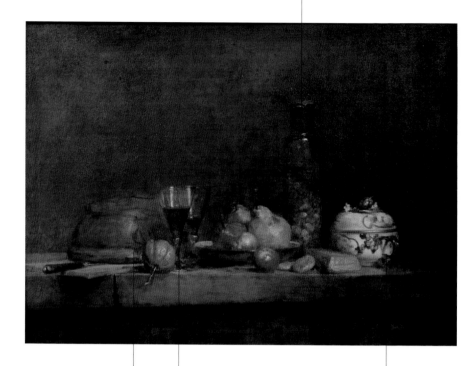

The rustic paté terrine evokes thoughts of one of the outstanding dishes in French cooking, a true national glory.

The two glasses suggest that red wine will be an ideal accompaniment for the main course.

The butter dish made of European porcelain indicates that this is a refined meal. It was in the 18th century, in fact, that European manufacturers discovered the secret of Chinese porcelain and succeeded in creating a similarly thin, white, high-quality product.

▲ Jean-Siméon Chardin, *The Jar of Olives*, 1760. Paris, Louvre.

Vinegar first became known from the spoiling of old wine, but it was soon discovered to be an excellent condiment and a useful preservative.

Vinegar

Pliny tells the story of a banquet held by Cleopatra, at which she dissolved a pearl from her earring in a goblet of vinegar in order to win a wager. Although vinegar resulted from the deterioration of wine, the Romans used it a good deal, for example in making *posca*, a drink made of water and vinegar that, as all the Gospels agree (Matt. 27:48; Mark 15:36; Luke 23:36; John 19:29–30), was given to Jesus Christ on the Cross. During the Middle Ages, vinegar, wine, and lemon or orange juice were basic ingredients for sauces whose purpose was not only to enrich dishes but also, along with spices, to smother the smell and taste of spoiled meat. The medical school at Salerno thought vinegar a valuable substance, with the result that in the mid-14th century it was used in large quantities to protect against the plague. At the close of the Middle Ages, because of improvements in wine technology, vinegar began to become scarce, and it had to be produced deliberately. Guilds of manufacturers of medicinal vinegar came into being, its members sworn to secrecy regarding the ancient, mysterious procedures used to acidify wine. In the 15th century, Ficino identified vinegar's most significant peculiarity: that of restoring a jaded palate and curing nausea. From the Renaissance onward, it seems that vinegar has never abandoned the kitchens and dining rooms of the West. It was seen as a valuable ingredient in recipes and an important condiment both on its own and as a base for sauces. In biblical exegesis, vinegar represents the corrupt mind, because it is the product of the corruption of wine, as well as deceit and fraud—something the devil spread among the Jews. It also represents impiety.

Sources
Pliny *Naturalis historia*
9.119; Rabanus Maurus,
PL 111, col. 596,
and 112, col. 853;
Marsilio Ficino, *Three
Books on Life*, 1.17
(1489; 1989, trans.
C. Fiske and J. Clark)

Meaning
Deceit, a corrupt mind

Iconography
Cleopatra's banquet
and still lifes

▼ Giambattista Tiepolo,
*The Banquet of Anthony
and Cleopatra* (detail),
1747–50. Venice,
Palazzo Labia.

Vinegar

The fish hung up to dry are almost a topos in Chardin's still lifes. He painted a number of variations on this theme.

This painting is dated and signed. It is possibly Chardin's last still life and bears witness to his keen, lifelong interest in cookery as an artistic subject.

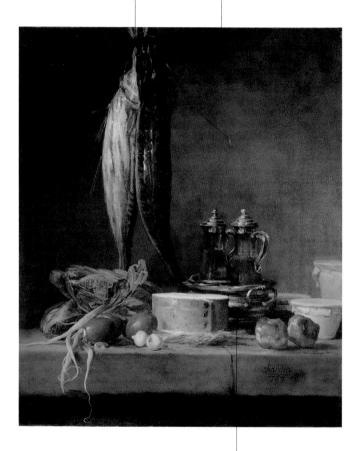

The silver cruet stand reminds us of the enduring validity of pairing oil and vinegar as condiments. It also illustrates the substantial increase in the 18th century of both precious and ordinary implements to cope with changes in the art of gastronomy and the evolution of the dining table.

▲ Jean-Siméon Chardin, *Still Life with Dried Fish*, 1769. Los Angeles, The J. Paul Getty Museum.

Along with fire, air, and earth, water is one of the four elements and hence one of the component parts of the universe. It is also a nutrient vital to the human body.

Water

Symbolically, water reminds us of the original blessed state of humanity and all living creatures. In Roman times, citizens who suffered the punishment of civil death could no longer receive water or fire. In the scriptures, water is a symbol of cleanliness and purification from sin, but it could also be a dreadful natural calamity, as in the case of the Flood. Moses caused water to spring from the rock to quench his people's thirst. In exegetical writings, it represents not only the Holy Spirit but also Christ, his teaching, and the sacrament of baptism. It also represents the wise minds of just men and the souls of the blessed, and its flow represents loquaciousness. It also had negative symbolic significance, representing the pleasures of the flesh and of temptation and sin. Cloudy water represents the arcane words of the prophets, and rough water the adversities of life. For Picinelli, water represents human life and its tumultuous course, but it is above all a symbol of Christ because he too washes, waters, and creates fruitfulness.

Clear water represents the immaculate or religious soul, and cloudy water is an emblem of a sinful soul. As a liquid vital for human life, it represents gain, because just as the teacher benefits those who wish to learn, so water benefits the thirsty, and charity aids those who lack the means of survival.

Sources
Rabanus Maurus, *PL* 112, cols. 860–61; Filippo Picinelli, *Mundus Symbolicus* (1687), book 2, chap. 20

Meaning
Simplicity, cleanliness of soul, Christian teaching, maternity

Iconography
Water is associated with Moses since he caused water to spring from a rock, and it also appears in paintings of Rebekah at the Well and the Marriage at Cana. It appears in the iconography of temperance, because the temperate person abstains from alcohol, for which water is the antidote. It frequently appears in both Flemish and Italian still lifes in the 17th and 18th centuries

◄ Agnolo Bronzino, *Temperance*, detail of the frescoes in the chapel of Eleanor of Toledo, ca. 1543–46. Florence, Palazzo Vecchio.

The frescoes on this wall of the chapel of Eleanor of Toledo depict two episodes from the Bible: the Gathering of the Manna and Moses Making Water Spring from a Rock.

The cup is a coupe de mariage *in imitation of antiquity. Here it may refer to Cosimo's marriage to Eleanor of Toledo, for whom he commissioned the work.*

The Bible tells us that the Jews in the desert were suffering from thirst and that at God's command Moses struck a rock with his rod, causing water to spring from it.

▲ Agnolo Bronzino, *Moses Making Water Spring from a Rock*, detail of a fresco in the chapel of Eleanor of Toledo, ca. 1543–46. Florence, Palazzo Vecchio.

From the Middle Ages onward, water in towns was often polluted. Hence the existence of water-sellers, whose job was to draw clean water from fountains and bring it to houses.

This painting may be referring to the Gospels of Mark (14:12–26) and Luke (22:7–23), where a man carrying a jar of water shows the apostles where the Last Supper is to be held.

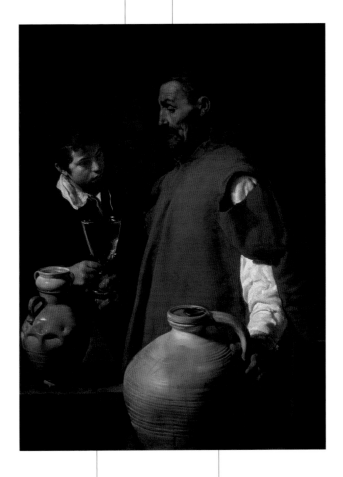

The boy's full glass is an allegory of the pure and religious soul.

The water in his jar represents Christ and his teachings, which is compared to water for the thirsty in exegetical sources.

▲ Diego Velázquez, *The Waterseller of Seville*, ca. 1620. London, Wellington Museum.

The Egyptians made beer from malted barley, water, yeast, and hops, and it was a staple of their diet. It was also known to the Babylonians, Hittites, Syrians, and Armenians.

Beer

Sources
Aeschylus *The Suppliants* 953; Herodotus *The Histories* 2.80; Pliny *Naturalis historia* 22.164

Meaning
National celebration

Iconography
Frequent as a national drink in 17th- and 18th-century Dutch genre scenes and still lifes, but also found in Impressionist paintings

▼ Pieter Claesz., *Still Life with a Glass of Beer*, 1636. Madrid, Thyssen-Bornemisza Museum.

In the ancient world, beer was valued for its thirst-quenching, diuretic, and soporific qualities. It was for this last quality that it was drunk at funerals in ancient Egypt: in memory of the dead person's virtues and to ensure that he would enjoy peaceful rest. The Egyptians attributed the discovery of this barley wine to Osiris. The Greeks drank it at the festivals of Demeter and during the Olympic Games, but they thought "barley wine" rather unmanly. In Rome, beer was called *cervisia* in honor of the goddess Ceres. Though it was not a popular drink in Rome, Agricola, governor of Britannia, brought three master brewers there in A.D. 83 to open a beerhouse. Beer was drunk by the Germanic and Celtic peoples, and when the Roman Empire fell, beer became a symbol of barbarian culture, along with meat and milk. In the Middle Ages, beer enjoyed a golden age: brewers in northern countries set up trade guilds, while in northern Italy beer was mostly produced by monks. In the 16th century, brewers succeeded in controlling the fermentation of barley and were able to improve their product in both quality and quantity. It became the drink of the Reformation, enjoyed for its own sake and as a product of human labor. It became a

trade commodity and a source of prosperity in countries that were now Protestant. Beer played an important economic role in the Thirty Years' War, because profits from the trade in beer, which was brewed by the Catholic nobility, were used to recruit mercenaries. In the 17th century, beer became the national drink in Germany, Britain, Denmark, and Holland, which are today's major producers in Europe.

Saint Brigid of Ireland chose the religious life when she was very young. She founded a convent at Kildare.

Among the stories told in her biography is that of the miraculous transformation of water into beer. The miracle is analogous to the one performed by Christ at the Marriage at Cana, but in this case the drink—beer instead of wine—was more appropriate to the saint's country: Ireland was one of the principal beer producers.

▲ Lorenzo Lotto, *Saint Brigid Blessing Water, which Turns into Beer*, 1524. Trescore Balneario, Oratorio Suardi.

The juxtaposition of bread, herring, and beer may be the artist's way of identifying his nationality. These were basic foods in the Dutch national diet.

Beer is a traditional drink in many northern countries. In the 16th century, beer producers began to succeed in controlling the fermentation of the barley, thereby obtaining larger quantities of a better-quality product. From this time onward, beer became a typical drink in Reformation countries and a source of prosperity for its merchants.

Herring was one of the most significant items on the Flemish fish market, partly because it could be preserved by salting and smoking.

▲ Pieter Claesz., *Still Life with Herring*, 1636. Rotterdam, Boymans–van Beuningen Museum.

Beer can be identified in the glass of the seated man. He is also smoking a typical Low Countries pipe, an item seen in numerous other paintings.

The pewter jug is for wine and shows that wine is the woman's preferred drink.

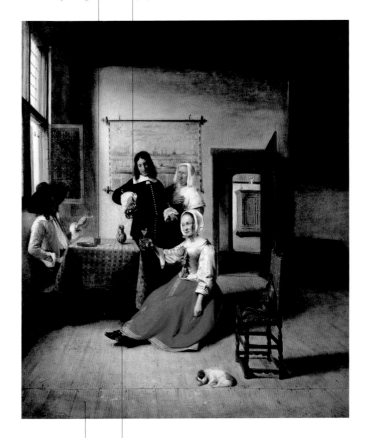

The fact that the woman and man are taking different drinks seems to suggest that beer is principally for men.

The stoneware jug is a traditional beer container.

▲ Pieter de Hooch, *A Woman Drinking*, 1658. Paris, Louvre.

It was in Paris that Van Gogh spent the most gregarious period of his life. He met other artists and frequented cafés, some of which became subjects for his paintings.

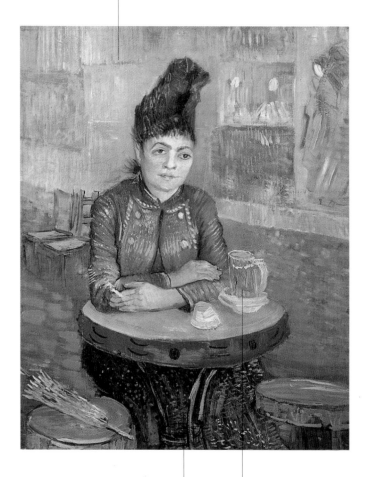

One café that Van Gogh frequented was the Café le Tambourin at Montmartre. It was owned by Agostina Segatori, an Italian woman who had formerly modeled for Degas. Van Gogh had a brief affair with her, during which he painted her portrait.

The beer in this painting is a significant detail. Being primarily a man's drink, it says something about the personality of Agostina, who ran a café and was an artist's model. She was thus an emancipated woman, her behavior flouting the canons of the bourgeoisie and common moral standards.

▲ Vincent van Gogh, *Agostina Segatori at the Café le Tambourin*, 1887. Amsterdam, Rijksmuseum.

In his play The Knights, *Aristophanes wrote: "When men drink, they become rich, their affairs prosper, they win their lawsuits, they are happy and help their friends. . . ."*

Wine

Wine is mentioned throughout the Bible, first in Genesis, when Noah becomes drunk after discovering its taste and effects. The Greeks dedicated the rites and customs of the grape harvest, drunkenness, and pleasure to Dionysus, because it was he who taught mortals how to cultivate the vine. From Homeric times onward, wine was drunk at symposia following the last course and played an important role because Dionysian drunkenness was deemed magical. Plato and his school in particular considered the altered state of consciousness a way of going beyond the self toward closer contact with the divine, and so opening the mind to superior understanding. The Greek cult of Dionysus spread to Rome and operated in very similar ways. In the Old Testament, wine is ambivalent in its significance, for it is both an expression of hospitality and an instrument of the wrath of God. In the Gospels it seals the first and final acts of the Incarnation of Christ: the Marriage at Cana and the Last Supper. When Christianity became established, therefore, its liturgical use was extended and it became sanctified in the Eucharist. In medieval exegesis, wine represents the blood of Christ, the mysteries of his divinity, and the rightness of his teaching. For the pious man, it symbolizes an understanding of the law, spiritual intelligence, and the contemplative life, as opposed to milk, which symbolizes the active life. Pure wine *merum* (Latin), represents sincerity and truth. On the negative side, it symbolizes the pleasures of sin and lust and the love of earthly pleasures.

Sources
Aristophanes *The Knights* 89–97; Plato *Phaedrus* 48; Rabanus Maurus, *PL* 111, col. 595, and 112, cols. 1078–79; Filippo Picinelli, *Mundus Symbolicus* (1687), book 9, chap. 35

Meaning
Union with the divine, the Passion of Christ, spiritual understanding, the love of earthly pleasures

Iconography
Symbolically, wine is linked to scenes of meals with Christ, such as the Last Supper, the Marriage at Cana, and the Supper at Emmaus, or to Old Testament scenes such as the Drunkenness of Noah. It forms an integral part of Bacchic iconography. It also appears in genre scenes and still lifes from the 17th to the 19th century

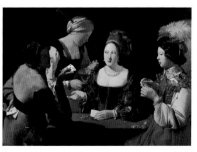

◄ Georges de La Tour, *The Cheat with the Ace of Diamonds*, 1620–40. Paris, Louvre.

Wine

The Drunkenness of Noah and the Sacrifice of Noah are shown in one of the fresco scenes painted by Paolo Uccello in the Green Cloister at Santa Maria Novella.

The vine growing over a pergola represents the origin of wine, which is an instrument of the wrath of God in the story of Noah.

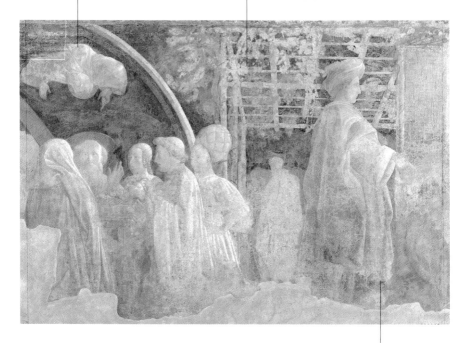

After the Flood, Noah planted a vine and became a tiller of the soil. One day he became drunk and lay naked in his tent, where he was seen by his son Ham, who reported the matter to his brothers Shem and Japheth. In order not to see their father's nakedness, they walked in backward and covered him with a garment. When Noah awoke, he blessed his two respectful sons and cursed the one who had seen him naked.

▲ Paolo Uccello, *The Sacrifice and Drunkenness of Noah*, from *Scenes from the Life of Noah*, ca. 1430. Florence, Santa Maria Novella, Green Cloister.

The roast lamb is served in a communal plate at the Last Supper. As a sacrificial victim, the lamb is a symbol of Christ.

Similarly, the bread is the body of Christ at this, the first celebration of the Eucharist.

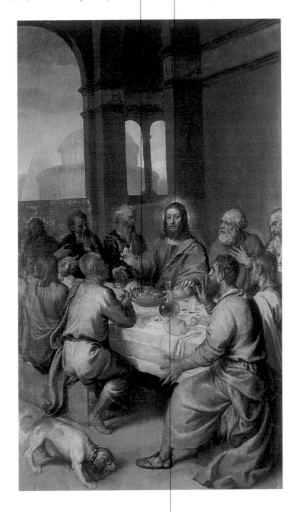

▲ Titian, *The Last Supper*, 1542–44. Urbino, Palazzo Ducale.

The wine in evidence at the center of the Last Supper table is a clear pictorial rendering of the Gospel story, in which Christ himself called the wine his blood and offered some to all his disciples.

Wine

The wine krater suggests that Titian was well informed about the ancient habit of drinking wine mixed with water in varying proportions rather than at full strength.

Wine was sacred to Bacchus and was never missing from festivities in his honor.

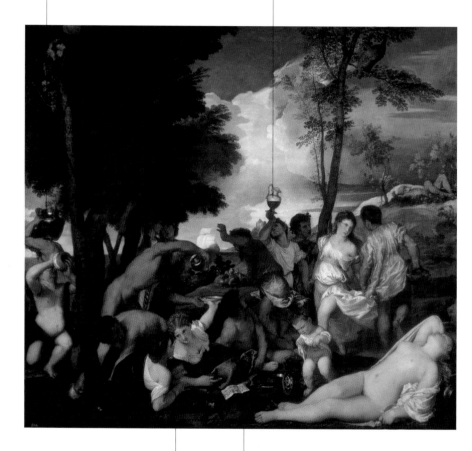

Bacchanal *is the Latin name for the Dionysiac orgies: festivities in honor of Dionysus that often went beyond their ritual purpose of honoring the god. The Roman Bacchanals, held in honor of Bacchus, also often cloaked disorderly behavior under the mantle of religion.*

This painting was executed for the Este court and is also known as The Andrians *or* The Arrival of Bacchus on Andros. *According to the* Eikones *of Philostratus, Andros was Bacchus's favorite island.*

▲ Titian, *Bacchanal*, 1518–19.
Madrid, Prado.

The crown of vine leaves identifies the youth as Bacchus, the god of wine and lord of souls.

Wine was sacred to Bacchus and played an important part not only at festivities in his honor but also at banquets in general. Thanks to the fact that it could inebriate and alter one's state of consciousness, it was seen as a way of bringing man closer to the divine.

The glass chalice that Bacchus seems to be offering to the spectator is Venetian in its design. Such glasses were first made by master glassmakers in Venice in the 16th century and later exported to the other European states.

The basket of fruit has a leading role in another painting, in the Pinacoteca Ambrosiana (see p. 53). Some of the fruit show signs of rotting, not only revealing the artist's naturalistic acumen but also making a clear reference to the ephemeral nature of material things.

The dirty fingernails are scarcely fitting for a young god, but they reveal Caravaggio's interest in the naturalistic.

▲ Michelangelo Merisi da Caravaggio, *Young Bacchus*, 1596–97. Florence, Uffizi.

Thanks to the invention of cork stoppers, the wine made by the monk named Dom Perignon became the most aristocratic of drinks, bolstering the image of France throughout the world.

Champagne

Meaning
Luxury, national pride

Iconography
Associated with the Impressionist iconography of urban high life

▼ Édouard Manet, *A Bar at the Folies Bergère* (detail), 1881–82. London, Gallery of the Courtauld Institute of Art.

Wine had a leading role in Western culture during the Renaissance, and as early as the 17th century the art of preserving it in barrels became established, followed by that of bottling it and sealing the bottles with corks. A Benedictine monk, Dom Perignon (b. 1638), developed the technique of producing champagne, and within fifty years of its invention it was much as it is today. At Hautvilliers Abbey in northern France, Dom Perignon had noticed that in some years wines made from the pinot grape underwent a second fermentation and, when separated from the marc, produced a pleasant effervescence accompanied by a fine bouquet. He made a careful study of the *perlage* in the bottles and learned how to control it by adding sugar; but most importantly, he realized that fermentation depended on the container being hermetically sealed. To this end he replaced traditional wooden pegs with corks that swelled when they were inserted into the bottle. His wines were so successful that they were adopted at Versailles to please the most refined aristocratic palates. That is how champagne became the expensive luxury product that it is today and an emblem of the high life. Champagne did not diminish in popularity even during the French Revolution, and the *Phylloxera* parasite, which severely damaged French vineyards in the mid-19th century, did not permanently harm champagne production.

This is one of Manet's last celebrations of contemporary life. The setting is a café, a typical meeting place for Parisian society in the late 19th century.

Mirrors often appear in Manet's paintings. This one reflects the bustle of customers in the café and conveys the impression of a crowded room, full of atmosphere.

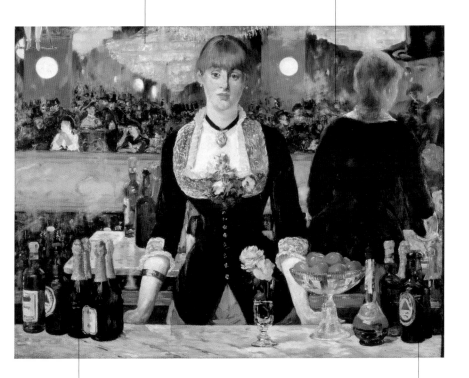

The champagne is instantly recognizable because it is so similar today. As a luxury French product, it celebrates French identity and shows that the café is frequented by customers of high social rank.

The presence of a bottle of English ale reflects Manet's anxiety to convey his anti-German feeling. Germany was at that time the biggest beer producer, and enmity between France and Germany was running high after the Franco-Prussian War, in which France had been defeated and humiliated. The Germans had now occupied Alsace, the prime source of beer in France, so Manet visually "boycotts" the German conquerors with this English brew.

▲ Édouard Manet, *A Bar at the Folies Bergère*, 1881–82. London, Gallery of the Courtauld Institute of Art.

Artemisia absinthium, also called wormwood, is a strongly aromatic herb with a bitter taste. It was used to produce absinthe, a fashionable liqueur in late-19th-century Paris.

Absinthe

Sources
Apicius *De re coquinaria*
1.2; 3.15; Platina, *De honesta voluptate et valetitudine* (1474), book 3, chap. 93; Alexandre Dumas, *Grand dictionnaire de cuisine* (1873)

Meaning
A social scourge

Iconography
A popular subject among the Impressionists

Absinthe was used in Roman times, along with citron, rose, and violet, to add flavor to wine, and Apicius says that it was also used as a flavoring for sauces. In the Renaissance, Platina recommended its use to reduce fevers, especially malarial fever. But *Artemisia* essence contains a toxic substance called thujone, which stimulates the central nervous system and can provoke dizziness, hallucinations, and behavioral disturbances, and even induce epileptic fits. Absinthe as a liqueur distilled from *Artemisia* was first made in the late 18th century and became popular in France after 1850, when it was responsible for a form of collective intoxication in avant-garde art circles. Verlaine wrote that it was "the green fairy, the worst witch of all." It drew Verlaine, Van Gogh, Manet, and Rimbaud under its spell. Baudelaire drank it, and the painter Toulouse-Lautrec hid it in a secret flask in his walking stick. Some mixed it with

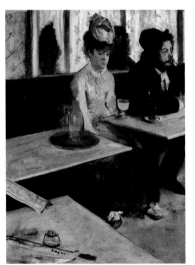

▶ Edgar Degas, *The Absinthe Drinkers*, 1876. Paris, Musée d'Orsay.

laudanum and copper sulfate, with devastating results. Dumas wrote: "Among our *bohémiens*, absinthe was called the green muse. A great many of them were not stupid, and yet they sadly died in her poisonous clutches." The phenomenon became so serious that in 1915 the French government prohibited the production and consumption of absinthe. This ban has recently been revoked.

The distillation of alcohol from wine, grain, and fruit has a long history, but it developed enormously in tandem with alchemy at Alexandria around the 3rd and 2nd centuries B.C.

Spirits

An essential instrument for distillation is the alembic, which was developed at Alexandria in Egypt. By the early Middle Ages, the distillation of spirits from wine and cereals was already widespread. The early alchemists distilled from many types of fruit, flowers, and leaves of a more or less aromatic kind in order to prepare their elixir. Later on, wine was distilled. This Italian discovery led to the production of what was called *aqua ardens*, *aqua vitae*, or *aquavit* and was considered a universal panacea. We do not know exactly how or when spirits or liqueurs became a popular drink rather than a medicine, but it is certain that in the 14th century "brandy" was traded and exported from Italy to other European countries. In the 15th century, spirits were sweetened with sugar or honey and flavored with oil of roses. The term brandy originally referred only to wine distillates, but later on its meaning was extended to include spirits made from all sorts of fruit, such as cherries, plums, pears, and apples. In the 16th century, distillation was widespread throughout Europe. In the 17th century, alcoholic drinks were widely used by soldiers and the poor, who found it a cheap way of escaping the troubles of everyday life. Symbolically, spirits represent vice, for although they look as clear as water, once drunk they are like fire. In a positive sense, spirits represent Holy Scripture, because there is great strength and flavor in just a few drops.

Sources
Filippo Picinelli,
Mundus Symbolicus
(1687), book 2, chap. 21

Meaning
Medicine, vice,
earthly pleasures

Iconography
Rarely depicted. Spirits
mostly appear in 18th- and
19th-century genre scenes,
and occasionally in still
lifes of the same period

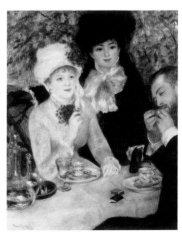

◄ Pierre-Auguste Renoir,
The End of Lunch, 1879.
Frankfurt, Städelsches
Kunstinstitut.

The presence of the eld-
erly bawd seems to sug-
gest that the scene is set in
a tavern, the most popular
public meeting place.

The candle serves partly to light up the small glass held
by the merry drinker, throwing it into extreme relief and
making it a central element in the painting. It must con-
tain brandy or gin, a distillate of grain flavored with
juniper that was very popular in 17th-century Holland.

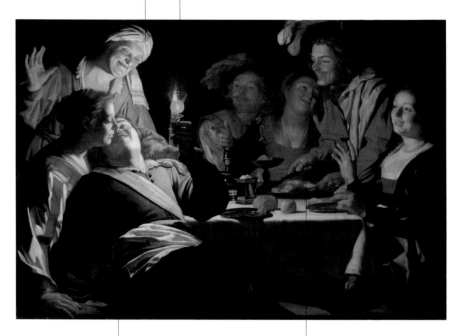

The lascivious attitude of this
couple seems to confirm that the
scene is set in a tavern, a place
where prostitutes had plied their
trade since ancient times.

The dish of succulent
roast chicken alludes to
the pleasures of the flesh.

▲ Gerrit van Honthorst, *The Merry
Company*, 1622. Munich, Alte
Pinakothek.

The custom of preserving fruit in spirits became very common in the 18th century. This was a time when many new kinds of spirits were developed and sweet liqueurs such as rosolio and ratafia became popular.

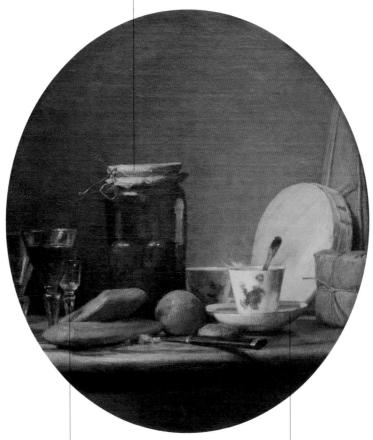

At this time drinking glasses took on new shapes and dimensions to suit the new drinks. Small goblets were intended for refined sweet liqueurs.

Coffee was usually drunk at the end of a meal, so its presence here indicates that fruit preserved in spirits was eaten at the same time.

▲ Jean-Siméon Chardin, *The Jar of Apricots*, 1756. Toronto, Art Gallery of Ontario.

Spirits

The obvious centerpiece of the painting is the jar of peaches. The setting is simpler than that of the 18th-century work that inspired it.

The fact that Monet returns to Chardin's subject is an indication of the fascination his still lifes held for the Impressionists.

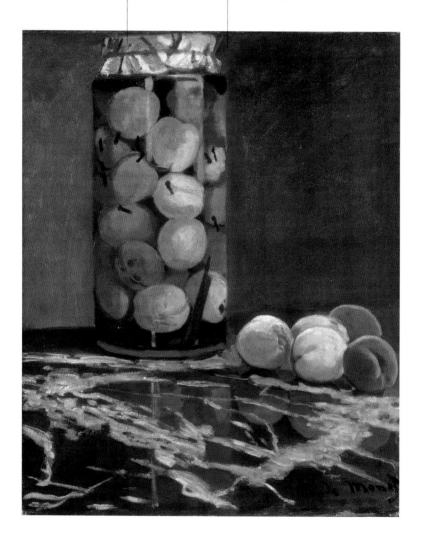

▲ Claude Monet, *Jar of Peaches*, 1866.
Dresden, Gemäldegalerie.

Cocoa was introduced to Europe after 1502, when Christopher Columbus's men captured a canoe containing dark seeds that the natives of Central America used as currency.

Chocolate

Cortés, welcomed by Montezuma in Mexico as a god, was shown a plantation of cocoa trees, which provided the Aztecs with food and currency. The powdered cocoa seeds were used to prepare *chocohlt*, a ritual food that bestowed strength and wealth. Cocoa was first brought to Spain in the 16th century, but it was imported in much larger quantities in the following century. It was then that Francesco Carletti taught Europeans how to make drinking chocolate, which became so popular that it nearly supplanted coffee. In the 17th century, drinking chocolate spread primarily in Spain: Brillat-Savarin says that it crossed the Pyrenees with Anne of Austria, daughter of Philip II, who married Louis XIII. From France it passed to Italy and England, and then to Holland, Germany, and Switzerland. The golden age of drinking chocolate was the 18th century, when it vied with coffee and tea as the favorite drink of the aristocracy.

There were treatises devoted to drinking chocolate, such as Vincenzo Corrado's *La manovra della cioccolata e del caffè*, which suggested novel applications. At first, drinking chocolate was made with water, but it was rendered tastier with milk or even cream, and sugar or vanilla, following a recipe invented by missionary nuns. It was a suitable drink for Lent and other periods of fasting and became widely known thanks to the Jesuits.

Sources
Francesco Carletti, *My Voyage around the World* (ca. 1600; 1964, trans. H. Weinstock); Vincenzo Corrado, *La manovra della cioccolata e del caffè* (1778); Jean Anthelme Brillat-Savarin, *The Physiology of Taste* (1825; 1999, trans. M. F. K. Fisher); Alexandre Dumas, *Grand dictionnaire de cuisine* (1873)

Meaning
Pleasure, refinement, exoticism

Iconography
Drinking chocolate appears mostly in genre scenes, especially in France, and in 17th- and 18th-century Spanish still lifes

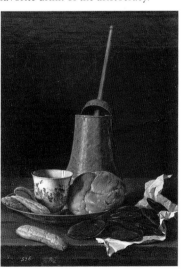

◄ Luis Meléndez, *Still Life with a Drinking Chocolate Set*, 1770. Madrid, Prado.

Chocolate

Drinking chocolate was particularly favored by women because it was sweet. Because it is here placed beside a rose, a symbol of femininity, it seems likely that reference is being made to an unseen woman.

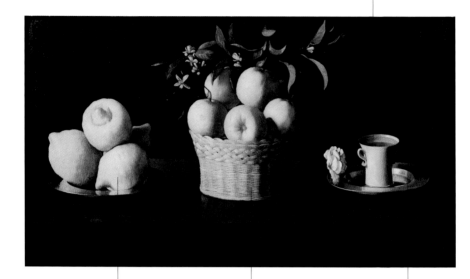

The lemons are symbolically linked to their tree and hence to fertility, because of the great quantity of fruit produced.

The basket of oranges is suggestive of marriage.

The small cup with its tall, curved lip clearly contains drinking chocolate. Soon after Cortés encountered cocoa in Mexico, it became part of the Spanish diet. As an exotic drink, it was a continual reminder to the Spanish of the great expanse of their empire, which spanned the globe.

▲ Francisco de Zurbarán, *Still Life with Lemons, Oranges, and Rose*, 1633. Pasadena, Norton Simon Museum.

The glass of water next to the chocolate suggests that its consumption had become a ritual with precise rules.

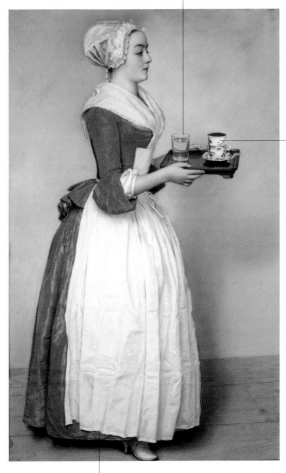

The cup is typically tall and bell shaped and in this case has a *trembleuse, a metal device that kept it steady on its saucer. This detail underscores the refinement of what is basically a simple cup-and-saucer set and illustrates a typically 18th-century attention to the rituals of food and drink.*

The pretty maid is in the act of serving a cup of chocolate. She shows that it was drunk in aristocratic circles in the 18th century.

▲ Jean-Étienne Liotard, *The Chocolate Girl,* 1744–45. Dresden, Gemäldegalerie.

The chocolate pot can be identified by the hole in the lid, through which a wooden stick is protruding. This was required to stir the drink and prevent the powder from settling to the bottom, as it was inclined to do.

The fact that there are two cups makes it clear that a second person was involved.

The upset chair shows that the tête-à-tête between the woman and an unseen person has been unexpectedly interrupted, creating confusion in the room and causing her to fear discovery (hence the title of the painting).

The chocolate ritual is evidently part of a rendezvous. We see a tousled bed and a woman with her clothes in disarray hence we can assume that the rendezvous was of an intimate nature.

▲ Jean-Baptiste Leprince, *Fear*, 1769. Toledo, OH, Museum of Art.

Our earliest notes about tea come from Marco Polo's journey to China in the 13th century, but only in the 16th century was there a complete account of the infusion process.

Tea

Tea was first imported by Portuguese and Arab merchants in the 16th century and by Jesuit missionaries in the 17th. In 1610, Dutch merchants of the East India Company began to import tea into Europe on a regular basis. Tea competed with coffee and alcoholic drinks, but in 1657 establishments were opened (for men only), with tea served as a cure-all for headaches, drowsiness, lethargy, paralysis, dizziness, epilepsy, biliousness, gallstones, and even consumption. Tea sales grew rapidly even in coffeehouses, which became the natural meeting places for the earliest English clubs. For a penny, you could buy a newspaper, drink tea, and join in conversation. In 1662, Catherine of Braganza introduced tea at the English court, where it soon became extremely popular. Tea was consumed in such large quantities in 18th-century England that it became a sort of national drink but was primarily enjoyed by the nobility. Such large-scale consumption brought enormous wealth to tea importers, so much that the government put a tax on the tea trade both in Britain and in the American colonies in order to curb their increasing economic clout. Tensions between the British crown and the Anglo-American merchants culminated in the Boston Tea Party in 1773 and the beginning of the War of American Independence.

Sources
Alexandre Dumas,
*Grand dictionnaire
de cuisine* (1873)

Meaning
National pride

Iconography
Tea appears as an English
national drink primarily in
18th-century genre scenes

▼ Jean-Étienne Liotard,
Still Life: Tea Set, ca.
1781–83. Los Angeles,
J. Paul Getty Museum.

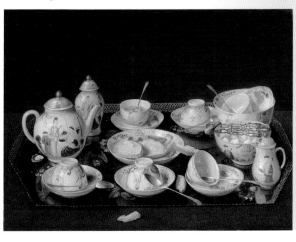

Tea

The gentleman in the middle, who commissioned the work, seems to be inviting the person sitting next to him to stop reading and have a cup of tea.

The milk jug makes it clear that as early as Hogarth's day it was the custom in England to drink tea with milk.

A kettle was often used to keep a supply of hot water on hand, so that the teapot could be refilled from time to time. This kept the tea from becoming bitter through too prolonged an infusion.

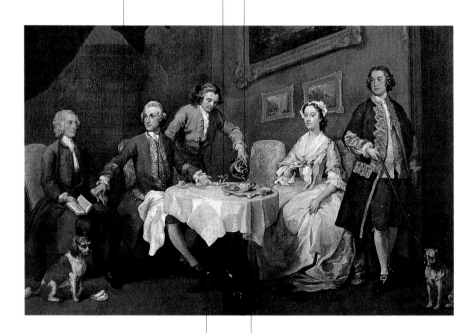

Taking tea was such an important ritual within the intimacy of families that it became part of their identity as proud Englishmen.

The silver tea service and characteristic silver salver (with little feet) are intended to emphasize the refined habits of this aristocratic English family.

▲ William Hogarth, *The Strode Family*, ca. 1738. London, Tate Gallery.

The butter knife shows that breakfast consisted of buttered bread. This was a typical northern custom that Longhi shows he had studied with care.

In many of Pietro Longhi's works, he depicted subjects drinking and serving coffee. Here, however, the lord is drinking tea, in keeping with his British nationality.

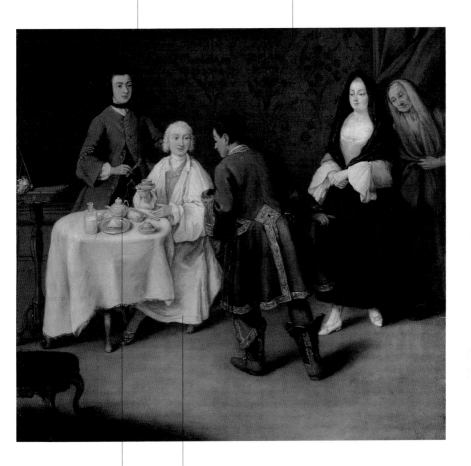

The plump silver teapot clearly shows what it must contain and emphasizes the refinement of the setting.

The lord's dressing gown and slippers and the presence of the dressing table show that morning tea and the visit are taking place in the bedroom.

▲ Pietro Longhi, *Milord's Visitor*, 1746. New York, Metropolitan Museum.

The imposing silver samovar is an eloquent item in
this genre scene, set in an English lord's elegant break-
fast room. The urn has a little heater and tap so that it
can supply hot water to fill and refill the teapot.

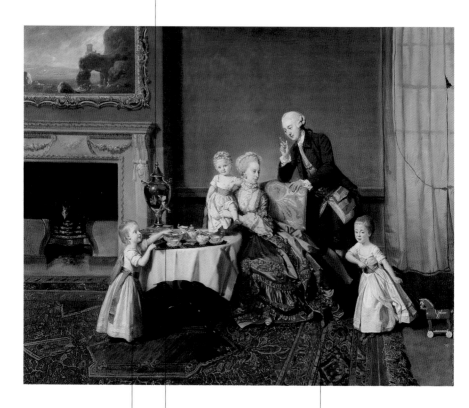

The little girl is helping
herself to a biscuit.

The tea service on the tray con-
sists of cups, a teapot, a sugar
bowl, and a biscuit bowl. The
18th century saw the introduction
of complete services like this one,
matching sets of all the objects
necessary for the preparation and
consumption of a drink, whether
it was tea, coffee, or chocolate.

The father is scolding the child for
her boldness. In correcting the child's
behavior, he is setting an example of
etiquette, a very common subject in
18th-century painting. Paintings like
this served to remind the spectator of
the rules of good behavior that
signified aristocratic distinction.

▲ Johann Zoffany, *John, Fourteenth
Lord Willoughby de Broke, and His
Family*, 1766. Los Angeles, J. Paul
Getty Museum.

Coffee was an Ethiopian drink that was adopted by the Turks. They improved it and imported it into Europe, where it soon became a fashionable drink for intellectuals.

Coffee

Coffee originated in the Ethiopian region of Kaffa and reached Europe (via Turkey) in the 17th century. In Paris in 1669, Suleiman Aga, the ambassador of Mahomet IV, adopted the practice of serving coffee in splendid decorated cups to visiting aristocratic ladies. His coffee became a topic of society conversation, and a Sicilian nobleman called Procopio, realizing that it could be traded profitably, renamed it Procope and opened a coffeehouse near the Comédie-Française. The drink was an immediate success, and the cafés where one could sip it became the cradle of the Enlightenment. At first, coffee was a luxury drink because the taxes levied on it made it very expensive, and it was served, as in its country of origin, in small metal or porcelain cups. The fashion for coffee soon spread to Italy and it became so popular that when Pietro Verri and Cesare Beccaria founded a philosophical and literary journal in 1774, they called it *Il Caffè* after a drink that "clarifies the mind and comforts the soul." Avant-garde intellectuals planned to use the journal to launch Enlightenment attacks on the traditions and prejudices of the day, and coffee was seen symbolically as the drink that, by clarifying the mind, would help to demolish prejudices. In the 19th century, coffee ceased to be confined to the nobility and became a habitual drink for the rising bourgeoisie. The price of coffee came down and it became an inexpensive drink for socializing, as well as a promoter of domestic intimacy, now that it was also drunk by women.

Sources
Alexandre Dumas,
*Grand dictionnaire
de cuisine* (1873)

Meaning
Exoticism and a critical
spirit, a national drink

Iconography
Coffee appears primarily in
18th- and 19th-century
genre scenes. It is often
seen in Venetian painting
and also appears in works
by Impressionists and
Macchiaioli

▼ Unknown artist,
The Coffeehouse, second
half of the 18th century.
Venice, Museo Correr.

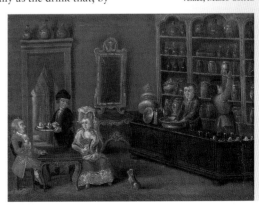

Coffee

Since the little cups on the tray resemble Turkish ones in size and shape, they must contain coffee, a very popular drink in Venice in the 18th century.

The elegance of the scene is underscored by the silver coffeepot on its silver dish.

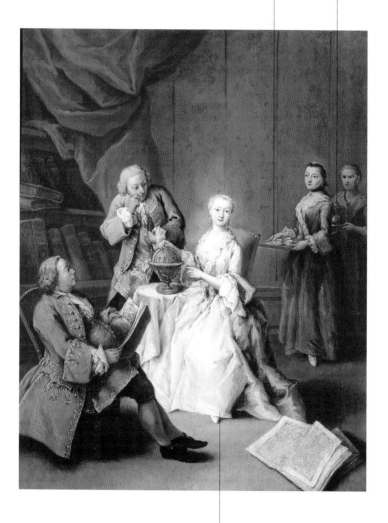

▲ Pietro Longhi, *The Geography Lesson*, 1752. Venice, Fondazione Querini Stampalia.

Because of its tonic and stimulant qualities, coffee was particularly favored by intellectuals, who made it their representative drink. It is not surprising, therefore, that the woman busy at her geography lesson should have coffee to fortify her.

*Coffee drinking began as an intel-
lectual, aristocratic ritual in the
18th century, but in the 19th cen-
tury coffee became a drink for all.*

*The scene shows the ritual
of afternoon coffee at an
upper-class villa in the
Tuscan countryside.*

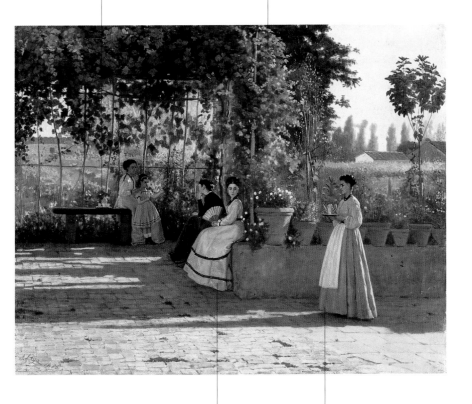

*The woman with a fan under the per-
gola suggests summer heat and the
slower pace that sets in after a meal.*

*The silver coffeepot brought
by the maid indicates the
social level of the scene.*

▲ Silvestro Lega, *After Lunch*, 1868.
Milan, Pinacoteca di Brera.

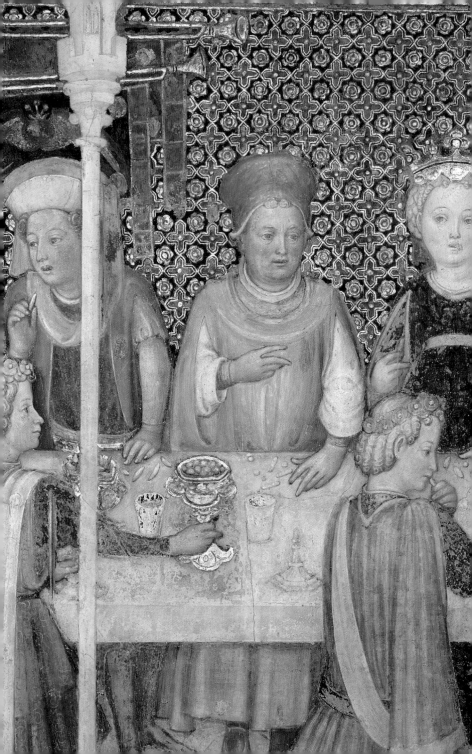

THE DINING TABLE
AND ITS FURNISHINGS

Tableware
Silverware
Tablecloths and Napkins
Plates
Cutlery
Toothpicks
Drinking Vessels
Ceremonial Drinking Vessels
Saltcellars
Vessels for Water and Wine
Amphorae, Ewers, Wine-Mixing Bowls, and Coolers
Hand Washing
Kitchen Utensils

◄ The Zavattari brothers, *The Wedding Feast of Theodolinda and Agilulf* (detail), 15th century. Monza, cathedral, chapel of Theodolinda.

In imperial Rome, the dining tables of the rich were covered with ornate tablecloths, and plates were finely chased and embossed with gold, silver, and precious stones.

Tableware

Sources
Rabanus Maurus, *PL* 111,
col. 598, and 112,
col. 998; Filippo Picinelli,
Mundus Symbolicus
(1687), book 15, chap. 13

Meaning
Good manners, suggestion
of the Eucharist

▼ Pierre Subleyras, *Christ in the House of Simon* (detail), 1737. Paris, Louvre.

The medieval dining table inherited the use of tablecloth and sideboard from ancient Rome but was poorly supplied with utensils. There were no drinking vessels, and for a long time the only cutlery was a knife to be shared among all the diners. The Renaissance retained the use of a tablecloth and introduced new materials for crockery, such as glass and majolica, which were often decorated. The principal guests at a Renaissance banquet had individual glasses but did not use cutlery. The crockery, moreover, was not set out on the table but placed on a sideboard, where silver mugs, glasses, valuable saltcellars, candlesticks, dishes, finger bowls, and ornamental objects were displayed to flaunt the wealth of the host. This usage continued into the next century, but in the 18th century the table became less cumbersome and the display of plates ceased. It was overshadowed by the appearance of the table runner, which originally had a practical purpose but later became purely decorative. As the number of servants decreased in the 19th century, glasses, cutlery, and napkins began to be placed directly on the table before the arrival of the guests, a practice that continued in the following century.

In medieval exegesis, the table set for a meal symbolizes Holy Scripture, for scholars saw a parallel between the place where food is eaten and the spiritual place where the true teaching can be assimilated. The table set for a meal also suggests the altar where the Eucharist is celebrated.

The display table is laden with valuable gold and silver plate. It had both a practical purpose, as a sideboard from which the steward served the meal, and an aesthetic purpose, as a dazzling display of the treasures of the house.

The diners at the banqueting table include the Duke of Berry and a cardinal, whom we can identify by their clothing.

The gold ceremonial chalice with a crown-like lid suggests that the purpose of the banquet is to reach a political agreement and formally celebrate it.

The gold navicula next to the duke is sufficiently large to contain everything necessary for his meal.

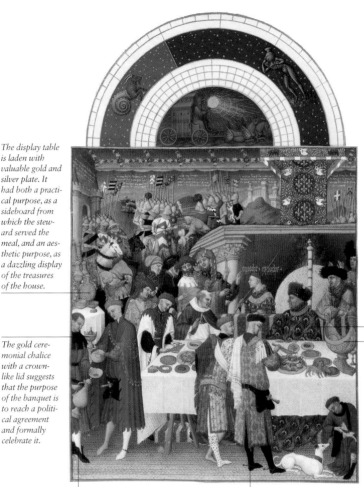

The cupbearer's job is to select the appropriate glass for a given drink and occasion, and to serve the drinks.

The carver's job is to cut the meat, and he does so in front of everybody. This was a very important task at a late-medieval banquet, because meat was the main dish at an aristocratic dining table.

▲ The Limbourg brothers, *January: The Duke of Berry's Banquet*, miniature from the *Très riches heures du duc de Berry*, 1413–16. Chantilly, Musée Condé.

Tableware

In the Middle Ages and Renaissance, great banquets provided an opportunity for the aristocracy to display their economic and social power.

The Medici coat of arms in the middle draws our attention to the role played by Lorenzo the Magnificent in arranging the Pucci-Bini marriage. Their coats of arms are on the side columns.

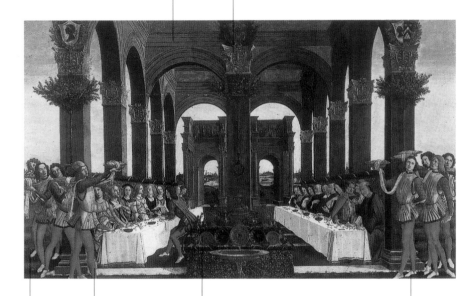

It was traditional in those days to seat men and women separately at banquets.

The symmetrical arrangement of the servants shows that their operations were in effect a choreographic display.

The fact that the display of plates takes up the center of the painting shows how important it was as a means of exhibiting one's wealth and refinement.

The servants are about to distribute sweetmeats. They were the final touch for any banquet, but especially a wedding banquet.

▲ Workshop of Botticelli, *The Story of Nastagio degli Onesti: The Wedding Banquet,* 1483. Private collection.

Even at this poor dining table, there is a silver saltcellar. It identifies the man with the bread as the head of the family.

Dark, coarse bread like this, made from a mix of grains, was eaten principally by the lowest urban classes and peasants.

In peasant households, from as early as the Middle Ages, wine was one of the principal components of the diet. Those who produced wine gave the best to satisfy the demands of their lord and kept the poorest for themselves.

The large cooking pot would stand on a tripod for cooking. It emphasizes the humble atmosphere of the scene and shows that a peasant meal consisted of a single dish.

There are no individual place settings and only a single central plate. The picture reminds us that at poor tables like this, everyone ate from one plate.

▲ Louis Le Nain, *Peasant Family in an Interior*, 1648. Paris, Louvre.

The ancients appreciated precious materials. Silver and gold brought brightness and elegance to the table, and their luminous sheen gave a sense of cleanliness to tableware.

Silverware

Sources
Rabanus Maurus, *PL* 112, cols. 863, 869–71; Platina, *De honesta voluptate et valetitudine* (1474), book 1, chap. 12; Filippo Picinelli, *Mundus Symbolicus* (1687), book 13, chap. 1

Meaning
Cleanliness, wealth, reference to the Eucharist

▼ Alexandre-François Desportes, *Still Life*, 1739–42. Stockholm, Nationalmuseum.

At the emperor's dining table in ancient Rome, jugs and plates of gold and silver would be on show; beside them would be crystal jugs and carafes. Generally speaking, the materials used for tableware were symbolic of purity and excellence, incorruptible and eternal in their splendor. In medieval exegesis, these noble materials all merited entries in the anagogical vocabulary of mysticism. Thus silver represents spiritual eloquence and the shining light of divine eloquence, because of its brightness and clear sound. Silver is also a symbol of the martyrs and of the lives of preacher saints. Gold represents the divinity of Christ himself because of its ineffable brightness, and hence it is a symbol of both spiritual and temporal excellence. In the Renaissance, gold and silver tableware gave a sense of wealth and elegance to a banquet. Platina claims that when silver is kept clean and shining, it gives the table a sumptuous appeal that stimulates the appetite. Under Francis I in France, New World gold and silver spread throughout Europe, but the great age of silverware was the 17th century, when Baroque taste for theatricality produced huge, splendid objects to embel-

lish elaborate royal banquets. In this period, silver was used not just for plates and trays but also for candlesticks and pieces of furniture. In the 18th century, its greater availability allowed silversmiths to explore more creative possibilities in much larger quantities. Silver became the symbol of aristocratic distinction, and it was to remain so even in the 19th century, when it came within the reach of the wealthy bourgeoisie.

This piece of still life exemplifies the Roman taste for using trompe l'oeil in wall paintings for both decorative and ritual purposes.

Even in antiquity, table napkins were used for drying the hands after washing them with water. This was done after each course in order to remove any traces of food on the hands.

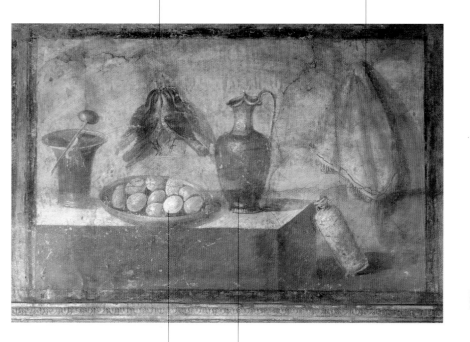

At Roman banquets, eggs were eaten as a starter and so suggest the beginning of a banquet.

Even though painted in fresco, the metallic luster of the metal jug is clear. It shows the high regard the Romans had for silver tableware on account of its bright, sparkling appearance.

▲ *A Table with Silverware and Eggs*, 1st century A.D. Naples, Museo Archeologico.

Silverware

The segregation of men and women in the grouping of the guests reflects a common custom at that time.

The display was nominally to show the silver and gold plate required for use, but its chief function was to satisfy the pride and vanity of the hosts.

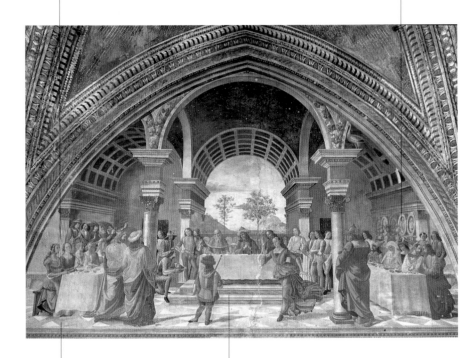

The Tornabuoni chapel was commissioned from Ghirlandaio by Giovanni Tornabuoni, uncle of Lorenzo the Magnificent. Ownership of a family chapel in those days was evidence of one's economic and political power within the city.

Steps have been set up to raise the central table. The custom of assigning the place of honor at banquets to the host was meant to indicate his central role both in the family and in the organization of the banquet.

▲ Domenico Ghirlandaio, *The Feast of Herod*, 1486–90. Florence, Santa Maria Novella, Tornabuoni chapel.

The son of Sir Francis Child, a well-known banker, commissioned this work from Hogarth as a record of his sumptuous, recently refurbished ballroom.

The silver kettle on the table is indicative of the 18th-century fashion in silverware.

The Louis XIV tea table, made entirely of silver, adds to the sumptuousness of the room.

The cups and teapot are also made of silver. They confirm the supremacy of tea as a national drink among the English aristocracy of the day.

▲ William Hogarth, *Assembly at Wanstead House* (detail), 1731. Philadelphia, Museum of Art.

Tablecloths were used in ancient Greece and republican Rome. They have long been thought to add decorum to a dining table, signifying distinction, elegance, and cleanliness.

Tablecloths and Napkins

Sources
Platina, *De honesta voluptate et valetitudine* (1474), book 1, chap. 12; Eustachio Celebrino, *Il refettorio* (1532; 1993, p. 25); Giovanni Della Casa, *Galateo* (1558), chap. 5; Domenico Romoli, *La singolar dottrina* (1610, p. 6)

Meaning
Cleanliness and decorum

Tablecloths are linked to the idea that cleanliness and hygiene stimulate the appetite. Thus the earliest tablecloth seems to have been white, though we also hear of colored tablecloths in Persia in the 3rd century B.C. The more elegant medieval banquets used white linen tablecloths in a herringbone or partridge-eye pattern, decorated with stripes and squares and with brightly colored edges. The improved Perugia tablecloths became established in the 15th and 16th centuries, with their blue bands along the sides. They became a traditional item in wedding trousseaux and were also used in the liturgy. Platina discusses tablecloths and napkins, advising against the use of colored ones, as they might annoy the guests. From the Renaissance onward, tablecloths and napkins were increasingly for everyday use. Since antiquity, the habit of eating with the hands had made it necessary to use suitable cloths for drying the hands after washing them in water. In the Middle Ages, these napkins were often shared between two people, but by the 16th century it was taken for granted that each individual should have a napkin and that it should be used appropriately and not dirtied in an indecorous way. In the 16th and 17th centuries, napkins became more decorative, with impressive folds that were listed in treatises, but from the 18th century onward they were required to be on one's lap and simply served to protect one's clothes.

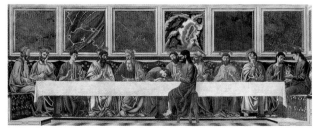

► Andrea del Castagno,
The Last Supper
(detail), 1447. Florence,
Sant'Apollonia, refectory.

The only drink available is wine, as one can tell from the glass that the head of the family seems to be raising in honor of the guest.

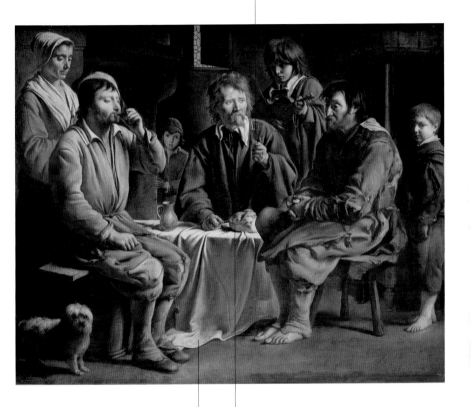

The torn, crumpled tablecloth on the table and the lack of napkins underline the fact that this is a humble peasant meal.

Bread was the basic peasant food, and its presence on the table here is indicative of the family's poverty.

▲ Louis Le Nain, *The Peasants' Meal*, 1642. Paris, Louvre.

This fresco of the Last Supper is in the refectory of the monastery of the Umiliati at the Ognissanti church in Florence.

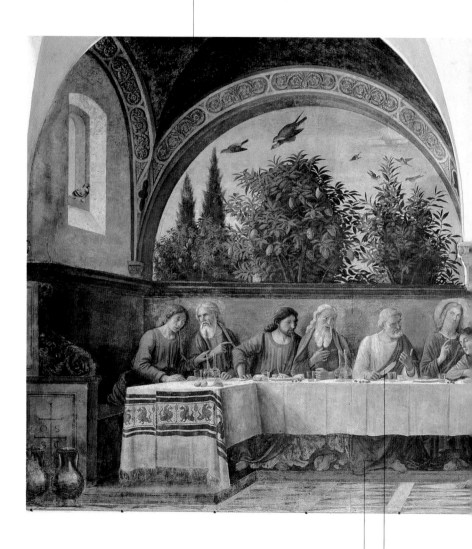

▲ Domenico Ghirlandaio, *The Last Supper*, ca. 1480. Florence, Ognissanti church, refectory.

The apostle next to Christ may perhaps be identified as Peter, who is denying any responsibility for the betrayal of Christ and pointing to the Lord with one hand while glancing at Judas, the real betrayer, who sits alone on the other side of the table.

The knife emphasizes the silent dialogue and is a symbol of betrayal.

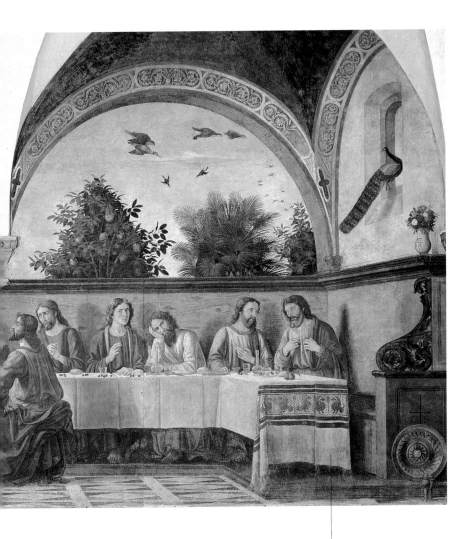

The Perugia tablecloth can be identified by its character-
istic blue and white woven stripes. It brings to mind the
Eucharist, because these tablecloths were used for litur-
gical purposes. The pattern with facing griffins is a clear
reference to Christ; these strange hybrids of eagle and
lion allude to his double nature, both human and divine.

The sculpture of a satyr eating grapes indicates that the group is in a refined garden and serves to highlight the wild, drunken nature of the lunch.

The fact that a guest has tucked a large napkin into his collar is indicative of the merry, informal nature of the gathering. From the 16th century onward, books on etiquette recommended that the napkin be used solely to protect clothes and be carefully placed on the lap, never around the neck.

Despite the euphoric disorder of the scene, the presence of well-mannered servants lends an aristocratic tone to the outdoor gathering.

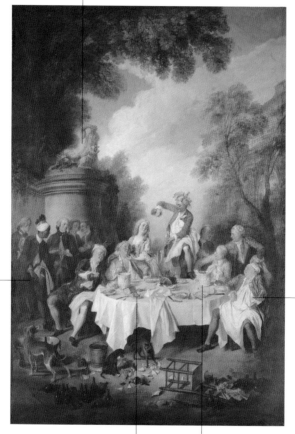

Porcelain plates, individual glasses, and knives and forks show that modern table setting has now become established, with individual place settings laid out before the meal.

In this period, silver glacettes—small buckets of ice to cool individual bottles—superseded the now-old-fashioned coolers.

▲ Nicolas Lancret, *Lunch with Ham*,
1735. Chantilly, Musée Condé.

It was the custom at Roman banquets to recline on triclinia at meals. The plate was held in the left hand and the right hand was used to take the food.

Plates

The use of plates was widespread in the ancient world. They were made of a great variety of materials, including glass, wood, pottery, crystal, and lowly earthenware. The richest dining tables had gold and silver plates set with precious stones. Flatbread was often used for the same purpose; indeed, the custom of serving food in this way seems to have lasted until after the fall of the Roman Empire. In the Middle Ages, most plates were made of wood and might be round or rectangular. But each individual did not necessarily get his or her own plate: it was very common for two people to share a plate at a banquet. During the Renaissance, it became fashionable to use plates made of majolica, pewter, gold, or silver, and they were often prized as much for their decorative value as for practical purposes. The rules of etiquette became established at this time, among which was the new concept of mutual respect among diners and the idea that each person should be supplied with a separate plate. In the 17th and 18th centuries, plates were richly painted, and Chinese porcelain became fashionable. Pewter and silver plates continued to be used in these two centuries, however, for they were robust and functional, able to withstand knocks and falls. In the 19th century, the shapes and uses of these inhabitants of the dining table increased considerably, and the use of sets made up of a number of identical items became established. At a mystic level, plates are reminiscent of the Eucharist paten and therefore linked to the symbolism of the Last Supper.

Sources
Rabanus Maurus,
PL 111, col. 599

Meaning
Links with the Eucharist

▼ Carlo Crivelli, *The Annunciation* (detail), 1486. London, National Gallery.

The right hand is free and can therefore pick up food from the plate.

The woman is clearly reclining on a typical triclinium. We are reminded that in the iconography of Etruscan painted sarcophagi, the dead are seen at a banquet that celebrates the end of their life on earth and the opening up of a new dimension.

The object that the Etruscan woman is holding in her left hand is usually interpreted as a mirror, but it may be a patera, a plate for banquets. This was a frequent attribute of figures of the dead on Etruscan sarcophagi.

▲ *The Sarcophagus of Larthia Seianti,* mid-2nd century B.C. Florence, Museo Archeologico.

The ceremonial cup that the bishop is holding shows that this is a formal occasion and at the same time reminds us of the container of wine at the Eucharist, which denotes the presence of the Lord.

The bishop's fine raiment contrasts with the humble monastic garb of the saint opposite him.

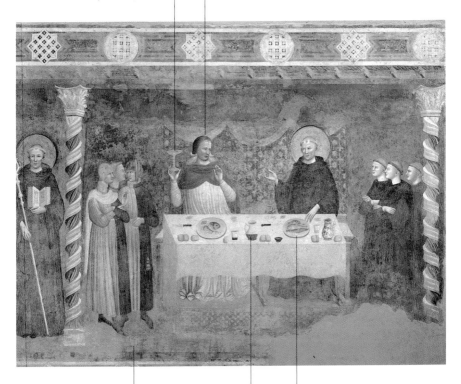

Saint Guido was abbot of the Benedictine abbey of Pomposa in the 8th century and his life is celebrated in an early-14th-century fresco cycle. Depicted here is his miraculous transformation of water into wine, to the amazement of the bishop of Ravenna and the joy of Guido's monks.

The bread and wine serve to remind us of the Eucharist table.

The fish on the table where the miracle was performed tells us of the presence of Christ, without whom the miracle would have been impossible. The two diners have individual plates, which was unusual in the late Middle Ages and confirms their prestigious status.

▲ Rimini Master, *The Banquet of Saint Guido with Bishop Geberardo of Ravenna* (detail), 14th century. Pomposa, abbey.

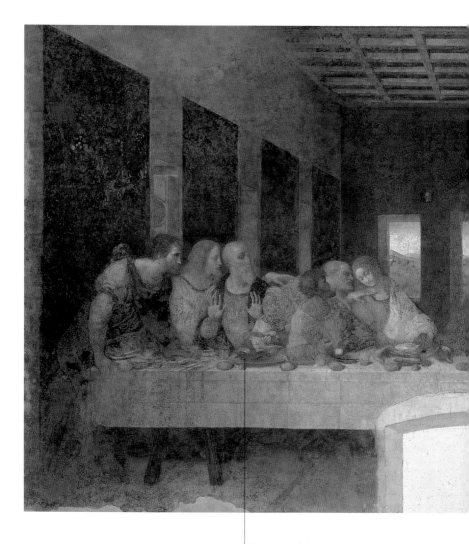

▲ Leonardo da Vinci, *The Last Supper*, ca. 1497. Milan, Santa Maria delle Grazie, refectory.

The number of plates shows that there was an individual place set for each apostle at the table, as though to emphasize the fact that they all had to be present, not simply as spectators but as principal actors in the Gospel scene.

In Leonardo da Vinci's Last Supper, *Christ occupies the place of honor, and his figure stands out against the natural light in the background window.*

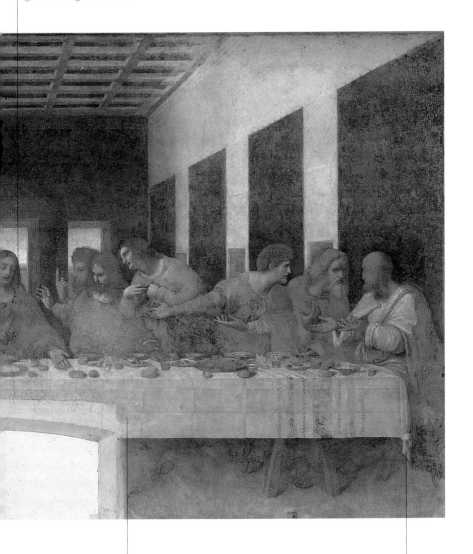

The regular folds that divide the Perugia tablecloth into rectangles make an essential contribution to the aesthetic of the table, to which the tablecloth lends cleanliness and decorum.

There is a touch of originality in the way the corners of the tablecloth are tied.

The food debris and dishes in disorder on the sideboard may be an allusion to the end of life. The center of the composition is dominated by the traditional rummer, in which the clear liquid may indicate the soul in its purity: the spirit.

The silver fruit stand on its side may indicate the end of some festivity.

The pewter dish is a typical 17th-century item, which often appears in still lifes and banqueting scenes. For dishes that were in frequent use, those made of metal lasted far longer than porcelain ones.

The single olive and the two walnuts in shadow emphasize that little food remains on the sideboard, thus suggesting the end of a meal.

▲ Pieter Claesz., *Still Life*, 1640–50.
Berlin, Gemäldegalerie.

Until the late 16th century, cutlery was a personal possession. It could sometimes be folded, and anyone invited to a banquet brought it in a case or attached to a belt.

Cutlery

The diners of ancient Greece and Rome ate with their hands, as did those of the Middle Ages, and even at the sumptuous banquets of the Renaissance, the use of cutlery was very limited. Cutlery did exist but was used only for serving and was much larger than in later centuries. A knife, for example, was a large object and, much more than those of today, looked like a lethal weapon or a tool of slaughter. Although there were carvers at Renaissance banquets whose specific job was carving the meat, each diner had a knife and sometimes a spoon. Both were set down on the table; hence the Italian term for cutlery: *posata*. In the 16th century, people began to feel that the well-mannered diner should remain at a certain distance from the food. This was quite a change from previous attitudes and meant that cutlery acquired a new and important role, allowing the habit of grasping the food with the hands to die out. These changes picked up speed in the 18th century, when the knife and spoon began to be accompanied by a fork, an implement that had hitherto been confined to the kitchen. Since a knife was a weapon as well as an item of cutlery, it kept its symbolic value as something potentially dangerous, and its intrinsic threat meant that the etiquette of the dining table enveloped it in prohibitions and precautions. Picinelli declared that the knife was a symbol of martyrdom as well as of betrayal, but was in any case a sign of the word of God, because both are equally sharp and penetrating.

Sources
Michel de Montaigne, *Montaigne's Travel Journal* (1774; 1983, trans. G. Davenport); Filippo Picinelli, *Mundus Symbolicus* (1687), book 15, chap. 8

Meaning
Elegance, refinement, betrayal, the word of God

▼ Hieronymus Bosch, *Musical Hell* (detail), from *Triptych of the Garden of Earthly Delights*, 1503–4. Madrid, Prado.

In this crowded Last Supper, Christ sits in the place of honor at the middle of the table.

As in the scriptures, Christ is shown blessing the bread and wine.

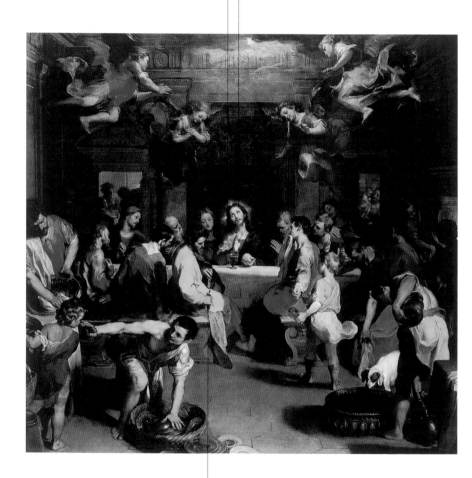

Judas sits opposite Christ and is shown in the act of replacing his knife—the symbol of betrayal—in its sheath. Knives were commonly used as personal weapons and were the first item of cutlery to appear on the dining table.

▲ Federico Barocci, *The Last Supper*, ca. 1580. Urbino, cathedral.

The glass of water, in a kind of noble isolation on the dish, is a symbol of the religious soul.

The lemon may symbolize fertility.

The chestnuts allude to chastity, and the sweetmeats seem to refer to marriage.

The knife is viewed at an angle, so that all one can see is the elegant handle inlaid with mother-of-pearl. It nevertheless adds a sense of depth to the scene, and we are made conscious of its latent threat as a weapon and its symbolic value as a sign of Christ's betrayal and martyrdom.

▲ Gotthardt Wedig, *Still Life with Candle*, first half of the 17th century. Paris, Louvre.

Cutlery

Every kind of excess was permitted at the feast of Twelfth Night, and the grotesque tones of this painting emphasize the atmosphere of transgression.

The elegant woman seems somewhat out of place in this atmosphere of disorderly merrymaking. In her hand she gracefully holds a fork, an item that was not yet in common use at the dining table in the 17th century. Here it is a sign of distinction and refinement.

▲ Jacob Jordaens the Elder, *The Bean King* (detail), ca. 1640. Vienna, Kunsthistorisches Museum.

The crown identifies this man as the Bean King, the chief figure at the feast.

A bean was cooked inside a cake, and whoever found it was proclaimed king of the feast. He could eat and drink as much as he liked, to cries of "The king is drinking!"

The painting shows
Lord George Graham
in the cabin of his ship.

The musicians are there to celebrate the
victory of the British fleet over the Dutch
in the waters of Ostend, in 1745.

The use of individual forks had become
established in the 18th century. Here the
fork indicates that it was no longer per-
missible to touch food with one's hands.

Although this is a ship's cabin,
it is clear that great care has
been taken in setting out the
silver plates and cutlery.

▲ William Hogarth, *Captain Lord
George Graham in His Cabin*, ca. 1745.
Greenwich, National Maritime Museum.

*The large cooking pot
emphasizes the scene's
humble atmosphere.*

▲ Jean-Baptiste Greuze, *The
Spoiled Child*, 1765. St. Petersburg,
The Hermitage.

*In spite of the poor appearance of
the room, the boy has a silver spoon
in his hand. Cutlery of this kind was
used for feeding children because
silver was thought to kill bacteria.*

341

In ancient Rome, the dentiscalpia *was used not only for removing food fragments from the teeth but also for picking up meat that was served at the table in small pieces.*

Toothpicks

Sources
Martial *Satires* 14.22;
Giovanni Della Casa,
Galateo (1558), chap. 29

We learn from Martial that Roman toothpicks were often made of wood, but that a feather could also be used for the same purpose. In the 16th century, some extremely valuable toothpicks were produced in gold, enamel, and precious stones. They were effectively jewels and might be worn around the neck like any other ornamental pendant. In his *Galateo*, Della Casa declares himself against this custom and against toothpicks in general, writing an amusing passage on the subject: "Anyone who wears a toothpick around his neck undoubtedly does ill, for apart from the fact that it is a strange instrument for a gentleman to be seen taking from his bosom and brings to mind those tooth-pullers we see climbing on benches, he is also showing how very well prepared and equipped he is for eating; and I wonder why such people do not wear a spoon around their neck as well."

▼ Paolo Veronese, *The Marriage at Cana* (detail), 1562–63. Paris, Louvre.

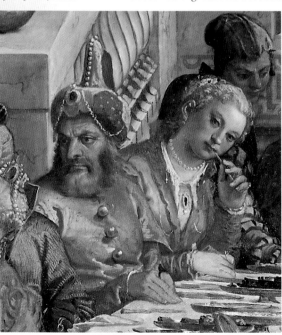

342

The two letters C and I inside the moon are a
cryptic reference to the lady's name: when
placed inside the Italian word luna, meaning
moon, they tell us that she is called Lucina.

▲ Lorenzo Lotto, *Portrait of Lucina
Brembati*, ca. 1518. Bergamo,
Accademia Carrara.

This pendant was for a long time thought to
be an amulet in the shape of a horn, but it is
in fact a gold toothpick. A passage in Della
Casa's Galateo tells us that such things were
indeed worn around the neck, and he empha-
sizes how ill-mannered such a fashion was.

There were many Venetians working in Flanders from the 15th century onward, and the drinking glasses known as façon de Venise *spread from there right across Europe.*

Drinking Vessels

Sources
Rabanus Maurus, *PL* 111, col. 599, and 112, col. 879; Filippo Picinelli, *Mundus Symbolicus* (1687), book 14, chap. 3

Meaning
Container of the blood of Christ, celebration

▼ Sebastian Stosskopf, *Still Life*, 1644. Strasbourg, Musée des Beaux-Arts.

While drinking vessels took a great variety of shapes from Roman times onward, by the beginning of the 15th century, Italy was already producing ones made of glass, and the traditional cylindrical shape had been adopted. In Germany and Flanders, the fashionable drinking glass was the so-called rummer, which was also cylindrical but decorated with protrusions or drops applied to the exterior. Sixteenth-century Venice became the capital of glass production, including drinking glasses, which now assumed new shapes. Cylindrical glasses acquired feet, their stems were lengthened, and the bowl became broader. The great variety of shapes and decorations became a European phenomenon: Venetian glassmakers emigrated to Holland, Germany, Spain, and France, and *façon de Venise* glassware spread throughout Europe. In the 16th century, crystal was also introduced for the more refined products, glass was colored or diamond engraved, and new shapes inspired by the antique were introduced, such as small cups with a rippled edge or glasses with a winged stem that made the glass look almost like lace. Saucers used as trays also appear during this period. From a mystic point of view, glasses are suggestive of the liturgical chalice, with its Christian meaning as wine container and therefore an emblem of Christ's blood and a reminder of his Passion. The chalice reminds us of Christ's agony in the garden of Gethsemane. The usual symbolic ambivalence also applies to glasses, for they may represent worldly pleasures. In the iconography of Saint Benedict, a glass reminds us of the miracle of the poisoning averted when its container broke.

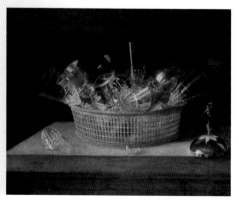

Also visible is a paten, the plate used to hold the consecrated host during the celebration of the Eucharist.

The attributes of Faith are the cross, a symbol of the Passion of Christ, and the chalice, a symbol of the Eucharist wine.

This is one of the theological virtues in a series of the seven theological and cardinal virtues, commissioned from the Florentine workshop of the Pollaiolo family for the Tribunale della Mercanzia.

▲ Antonio del Pollaiolo and Piero del Pollaiolo, *Faith*, ca. 1470. Florence, Uffizi.

The fact that the drinking vessel is shaped like a liturgical chalice shows that the artist has transformed the Last Supper into a straightforward celebration of the Eucharist.

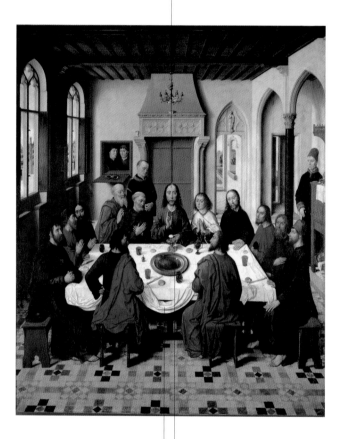

Sharing a napkin was normal at this time, but as the Renaissance progressed, the need for individual place settings became more pressing.

The central dish brimming with blood-colored wine is a clear allusion to the wine of the Eucharist and at the same time illustrates the contemporary custom of laying a table without individual plates but with a single platter of food, from which each person would take a portion.

▲ Dieric Bouts the Elder, *The Last Supper*, 1464–68. Louvain, Saint-Pierre.

Saint Benedict founded the Benedictine order and the monastery at Montecassino. He was a very severe person, and legend has it that his monks were so dissatisfied with his regime that they tried to kill him by getting him to drink poisoned wine.

Saint Benedict blessed the cup before drinking and it broke, spilling the poisoned liquid and so saving his life.

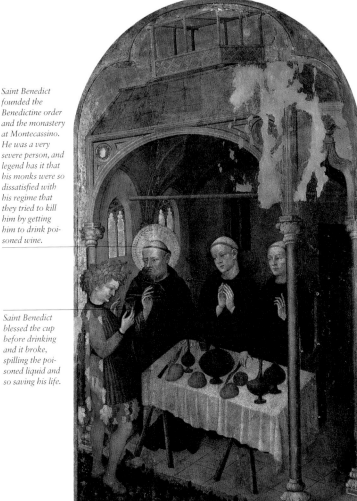

▲ Niccolò di Pietro, *Saint Benedict Blessing the Cup of Poisoned Wine*, early 15th century. Florence, Uffizi.

The monochrome figures of Saint John the Evangelist and Saint John the Baptist stand opposite each other on the outer wings of The Adoration of the Lamb Altarpiece, among the kneeling donors. The book of Revelation was attributed to Saint John the Evangelist and provided the inspiration for the Adoration of the Lamb, which occupies the central panel of the polyptych.

The chalice with a serpent is one of the most common attributes of Saint John. According to legend, the priest of the temple of Diana wanted to put John's faith to the test and so offered him a cup of poison, which had already killed two people. John drank the contents and not only remained unharmed but also restored the other victims to life. The serpent represented Satan, and in time the chalice came to symbolize the Church.

·IOHES·EWAN·

Wine is the accomplice in this encounter, as we can tell from the characteristic pewter jug.

The shape of the glass tells us that it is a verre d'amitié, which emphasizes the intimate relationship between the couple.

The two copulating dogs emphasize the sordid nature of the place and the purpose of the meeting between the two figures.

◀ Jan van Eyck, *Saint John the Evangelist*, from *The Adoration of the Lamb Altarpiece*, 1432. Ghent, Saint-Bavon.

▲ Frans van Mieris the Elder, *Brothel Scene*, 1658. The Hague, Mauritshuis.

The juxtaposition of beer, wine, tobacco, and playing cards in this still life creates the atmosphere of a Flemish tavern, a common meeting place for men.

This particular beer glass has a number of horizontal stripes, which show how much beer has been drunk. This is a shared passglas, which was passed from one drinker to the next in a sort of male ritual of brotherliness.

▲ Jan van de Velde III, *Still Life with a Glass of Beer*, 1653. Oxford, Ashmolean Museum.

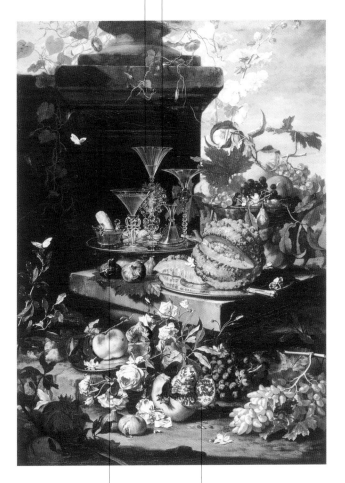

The complicated, virtuoso shapes of the blown glass illustrate the popularity in northern Europe of the tastes and techniques of the Venetian master glassmakers.

The lightness and delicacy of these wing-stemmed glasses remind us of the fragility of glass as a material.

The ladyfinger dipped in wine illustrates a traditional way of eating this prized biscuit and reminds us of the bread and wine of the Eucharist.

The partly eaten pieces of fruit are symbolic of earthly pleasures and their ephemeral nature.

▲ Christian Berentz, *Flowers, Fruit, and Glasses on a Tray*, 1696. Pesaro, Museo Civico.

These drinking vessels are elaborately crafted and made of precious metal. They were kept safe in the treasury and brought out only for ceremonial purposes.

Ceremonial Drinking Vessels

Sources
Rabanus Maurus, *PL.* 111,
col. 599, and 112, col. 879;
Filippo Picinelli, *Mundus
Symbolicus* (1687), book
14, chap. 3

Meaning
Container of the blood of
Christ, celebration

In the 16th century, when European banquets became more elaborate and imposing, the increasing desire for elegance led to greater use of ceremonial chalices. These were ornate drinking vessels with a lid, and their shape and dimensions clearly show that they were intended for toasts and other ritual purposes. They were often made of precious metals, but blown glass worked to look like lace might also be used. One of the most interesting types of ceremonial drinking vessels is the drinking horn. These were already in widespread use in the 15th century and appear in Flemish paintings up to the 17th. It is possible that they evolved from the Greek *rhyton* or the Roman *rithium*. They were generally hollowed out from an ox or buffalo horn or an elephant tusk and then mounted in silver or gilt silver. Ceremonial chalices in *façon de Venise* glass often appear in 17th-century Flemish still lifes along with the more typical metal type in gold or gilt silver, which look very like liturgical objects. Hence they suggest more strongly than ordinary glasses a symbolic connection with the mystic chalice of the Eucharist as representing the Passion of Christ and the Christian faith.

► Veit Moringer, *Chalice
with Lid*, 1565. Madrid,
Thyssen-Bornemisza
Museum.

Objects like this were widespread in
northern Europe. As a ceremonial
drinking vessel, the drinking horn could
also be used for liturgical purposes.

The gilt silver eagle acting
as a support for the ivory
horn is a symbol of Christ
and was often used in
objects of this kind.

▲ Jakob Mores the Elder, *Drinking
Horn*, late 16th–early 17th century.
Moscow, Kremlin Museum.

When a simple, traditional rummer is mounted on a gilt présentoir, it changes shape, becomes more imposing, and turns into a ceremonial glass.

The turkey illustrates the Renaissance custom of presenting roasted birds at table with their feathers replaced. When birds were treated in this way, they were often used simply for decorative purposes and not eaten.

The handshake between these two men is a clear sign that agreement has been reached and identifies them as leading figures at the Peace of Münster.

The silver drinking horn in the left hand of one of the two key figures fully displays its ceremonial qualities.

▲ Bartholomeus van der Helst, *The Celebration of the Peace of Münster*, 1648. Amsterdam, Rijksmuseum.

The least extravagant luxury at the Roman dining table was the salinum, *the ritual saltcellar that, together with the* patera, *offered grain and salt to the* Penates, *gods of the larder.*

Saltcellars

Even the earliest saltcellars were made of precious metal, because salt was an expensive commodity, heavily taxed, and therefore treated with great respect. Salt, moreover, was used not solely for flavoring food but also for preserving meat, fish, and vegetables. At the dining tables of the nobility, there would be two saltcellars: a monumental one to the right of the hostess and a smaller one at the other end of the table; those who sat beyond the latter were "below the salt," unworthy of notice. Monumental saltcellars would figure among the principal table ornaments in the Middle Ages and Renaissance. They were often shaped like seashells, or even made from real seashells, such as nautilus, mounted in gold or gilt silver. It was the fear of poisoning (salt could be laced with arsenic powder) that led to enclosed saltcellars, salt boats, and salt caskets, but the salt boat, or navicella, outgrew this original purpose. It became a larger container for all the lord's implements: napkin, knife, spoon, and sometimes even his plate. During the 16th century, saltcellars decreased in size, and in the 17th century, divided containers were devised to hold salt, pepper, and other spices. Saltcellars were symbolically linked to their contents and were often used in paintings to represent salt in whatever way fitted the style of the image.

Sources
Isidore of Seville,
PL 82, col. 715

Meaning
Aristocracy, power,
and, in relation to their
content, surprise

▼ Benvenuto Cellini,
Saltcellar, ca. 1545. Vienna,
Kunsthistorisches Museum.

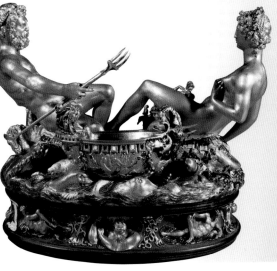

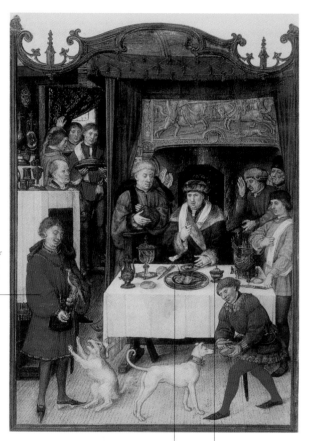

The falconer, a bystander at the banquet, is one of several references to hunting in this miniature.

The roast game is indicative of the aristocratic preference for meat, especially that taken in the hunt.

A small saltcellar is being used simply to hold salt, but its splendid gilt silver lid shows that this is a sumptuous meal.

▲ Gerard Horenbout, *The Lord's Banquet*, miniature from *The Breviary of Cardinal Grimani*, 1510–20. Venice, Biblioteca Nazionale Marciana.

According to Mannerist taste, the nautilus was one of those extraordinary natural forms that aroused wonderment and awe. Artists of the time included them in objects where jewels and precious metals could enhance their aesthetic qualities.

The satyr is an emblem of wisdom and alludes to the purpose of the whole object as a container of salt, itself a symbol of intellectual acumen.

▲ Cornelis Floris, Nautilus Mounted in Gilt Silver, 1548–77. Madrid, Thyssen-Bornemisza Museum.

The Triton stresses the marine symbolism of the saltcellar. Since the sea is a source of food and economic prosperity, it may represent Divine Providence.

The blown-glass ceremonial chalice with a lid is intended to hold wine and therefore alludes to the Passion of Christ.

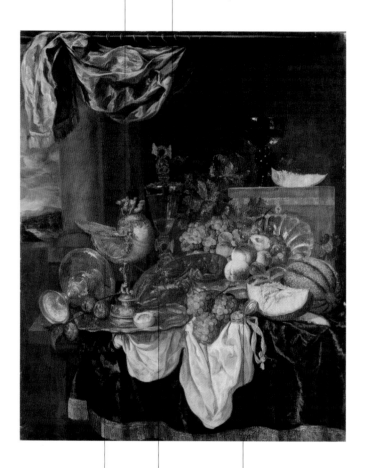

It was originally thought that this nautilus was a monumental saltcellar. But it now seems that it was either a kind of ceremonial drinking vessel or else a purely ornamental object.

Because a lobster molts its outer shell every year, it is a symbol of the Resurrection.

The watch marks the passage of time and hence the speed with which human life and earthly pleasures pass by.

▲ Abraham van Beyeren, *Large Still Life with Lobster*, 1653. Munich, Alte Pinakothek.

This empty drinking glass is a delicate, precious object. It may symbolically convey the fragility of the material envelope in which a human being is wrapped.

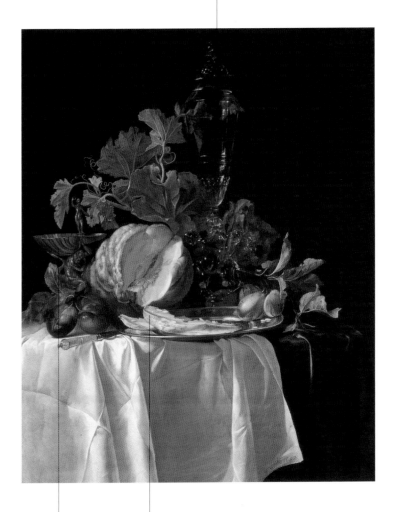

This tall saltcellar is shaped like a seashell supported by a satyr. As a salt container, it symbolizes wealth.

The squash, an iconographic alternative to the melon, alludes to material pleasures.

▲ Willem van Aelst, *Still Life with Fruit*, 1652. Florence, Galleria Palatina.

In the 15th century, wine bottles combined simplicity of shape with a careful study of proportions and an elegance that preserves traces of the Roman art of glassmaking.

Vessels for Water and Wine

Sources
Rabanus Maurus, *PL* 111,
cols. 597, 600, and 112,
col. 1072; Filippo Picinelli,
Mundus Symbolicus
(1687), book 15, chap. 7

Meaning
The human condition, with
reference to content

In 15th-century Italy, bottles with a circular base, a rounded body, and a long neck were very frequently used for pouring wine. Throughout Europe, travelers used a flask—a closed container with flattened sides, which took up little space and could be easily stowed. Ceramic jugs, on the other hand, were used when in company, and they held a fixed quantity of wine. In the 16th century, the bodies of bottles became longer and their necks narrower, while the bases of carafes were raised and their handles embellished with animals and monsters from a Mannerist repertory inspired by classical decoration. Traveling flasks were now luxury objects, made of precious materials and elegantly decorated. In more modest quarters, the 15th-century designs of bottles, cylindrical glasses, and ceramic jugs persisted, and leather- or straw-covered flasks were also used.

On the dining tables of the wealthy, we now find old-fashioned jugs in decorated pottery or embossed and engraved metal, with one highly decorated handle. In the 17th century plate displays, we see carafes rather than bottles, but in lower-class homes, especially in the north, we frequently find pewter jugs with lids, intended for wine or beer. The 18th century witnessed the triumph of glass and crystal bottles of all shapes and sizes. The lip of the water carafe became wider. Wine was now stored in dark glass bottles, to shield it from the damaging effects of light. Symbolically, the container generally stands for the contents, but in biblical exegesis, wine and water containers represent the human condition if they are made of ordinary materials, but the life of saints if the materials are precious. For Picinelli, a carafe pierced by a ray of sunlight represents divine wisdom, because it illuminates and sets light to the fire of faith.

Saint Bertin was a 6th-century monk schooled in the Rule of Saint Columban, who founded an abbey at Sithiu in France.

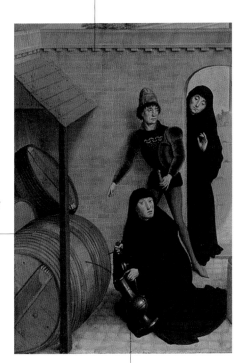

Saint Bertin is famous for his ability to perform miracles, including that of drawing wine from a barrel that was thought to be empty.

The pewter jug is shown in its traditional use as a wine container.

◄ Antonio del Pollaiolo and Piero del Pollaiolo, *Temperance*, ca. 1470. Florence, Uffizi.

▲ Simon Marmion, *The Miracle of Saint Bertin* (detail), 1459. Berlin, Gemäldegalerie.

This jug was made in Montelupo
toward the end of the 16th century.

▲ Montelupo manufactory, Jug
with the Monogram of Christ, 16th
century. Florence, Bargello.

Decoration with the
Bernardinian monogram
IHS was a constant in
Renaissance majolica, but
floral decoration was also
favored. Such objects were
not just for the ordinary
market: they were also
bought by members of the
patrician classes.

This fanciful object is decorated with snakes, dragons, and a horse's head, images from a bizarre Mannerist menagerie.

The jug consists of two nautiluses facing each other and bound together with gilt silver. Clearly its purpose was more decorative than practical.

The use of seashells reflects the Mannerist taste of the time, which sought to enhance the extraordinary natural forms with the work of virtuoso goldsmiths. The latter used precious materials—mother-of-pearl, gilt silver, rubies, and turquoise—to add unusual refinement to what was already a very original object.

▲ Chinese and Flemish manufacture, Ewer, late 16th century. Florence, Museo degli Argenti.

The beans being devoured
in this genre scene empha-
size the low-class setting.

This painting of fishmongers is one of
several works by Vincenzo Campi that
celebrate abundance and trade. Such works
reflect the spirit of curiosity and catalogu-
ing that underlay the rage for collecting
exemplified by the Wunderkammern.

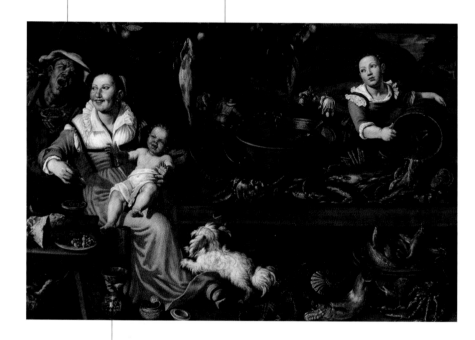

The polychrome ceramic jug
is a typical late-15th-century
product with Gothic floral
decoration. It may have been
made at Faenza.

▲ Vincenzo Campi, *Fishmongers*,
1580–90. Milan, Pinacoteca di Brera.

Caravaggio presents Mary Magdalene as a young woman nodding off to sleep. She is not easy to identify because her usual jar of ointment is missing.

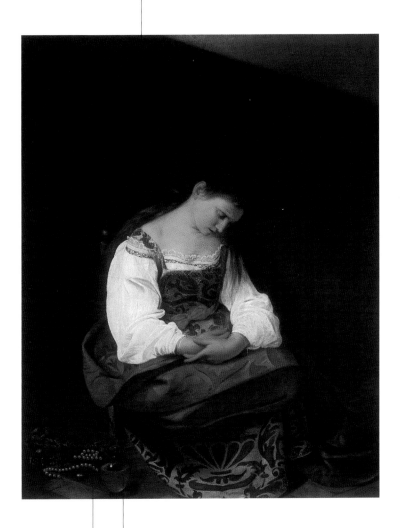

The jewels in a disorderly pile on the ground are an allusion to her renouncing earthly goods in order to follow the spiritual teaching of Christ.

Instead of her usual attribute, she has a clear glass bottle. The fact that it can be seen to contain water shows that she represents the pure, pious soul.

▲ Michelangelo Merisi da Caravaggio, *Mary Magdalene*, 1594–95. Rome, Galleria Doria Pamphili.

Vessels for Water and Wine

The glass bottle is a fragile container and hence is suggestive of the human condition.

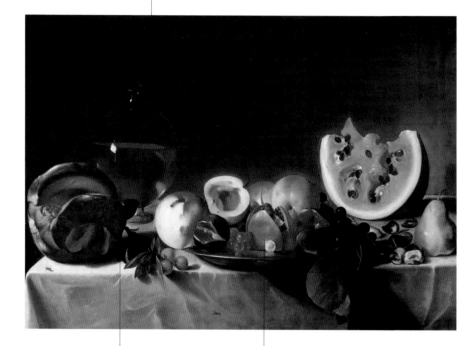

Wine is a drink that promotes contemplation. It seems to suggest that although the soul is contained within the body, its aspirations are higher.

The fruit is past its prime and has already been handled by man. Perhaps this is an allusion to the ephemeral nature of material things, which are rapidly corrupted with the passing of time.

▲ Pensionante del Saraceni, *Still Life with Fruit and Carafe*, 1615–20. Washington, National Gallery.

The fruit represents material pleasures and reminds us that beyond the earthly dimension, it is the fruits of the spirit that will bring us joy.

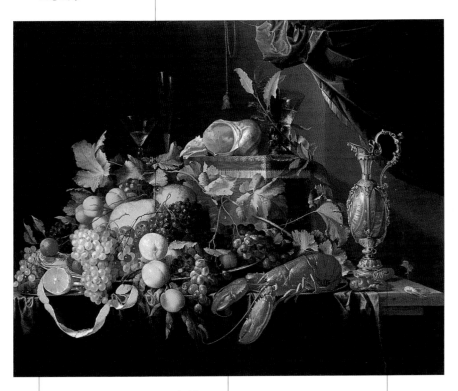

The lobster is a symbol of the Resurrection.

The lemon with its peel cut in a spiral is a metaphor for the journey of life, during which the outer material skin is gradually abandoned in order to reach the flesh, the spiritual essence.

In this ewer, an artist of Mannerist inspiration has fused two nautilus shells with ornate precious metal. The use of precious metal for such a container means that it symbolizes spiritual excellence, and in fact represents saintliness.

▲ Jan Davidsz. de Heem, *Still Life with Fruit and Lobster*, ca. 1648–49. Berlin, Gemäldegalerie.

Vessels for Water and Wine

The pewter jug is typical of the time. Such jugs often appear in Flemish paintings and show that the party drink is wine.

The crown tells us that the fat man at the center of the scene is the Bean King, the leading figure at the Twelfth Night celebration.

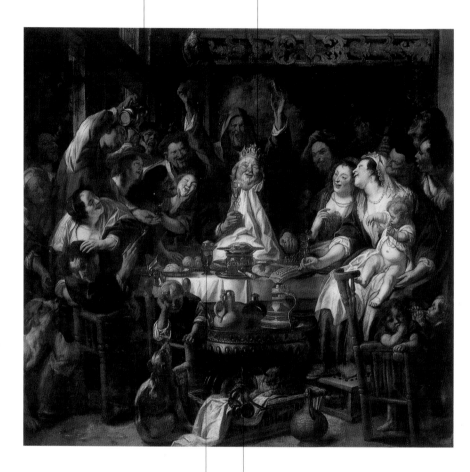

The saltcellar beside the Bean King identifies him as the central figure.

The cooler with baccellato decoration is very large and tells us just how much drink is available for those enjoying the feast.

▲ Jacob Jordaens the Elder, *The King Is Drinking*, ca. 1640. Brussels, Musées Royaux des Beaux-Arts.

In the Roman world, wine was kept in amphorae. These special containers allowed wine to be transported by sea or on land and ensured that it would keep.

Amphorae, Ewers, Wine-Mixing Bowls, and Coolers

Sources
Isidore of Seville, *PL* 82,
col. 717; Rabanus Maurus,
PL 111, cols. 599–601,
and 112, cols. 857, 888

Meaning
The human body,
tribulations, reference
to their contents

In ancient times, wine was rarely drunk in its pure state. At banquets, a sealed amphora was opened in the dining room and a quantity was poured into a wine bowl, where it could be mixed with water. The wine bowl was usually made of earthenware or bronze and a small ladle called a *simpulum* was used to transfer the wine to the guests' drinking vessels. Other types of containers for valued drinks were large jars and ewers. Amphorae very much like those of classical times were used in the 16th century, along with casks that resembled the jars and ewers of antiquity, as well as bowls for mixing wine and water. This was the period when coolers also appeared on the scene. They were specially designed basins, often made of embossed metal, to contain ice or snow for cooling drinks in bottles or flasks. Coolers continued to be used in later centuries, now in the form of precious, refined *glacettes*, which adopted a denticulate oval shape. Wine flutes could be lowered into the crushed ice or ice water, their bases secured by the ornamentation. Biblical exegesis held that water and wine containers such as amphorae and ewers represented the human body. They were also anagogic representations of avarice if they contained water, and of contemplation if they contained wine. A wine bowl was used for mixing two liquids and had two handles, thus symbolizing the Bible's two Testaments on one hand and human tribulations on the other.

▼ Giotto, *The Marriage at Cana*, from *Scenes from the Life of Christ*, 1303–5. Padua, Scrovegni Chapel.

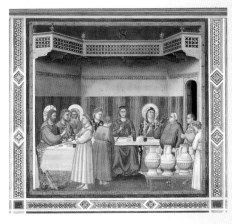

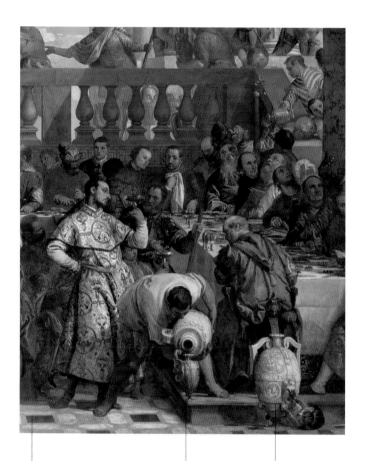

The steward is assessing the wine, which Christ miraculously made from water.

The wine was poured from the amphorae either into bowls to be mixed with water or directly into jugs, as in this painting.

At Renaissance banquets, as at those of ancient Rome, the amphorae were opened in the dining room itself so that there could be no doubt about the quality of the wine.

▲ Paolo Veronese, *The Marriage at Cana* (detail), 1552–63. Paris, Louvre.

The ceremonial chalice suggests a festive occasion.

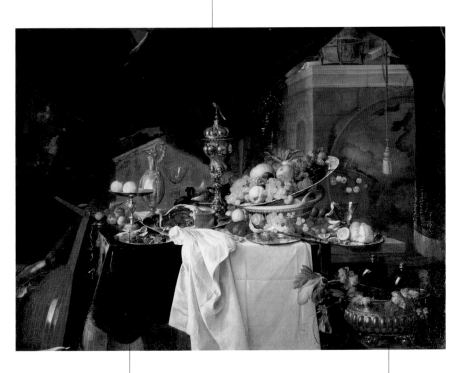

The tall silver dish seems to contain an allusion to marriage because of the precious metal of which it is made and the pair of lemons.

Baccellato coolers frequently appear in 16th- and 17th-century banqueting scenes. These basins would be filled with snow or very cold water and their breadth allowed them to accommodate a number of bottles or flasks. Their presence here indicates a festive occasion.

▲ Jan Davidsz. de Heem, *Still Life*,
1640. Paris, Louvre.

This is one of a cycle of paintings called A Rake's Progress, *a satire on the figure of the bourgeois libertine who squanders the fortune he has inherited until he is finally ruined.*

In The Awakening, *Tom Rakewell finds himself in his new home surrounded by a swarm of people whose one desire is to part him from his money.*

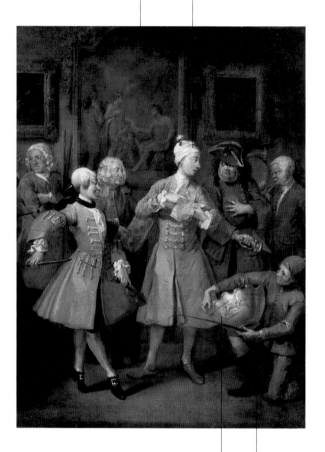

The trophy is in fact a cooler for glasses and bottles. The scalloped edge allowed glasses to be kept in place: their bowls were immersed in ice, while the feet remained outside the cooler, caught in a scallop.

The kneeling page may be a riding instructor who is trying to entice the libertine by showing him a trophy.

▲ William Hogarth, *A Rake's Progress: The Awakening*, 1733–35. London, Sir John Soane's Museum.

A pitcher with a spout and handle and an accompanying basin were used from ancient times up to the early 18th century for washing one's hands at table both before and after meals.

Hand Washing

Between courses at ancient Roman banquets, a slave would bring in cool perfumed water for washing the hands, which the guest then dried on a towel draped over the servant's arm. The need for cleanliness was a recurring topic in Roman literature. Authors advised that before going to a banquet, diners should purify themselves with a thorough wash. As time went by, this ritual rule was reduced to washing the hands, and finally even hand washing between courses was abandoned as napkins and cutlery came into use in the 17th century. However, when Della Casa's *Galateo* was written, it was customary to wash one's hands in the presence of others. Indeed, he maintained that while washing of all kinds should be carried out in total privacy, hand washing was an exception: "When you are going to table, you should wash your hands in full view even if you do not really need to, for in this way anyone eating from the same plate knows that all is well." In Christian ritual, hand washing is still part of the celebration of the Eucharist as a reminder of the need for cleanliness and consequent purity when approaching the spiritual food at Christ's table. The act of washing the hands, performed with the jug and basin, is thus a sign of seeking a cleanliness that symbolizes a return to an original state of purity.

Sources
Columella *De re rustica*
12.4; Giovanni Della Casa,
Galateo (1558), chap. 30;
Filippo Picinelli, *Mundus
Symbolicus* (1687),
book 2, chap. 20

Meaning
Cleanliness and purity

▼ Bernardino Luini, *The Birth of the Virgin*, 1516. Milan, Pinacoteca di Brera.

This typical wedding cake is appropriate to the context.

Musical instruments litter the floor. It is an ancient custom to play music during banquets.

▲ Leandro Bassano, *The Marriage at Cana*, ca. 1578. Paris, Louvre.

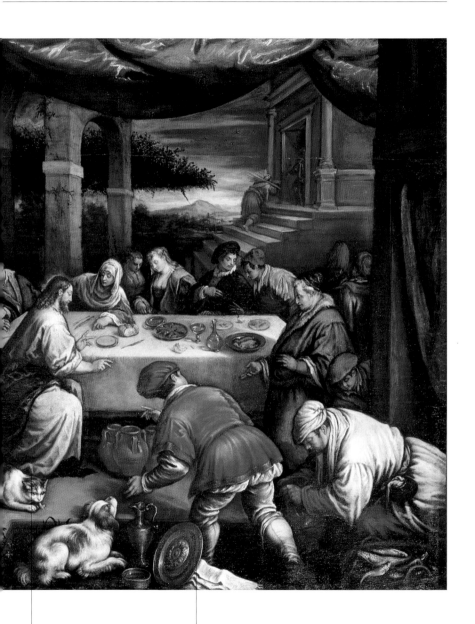

Christis shown in the act of
changing the water into wine.

The ewer and basin reflect the custom of
rinsing one's hands from time to time dur-
ing banquets. Even in the 16th and 17th
centuries, food was still eaten by hand
because cutlery was not yet widely used.

The cooking of food began in prehistoric times, and cooking brought with it the need for appropriate utensils.

Kitchen Utensils

Sources
Rabanus Maurus, *PL* 111,
cols. 587, 592, and 112,
col. 1011; Filippo Picinelli,
Mundus Symbolicus
(1687), book 15, chap. 19

Meaning
Alchemical and diabolical
instruments, spiritual
development

▼ Jean-Siméon Chardin,
A Copper Water Urn,
ca. 1734. Paris, Louvre.

From the time of ancient Rome until today, there has been substantial continuity in the shapes and uses of utensils, especially those found in the kitchen. Among the remains of the Etruscan city of Caere, archaeologists have identified spits, saucepans, mortars, knives, and ladles that are very similar to the ones we use today. In Roman times, cooking utensils were kept along with the iron grate next to the hearth. The spacious kitchens in the homes of the nobility were very well equipped, with knives, chopping boards, semicircular chopping knives, carving knives, spoons, ladles, large forks, graters, sprung nutcrackers, and skewers of various metals. You would find mortars for vegetables, sauces, or spices, and even skimmers for soups and stews. The fire was always lit in the medieval kitchen, and a large pot was always hung over the fire for boiling meat and preparing porridge and soups.

Spits for roasting meat were used from the age of Homer to modern times, especially from the 15th century to the 17th, as many paintings show. In both Roman and Renaissance kitchens, there were stone ovens, but metal ones as well, with ingenious systems for ensuring a good seal. In medieval exegesis, gastronomic and indeed all kitchen activities symbolized the act of meditating on the word of God in one's heart, whereas eating represented its spiritual absorption. The frying pan was thought to symbolize hard work as well as a sinful mind and diabolical cunning. Picinelli associates the saucepan with the crucible in which the wanton slattern prepares her evil potions.

The discs of jellied fruit show that sweets were sold in spice shops along with beans and dried fruit.

Because spices were always pounded before use, the mortar was an essential piece of equipment in the kitchen.

The interior shown here illustrates the fact that spice shops sold more than just spices. In the 17th century, moreover, there was a gradual decline in the use of spices in the kitchen and an increasing use of fresh aromatic herbs from the kitchen garden, the latter being cheaper and easier to obtain.

▲ Paolo Antonio Barbieri, *The Spice Shop*, ca. 1637. Spoleto, Pinacoteca Civica.

Kitchen Utensils

The tired expression on the woman's face
in this 18th-century work suggests that the
painting may be a critique of the conditions
under which scullery maids worked.

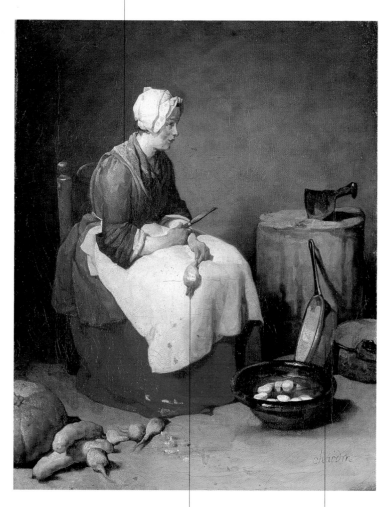

The young woman has
been given the humble
task of cleaning turnips.

The frying pan and cooking pot
show that this is a kitchen. The
precision with which they are
painted illustrates Chardin's
interest in cooking utensils, in
line with the Enlightenment
and Encyclopaedist spirit
of the time.

▲ Jean-Siméon Chardin, *A Woman
Scraping Turnips*, 1738. Munich,
Alte Pinakothek.

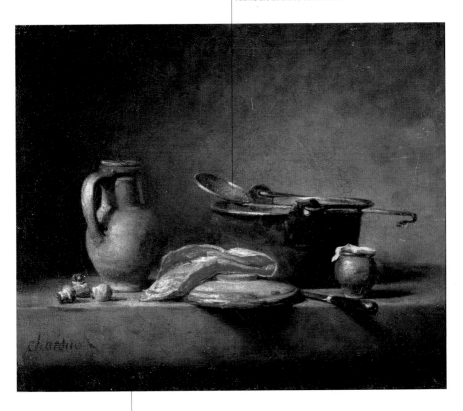

▲ Jean-Siméon Chardin, *Still Life*,
1750–60. Paris, Louvre.

General Index

Absinthe 298
Amphorae, Ewers, Wine-Mixing Bowls, and Coolers 369
Apples 229
Artichokes 206

Banquet of Cleopatra, The 40
Banquet of Esther and Ahasuerus, The 12
Banquets 101
Battle of the Lapiths and Centaurs, The 38
Beef 132
Beer 286
Belshazzar's Feast 9
Bread 120
Breakfast 87

Cafés 82
Carnival, a Festival of Food 109
Ceremonial Drinking Vessels 352
Champagne 296
Charcuterie 145
Cheese 185
Cherries 242
Chestnuts 238
Chocolate 303
Christ in the House of Martha and Mary 17
Christ in the House of Simon 15
Coffee 311
Crustaceans 177
Cutlery 335

Dates 251
Dining Rooms and Banqueting Halls 75
Dinner 92
Dried Fruit and Nuts 253
Drinking Vessels 344

Eggs 191
Etiquette 112

Fantasies 52
Feast in the House of Levi, The 19
Feast of Absalom, The 11
Feast of Herod, The 13

Feast of Saint Gregory the Great, The 32
Feast of the Gods, The 33
Figs 236
Fish 161
Fruit 221

Garlic 202
Gathering of the Manna, The 10
Genre Scenes and Food 60
Golden Age of Still Life, The 53
Grace before a Meal 110
Grapes 248

Hand Washing 373
Honey 266

Kitchens 73
Kitchen Utensils 376

Lamb 151
Last Supper, The 25
Legumes 217
Lemons and Citron 247
Lettuce 209
Lunch 90

Markets 66
Marriage at Cana, The 22
Melons 234
Milk and Butter 181
Miracles of Saint Benedict, The 31
Mollusks 170
Mushrooms and Truffles 212

Nineteenth Century and Still Life, The 55

Olive Oil and Olives 278
Onions 204
Original Sin 8

Parable of the Wedding Banquet, The 24
Pepper and Chilis 276
Philemon and Baucis 37
Picnics 97
Plates 329
Plato's Banquet 39

Pomegranates 240
Pork and Boar 141
Porridge and Polenta 128
Potatoes 214
Poultry and Game 155

Refectories 79
Restaurants 85

Saint Hugh in the Carthusian Refectory 30
Salt 271
Saltcellars 355
Sense of Taste, The 47
Shops 70
Silverware 320
Sin of Gluttony, The 44
Spirits 299
Story of Nastagio degli Onesti, The 41
Sugar 270
Supper at Emmaus, The 28
Sweets 257

Tablecloths and Napkins 324
Tableware 316
Taverns 80
Tea 307
Toasts 117
Tomatoes 216
Toothpicks 342
Twentieth Century and Food, The 57

Vegetables 199
Vessels for Water and Wine 360
Vinegar 281

Water 283
Wine 291

Xenia 50

Index of Artists

Aelst, Willem van 359
Aertsen, Pieter 17, 134, 135, 200
Agnolo di Cosimo, *see* Bronzino, Agnolo
Allori, Alessandro 18, 93, 104, 115
Andrea del Castagno 324
Antonello da Messina 243
Arcimboldi, Giuseppe 52, 128, 141, 155, 201, 204, 206, 248

Balen, Hendrik van, I 36
Barbieri, Giovan Francesco, *see* Guercino
Barbieri, Paolo Antonio 377
Barocci, Federico 336
Bassano, Francesco, 94, 136
Bassano, Jacopo 152, 165, 195
Bassano, Leandro 114, 185, 374–75
Baugin, Lubin 127, 261
Bazzi, Giovanni Antonio, *see* Sodoma
Beert, Osias, the Elder 239, 278
Benci, Antonio, *see* Pollaiolo, Antonio del 278
Benci, Piero, *see* Pollaiolo, Piero del
Béraud, Jean 70
Berckheyde, Job 72
Berentz, Christian 149, 260, 351
Best, Mary Ellen 77
Beuckelaer, Joachim 199
Beyeren, Abraham van 358
Bimbi, Bartolomeo 229, 237, 242, 247, 251
Boccioni, Umberto 58
Boeckhorst, Jan 67
Bononi, Carlo 22
Bonvin, François 190
Bosch, Hieronymus 23, 45, 143, 171, 193, 244, 335
Botticelli, workshop of 41, 318
Boucher, François 89, 245, 250
Bouts, Dieric, the Elder, 76, 122, 346
Bramantino 156
Bronzino, Agnolo 267, 283, 284
Bruegel, Pieter, the Elder 46, 64, 109, 129, 130
Brueghel, Jan, the Elder 48–49

Brugghen, Hendrick ter 220

Caliari, Paolo, *see* Veronese, Paolo
Campi, Vincenzo 118, 161, 186, 224, 259, 364
Caravaggio, Michelangelo Merisi da 53, 222–23, 225, 295, 365
Carlo della Torre 213
Carracci, Annibale 71, 218
Carucci, Jacopo, *see* Pontormo
Cellini, Benvenuto 355
Ceruti, Giacomo 148
Cézanne, Paul 56
Chardin, Jean-Siméon 111, 139, 168, 176, 197, 198, 202, 205, 238, 264, 279, 280, 282, 301, 376, 378, 379
Chimenti, Jacopo, *see* Jacopo da Empoli, Cittadini, Pier Francesco 254
Claesz., Pieter 160, 179, 286, 288, 334
Cleve, Joos van 120
Cleve, Marten van, I 81
Courbet, Gustave 97
Crivelli, Carlo 329

Dandini, Cesare 159
David, Gerard 123, 133
Degas, Edgar 298
Delacroix, Eugène 177
Desportes, Alexandre-François 320
Dou, Gerrit 203
Drölling, Martin 73
Dürer, Albrecht 6
Dyck, Anthony van 226

Elsheimer, Adam 92
Errò 59
Eyck, Jan van 348

Fetti, Domenico 24
Feuerbach, Anselm 39
Flandes, Juan de 164
Flegel, Georg 54, 167, 253, 255, 256
Floris, Cornelis 357
Fourié, Albert-Auguste 108
Fra Angelico 79
Franceschini, Baldassarre 275

Franchi, Alessandro 154
Francken, Frans, II 172–73
Garzoni, Giovanna 189
Gauguin, Paul 55
Gennari, Lorenzo 125
Ghirlandaio, Domenico 272, 322, 326–27
Giotto 121, 369
Giovanni da Milano 16
Giulio Romano 33, 34–35
Gogh, Vincent van 82, 86, 214, 215, 290
Goya, Francisco de 151
Greuze, Jean-Baptiste 341
Grün, Jules-Alexandre 96
Guercino 266
Guido di Pietro, *see* Fra Angelico
Gundmundsson, Gudmundur, see Errò

Hals, Frans 105, 137, 180
Hamen y León, Juan van der 262
Heda, Willem Claesz. 174, 274, 276
Heem, Jan Davidsz. de 178, 367, 371
Heemskerck, Maerten van 62–63
Helst, Bartholomeus van der 354
Hogarth, William 80, 88, 106–7, 140, 308, 323, 340, 372
Honthorst, Gerrit van 300
Hooch, Pieter de 183, 289
Horenbout, Gerard 356

Jacopo da Empoli 212
Jordaens, Jacob the Elder 91, 184, 338–39, 368

Kalf, Willem 240, 270

Lancret, Nicolas 328
La Tour, Georges de 219, 291
Lega, Silvestro 313
Le Nain, Louis 319, 325
Le Nain, Mathieu 28
Leonardo da Vinci 217, 332–33
Leprince, Jean-Baptiste 306
Liagno, Filippo, *see* Napoletano, Filippo
Limbourg brothers 317

Linard, Jacques 227
Liotard, Jean-Étienne 305, 307
Lippi, Filippo 13
Longhi, Pietro 69, 131, 211, 263,
 309, 312
Loo, Carle van 100
Lotto, Lorenzo 287, 343
Luini, Bernardino 373

Maes, Nicolaes 110
Mälesskircher, Gabriel 15
Manet, Édouard 84, 90, 98–99, 150,
 169, 170, 246, 265, 296, 297
Marmion, Simon 361
Master of the Acquavella Still Life 210
Master of the Gathering of the
 Manna 10
Master of the Housebook 27
Meléndez, Luis 216, 234, 236, 303
Merisi, Michelangelo, see Caravaggio,
 Michelangelo Merisi da
Metsu, Gabriel 138, 233
Metsys, Quentin 182
Mieris, Frans van, the Elder 349
Monet, Claude 87, 132, 302
Mores, Jakob, the Elder 353
Moringer, Veit 352
Murillo, Bartolomé Esteban 61, 235

Napoletano, Filippo 221
Niccolò di Pietro 347
Noter, David de 209

Paolo di Dono, see Uccello, Paolo
Passarotti, Bartolomeo 157

Passini, Ludwig 83
Pensionante del Saraceni 366
Piero di Cosimo 38, 268–69
Piero di Lorenzo di Chimenti, see Piero
 di Cosimo
Pippi, Giulio, see Giulio Romano
Pissarro, Camille 42
Pollaiolo, Antonio del 163, 345, 360
Pollaiolo, Piero del 163, 345, 360
Pontormo, 29
Poussin, Nicolas 252
Preti, Mattia 11

Recco, Giovanni Battista 188
Rembrandt van Rijn 153
Reni, Guido 232
Renoir, Pierre-Auguste 85, 299
Ricci, Sebastiano 228
Robusti, Jacopo, see Tintoretto
Romani, Girolamo, see Romanino
Romanino, 271
Rombouts, Theodoor 47
Rubens, Peter Paul 8
Rubens, Peter Paul, workshop of 37

Signorini, Telemaco 66
Snyders, Frans 67, 144, 249
Sodoma 31
Steen, Jan 146, 147, 175, 257
Stom, Matthias 95
Stosskopf, Sebastian 344
Strobel, Bartholomäus, the Younger 116
Suardi, Bartolomeo, see Bramantino

Subleyras, Pierre 316

Taddeo di Bartolo 44
Teniers, David, the Elder 74
Teniers, David, the Younger 60
Tiepolo, Giambattista 25, 40, 281
Tintoretto 9, 75, 231, 258
Titian 194, 273, 293, 294
Tiziano Vecellio, see Titian
Troy, Jean François de 78

Uccello, Paolo 292

Vallayer-Coster, Anne 145
Vasari, Giorgio 12, 32
Velázquez, Diego 166, 191, 277, 285
Velde, Jan van de, III 350
Vermeer, Jan 124, 181
Veronese, Paolo 2, 19, 20–21, 342, 370
Volterrano, Il, see Franceschini
 Baldassarre
Vos, Cornelis de 241

Warhol, Andy 57
Watteau, Jean-Antoine 117
Wedig, Gotthardt 337
Weyden, Rogier van der 14
Wtewael, Joachim Anthonisz 158

Zavattari brothers, 314
Zoffany, Johann 68, 310
Zurbarán, Francisco de 30, 196, 304

Photograph Credits

Akg Images, Berlin: cover and pp. 8, 24, 30, 37, 39, 41, 42, 45, 46, 54, 58, 61, 62–63, 73, 75, 82, 83, 87, 98–99, 103, 112, 124, 138, 143, 146, 156, 160, 164, 166, 170, 172–73, 191, 197, 206, 207, 214, 215, 230, 239, 252, 256, 264, 267, 273, 277, 285, 291, 294, 296, 297, 301, 302, 305, 316, 322, 329, 348, 379 © Amsterdam, Rijksmuseum: pp. 181, 257, 290, 354
Antonio Quattrone, Florence: pp. 16, 187
Archivi Alinari, Florence: pp. 66, 121
Archivio Mondadori Electa, Milan, by permission of the Ministero per i Beni e le Attività Culturali: pp. 13, 19–21, 29, 31, 33–35, 44, 51, 69, 81, 118, 125, 131, 148, 152, 154, 157, 159, 162, 163, 194, 212, 221, 224, 225, 226, 231, 242, 247, 254, 258, 259, 263, 271, 293, 295, 313, 336, 347, 356, 363, 364, 373, 377; Anelli Sergio, Milan: pp. 205, 314, 343; Bruno Balestrini, Milan: pp. 324, 326–27, 365; Bardazzi Fotografia, Sesto Fiorentino: pp. 171, 193, 244, 335; Foto Brunel, Lugano: p. 357; Laurent Lecat, Paris: p. 298; Antonio Quattrone, Florence: pp. 287, 332–33; Pirozzi, Rome: p. 260; Marco Ravenna, Bologna: p. 22
Archivio Seat/Gestione Archivi Alinari: pp. 208, 229, 251, 359
Art Gallery, Glasgow: p. 150
Artothek, Weilheim: pp. 17, 92, 116, 144, 235, 240, 300, 340, 358, 378
Berlin, Gemäldegalerie: pp. 27, 76, 130, 158, 278, 334, 367
Boston, Museum of Fine Arts: p. 234
Bridgeman Art Library, London: pp. 36, 40, 47, 55, 60, 64, 70, 72, 78, 79, 84, 90, 94, 96, 97, 100, 109, 114, 135, 137, 155, 180, 184, 196, 209, 216, 228, 241, 245, 246, 248, 250, 261, 266, 268–69, 280, 284, 289, 304, 317, 325, 328, 353, 360, 371

Brussels, Musées Royaux des Beaux-Arts: pp. 123, 368
Budapest, Museum of Fine Arts: p. 166
© Cameraphoto Arte, Venice: pp. 69, 211, 281, 312
Cologne, Wallraf-Richartz Museum: p. 167
© Corbis/Contrasto, Milan: p. 38
(National Gallery Collection; by kind permission of the Trustees of the National Gallery, London); p. 53
(Archivio Iconografico, S.A.); pp. 74, 110, 169, 179, 349 (Francis G. Mayer); p. 323 (Philadelphia Museum of Art); Cremona, Museo Civico: p. 204
Erich Lessing/Contrasto, Milan: pp. 18, 25, 48–49, 52, 56, 77, 80, 106–7, 108, 111, 120, 127, 139, 140, 141, 147, 151, 153, 168, 176, 177, 178, 185, 198, 202, 203, 219, 222, 233, 236, 238, 243, 274, 276, 319, 338–39, 342, 346, 355, 370, 372, 374–75, 376
Florence, Accademia della Crusca: pp. 126, 187
Fort Worth, Kimbell Art Museum: pp. 71, 195
Francesco Turio Böhm, Venice: p. 311
Frankfurt, Städelsches Kunstinstitut: p. 299
Gusman/Leemage: p. 279
Haarlem, Frans Hals Museum: p. 105
The Hague, Mauritshuis: p. 175
Kassel, Staatliche Kunstsammlungen: p. 199
Kirchheim, Fuggerschloss: p. 161
© London, National Gallery: p. 88
London, Tate Gallery: pp. 68, 308
Los Angeles, The J. Paul Getty Museum: pp. 183, 210, 282, 307, 310
Louvain, Saint-Pierre: p. 122
Luciano Pedicini Archivio dell'Arte, Naples: pp. 50, 101, 102, 188, 232, 321
Madrid, Museo Nacional del Prado: pp. 262, 303;

Madrid, Museo Thyssen-Bornemisza: pp. 95, 220, 270, 286, 352
New York, Metropolitan Museum: pp. 265, 309;
Oronoz, Madrid: pp. 136, 174
Otterlo, Rijksmuseum Kröller-Müller: p. 86
Oxford, Ashmolean Museum: p. 350
Padua, Musei Civici, Cappella degli Scrovegni: p. 369
Pesaro, Museo Civico: p. 351 © Photo RMN, Paris: pp. 2 (00-003540, René-Gabriel Ojéda), 89 (94-061152, Daniel Arnaudet), 132 (00-022553, Hervé Lewandowski), 133 (93-001938-01), 190 (02-010124, Hervé Lewandowski), 217 (03-006118, René-Gabriel Ojéda), 337 (79-000571, Jean-Gilles Berizzi)
Rotterdam, Boymans–van Beuningen Museum: pp. 23, 288
St. Petersburg, The Hermitage: p. 341
© Scala Group, Florence, by permission of the Ministero per i Beni e le Attività Culturali: pp. 9, 11, 12, 15, 26, 32, 57, 67, 91, 93, 101, 104, 113, 115, 142, 149, 165, 189, 192, 218, 237, 272, 275, 292, 330, 331, 345, 362; Scala Group, Florence/Bildarchiv Preussischer Kulturbesitz, Berlin: pp. 14, 117, 145, 182, 200, 361
Stockholm, National Gallery: pp. 59, 85, 249, 320
Stockholm, Skokloster Castle: p. 201
Strasbourg, Musée des Beaux-Arts: pp. 227, 344
Stuttgart, Staatsgalerie: p. 213
Toledo (Ohio), Museum of Art: p. 306
Vienna, Kunsthistorisches Museum: pp. 128, 129, 134
© Washington, National Gallery: p. 366

The publisher will provide all entitled parties with any unidentified iconographical sources.